SELF EVIDENT TRUTHS

SELF EVIDENT TRUTHS

10,000 PORTRAITS OF QUEER AMERICA

iO TILLETT WRIGHT

FOREWORD BY
PATRISSE CULLORS

PRESTEL

MUNICH · LONDON · NEW YORK

CONTENTS

398 #7,573–7,602
University of Delaware
Newark, DE
September 19

400 #7,603–7,808
South Carolina Pride
Columbia, SC
September 20

409 #7,809–7,845
Portland, ME
September 21

411 #7,846–7,905
Rhode Island School
of Design
Providence, RI
September 22

414 #7,906–7,945
Salisbury University
Salisbury, MD
September 24

416 #7,946–8,015
University of Louisville
Louisville, KY
September 25

420 #8,016–8,170
Virginia PrideFest
Brown's Island, VA
September 27

427 #8,171–8,227
New London, CT
September 29

430 #8,228–8,254
Furman University
Greenville, SC
October 9

2015

433 #8,255–8,256
New York, NY
March

434 #8,257–8,308
Laramie, WY
April 10

436 #8,309–8,373
Honolulu, HI
May 23

439 #8,374–8,524
Anchorage PrideFest
Anchorage, AK
June 6

446 #8,525–8,627
PrideFest Milwaukee
Milwaukee, WI
June 7

451 #8,628–8,727
Albuquerque Pride
Albuquerque, NM
June 13

455 #8,728–8,878
North Jersey Pride
Maplewood, NJ
June 14

462 #8,879–9,078
Heartland Pride
Omaha, NE
June 20

472 #9,079–9,298
Seattle Pride
Seattle, WA
June 28

482 #9,299–9,356
Boise Pride Festival
Boise, ID
July 6

488 #9,357–9,361
Los Angeles, CA
November

490 #9,362–9,386
The Atlantic LGBT Summit
Washington, DC
December 10

2016

493 #9,387–9,459
Rainbow Pride of West Virginia
Charleston, WV
June 2

498 #9,460–9,492
Big Sky Pride
Helena, MT
June 21

502 #9,493–9,592
Mississippi Pride
Jackson, MS
June 25

2017

509 #9,593–9,598
Los Angeles, CA
July

2018

513 #9,599–9,616
New York, NY
August

2019

517 #9,617–9,644
Levi's
Los Angeles, CA
September 5

521 #9,645–9,662
Levi's
New York, NY
September 7

522 #9,663–9,772
New York, NY
September 9

527 #9,773–9,787
New York, NY
September 10–13

528 #9,788–9,852
Los Angeles, CA
September 14

531 #9,853–9,874
Los Angeles, CA
October–November

532 #9,875–10,000
New York, NY
December

FOREWORD

Poetry is not only dream and vision; it is the skeleton architecture of our lives. It lays the foundations for a future of change, a bridge across our fears of what has never been before.
—Audre Lorde, "Poetry is Not a Luxury," 1985

I am grateful for Audre Lorde and the way she consistently showed up as her full self, unapologetically. As a young Black queer girl coming of age in the 1990s, I looked to her as my compass of courage to express *my* full self in a time when queerness was largely invisible. She was my poetry. Today iO Tillett Wright is doing the archival work that I wished I had more of growing up. This book is the largest collection of photographs of queer, trans and non-binary people— 10,000 beautiful images that capture us in all of our complexity, our honesty, our raw selves. This is an act of resistance as we make ourselves visible during these anti-queer and anti-transgender times.

I first met iO when he photographed me and my partner, Future, at a park as part of a project documenting queer love for *Vogue*. Future, a trained fighter in the ring, was teaching me to box. There I was, a total novice, hyper-focused on not looking completely ridiculous—as the images would be archived forever. Future, of course, was in their element, so they effortlessly executed the best angles and poses. But this was still just another day in our lives, a fun experience like many we had had before and the many that have come since. Yet, as I look at these images, I am stunned by how an ordinary day can be transformed into artistic expression. These photographs reflect back intimate renderings of love. Black and Brown faces fill up the space with possibilities. iO was clear about who it was that he wanted to capture; he was clear that *all* of us needed to be seen. And these everyday images of the queer community are the representations we seldom see as part of the cultural conversation in the United States. We have made great strides in the last few decades, and for those victories we are indebted to the ancestors whose shoulders we stand on, who quite literally risked their lives on the front lines against white cisheteropatriarchy.

As I see it, we have been left with a new charge: to amplify, complicate, and enumerate the stories about who we are. Popular culture has allocated us one-dimensional, palatable portrayals: we are the comedic relief, the sassy best friend, or the snarky-but-stylish character we all hate to love. And while these depictions may be true for some of us, there is a pantheon of narratives that remains unexplored. This collection of images, with depictions of us living out our authentic lives in all ranges of emotion and expression, has created a platform to transform the cultural narrative. The form of visibility that iO has skillfully outlined for us is the "bridge across our fears" to which Lorde was alluding. This collection serves as a reclamation of our full selves.

I often imagine what world would be possible if we could see ourselves mirrored back at us through art. How many lives would be saved? How many stories would be shared? How much brilliance would be acknowledged? The portrayals that iO has so brilliantly captured are monumental and necessary and expand the tapestry of our stories as queer, transgender, and non-binary people. These images represent the bold statement and affirmation that we are still here—more grand, exquisite, and powerful than ever. I am honored to uplift iO's work as a continuation of the rich legacy of artists who see us, validate us, and transform us into works of art. Thank you, iO, for your years of effort to make space for us in the canon. The world is seeing us too.

—Patrisse Cullors

Patrisse Cullors is an artist, organizer, educator, and freedom fighter. Born and raised in Los Angeles, California, Cullors is one of the nation's most prominent civil rights leaders. She has been at the heart of several social movements, including founding Reform LA Jails and co-founding Black Lives Matter. In 2018 Cullors became an instant New York Times bestseller for When They Call You a Terrorist: A Black Lives Matter Memoir. *You can find her portrait on page 519 of this book.*

INTRODUCTION

"They were going to leave me to die." The young woman looks into my eyes as she tells me how she came to be in this room.

We're at the top of an auditorium where I've just given a talk. A student asked me to come up and meet their best friend, who couldn't traverse the stairs in her electric wheelchair. It's 2016, and I've photographed thousands of queer people across America over the last six years. I've heard many stories that shred the heart—I'm not an easy cry—but something about this person hits me in the chest. I sit down on a railing and bend my body toward her soft voice.

The young woman, a slight figure in an elegant sweater with a smudge of bright pink across each of her cheeks, smiles gently as she tells me how she immigrated to this country with her family from Guatemala. She describes how, at fifteen, in their shared apartment in Maryland, muscular dystrophy took the function of her legs. Her family, all blue-collar workers, couldn't reckon with her condition so they would go to work every day and leave her in the apartment to fend for herself. She told me of dragging herself across the house and into the shower using her forearms. Her high school guidance counselor helped her to find medications, insurance, and a wheelchair. Life was hard, but manageable. Then, she told her family she was transgender. "They started making arrangements to send me back to Guatemala. Do you know what they do with people like me in Guatemala? They wheel you into a field, dump you out of your chair, and leave you to die."

Suddenly, I am acutely aware of the privilege I have in being able to feel the staircase railing cutting into my backside.

The young woman tells me how she moved in with her guidance counselor (who legally adopted her), finished high school with excellent grades, and got a scholarship to the college I was hired to speak at. The college that put us both in this room. When she turned eighteen she was able to get access to the hormones she had longed for, but there was a problem. A big problem. Estrogen, which she needed to take

to feel like she was in the right physical form, was counter-acted by another drug she was already on—Prednisone, which staves off the inevitable consumption of her body by her disease and, ultimately, her death. The thing that was keeping her alive was keeping her in a half-life.

I could feel the hairs on my neck stand up. Being a trans person not yet ready to commit to what I knew was going to be my own journey, I braced for what she said next.

"I stopped taking the Prednisone, because I would rather live a shorter life as myself than a longer one as a lie."

Tears pushed up and out of my eyes, entirely out of my control. I wanted to hug her, to hold her tender, precious form and tell her it was a treasure. That she should chase down and embrace whatever it took for her to feel whole. But who was I to tell her anything about her body?

I didn't know it at the beginning, but it is stories like this that I wanted *you* to know. It's stories like hers that are why all this happened.

Let's rewind to January 2010, when the whole thing began.

It was the middle of the night in my small bedroom in Brooklyn. A radiator clanked in the corner, and my youthful idealism bulged the paper-thin walls of the apartment. Some 3,000 miles away, the Mormon and Catholic churches were fueling a fierce disagreement over Proposition 8—a law banning same-sex marriage—in the State of California. Prop 8 had passed in 2008 but was now being contested by civil rights advocates, and both churches were pouring millions into its defense under the guise of the "protection" of marriage and families. The high-stakes squabble ignited a nationwide debate about whether or not gay people were sex-offending misfits whose marital unions threatened the moral fabric of the United States. Religious and conservative groups were painting homosexuality and gender "variance" as predatory, as corrupting of innocent children, and as the first stop on

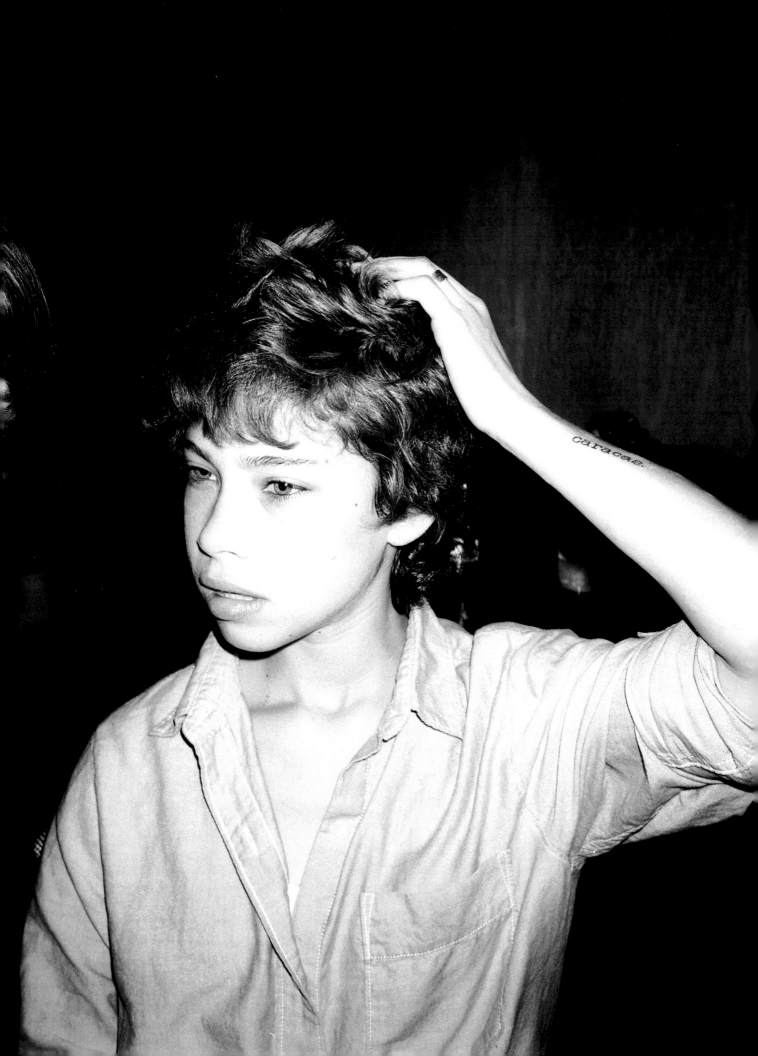

a short road to bestiality. On the other side, queer people closed ranks and argued for their basic dignity. At the time, not only could queer people not marry in most US states, but in 37 of them you could be fired for your gender or sexuality. It was forbidden to be out in the military, and conversion "therapy" was both legal and a common practice in some areas.

The statistic being used in 2010 was that 3 percent of the population was gay (trans people and other stripes on the rainbow hadn't entered the popular equation yet), which was a number pulled from self-identifiers on the United States Census. With the stakes still high for out queer people in non-coastal areas, it was safe to assume that many did not choose to self-identify and that the percentage was actually a lot higher. (If one wanted to expand the criteria to include the spectrum of non-heteronormativity, the number would surely balloon further.) An estimate of 7 percent felt like a fair compromise between instinct and statistics, so I did a little calculation on a napkin: if 7 percent of the population were something other than straight, with 370 million people in the United States that would mean there were almost 26 million of us. To use a drag colloquialism, that number blew my wig back.

I was raised by a mother who, at first glance, most people thought was a man. My father had a brief affair with my godfather in the 1970s, and both of my parents' best friends died of AIDS. My pre-K and elementary schools were in New York City's historic gay neighborhood, and I pronounced to my parents at age six that, despite being born with a vulva, I was in fact a boy. To say that we are a queer family is an understatement. Discrimination, shame, and fear are ingredients baked into my emotional cake—being a trans child teaches you as much. But as a growing political awareness set into my young mind, I was blown away by the ludicrous nature of the reality for people who were anything other than straight in 2010, in the "land of the free." This massive population was still living in a legal ghetto. Why?

I studied the people I saw on television who argued in earnest that our "limp wrists" and "butch" haircuts symbolized some kind of "deviant lifestyle." I tried my best to square the love that Christians claimed was at the heart of their church with the hatred and marginalization of millions of Americans under the loose banner of "family values." I knew deeply that they were wrong, but I became fixated on the gulf between who "we" were and what they believed "us" to be. I knew that there was no "us," except when they drew the widest of circles around all of "us" to quarantine "us" away from their children. Sexual orientation and gender are not lifestyles or binding agents, they are immutable biological realities that produce as many

different lifestyles and moral compasses as race or nationality. There are trans Republicans and intersex football players; gay ministers pound the pulpit more vigorously than most; and a basic criterion for being a nun is asexuality. These crusaders for the "defense" of modern morality were unquestionably off in their assessment of both "us" as a community, and what "we" as a community liked to do with our Saturday nights. I wondered what could be done about that.

In 2010 I had recently made a career change, from an implausible tenure in independent art magazine publishing to an even more financially unviable stint as a fine art photographer. I had two columns with the *New York Times* that paid me just enough to cover my monthly MetroCard and an occasional bowl of instant ramen. My artwork—grainy, monochrome photographs of young people emerging from the inky blackness of night—were an exploration of myself and why I felt out of place in my skin. I would toil over these images in the closet-sized Chinatown darkroom I shared with three other guys, blasting Biggie and generally resigning myself to my role as a hipster stereotype. I was in no way an activist, but I was an empath with an eye for injustice and some free time on my hands.

In light of the increasingly tense legal situation for queer people in the US, a friend of a friend was mounting a massive art show in Los Angeles called *Manifest Equality*. Yosi Sergant had worked for Barack Obama in the heady early days of his campaign, and now he wanted to stage a 170-person group show in solidarity with LGBTQ+ people. A true ally. His was my first invitation to exhibit my photos, alongside a slew of accomplished painters and sculptors, and I was desperate not to fuck it up. I had settled on a beautiful image painstakingly printed on museum-quality paper and mounted by the best framers in town (the shipping alone cost more than my rent), but something felt lackluster about a fancy print of a pretty person being my contribution to this cause. The issue at hand was real; it was life or death for many and meant others would lose their homes, jobs, and families. If I was going to speak to the problem, I should at least try to come up with a solution to it.

Which brings us back to that frigid January night when the muses slapped me awake with a realization: "They think they don't know us. They think we are less human than they are. They think we're beasts." This gave me a way in to a solution: I decided that I was going to apply what I was decently good at to what I hoped to change, and I wouldn't stop until things were better. I was going to photograph every queer person I could find and try to introduce them to the people who discriminated against them, because knowing someone

This photo of Camila set the bar for everything I pursued in my fine art work for years to come. Candid, honest, direct.

is the key to melting hatred. In the winter of 2010, "everyone I knew" was 34 people.

Between January and March I tumbled over snow banks and into lakes of filthy slush, making my way around New York photographing people on the street, mostly in front of their homes. I got terribly sick, but in the end I had the portraits I needed. I made five small prints of each portrait and got on a plane with a pocketful of faces. I set the images out in neat stacks on a chair, and the doors to *Manifest Equality* opened. I watched as curious gallery-goers paused in front of the piles, unsure if they were to be touched. One man pushed a few aside with a fingertip and picked up a portrait of a beautiful Israeli boy, slipping it into his jacket. A tall blonde woman approached and bent her torso over the chair. It was the actress Daryl Hannah. She rifled through and handed a print to her companion. On it went all night, and all through the opening weekend, until there were a scant few images left on that little chair. My experiment had worked: people were curious about each other. They had largely picked through the images for their crushes, but they had taken the pictures home and put them on their fridges, and the inevitable "Who the hell is that?" from loved ones had sparked important conversations. When one of the exhibition's sponsors later approached me and asked what I wanted to do with the idea, I said, "Well, I've photographed every cute lesbian in Williamsburg— I guess it's time to take the project national."

In my limited, 25-year-old city-kid brain, I could only dream of photographing gay black cowboys in Montana, queer truckers in Texas, and undercover farmers in Louisiana. I longed to see that side of America and bring it out of the shadows. I was afraid of what might happen, thinking of Brandon Teena's and Matthew Shepard's fates, but I was more invigorated by the possibility of contributing something good to the world.

First, I had to name the thing, and what better phrase to speak to the simple moral lapse I was trying to elucidate than the basic premise upon which this country was built:

WE HOLD THESE TRUTHS TO BE SELF-EVIDENT, THAT ALL MEN ARE CREATED EQUAL

It was written in the Declaration of Independence, but this fundamental tenet of Americanness was being forgone in favor of religious fervor. My simple challenge became to ask: "Look these people in the eye and tell me that they deserve less than you." Next I had to figure out how to make something truly egalitarian. How do you represent a large number of people equally?

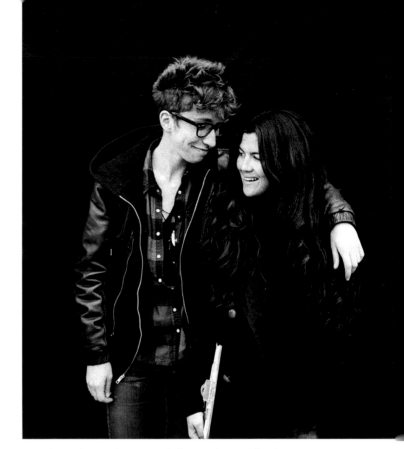

Me and my producer, Kashi Somers, at the first open shoot, in Williamsburg, Brooklyn, 2011.

I turned to some of the work I was most moved by: Irving Penn's *Small Trades* photo series from 1950–51, showcasing blue-collar tradesmen in his elegant studio context; Richard Avedon's *In the American West* from the late 1970s and early '80s, where he coaxed farmers and laymen out of county fairs and from their trucks for a confronting portrait against a clean white backdrop; Bernd and Hilla Becher's systematically arranged portraits of buildings. But there was one particular collection of images that moved me like no other, because it was not, in fact, a body of work but the document of an atrocity—a collection of photos of people who were awaiting their execution at S-21, the Khmer Rouge killing center used during the Cambodian genocide of 1975–79. At least 14,000 people were slaughtered there, and a teenager named Nhem En created what I understand to be the largest single document of a population in history. Nhem En, a staff photographer at the facility and under threat of death himself, placed every unsuspecting prisoner in front of a white wall, pinned a number to their shirt (or sometimes their bare skin), positioned their head optimally for the flash, and took a mugshot.

The unifying format signaled membership of a community that outweighed each person's individual humanity; the number showed their reduction to a statistic. Yet, despite their being imprisoned, stripped of their personal effects,

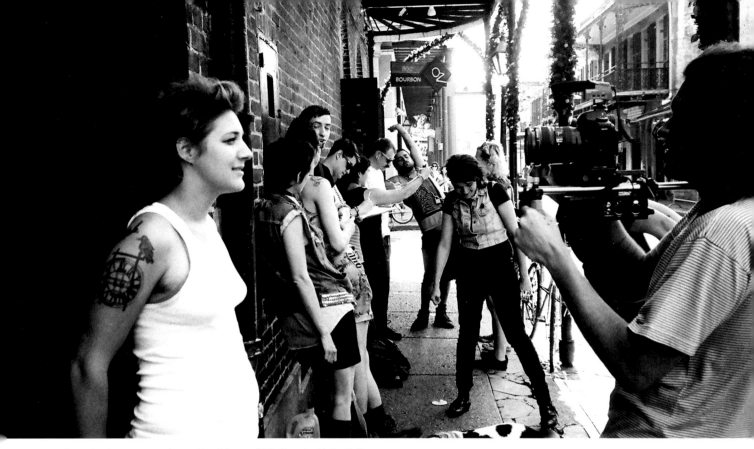

A crowd gathers at an open shoot in New Orleans in 2012. Filmmaker Nathan Drillot films a video portrait in the background.

and undoubtedly aware that something horrific awaited them, so much humanity radiates from the people in those photographs.

Armed with this pared-down approach, and inspired by the subjects emerging from darkness in Caravaggio's and Nan Goldin's work, I chose to use a black backdrop and natural daylight only for the Self Evident Truths project. This was not to be a series of lighthearted, pretty pictures but a confronting document of a class of people subjected to discrimination and violence. Then I worked to erase my own perspective as an artist, allowing the simplicity of the subject's humanity to shine clearly, with as little manipulation from me as possible. I would not instruct people on what to wear, and there would be no glam or blemish retouching. Just them, as they walked in off the street and wanted to present themselves.

Over the course of late 2010 and early 2011, my producer Kashi Somers and I figured out an absolutely inclusive call—one that was directed not to gay people specifically but to any variance from heteronormativity, to encompass the vastness of the group these discriminatory laws affected: "If you feel like you are anything OTHER than 100 percent straight or cisgender, I want to take your picture." In April 2011 we announced the first open calls with a simple flyer sent to our friends and hoped that the internet would do its work of contagion.

During ten shooting days, 265 people offered their faces to the project. Often it took some convincing—many weren't out to their families at home—but once we learned to articulate what we were doing and why visibility was going to be key to winning the hearts of our detractors, everyone was game. At the end of two weeks of shooting, I knew we needed more. Many more. The point of our individuality needed to be told en masse.

As I read more about social psychology, researched successful civil rights movements, and had discussions with the subjects, my unconscious instinct became a clearly voiced perspective drawing from the age-old truth that you can hate something only until it springs up in your own family: "Familiarity breeds empathy."

"Familiarity" springs literally from the idea of family. It refers to those we know. This is the family of humankind. The more you see of your family, the more you want to love and protect it. It's easy to denigrate people you've never met, but it's hard to hate them when they're standing in front of you.

We hate what we fear, and we fear what we don't know. So to dismantle hate, we have to create familiarity.

VISIBILITY IS EVERYTHING.

Tyler Renner and me at the end of the last public shoot, in Jackson, Mississippi, in 2016.

Using footage from the initial New York shoots we created a two-minute manifesto video, stripping back my big ideas to their most fundamental goal. We uploaded it online and again waited to see what would echo back from the abyss of the internet. About 85,000 people watched it and our inbox became an avalanche of messages. People from every corner of the country wanted to stand up and be seen. They were ready for the injustice and mischaracterization to end, and if putting a face to the label would help, they were champing at the bit to do it.

In mid-2011 I mounted a Kickstarter campaign to visit San Francisco and Los Angeles to photograph more people, and then the playwright Eve Ensler got hold of me wishing to make a private donation. She offered me $10,000 and asked what I would do with it. I said I wanted to go to the deep South. I wanted to point my lens at the queer people who are erased and ignored the most. Eve cackled and said I had a death wish—but she liked it, and a check was in the mail. In early 2012 I put her money into a seventeen-day tour of twelve cities across the South, returning with 1,200 new Self Evident portraits. Flabbergasted that I had kept my word, Eve invited me to close out TEDxWomen with a speech about my project.

Sweating and freezing at the same time, I got up on a stage in Washington, DC, in front of three hundred brilliant minds and told them my dream: a world in which sexuality and gender are recognized for the spectrum that they are, and where queer people are allowed to be nuanced. We are not all one thing, and to force us to operate as such is to flatten our humanity into a two-dimensional trope. I called the talk "Fifty Shades of Gay" and begged the audience to recognize that queer people had evolved past the simple boundaries painted around us by others trying to "protect" the world from what had historically been perceived as a mental defect. We were ready to be understood as multifaceted human beings.

In January 2013 my talk went live on TED.com, and everything changed. Almost overnight I became an educator and orator, speaking at schools I couldn't have beaten the door down to get into back when I briefly thought college was a good idea. Stanford, Georgetown, and so many others invited me to rabble-rouse their students and encourage them to do things their own way, and the project was injected with rocket fuel. It became clear that, for the Self Evident Truths project to represent the entire spectrum of our community and be nationally impactful, I would have to photograph 10,000 people and shoot in every single state. I had no earthly clue how it would happen, but it was go big or go home.

In 2014 I met Tyler Renner, a wide-eyed young man from Santa Barbara whose infectious charm would magnetize thousands of people to the project. I plucked him up and took him to thirty states over four years, running through airports with one shoe on, chasing pride festivals and queer gatherings across the country. We slept in bottom-of-the-barrel hotels and sampled the Thai food in three dozen cities. Eventually we solidified our shtick: we'd arrive at a pride festival in you-name-it city and he'd charm the stage manager into letting me onstage at a moment of heightened audience attention. I would run up and speed through telling thousands of people that this was their only chance to represent their state in what was going to be the largest document of queer people in history, and to "Meet me over there where that cute boy with the blue hair is waving." I'd get offstage and a stampede of people would follow. Often that stampede largely comprised white, lesbian-identifying people, so I sent Tyler out on a mission: to prioritize recruiting people of color and gender-nonconforming people. For this project to be truly effective it had to represent the truth of the spectrum, not just who pays attention when a white kid gets up and asks them to participate in something. This project could not be a mirror of me. Bless Tyler Renner's pretty eyes and gleaming smile forever, because it worked.

Ten years later, I have photographed 10,000 other-than-straight people in every state in the United States. The diversity in these pages was hard-won and deeply intentional. "We"

don't look like any one thing, and neither do these portraits. Every shoot was free, open to the public, and without qualification. There are those who are proud to admit their place in this circle, and there are many others for whom this book is their first step into the public gaze. The subjects encompass everyone, from the most flamboyant queers to grandmothers who once had a passing fancy for other women—because in many US states, that is enough for them to be fired. It is the modern version of the one-drop rule: 1 percent is enough. One glance, one kiss means you have *the queer*, and discriminating against you is legal.

I have photographed both of my parents, my brother, his wife, and nearly everyone I know. I shot the model Cara Delevingne in an alley in Chinatown while she was on a break from shooting a DKNY campaign, with my backdrop taped to a greasy wall; writer and actor Lena Waithe let me shoot her next to the hot tub outside her bedroom; and actor Sarah Paulson fell in love with my dog as he terrorized her backyard.

I met those gay black cowboys, those truckers, the farmers, and so many others I never could have dreamed of: the trans cop in San Francisco working to disrupt the system from within; the Oklahoma rancher who spent twenty undercover years with the love of his life after they met playing high school baseball; the family in Arkansas who left their Baptist church when they realized it was preaching self-hatred to their newly out lesbian teenager.

There were the tragedies, the stories of friends and lovers lost to torment, untreated mental illness, and suicide; countless tales of homelessness and of families kicking their kids out; there was sickness and depression, grief, and legal battles—but more than anything else, there was resilience. I met 10,000 people who have overcome a society telling them that they're sick, who have found the strength to persevere and live beautifully, fully, and with grace. I found myself through this project, and I found a community—not because someone tells us we have to be, but because we choose each other.

This book and this project are the tiniest kernel of sand on a vast queer beach, but every single face is a story, a world, and carries pain. This is a document of a group of people ravaged by the legal system, abandoned by the government, and uplifted by love. This book shows 10,000 faces of survival, charisma, and charm. We are your friends, your cooks, your bus drivers, your children. We are your parents, your teachers, your housekeepers. We design your clothes and your technology. We keep the lights on.

WE ARE YOU.

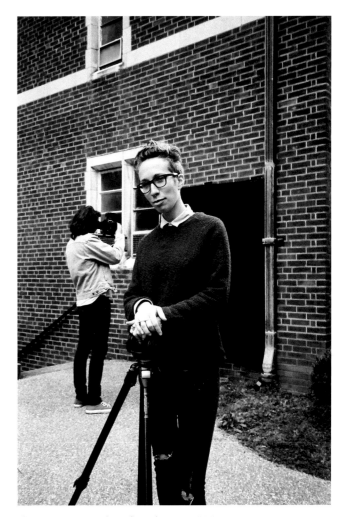

Shooting at a university during the southern tour in 2012.

I've done my best to make this project a reflection of what I believe the community should be—a love without condition. We hold an open seat at the table for you, without qualification. Welcome to the family.

—iO Tillett Wright

17

FAMILIARITY IS THE GATEWAY

DRUG TO EMPATHY

2010

1-36 New York, NY

Maryellen

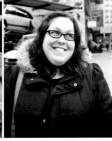

Amy, editor

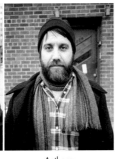

Anthony

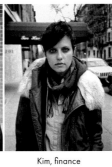

Kim, finance

Molly, dancer

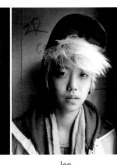

Jen

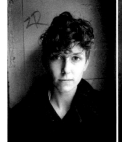

Holly

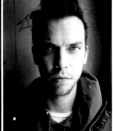

Neal, photographer

Natalia, director

Stacey

Juliana, sculptor

Amelia

Kate

Twiz, artist

Antonia

Molly

Larin, writer

Rosalina, editor

Leslie, filmmaker

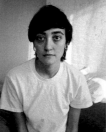

Nina, writer

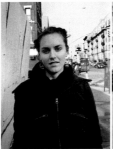

Evangeline

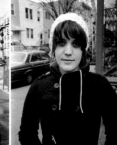

Giuliana, restaurant manager

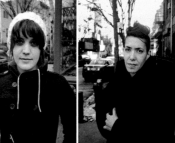

Katerina, curator

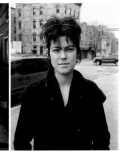

Laura

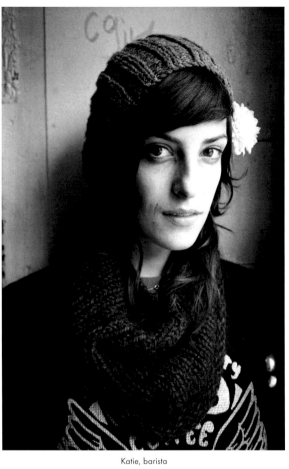

Katie, barista

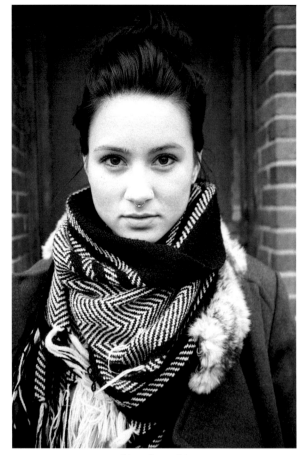

Erin, makeup artist

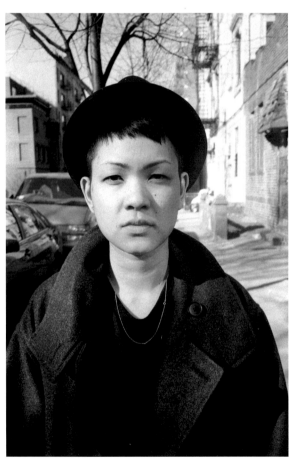

Christelle, photographer

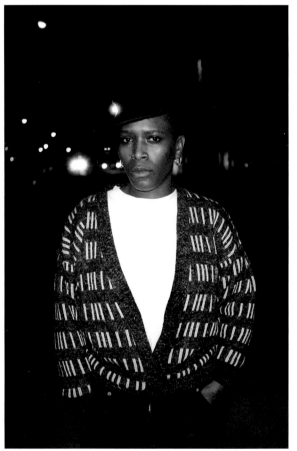

Shannon, musician

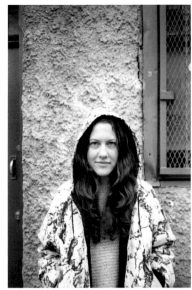

Katherine

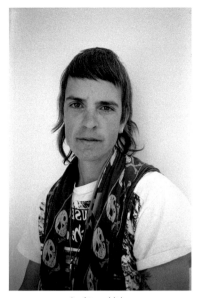

Sophie, publisher

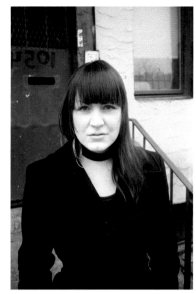

Rachel

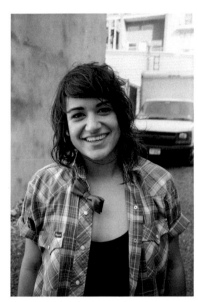

Sabrina, comedian

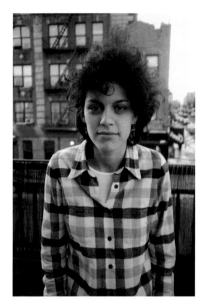

Luiza, sound mixer

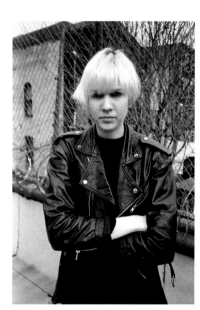

Lauren, DJ

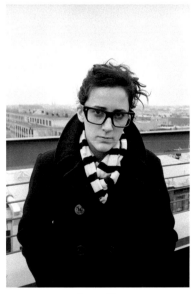

Lauren, DJ

Amy, merchandise coordinator

2011

Adelmo, 28, photo assistant

Karen, 30, therapist

Wendy, 40, vocal coach

Caitlin, 25, musician

Barbara, 33, yoga teacher

Alexandra, 27, filmmaker

Zoe, 26, corporate strategist

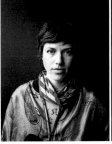
Amy, 32, artist

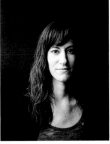
Danielle, 29, nurse

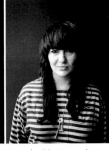
Amanda, 28, interior designer

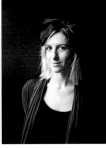
Lily, 23, writer

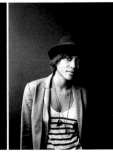
Tina, 27, editor

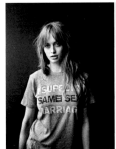
Ashley, 29, doctor

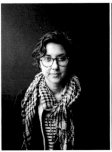
Christina, 27, restaurateur

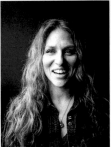
Isabel, 37, artist

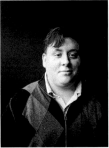
Kyle, 30, flea market
manager

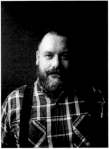
Robert, 36, fashion designer

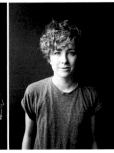
Erika, 25, server

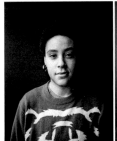
Acacia, 22, barista

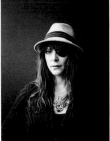
Bryn, 32, creator

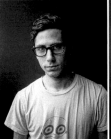
Adam, 28, creative director

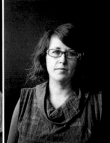
Miya, 36, artist

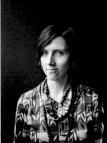
Ruby, 34, city government

Jacob, 31, educator

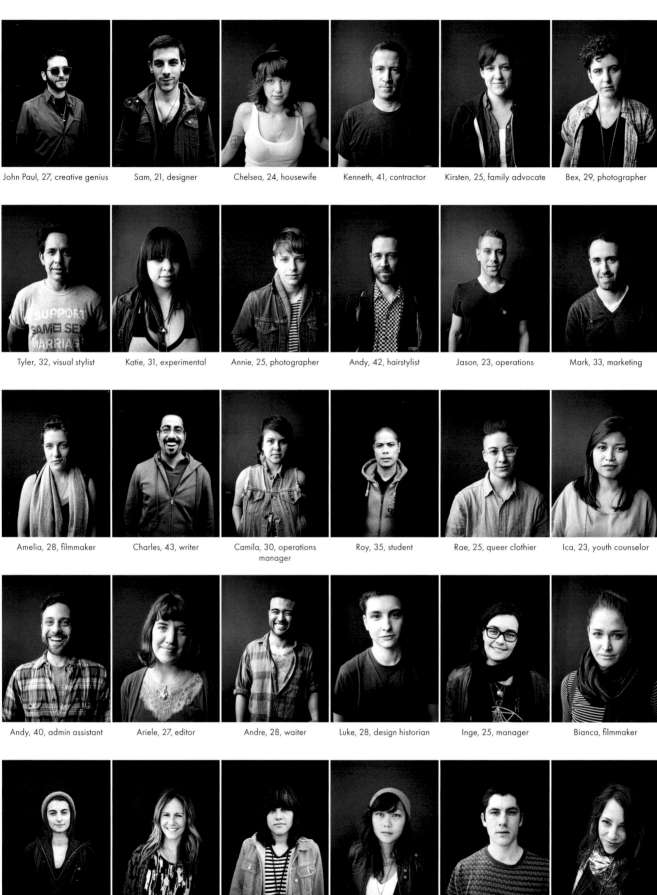

John Paul, 27, creative genius

Sam, 21, designer

Chelsea, 24, housewife

Kenneth, 41, contractor

Kirsten, 25, family advocate

Bex, 29, photographer

Tyler, 32, visual stylist

Katie, 31, experimental

Annie, 25, photographer

Andy, 42, hairstylist

Jason, 23, operations

Mark, 33, marketing

Amelia, 28, filmmaker

Charles, 43, writer

Camila, 30, operations manager

Roy, 35, student

Rae, 25, queer clothier

Ica, 23, youth counselor

Andy, 40, admin assistant

Ariele, 27, editor

Andre, 28, waiter

Luke, 28, design historian

Inge, 25, manager

Bianca, filmmaker

Federica, 25, filmmaker

Lauren, 33, prop stylist

Abby, 31, miscellaneous

Lia, 31, creative director

Jason, 25, public policy

Liz, 33, writer

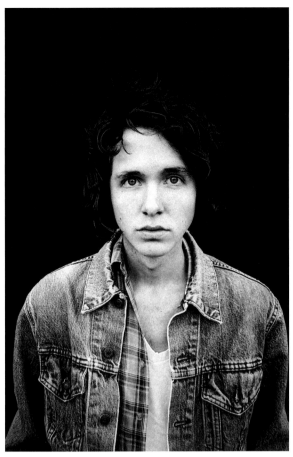

Cody, 23, photographer

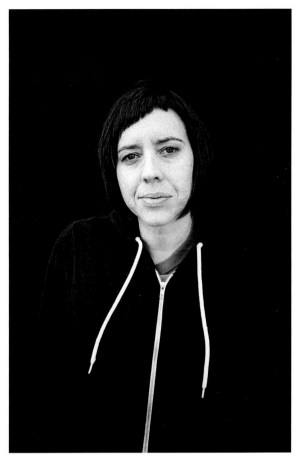

Galina, 34, photographer

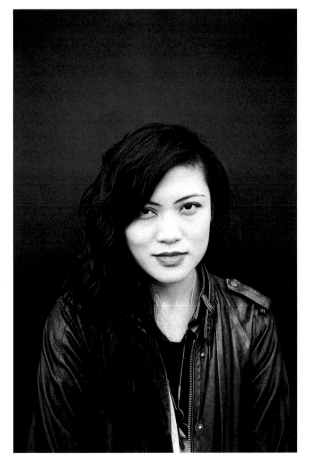

Cassidy, 33, marketing director

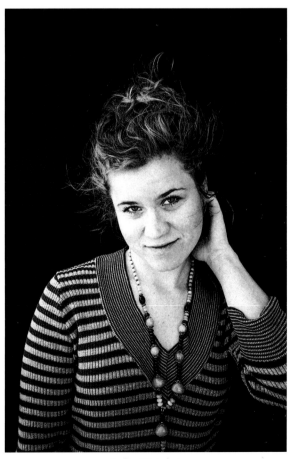

Sophia, 22, student

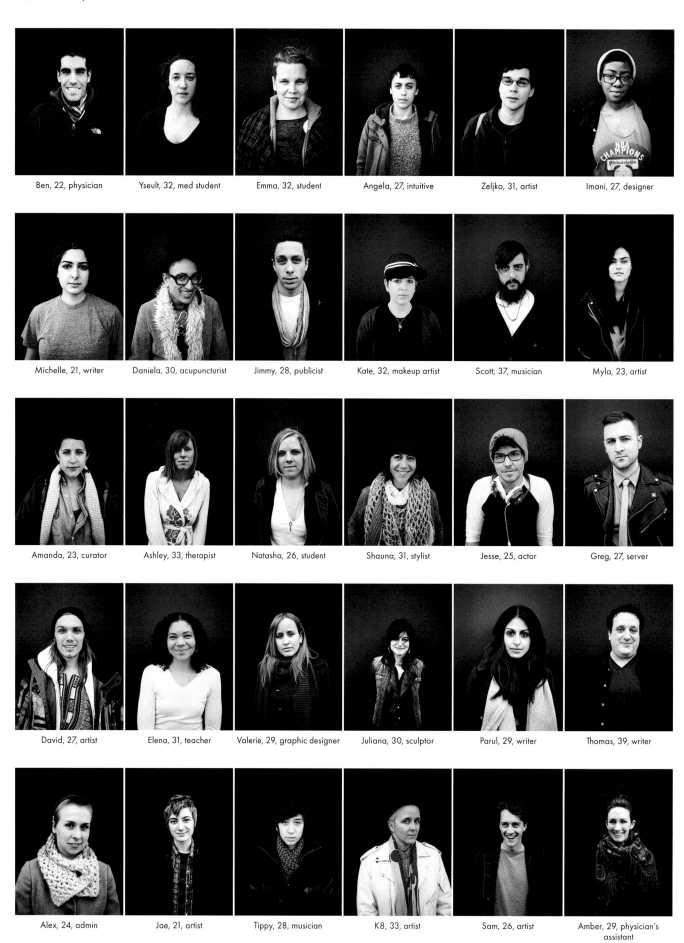

Ben, 22, physician

Yseult, 32, med student

Emma, 32, student

Angela, 27, intuitive

Zeljko, 31, artist

Imani, 27, designer

Michelle, 21, writer

Daniela, 30, acupuncturist

Jimmy, 28, publicist

Kate, 32, makeup artist

Scott, 37, musician

Myla, 23, artist

Amanda, 23, curator

Ashley, 33, therapist

Natasha, 26, student

Shauna, 31, stylist

Jesse, 25, actor

Greg, 27, server

David, 27, artist

Elena, 31, teacher

Valerie, 29, graphic designer

Juliana, 30, sculptor

Parul, 29, writer

Thomas, 39, writer

Alex, 24, admin

Jae, 21, artist

Tippy, 28, musician

K8, 33, artist

Sam, 26, artist

Amber, 29, physician's assistant

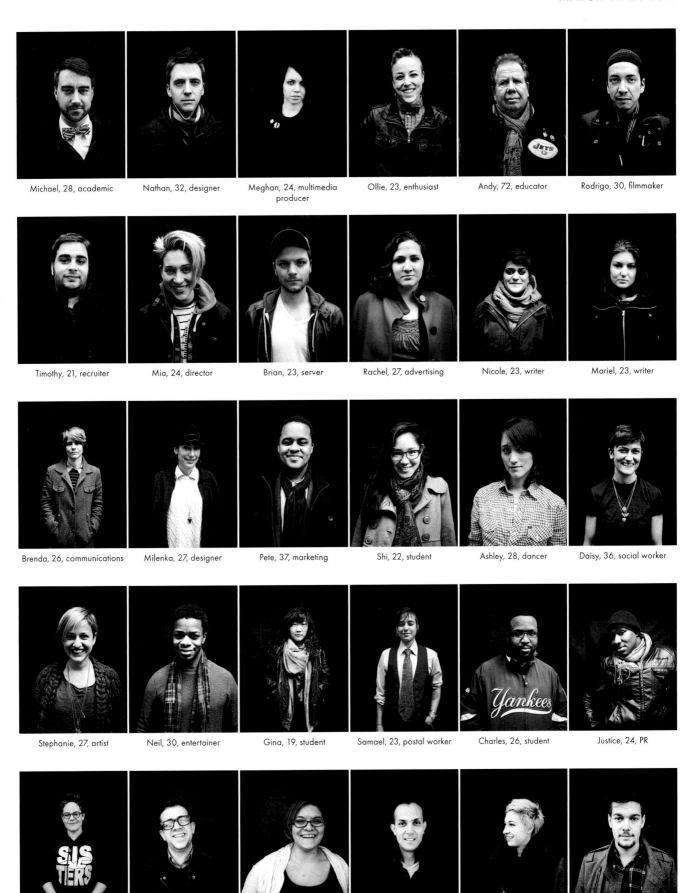

Michael, 28, academic

Nathan, 32, designer

Meghan, 24, multimedia producer

Ollie, 23, enthusiast

Andy, 72, educator

Rodrigo, 30, filmmaker

Timothy, 21, recruiter

Mia, 24, director

Brian, 23, server

Rachel, 27, advertising

Nicole, 23, writer

Mariel, 23, writer

Brenda, 26, communications

Milenka, 27, designer

Pete, 37, marketing

Shi, 22, student

Ashley, 28, dancer

Daisy, 36, social worker

Stephanie, 27, artist

Neil, 30, entertainer

Gina, 19, student

Samael, 23, postal worker

Charles, 26, student

Justice, 24, PR

Lauryn, 33, producer

Jeffrey, 22, actor

Hillary, 22, television

John, 40, web producer

Kelly, 22, student

Mitch, 22, bartender

Matthew, 31, photographer

Crystal, 23, photographer

Stef, 24, photographer

Allyson, 20, student

Kashi, 34, creative director

Olivia, actress

Julie, 25, assistant director

Terence, artist

Vala, 26, event director

Mey, 27, farmer

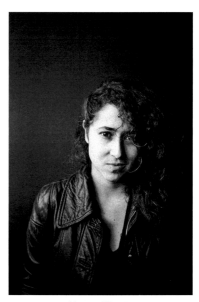

Meriem, 22, artist

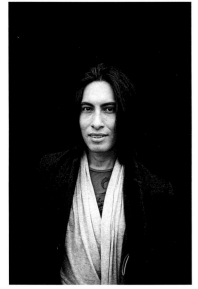

Carlos, 28, manager

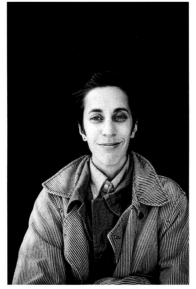

Mel, 32, artist

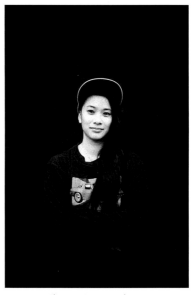

Christine, 22, event planner

Aviva Jaye, 27, musician

Vanessa, 25, musician

Nei, 49, makeup artist

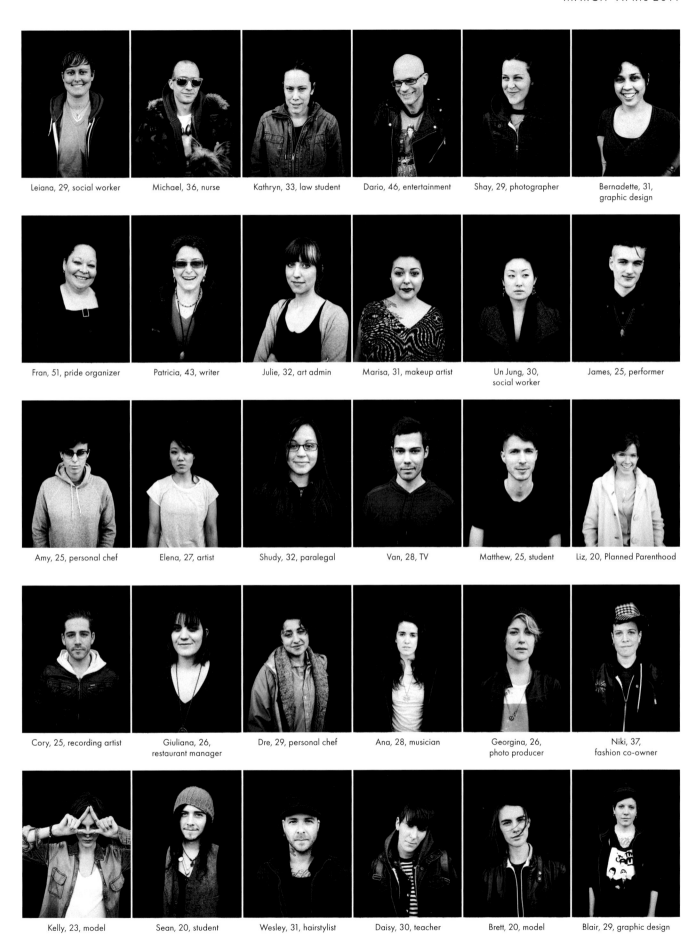

Leiana, 29, social worker

Michael, 36, nurse

Kathryn, 33, law student

Dario, 46, entertainment

Shay, 29, photographer

Bernadette, 31,
graphic design

Fran, 51, pride organizer

Patricia, 43, writer

Julie, 32, art admin

Marisa, 31, makeup artist

Un Jung, 30,
social worker

James, 25, performer

Amy, 25, personal chef

Elena, 27, artist

Shudy, 32, paralegal

Van, 28, TV

Matthew, 25, student

Liz, 20, Planned Parenthood

Cory, 25, recording artist

Giuliana, 26,
restaurant manager

Dre, 29, personal chef

Ana, 28, musician

Georgina, 26,
photo producer

Niki, 37,
fashion co-owner

Kelly, 23, model

Sean, 20, student

Wesley, 31, hairstylist

Daisy, 30, teacher

Brett, 20, model

Blair, 29, graphic design

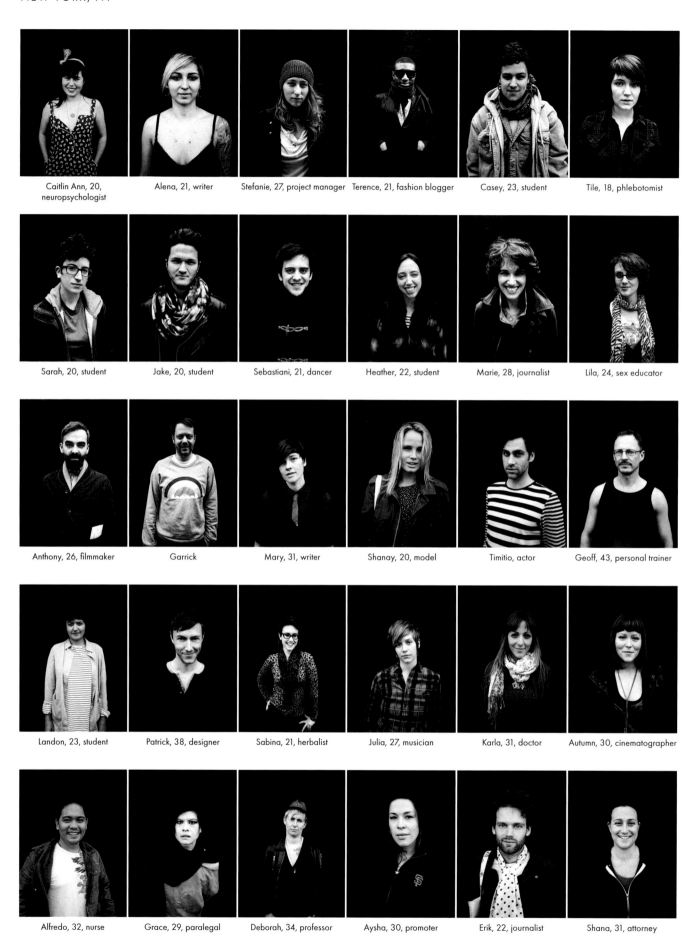

Caitlin Ann, 20, neuropsychologist

Alena, 21, writer

Stefanie, 27, project manager

Terence, 21, fashion blogger

Casey, 23, student

Tile, 18, phlebotomist

Sarah, 20, student

Jake, 20, student

Sebastiani, 21, dancer

Heather, 22, student

Marie, 28, journalist

Lila, 24, sex educator

Anthony, 26, filmmaker

Garrick

Mary, 31, writer

Shanay, 20, model

Timitio, actor

Geoff, 43, personal trainer

Landon, 23, student

Patrick, 38, designer

Sabina, 21, herbalist

Julia, 27, musician

Karla, 31, doctor

Autumn, 30, cinematographer

Alfredo, 32, nurse

Grace, 29, paralegal

Deborah, 34, professor

Aysha, 30, promoter

Erik, 22, journalist

Shana, 31, attorney

A.L., 43, artist

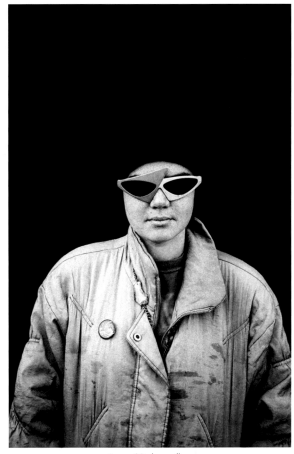

Jenna, 30, dog walker

Rickie, 21

Alana, 30, officer

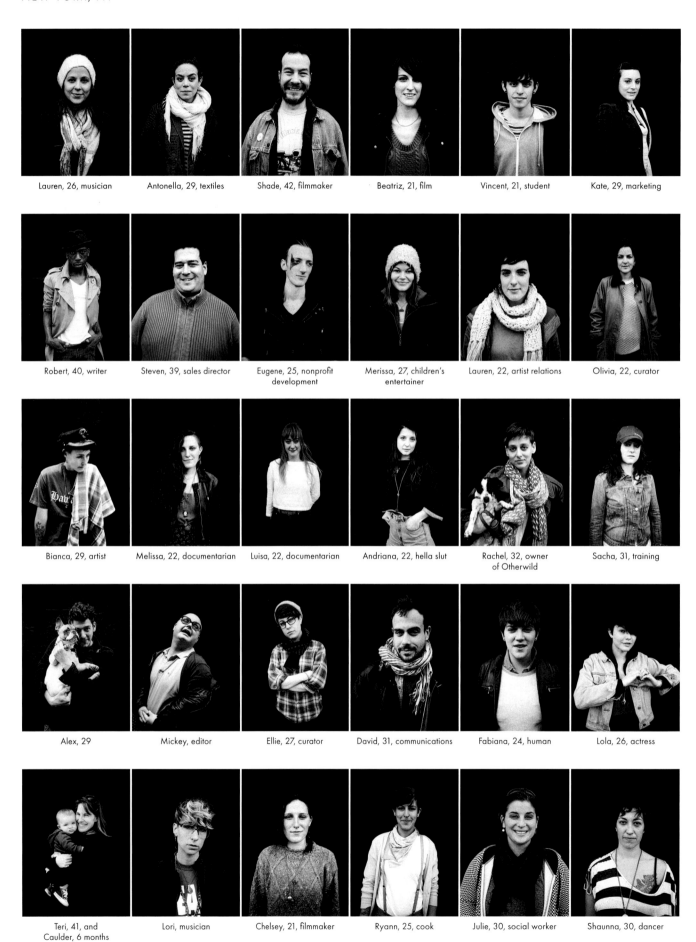

Lauren, 26, musician

Antonella, 29, textiles

Shade, 42, filmmaker

Beatriz, 21, film

Vincent, 21, student

Kate, 29, marketing

Robert, 40, writer

Steven, 39, sales director

Eugene, 25, nonprofit development

Merissa, 27, children's entertainer

Lauren, 22, artist relations

Olivia, 22, curator

Bianca, 29, artist

Melissa, 22, documentarian

Luisa, 22, documentarian

Andriana, 22, hella slut

Rachel, 32, owner of Otherwild

Sacha, 31, training

Alex, 29

Mickey, editor

Ellie, 27, curator

David, 31, communications

Fabiana, 24, human

Lola, 26, actress

Teri, 41, and Caulder, 6 months

Lori, musician

Chelsey, 21, filmmaker

Ryann, 25, cook

Julie, 30, social worker

Shaunna, 30, dancer

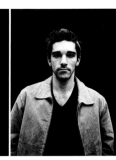

Trudi, 26, doctor Arabella, 28, acupuncturist Cherlyn, 26, art director Lily, 22, nothing Kelly, 32, consultant Peter, 26, actor

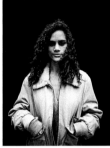
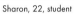
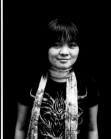
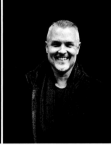
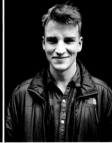
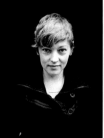
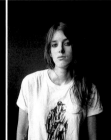

Sharon, 22, student Lin, 19, photographer Patrick, 46, interaction designer Patrick, 19, publicist Kristina, 32, bartender Emily, photographer

JD, musician Venus, 25, DJ Linnaea, lighting designer

SEPTEMBER 20, 2011

"DON'T ASK, DON'T TELL" IS REPEALED,
ENDING THE BAN ON OPENLY GAY MEN,
LESBIANS, AND BISEXUALS FROM SERVING
IN THE MILITARY.

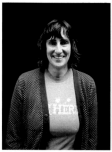

Lori, 37, operations

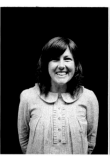

Avry, 30, social worker

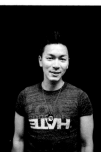

Ben, 30, marketing

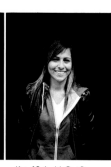

Kat, 19, In-N-Out Burger

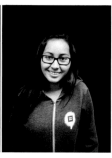

Liz, 20, In-N-Out Burger

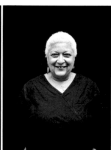

Jewelle, 63, writer

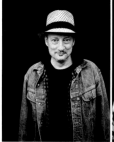

Jim, 52, photographer

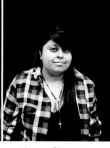

Marissa, 21, waitress

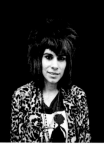

Elizabeth, 27, YouTube

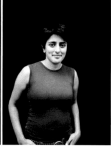

Shradha, 35, physician

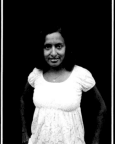

Jessy, 42, RN

Heather, 40, technical writer

Stephen, 47, antiques dealer

Chuck, 54, retired

Patrick, 45, sales

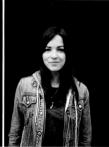

Aja, 32, musician

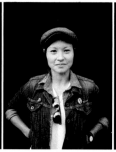

Cat, 30, graphic design

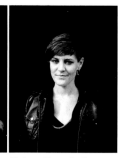

Chelsea, 28, medical assistant

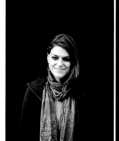

Alice, 28, medical assistant

Andrea, 36, CEO

Claros, 37, engineer

Carlos, 23, student

Kaitlan, 19, Target

Jennifer, 19, student

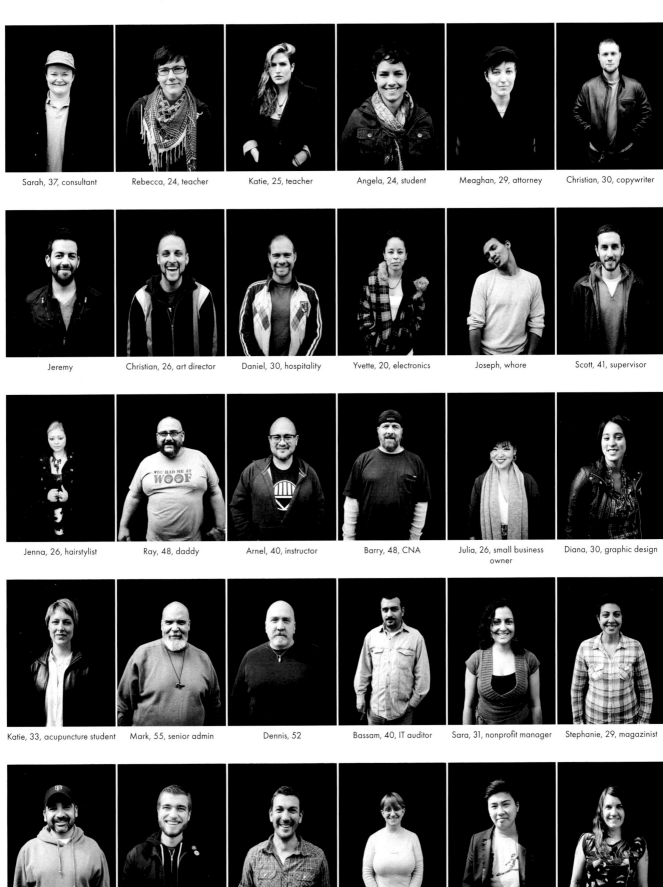

Sarah, 37, consultant Rebecca, 24, teacher Katie, 25, teacher Angela, 24, student Meaghan, 29, attorney Christian, 30, copywriter

Jeremy Christian, 26, art director Daniel, 30, hospitality Yvette, 20, electronics Joseph, whore Scott, 41, supervisor

Jenna, 26, hairstylist Ray, 48, daddy Arnel, 40, instructor Barry, 48, CNA Julia, 26, small business owner Diana, 30, graphic design

Katie, 33, acupuncture student Mark, 55, senior admin Dennis, 52 Bassam, 40, IT auditor Sara, 31, nonprofit manager Stephanie, 29, magazinist

Robert, 43, media planner Eric, 19, student Kevin, 35, student Jessica, 46, lawyer Sench, 32, Greenpeace Rion, 35, special ed teacher

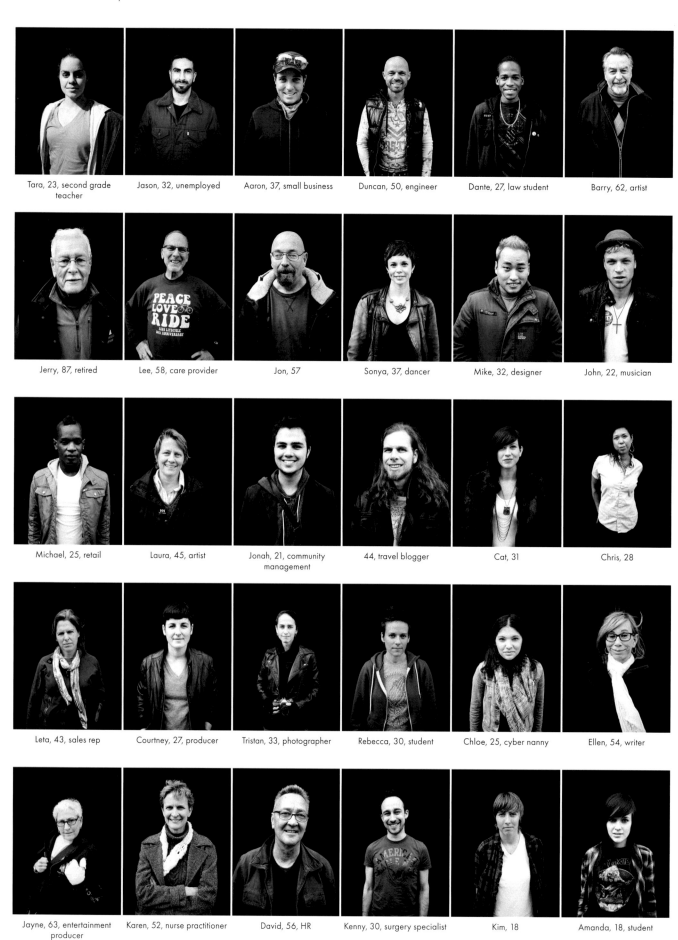

Tara, 23, second grade teacher

Jason, 32, unemployed

Aaron, 37, small business

Duncan, 50, engineer

Dante, 27, law student

Barry, 62, artist

Jerry, 87, retired

Lee, 58, care provider

Jon, 57

Sonya, 37, dancer

Mike, 32, designer

John, 22, musician

Michael, 25, retail

Laura, 45, artist

Jonah, 21, community management

44, travel blogger

Cat, 31

Chris, 28

Leta, 43, sales rep

Courtney, 27, producer

Tristan, 33, photographer

Rebecca, 30, student

Chloe, 25, cyber nanny

Ellen, 54, writer

Jayne, 63, entertainment producer

Karen, 52, nurse practitioner

David, 56, HR

Kenny, 30, surgery specialist

Kim, 18

Amanda, 18, student

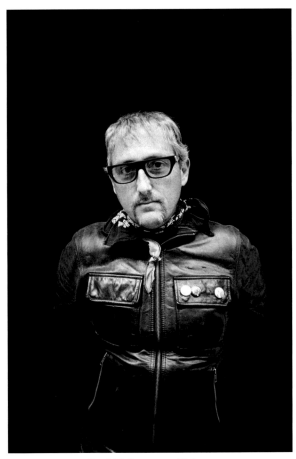

Freud, 28, Department of Defense

John, 56, hospital employee

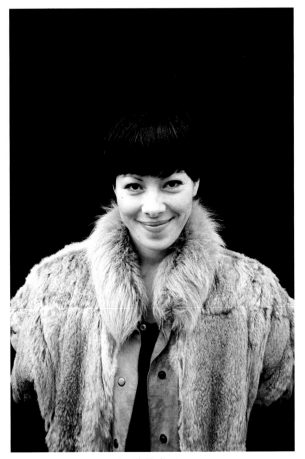

Ingrid, 31, director

Felicia, 65, retired

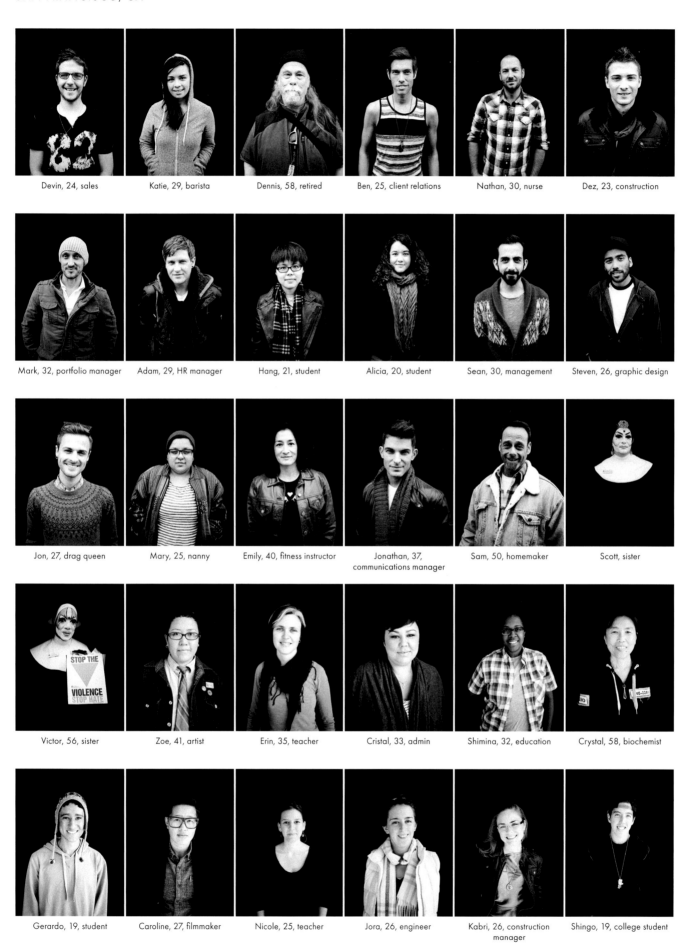

Devin, 24, sales

Katie, 29, barista

Dennis, 58, retired

Ben, 25, client relations

Nathan, 30, nurse

Dez, 23, construction

Mark, 32, portfolio manager

Adam, 29, HR manager

Hang, 21, student

Alicia, 20, student

Sean, 30, management

Steven, 26, graphic design

Jon, 27, drag queen

Mary, 25, nanny

Emily, 40, fitness instructor

Jonathan, 37, communications manager

Sam, 50, homemaker

Scott, sister

Victor, 56, sister

Zoe, 41, artist

Erin, 35, teacher

Cristal, 33, admin

Shimina, 32, education

Crystal, 58, biochemist

Gerardo, 19, student

Caroline, 27, filmmaker

Nicole, 25, teacher

Jora, 26, engineer

Kabri, 26, construction manager

Shingo, 19, college student

Adam, 19, student

Lindsi, 34, software product manager

Adialuz, 33, student

Sheila, 45, water analyst

Jane, 23, tech

Sivan, 26, musician

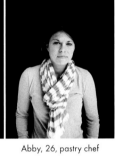

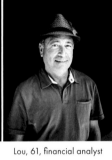

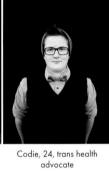

Claire, 27, engineer

Tamsin, 36, MD

Thuy, 27, admin assistant

Kathie, 26, yoga instructor

Terry, 40, social worker

Adjoa, 54, homeopath

Adeola, 29, marketing manager

Abby, 26, pastry chef

Lou, 61, financial analyst

Codie, 24, trans health advocate

Patricia, 53, healthcare

Jon, 32, CPA

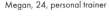

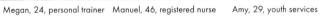

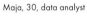

Megan, 24, personal trainer

Manuel, 46, registered nurse

Amy, 29, youth services

Benjamin, 32, finance manager

David, 36, manager

Maja, 30, data analyst

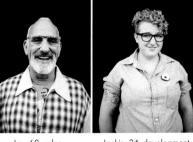

Jessica, 36, behavioral therapist

Vivian, 33, DJ

Heather, 24, project coordinator

Jay, 60, sales

Jackie, 24, development associate

Marianne, 57, consultant

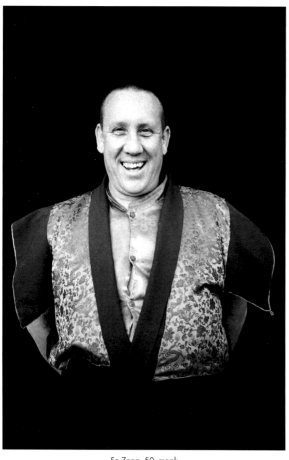

Fa Zang, 50, monk

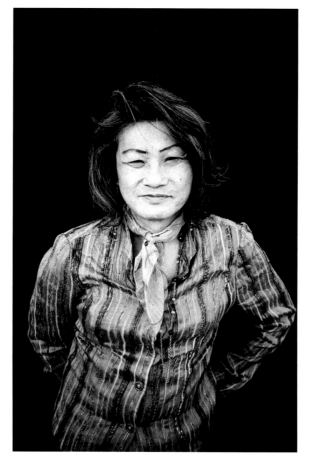

Jasmine, 62, unemployed

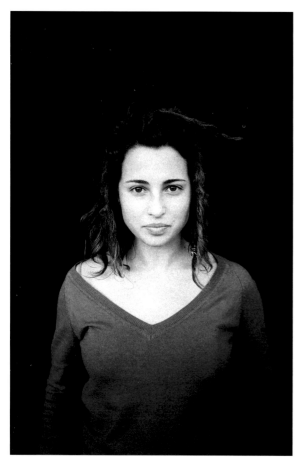

Jackie, 17, student

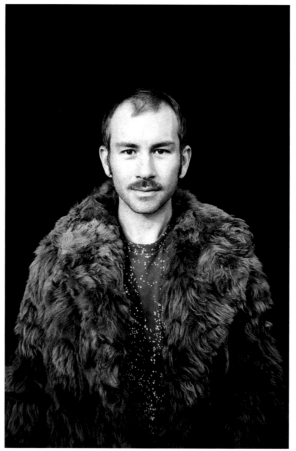

Dillon, 35, perfumer

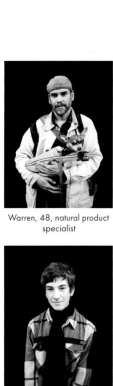

Warren, 48, natural product specialist

Lianna, 21, student

Hannah, 23, dog walker

Robin, 23, artist

Erin, 56, high tech

Loie, 15, student

 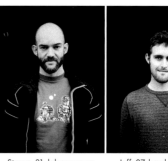 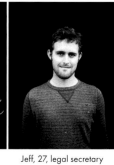

Adam, 15, student

Amelia, 15, student

Jocelyn, 17, student

Carlos, 56, project manager

Steven, 31, lab manager

Jeff, 27, legal secretary

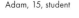 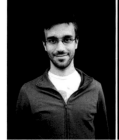 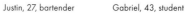 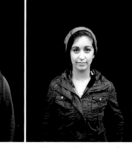

Sam, 25, grad student

Gemma, 25, film editor

Tifa Love, 24, student

Justin, 27, bartender

Gabriel, 43, student

Monica, 24, personal assistant

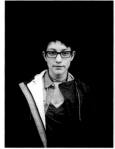 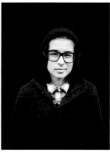 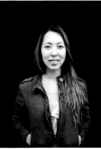 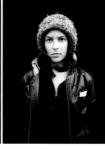 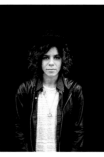 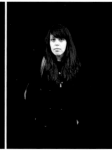

Natalie, 30, fabricator

Ari, 26, merchandise planner

Tanya, 27, bookseller

Machu, 21, student

Nico, 27, artist

Terra, 26, musician

Jordyn, 22, student

Jennifer, 34, engineer

24, preschool teacher

Yelz, 24, entrepreneur

Benjamin, 25, landscape designer

Janel, 23

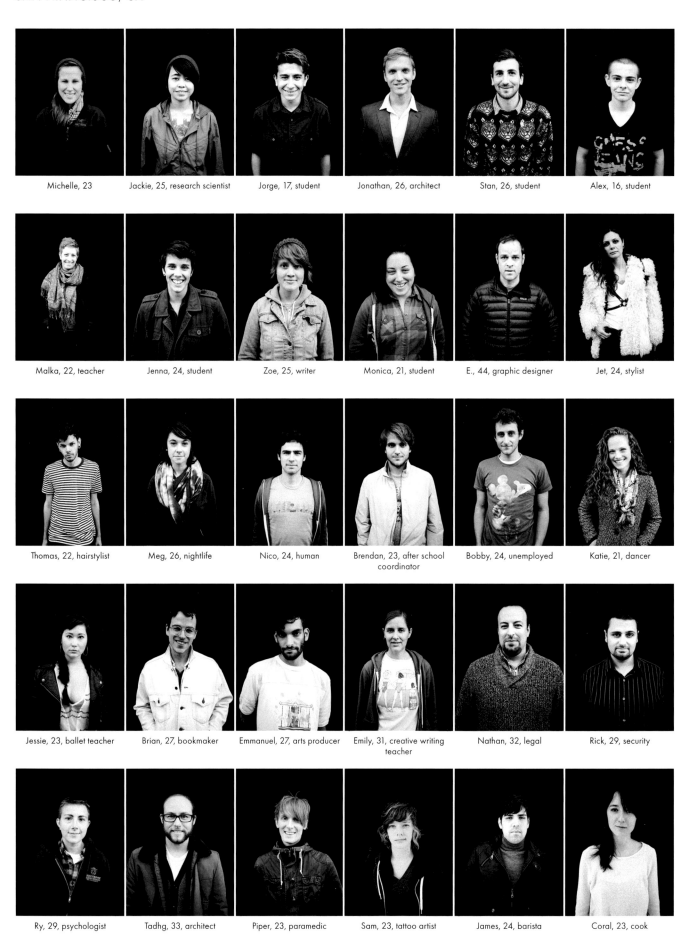

Michelle, 23

Jackie, 25, research scientist

Jorge, 17, student

Jonathan, 26, architect

Stan, 26, student

Alex, 16, student

Malka, 22, teacher

Jenna, 24, student

Zoe, 25, writer

Monica, 21, student

E., 44, graphic designer

Jet, 24, stylist

Thomas, 22, hairstylist

Meg, 26, nightlife

Nico, 24, human

Brendan, 23, after school
coordinator

Bobby, 24, unemployed

Katie, 21, dancer

Jessie, 23, ballet teacher

Brian, 27, bookmaker

Emmanuel, 27, arts producer

Emily, 31, creative writing
teacher

Nathan, 32, legal

Rick, 29, security

Ry, 29, psychologist

Tadhg, 33, architect

Piper, 23, paramedic

Sam, 23, tattoo artist

James, 24, barista

Coral, 23, cook

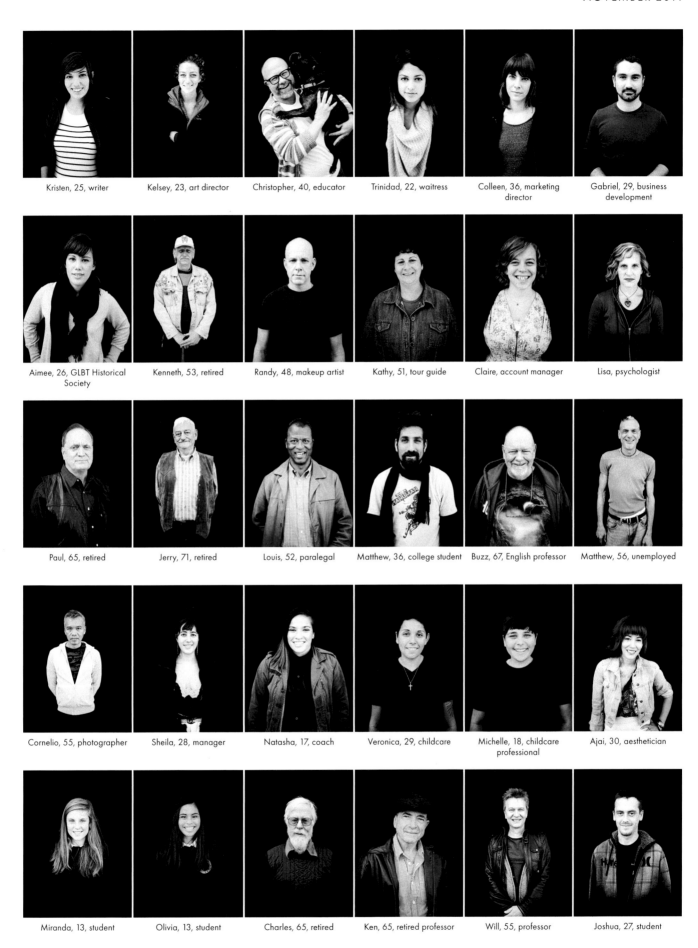

Kristen, 25, writer

Kelsey, 23, art director

Christopher, 40, educator

Trinidad, 22, waitress

Colleen, 36, marketing director

Gabriel, 29, business development

Aimee, 26, GLBT Historical Society

Kenneth, 53, retired

Randy, 48, makeup artist

Kathy, 51, tour guide

Claire, account manager

Lisa, psychologist

Paul, 65, retired

Jerry, 71, retired

Louis, 52, paralegal

Matthew, 36, college student

Buzz, 67, English professor

Matthew, 56, unemployed

Cornelio, 55, photographer

Sheila, 28, manager

Natasha, 17, coach

Veronica, 29, childcare

Michelle, 18, childcare professional

Ajai, 30, aesthetician

Miranda, 13, student

Olivia, 13, student

Charles, 65, retired

Ken, 65, retired professor

Will, 55, professor

Joshua, 27, student

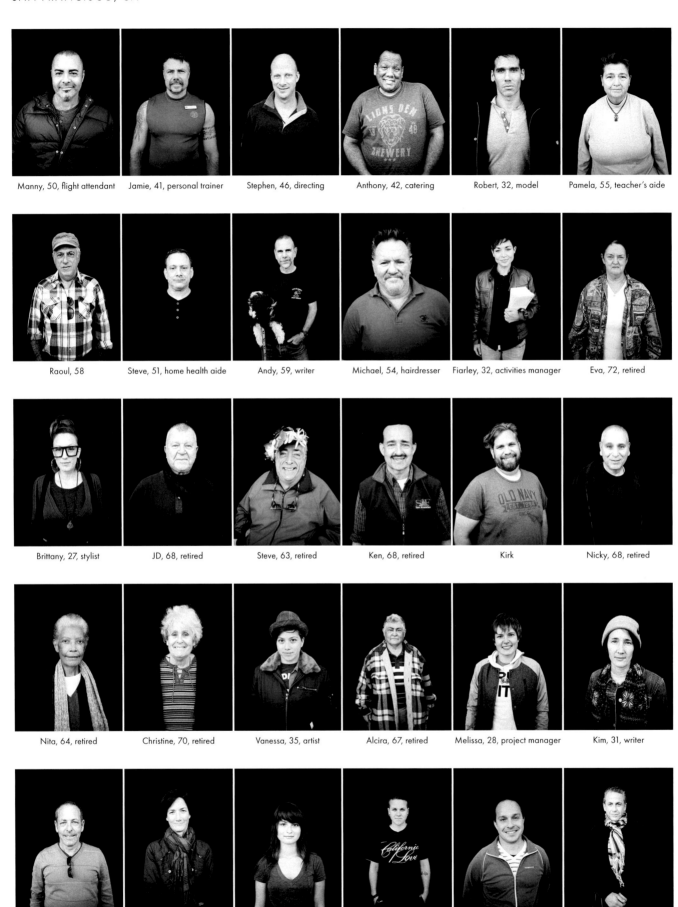

Manny, 50, flight attendant Jamie, 41, personal trainer Stephen, 46, directing Anthony, 42, catering Robert, 32, model Pamela, 55, teacher's aide

Raoul, 58 Steve, 51, home health aide Andy, 59, writer Michael, 54, hairdresser Fiarley, 32, activities manager Eva, 72, retired

Brittany, 27, stylist JD, 68, retired Steve, 63, retired Ken, 68, retired Kirk Nicky, 68, retired

Nita, 64, retired Christine, 70, retired Vanessa, 35, artist Alcira, 67, retired Melissa, 28, project manager Kim, 31, writer

Mike, 52, self-employed Pam, 48, marketing consulting Taylor, 23, restaurant Erin, 28, server Juan, 41, wig maker Sam, 44, flight attendant

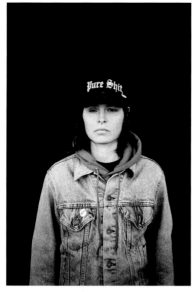

Shaggy, 27

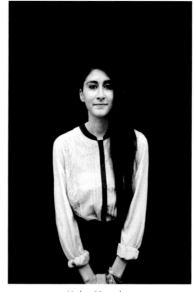

Violet, 23, student

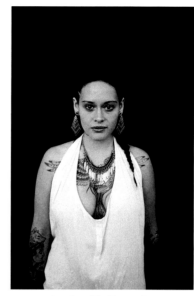

Jacqulynn, 26, videographer

Raymond, 20, homeless

Broderick, 33, police officer

Eddie, 32, student

Matthew, 42

Mikale and Olive

Bernadette, 19, restaurant hostess

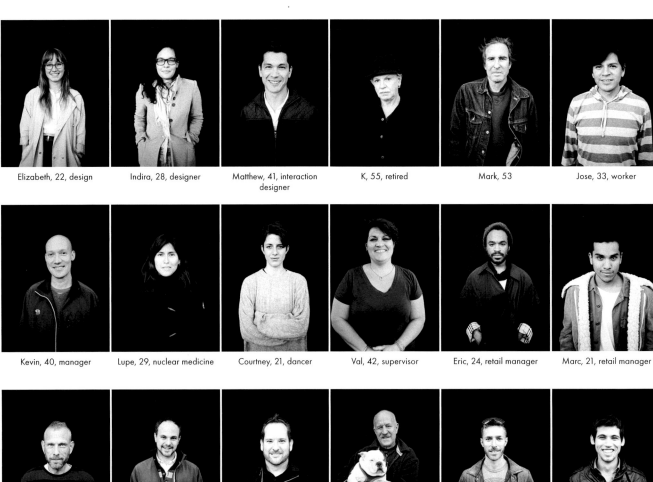

Elizabeth, 22, design

Indira, 28, designer

Matthew, 41, interaction
designer

K, 55, retired

Mark, 53

Jose, 33, worker

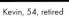

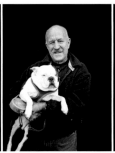
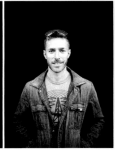
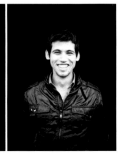

Kevin, 40, manager

Lupe, 29, nuclear medicine

Courtney, 21, dancer

Val, 42, supervisor

Eric, 24, retail manager

Marc, 21, retail manager

Kevin, 54, retired

Marc, 37, flight attendant

David, 41, flight attendant

Brian, 61, businessman

Adam, 38, homeless outreach

Armando, 27, student

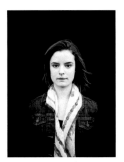

Megan, 20, dancer

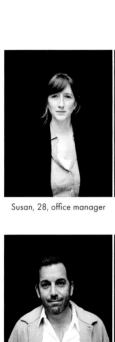

Susan, 28, office manager Keri, 41, senior director Shari, 38, Access LA coordinator Alonso, 44, film critic Christopher, 41, filmmaker Susan, 42, senior director of Outfest

Kevin, 44, corporate sponsorship Abel, 31, membership coordinator Brooke, 30, production manager Michelle, 20, student Marina, 22, loving life Mariah, 18, student

Molly, 36, PR Penny Kevin, 36, recording engineer Marni, 32, singer Benjamin, 21, student Duncan, 49, director

Alex, 20, student Jessica, 21, student Heather, 40, massage therapist Simon, 25, fundraiser Deidres, 50, entertainment Minta, 43, organizer

John, restaurant manager

Jolenny, 32, spiritual counselor

Tegan, musician

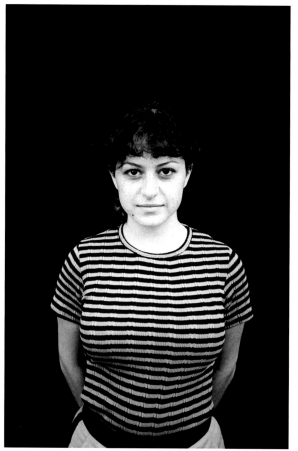

Alia, 22, actor

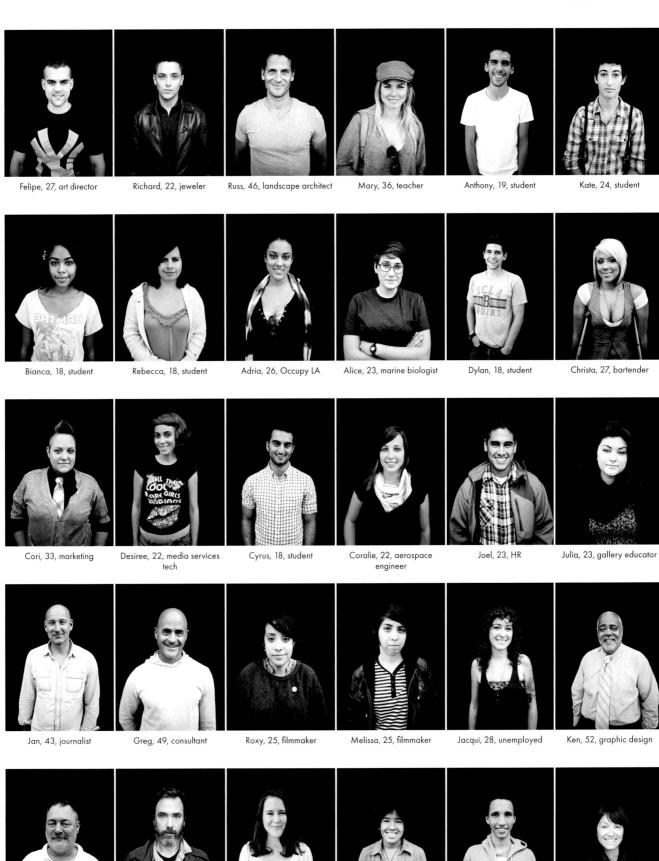

Felipe, 27, art director

Richard, 22, jeweler

Russ, 46, landscape architect

Mary, 36, teacher

Anthony, 19, student

Kate, 24, student

Bianca, 18, student

Rebecca, 18, student

Adria, 26, Occupy LA

Alice, 23, marine biologist

Dylan, 18, student

Christa, 27, bartender

Cori, 33, marketing

Desiree, 22, media services tech

Cyrus, 18, student

Coralie, 22, aerospace engineer

Joel, 23, HR

Julia, 23, gallery educator

Jan, 43, journalist

Greg, 49, consultant

Roxy, 25, filmmaker

Melissa, 25, filmmaker

Jacqui, 28, unemployed

Ken, 52, graphic design

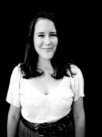

Garrett, 49, job developer

Dan, 43, photographer

Sarah, 18, student

Lillian, 17, writer

Joseph, 17, student

Breye, 35, grad student

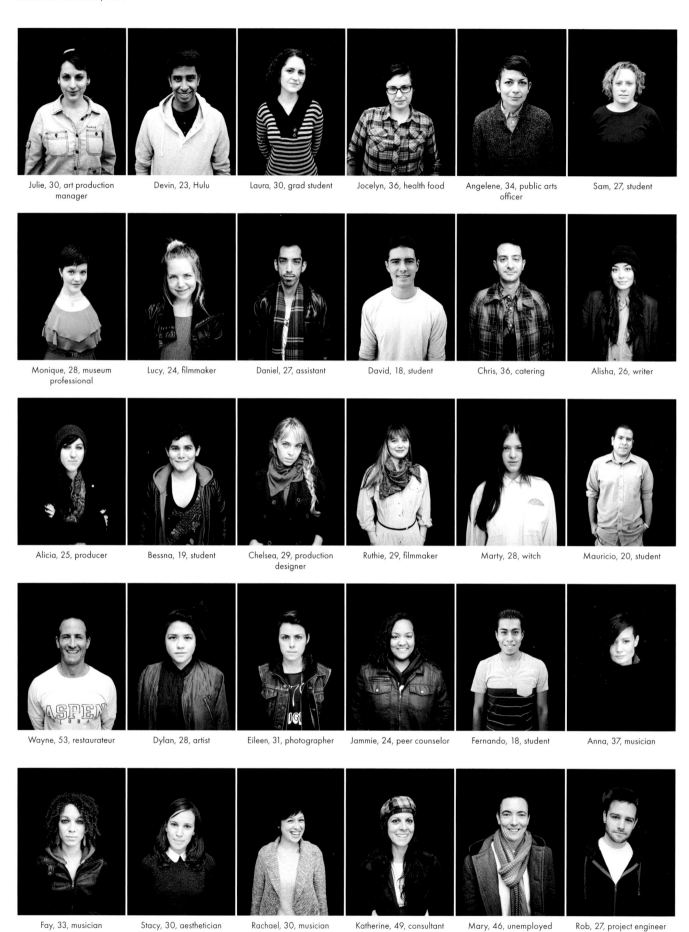

Julie, 30, art production manager

Devin, 23, Hulu

Laura, 30, grad student

Jocelyn, 36, health food

Angelene, 34, public arts officer

Sam, 27, student

Monique, 28, museum professional

Lucy, 24, filmmaker

Daniel, 27, assistant

David, 18, student

Chris, 36, catering

Alisha, 26, writer

Alicia, 25, producer

Bessna, 19, student

Chelsea, 29, production designer

Ruthie, 29, filmmaker

Marty, 28, witch

Mauricio, 20, student

Wayne, 53, restaurateur

Dylan, 28, artist

Eileen, 31, photographer

Jammie, 24, peer counselor

Fernando, 18, student

Anna, 37, musician

Fay, 33, musician

Stacy, 30, aesthetician

Rachael, 30, musician

Katherine, 49, consultant

Mary, 46, unemployed

Rob, 27, project engineer

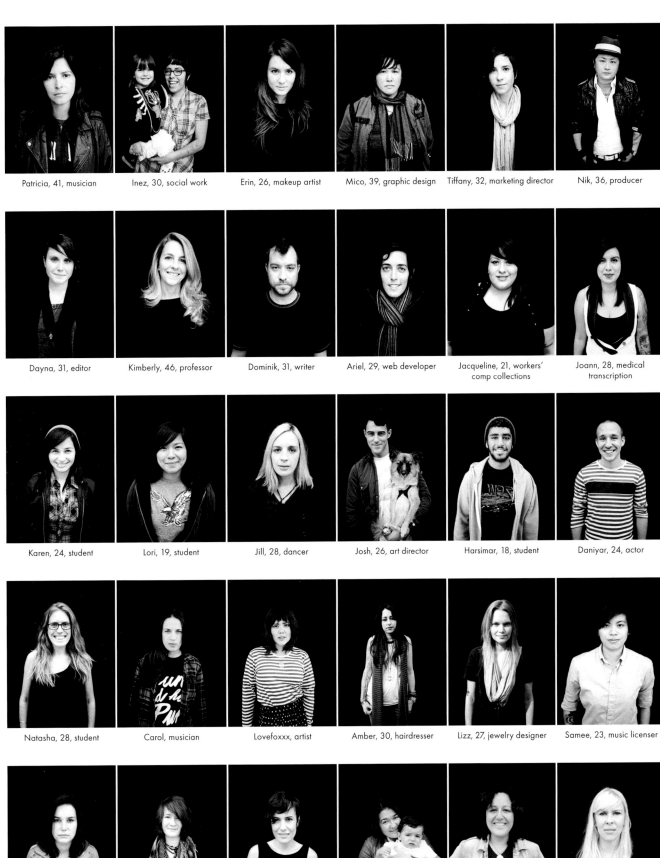

Patricia, 41, musician

Inez, 30, social work

Erin, 26, makeup artist

Mico, 39, graphic design

Tiffany, 32, marketing director

Nik, 36, producer

Dayna, 31, editor

Kimberly, 46, professor

Dominik, 31, writer

Ariel, 29, web developer

Jacqueline, 21, workers' comp collections

Joann, 28, medical transcription

Karen, 24, student

Lori, 19, student

Jill, 28, dancer

Josh, 26, art director

Harsimar, 18, student

Daniyar, 24, actor

Natasha, 28, student

Carol, musician

Lovefoxxx, artist

Amber, 30, hairdresser

Lizz, 27, jewelry designer

Samee, 23, music licenser

Nicole, 22, PA

Natalie, 27, GIS and DBA

Jennifer, 34, producer

Amada, 37, government

30, story producer

Sylvia, 20, director

Raja, 29, educator

Andersen, 19, student

Chaz, 22, program coordinator

Matt, 21, student

Ken, 37, engineer

Justin, 18, student

Billy, 52, actor

Chelito, 36, interior designer

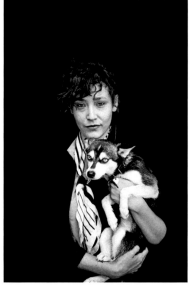

Marisa, 27, artist

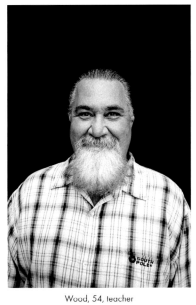

Wood, 54, teacher

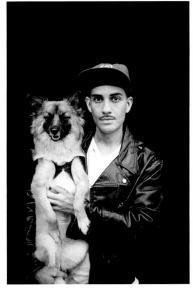

William, 32, artist

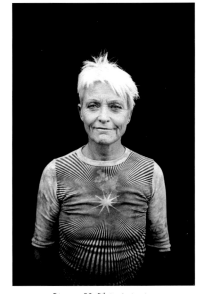

Dianne, 58, Pilates instructor

Christian, 19, student

Joshua, 27, flight attendant

Santy, 25, museum registrar

Al, 71, INS

Ingrid, 25, model

Nikki, 14, student

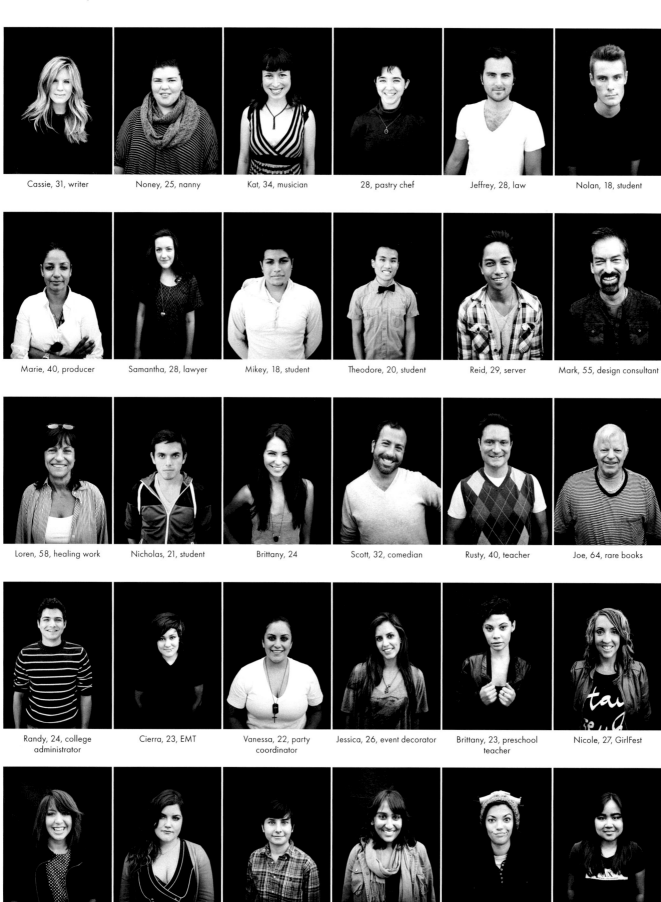

Cassie, 31, writer

Noney, 25, nanny

Kat, 34, musician

28, pastry chef

Jeffrey, 28, law

Nolan, 18, student

Marie, 40, producer

Samantha, 28, lawyer

Mikey, 18, student

Theodore, 20, student

Reid, 29, server

Mark, 55, design consultant

Loren, 58, healing work

Nicholas, 21, student

Brittany, 24

Scott, 32, comedian

Rusty, 40, teacher

Joe, 64, rare books

Randy, 24, college administrator

Cierra, 23, EMT

Vanessa, 22, party coordinator

Jessica, 26, event decorator

Brittany, 23, preschool teacher

Nicole, 27, GirlFest

Kara, 25, comedian

Suzie, 24, film student

Mel, 25, grad student

Megha, 23, producer

Danielle, 24, marketing

Sara, 24, accountant

Kristina, 35, web developer Matt, 25, graphic design Richard, 40, sales James, 28, designer Stefano, 28, hospital administration Aaron, 27, business owner

Shelly, 27, student Anne, 26, artist Alexis, 35, producer Matthew, 33, attorney Alissa, 25 Olivia, 25

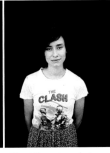

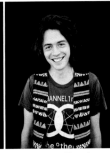

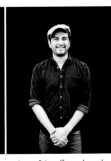

Emery, 36, doctor Lauren, 26, actor Tabitha, 21, actor Diaz, 34, costume designer Nathan, 27, filmmaker Ivan, 36, self-employed

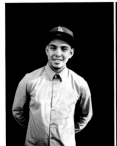

Eddie, 19, student Leia, 18, student Taylor, 19, student Brian, 21, student Madison, 17, student Christopher, 37, actor

Amber, 25, actress Briana, 20, student Iris, 19, student Airon, 27, student

2012

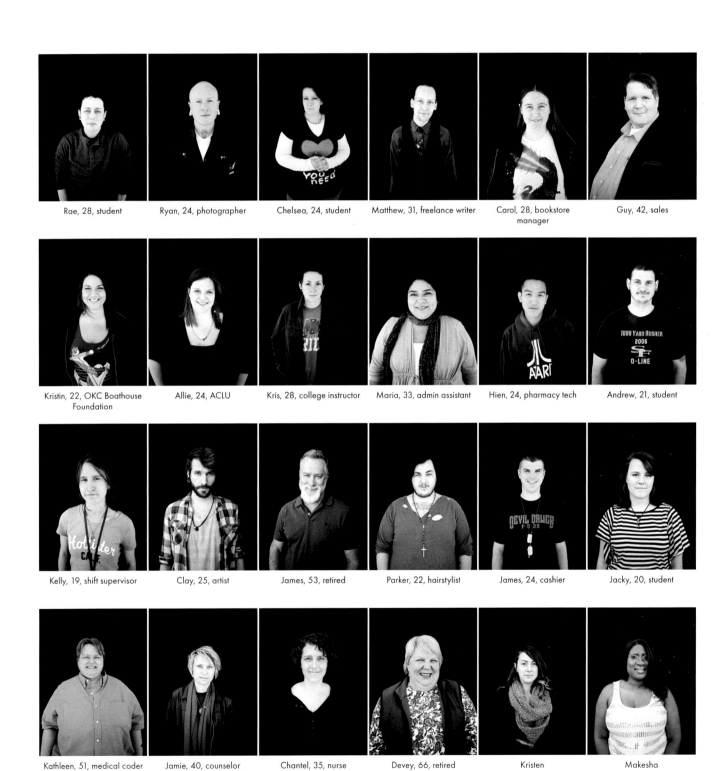

Rae, 28, student

Ryan, 24, photographer

Chelsea, 24, student

Matthew, 31, freelance writer

Carol, 28, bookstore manager

Guy, 42, sales

Kristin, 22, OKC Boathouse Foundation

Allie, 24, ACLU

Kris, 28, college instructor

Maria, 33, admin assistant

Hien, 24, pharmacy tech

Andrew, 21, student

Kelly, 19, shift supervisor

Clay, 25, artist

James, 53, retired

Parker, 22, hairstylist

James, 24, cashier

Jacky, 20, student

Kathleen, 51, medical coder

Jamie, 40, counselor

Chantel, 35, nurse

Devey, 66, retired

Kristen

Makesha

Xavier, 20, desk clerk

Rick, 50, inventory

Barbara

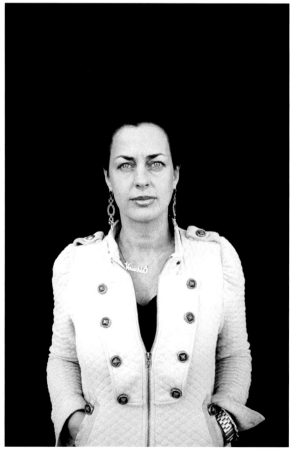

Amy, 40, hairstylist

Jordan

Dorothy, 77, retired lawyer

Cody, 20, student

Todd, 43, HIV tester

Austin, 20, office assistant

Jaclyn, 24, reporter

Mandi, 31, stylist

Deanna, 24, grad student

Abigail

Shane, 38, student

Alexis

Vance, 23, bartender

James, 29, English professor

Jamie, 20, student

Sky, 20, student

Stephen, 19, student

Katie

Curtis, 52, chef

Andrew, 31, US Air Force

Jennifer, 28, counselor

Peggy, 54, musician

Cassie, 28, therapist

Victor

Catrina, 17, student

Michael, 42, waitress

Scott, 52, social worker

Larry, 48, attorney

Richard, 40, deep cleaner

Shaun, 33, retail management

Brandon, 21, receptionist

Tiana, 21, cashier

Damien, 20, scribe

Etta, 20, student

Adrienne, 19, student

Scott, 26, registered nurse

Kristen, 21, student

Nicole, 20, flower delivery
driver

Nicole, 21, server

Kevin, 21, delivery driver

Amber, 21, website
photographer

Kirsten, 20, student

Rachel, 21, student

Elizabeth, 22, student

Frank, 22, student

Liane, 19, student

Jesse, 26, factory worker

Ashley, 21, manager

Deonna, 21, receptionist

Lisa, 34, registered nurse

Jodie, 26, model

Lacey, 27, registered nurse

Julie, 21, retail

Sarah, 19, student

Shelby, 21, student

Boston, 21, Zumba instructor

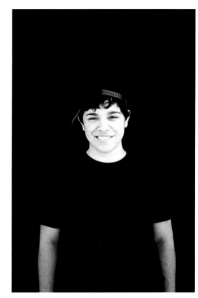

Mattie Jo, 19, cook

Deryl, 22, student

Michelle, 29, manager

DALLAS, TX
FEBRUARY 2012

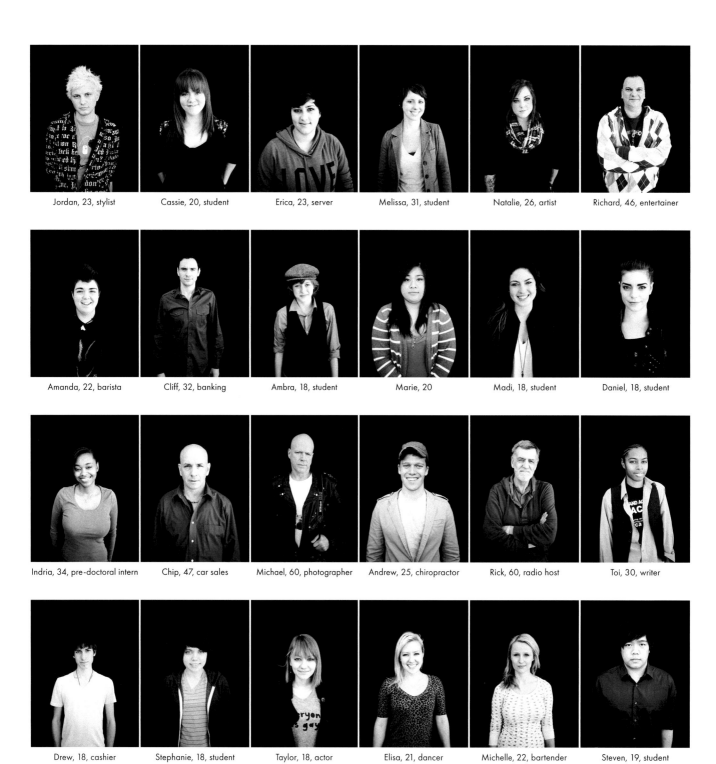

Jordan, 23, stylist

Cassie, 20, student

Erica, 23, server

Melissa, 31, student

Natalie, 26, artist

Richard, 46, entertainer

Amanda, 22, barista

Cliff, 32, banking

Ambra, 18, student

Marie, 20

Madi, 18, student

Daniel, 18, student

Indria, 34, pre-doctoral intern

Chip, 47, car sales

Michael, 60, photographer

Andrew, 25, chiropractor

Rick, 60, radio host

Toi, 30, writer

Drew, 18, cashier

Stephanie, 18, student

Taylor, 18, actor

Elisa, 21, dancer

Michelle, 22, bartender and accountant

Steven, 19, student

Bruce, 57, costume designer

Paul, 53, self-employed

Q, 31, media visionary

Akiko, 43, research scientist

Aaron, 30, craftsman

Windy, 30, social worker

Stefanie, 22, student

Ritchie, 46, SPI

Brittany, 21, student

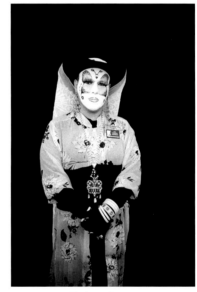

Maelynn, 41, sister

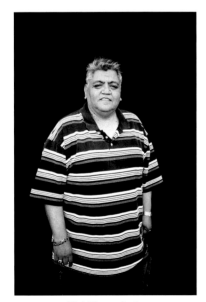

Ethel, 50, coordinator

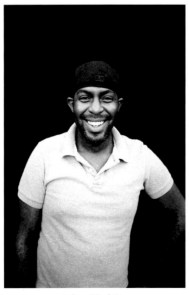

Joshua, 30, claims

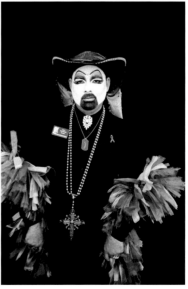

Kerianna Kross, 38, sister

Daniela, 25, student

CC, 26, artist

Hollis, 32, graphic designer

Larry the Fairy, 27, admin

April, 25, teacher

Beth, 27, business analyst

James, 39, drag superstar

Jordan, 30, insurance agent

Jamison, 39, tow truck operator

Chris, 29, student

Rey, 23, nurse

Ellie, 17, student

Mary, 24, editor

Hyleigh Suspicious, 39, sister

Jan, 25, student

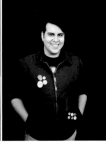

Alejandro, 20, tutor

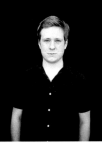

Eric, 21, student

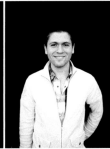

Michael, 21, student

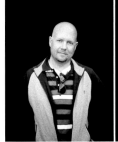

David, 39, claims rep

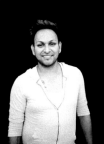

Jesse, 29, hairstylist

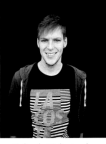

Richard, 22, bartender

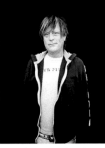

Jody, 45, merchandise manager

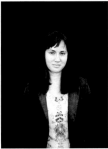

Maritza, 34, unemployed

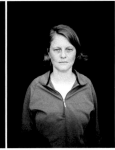

Sara, 37, educational administrator

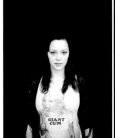

Sara, 23, visual artist

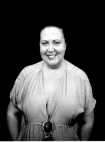

Bianca, 29, executive assistant to VP

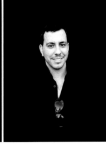

Brock, 31, real estate

Christopher, 33, business owner

Dustin, 30, sales

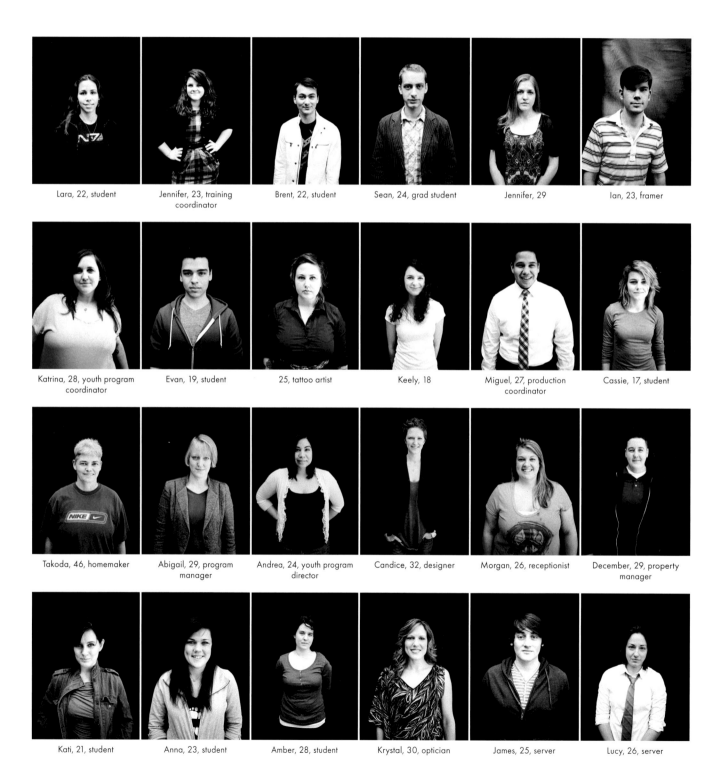

Lara, 22, student

Jennifer, 23, training coordinator

Brent, 22, student

Sean, 24, grad student

Jennifer, 29

Ian, 23, framer

Katrina, 28, youth program coordinator

Evan, 19, student

25, tattoo artist

Keely, 18

Miguel, 27, production coordinator

Cassie, 17, student

Takoda, 46, homemaker

Abigail, 29, program manager

Andrea, 24, youth program director

Candice, 32, designer

Morgan, 26, receptionist

December, 29, property manager

Kati, 21, student

Anna, 23, student

Amber, 28, student

Krystal, 30, optician

James, 25, server

Lucy, 26, server

Alyss, 18, student

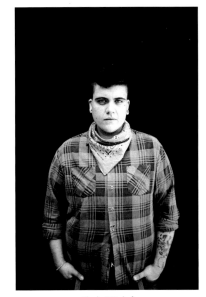

Cash, 27, chef

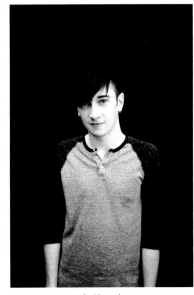

Josh, 12, student

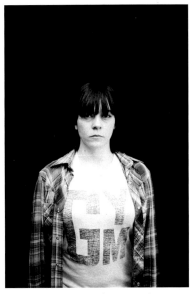

Tera, 35, server and nursing student

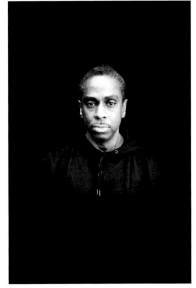

Vernon, 51, artist

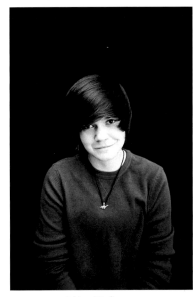

Adrian, 14, dinosaur

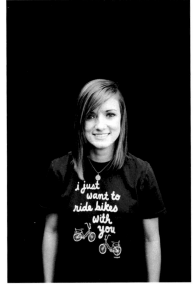

Whitney, 23, med student

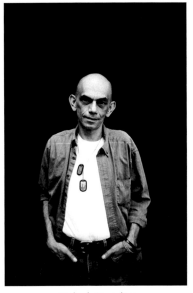

Michael, 46, student

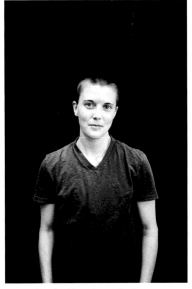

Angela, 28, student and volunteer

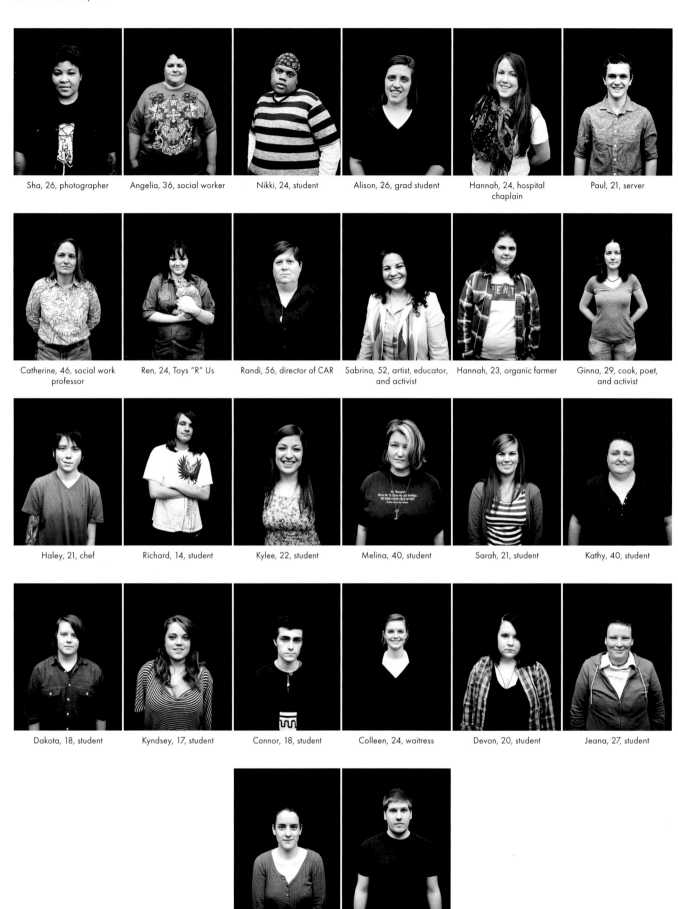

Sha, 26, photographer

Angelia, 36, social worker

Nikki, 24, student

Alison, 26, grad student

Hannah, 24, hospital chaplain

Paul, 21, server

Catherine, 46, social work professor

Ren, 24, Toys "R" Us

Randi, 56, director of CAR

Sabrina, 52, artist, educator, and activist

Hannah, 23, organic farmer

Ginna, 29, cook, poet, and activist

Haley, 21, chef

Richard, 14, student

Kylee, 22, student

Melina, 40, student

Sarah, 21, student

Kathy, 40, student

Dakota, 18, student

Kyndsey, 17, student

Connor, 18, student

Colleen, 24, waitress

Devon, 20, student

Jeana, 27, student

Brett, 28, nonprofit communications

Joseph, 23, nurse

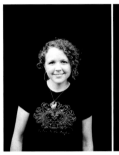
Allison, 24, grad student

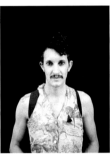
Owen, 26, performer

Victoria, 22, student

Jonathan, 29, security

Jeffrey, 24, retail

Ivy, 25, student

Natalie, 21, cosmetologist

LD, 23, AmeriCorps

Amanda, 30, PhD student

Anna, 26, artist

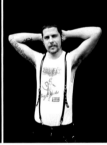
Peter, 25, musician

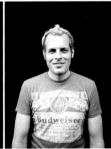
Tom, 37, retired US Marine

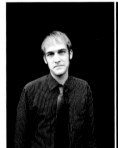
JC, 22, harmonica player

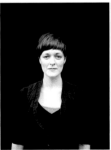
Emily, 27, admin assistant

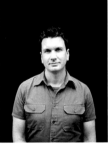
Steve, 33, real estate

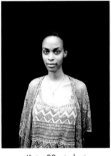
Kate, 22, student

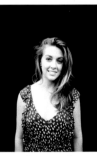
Alex, 20, student

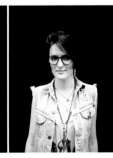
Madeline, 19, student

Brian, 23, singer, actor,
and dancer

Rebecca, 38, nanny
and performance artist

Colin, 26, waiter

Christopher, 49, painter

Kendall, 23

Andy, 33, programmer

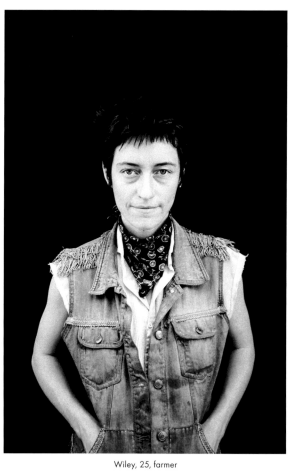

Wiley, 25, farmer

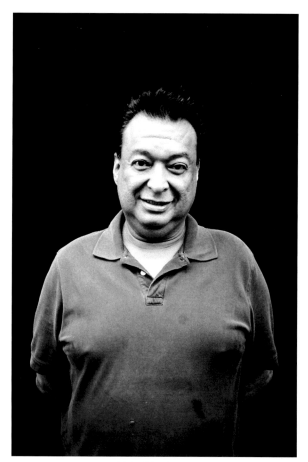

Michael, hairdresser

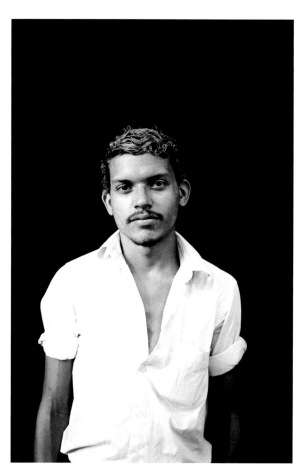

Cody, 24, farmer

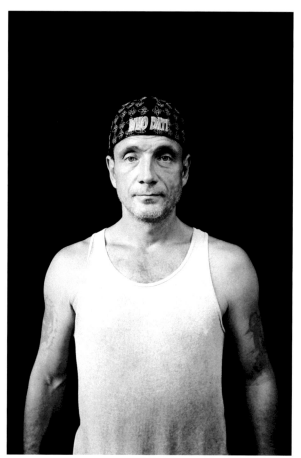

Brian, 47

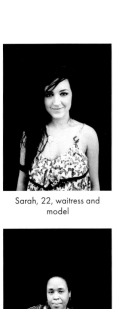

Sarah, 22, waitress and model

Krystal, 28, waiter

Griffin, 23, choreographer

Skip, 26, funemployed

Alison, 19

Meg, 27, artist

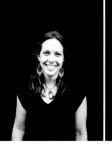

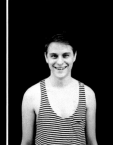

Lilli, 36, musician

Mason, 22, farmer and mechanic

Dziga, 22, web developer

Vanessa, 27, artist

Natalie, 29, Peace Corps

Kyle, 21, student

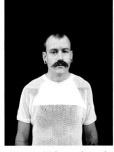

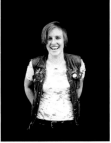

Vincent, 27, bartender and farmhand

Katie, 25, punk

Matthew, 21, medical historian

Shanique, 19, student

Austin, 19, student

Lane, 24, baker

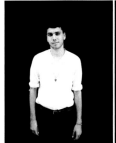

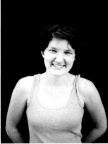

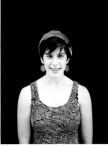

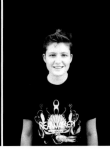

Alex, 24, social worker

Maddie, 25, student

Sara Beth, 24, waitress

Ashley, 23, student

Jordan, 25, organizer

Ron, 25, social worker and designer

Wil, pastor

Alexandra, 24, actress

Ariana, 21, student

Courtney, 35, filmmaker

Caroline, 22, Trinity Episcopal Church

Kiernan, 24, artist

Teilyn, 21, student

Allison, 21, student

Elizabeth, 64, retired architect

Donna Jean, retired

Robbie, 27, MD

Jenn, 20, student

Mackenzie, 19, student

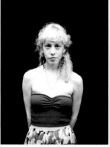

Noelle, 18, student

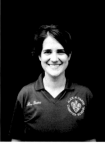

Laura, 24, teacher

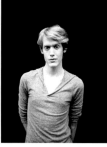

Troy, 22, retail

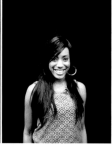

Toi, 22, visual merchandiser

Perry, 23, student

Joseph, 24, hatter

Tyrone, 32, art store associate

Liz, 30, legal assistant and musician

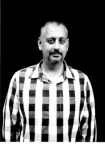

Tysen, 41, retail

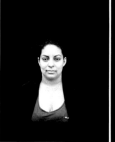

Michelle, 24

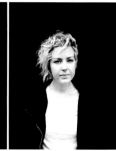

Emily, 27, law student

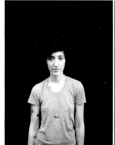

Paige, 21

Marianne, 18

Anne, 22, student

Crosby, 22, student

Princess Stephanie, 56, entertainer

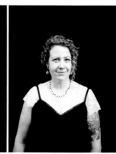

Chaos, 36, server

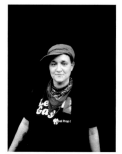

Jessica, 37, cook

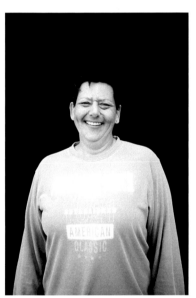

Deborah, 48, mechanic

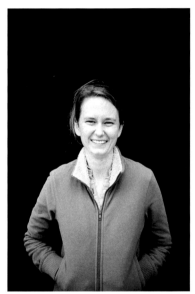

Heather, 24, librarian

Jordan, 41, reporter

Donna, 51, writer

Genevieve, 24, student

KJ, 23, animal care student

Krista, 18 Bri, 24, student Morgan, 23, nurse Jessica Jamee, 33, pizza delivery Wheelo, 27, theater design

Elizabeth, student and bookkeeper Valerie, 29, graduate research assistant Samantha, 25, writer, student, and librarian Will, 18 Kai, 22 Eli, 14, student

Adam, 33, farmer Eric, carpenter Jill, 37, professor Ashley, 26, chiropractor's assistant

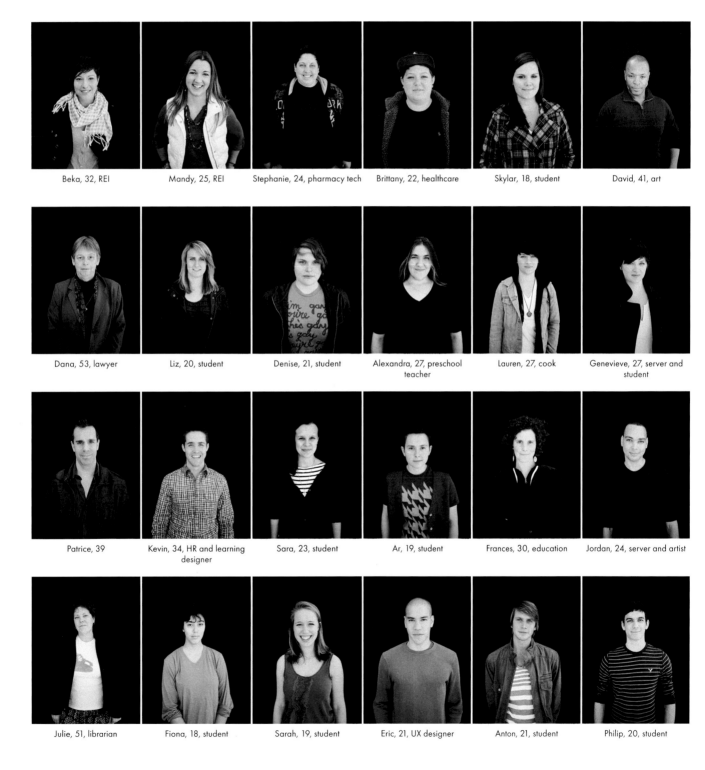

Beka, 32, REI

Mandy, 25, REI

Stephanie, 24, pharmacy tech

Brittany, 22, healthcare

Skylar, 18, student

David, 41, art

Dana, 53, lawyer

Liz, 20, student

Denise, 21, student

Alexandra, 27, preschool teacher

Lauren, 27, cook

Genevieve, 27, server and student

Patrice, 39

Kevin, 34, HR and learning designer

Sara, 23, student

Ar, 19, student

Frances, 30, education

Jordan, 24, server and artist

Julie, 51, librarian

Fiona, 18, student

Sarah, 19, student

Eric, 21, UX designer

Anton, 21, student

Philip, 20, student

Vickie, 22, student

Renee, 50, entrepreneur

Diamond, recording star

Hurst, 18, student

 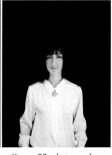 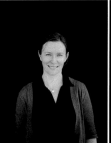 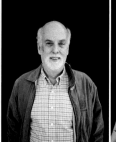 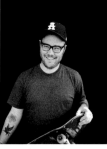

Luci, 31, writer and musician Karen, 32, photographer Rachel, 31, school psychologist Dave, writer Chip, 37, chemist Marcia, 34, student

 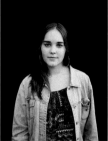 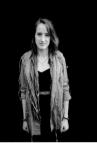 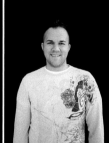

Leela, 17, student Joshua, 17, student Martha, 35, sales Cecilia, 18, student Amelia, 18, student Timothy, 24, retail manager

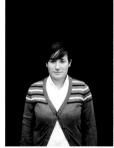 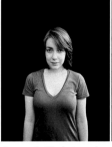 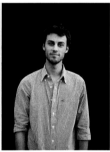 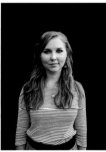 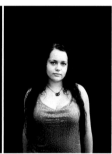

Katherine, 30, river conservationist and teacher Savannah, 15, photographer and student Tyler, 21, student Madison, 17, student Frances, 18, student

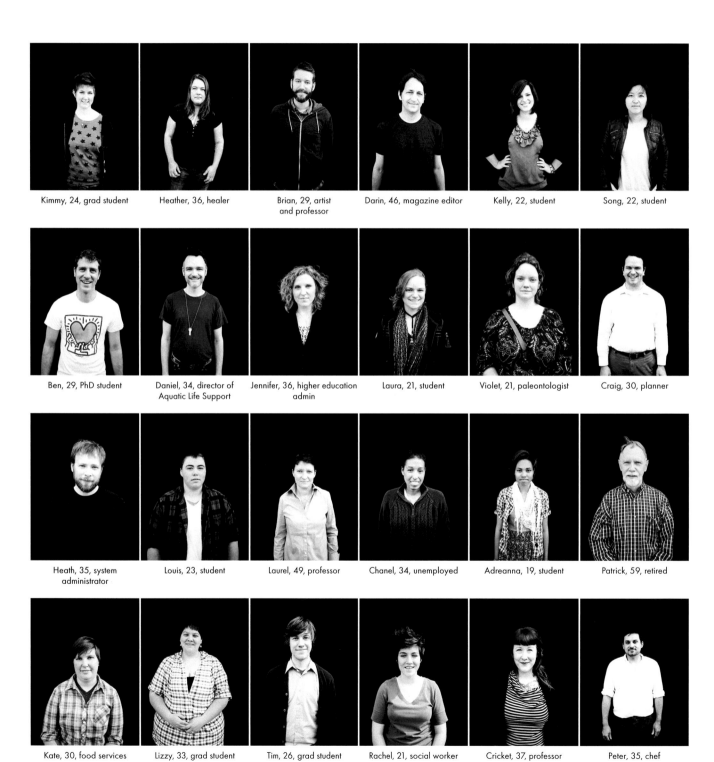

Kimmy, 24, grad student

Heather, 36, healer

Brian, 29, artist
and professor

Darin, 46, magazine editor

Kelly, 22, student

Song, 22, student

Ben, 29, PhD student

Daniel, 34, director of
Aquatic Life Support

Jennifer, 36, higher education
admin

Laura, 21, student

Violet, 21, paleontologist

Craig, 30, planner

Heath, 35, system
administrator

Louis, 23, student

Laurel, 49, professor

Chanel, 34, unemployed

Adreanna, 19, student

Patrick, 59, retired

Kate, 30, food services

Lizzy, 33, grad student

Tim, 26, grad student

Rachel, 21, social worker

Cricket, 37, professor

Peter, 35, chef

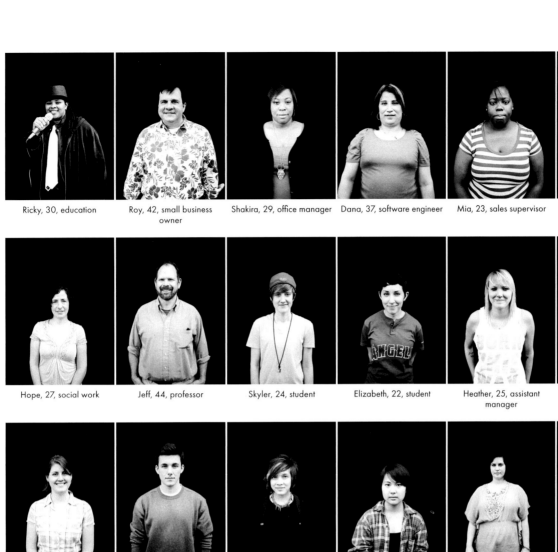

Ricky, 30, education Roy, 42, small business owner Shakira, 29, office manager Dana, 37, software engineer Mia, 23, sales supervisor Arina, 28, student

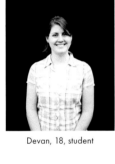

Hope, 27, social work Jeff, 44, professor Skyler, 24, student Elizabeth, 22, student Heather, 25, assistant manager Alma, 22, server

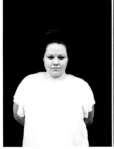 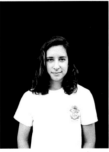 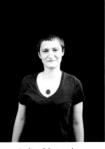 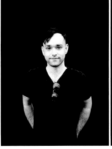

Devan, 18, student Leo, 19, student Rin, 18, student Amanda, 20, student Tiana, 34, massage therapist Landon, 20, student

Heather, 23, nurse Dorothy, 22, student India, 28, teacher Ian, 24, screenprinter Luke, 30, coach Ciera, 19, student

Jess, 28, student Uma, 24, student Adrienne, 24, cook Tod, poet and teacher Desiree, 25, veterinary student Aimee, 24, waitress

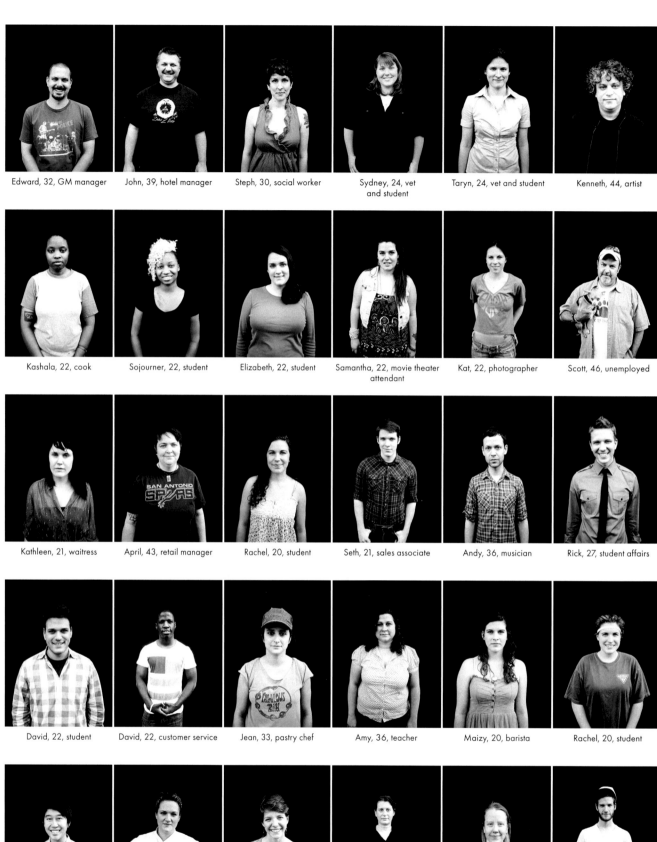

Edward, 32, GM manager John, 39, hotel manager Steph, 30, social worker Sydney, 24, vet and student Taryn, 24, vet and student Kenneth, 44, artist

Kashala, 22, cook Sojourner, 22, student Elizabeth, 22, student Samantha, 22, movie theater attendant Kat, 22, photographer Scott, 46, unemployed

Kathleen, 21, waitress April, 43, retail manager Rachel, 20, student Seth, 21, sales associate Andy, 36, musician Rick, 27, student affairs

David, 22, student David, 22, customer service Jean, 33, pastry chef Amy, 36, teacher Maizy, 20, barista Rachel, 20, student

Minh, 18, student Sarah, 25, chef Katie, 20, student Emily, 33, human resources director Amanda, 36, attorney David, 19, student

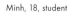

Edwin, 81, retired

Collette, 20, student

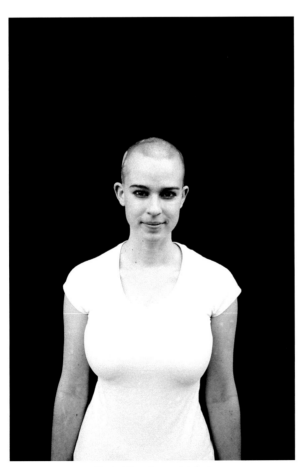

Carrie, 19, waitress and student

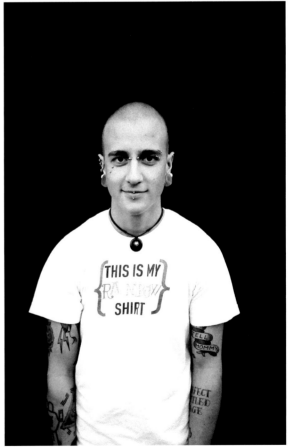

Dae, 23, piercer

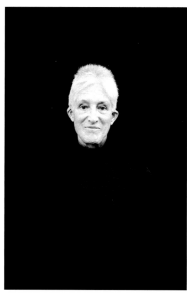

Annette, 71, retired editor

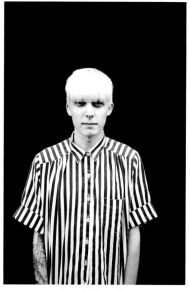

Brian, 24, hairstylist

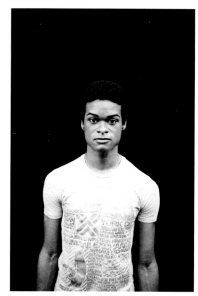

Roxie, 20, student

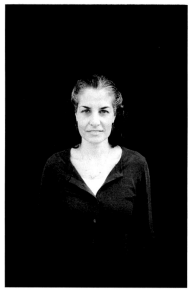

Diane, 45, university administrator

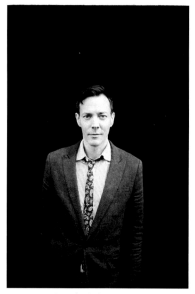

Daniel, 42, theater artist

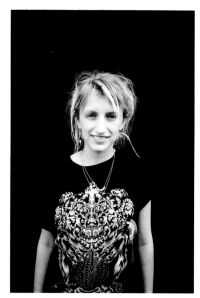

Abi, 18, student

Janet, 23, life

Jeremy, 63, yoga teacher and photographer

Austin, 31, factory worker Carl, 38, RN Carolyn, 27, recreation and parks John, 69, retired Ryan-Ashley, 24, field organizer and artist Mary, 32, student

Tavis, 35, self-employed Stephanie, 25, student Elizabeth, 29, singer and student Meredith, 23, student Kimberly, 30, sales analyst Mitchell, 33, restaurant manager

Jake, 27, meteorologist Haley, 28, nurse Ann, 32, HR Josh, 25, video professional Heather, 25, audio engineer Lyndsey, 23, student

McKenzie, 24, building superintendent Marie, 25, admin assistant Dustin, 24, student and singer Al, 77, retired Jodi, 35, baker and shop owner Erica, 29, admin

Freddie, 23, system
administrator

Sage, 21, tree worker

Casey, 23, student

Zorah, 18, photographer

Alyssa, 18, student

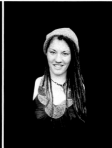

Abigail, 23, massage
therapist and musician

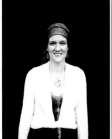

Charlotte, 34, business owner

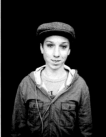

Oz, 13

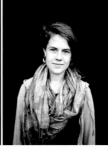

Jill, 20, student

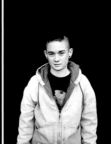

Little Bear, 21, student

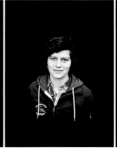

Xenia, 21, student and forester

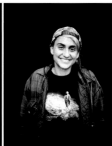

Alex, 23, student

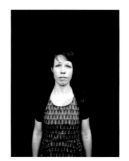

Erin, 32, barista

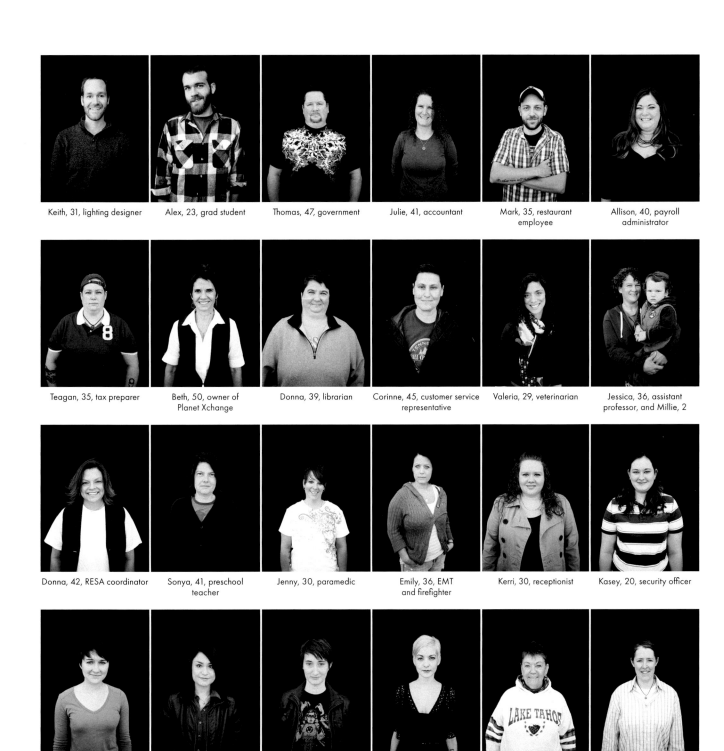

Keith, 31, lighting designer

Alex, 23, grad student

Thomas, 47, government

Julie, 41, accountant

Mark, 35, restaurant employee

Allison, 40, payroll administrator

Teagan, 35, tax preparer

Beth, 50, owner of Planet Xchange

Donna, 39, librarian

Corinne, 45, customer service representative

Valeria, 29, veterinarian

Jessica, 36, assistant professor, and Millie, 2

Donna, 42, RESA coordinator

Sonya, 41, preschool teacher

Jenny, 30, paramedic

Emily, 36, EMT and firefighter

Kerri, 30, receptionist

Kasey, 20, security officer

Caroline, 20, student

Samantha, 23, graphic designer

Summer, 32, teacher

Brynn, 30, hairstylist

Jill, 69, retired

Renee, 42, drug counselor

Dino, 44, postal worker

Carla, 40, software developer

Kristiana, 38, mother and Whole
Foods supervisor

Carol, 51, teacher

Landon, 40, teacher

Jeriah, 12, student

Gail, 70, retail

Kathy, 59, emotional health therapist

Colleen, 32, self-employed

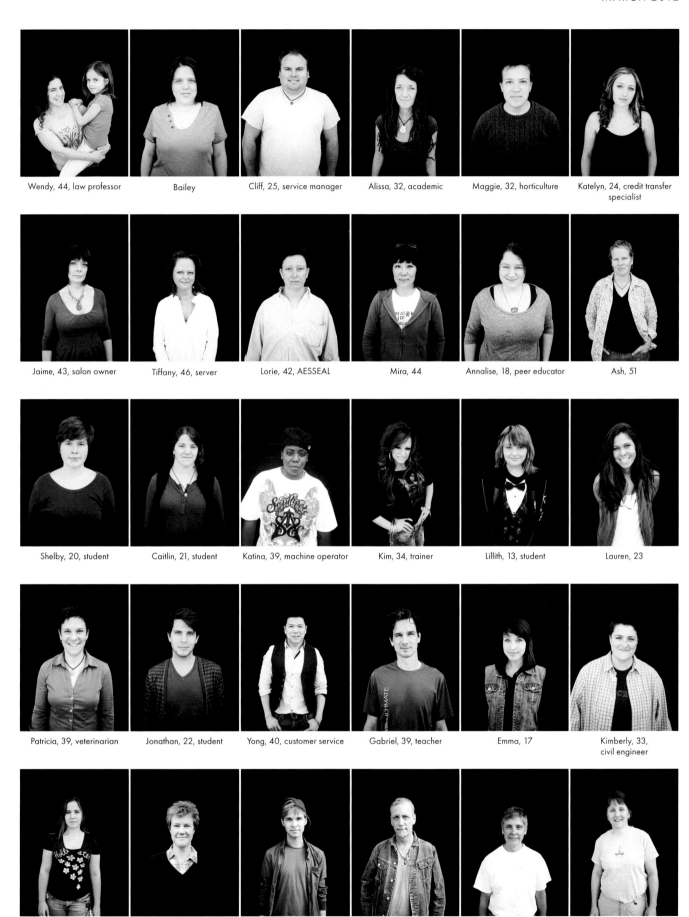

Wendy, 44, law professor

Bailey

Cliff, 25, service manager

Alissa, 32, academic

Maggie, 32, horticulture

Katelyn, 24, credit transfer specialist

Jaime, 43, salon owner

Tiffany, 46, server

Lorie, 42, AESSEAL

Mira, 44

Annalise, 18, peer educator

Ash, 51

Shelby, 20, student

Caitlin, 21, student

Katina, 39, machine operator

Kim, 34, trainer

Lillith, 13, student

Lauren, 23

Patricia, 39, veterinarian

Jonathan, 22, student

Yong, 40, customer service

Gabriel, 39, teacher

Emma, 17

Kimberly, 33, civil engineer

Dakota, 20, student

Sophy, 40, veterinarian

Chip, 24, server and music promoter

Brent, 51, hairstylist

Debbie, 60, RN

Joan, 51, RN

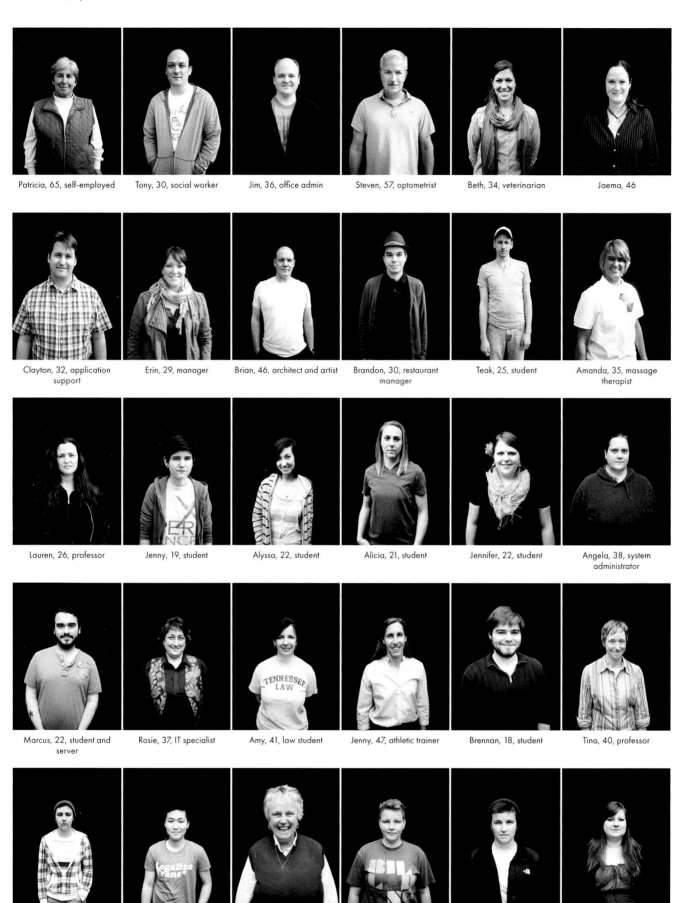

Patricia, 65, self-employed

Tony, 30, social worker

Jim, 36, office admin

Steven, 57, optometrist

Beth, 34, veterinarian

Jaema, 46

Clayton, 32, application support

Erin, 29, manager

Brian, 46, architect and artist

Brandon, 30, restaurant manager

Teak, 25, student

Amanda, 35, massage therapist

Lauren, 26, professor

Jenny, 19, student

Alyssa, 22, student

Alicia, 21, student

Jennifer, 22, student

Angela, 38, system administrator

Marcus, 22, student and server

Rosie, 37, IT specialist

Amy, 41, law student

Jenny, 47, athletic trainer

Brennan, 18, student

Tina, 40, professor

Bree, 19, Office Depot

Tara, 21, student and graphic designer

Kathy, 67

Chelsea, 21, student

Lindsey, 19, student

Pamela, 31, administrative specialist

Randi, 20, student

Donald, 57, quality control

Joel, 36, housing assignment manager

Kamiko, 20, student and athlete

Robyn, 17, student

Ali, 20, advertising sales

Renee, 52, professional

Thien, 21, student

Coleman, 22, student

Porsha, 21, student

Sabra, 28, hairstylist

Samantha, 19, cashier

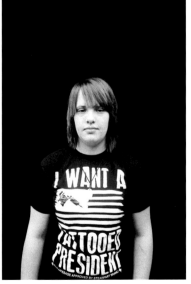

Kansas, 20, deli worker

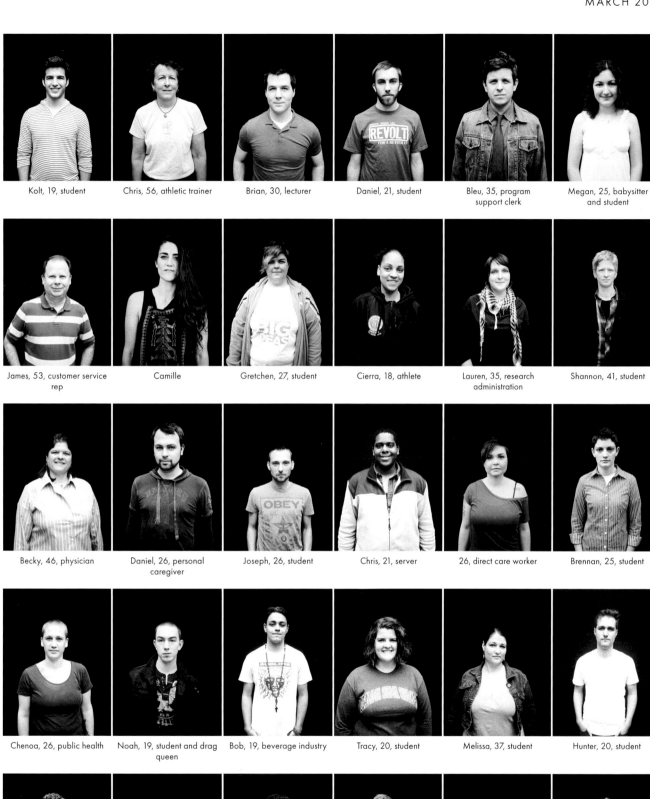

Kolt, 19, student

Chris, 56, athletic trainer

Brian, 30, lecturer

Daniel, 21, student

Bleu, 35, program support clerk

Megan, 25, babysitter and student

James, 53, customer service rep

Camille

Gretchen, 27, student

Cierra, 18, athlete

Lauren, 35, research administration

Shannon, 41, student

Becky, 46, physician

Daniel, 26, personal caregiver

Joseph, 26, student

Chris, 21, server

26, direct care worker

Brennan, 25, student

Chenoa, 26, public health

Noah, 19, student and drag queen

Bob, 19, beverage industry

Tracy, 20, student

Melissa, 37, student

Hunter, 20, student

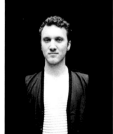

Adam, 20, student

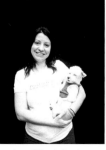

Amy, 37, veterinarian

Gerardo, 32, teacher

Jonathan, 25, student and veterinary tech

Kelsey, 22, student

Jessica, 21, student

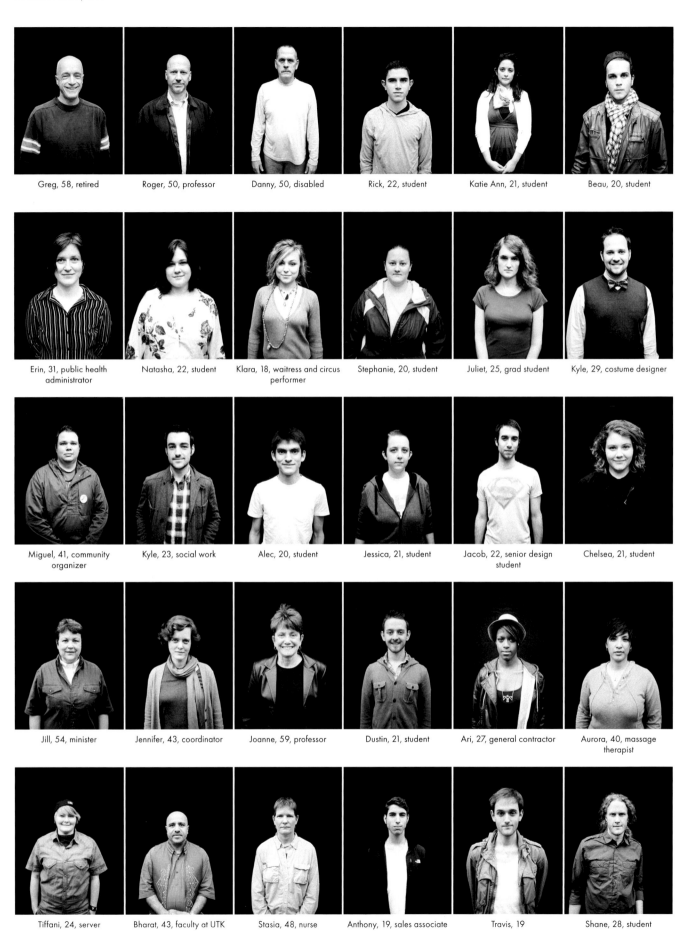

Greg, 58, retired

Roger, 50, professor

Danny, 50, disabled

Rick, 22, student

Katie Ann, 21, student

Beau, 20, student

Erin, 31, public health administrator

Natasha, 22, student

Klara, 18, waitress and circus performer

Stephanie, 20, student

Juliet, 25, grad student

Kyle, 29, costume designer

Miguel, 41, community organizer

Kyle, 23, social work

Alec, 20, student

Jessica, 21, student

Jacob, 22, senior design student

Chelsea, 21, student

Jill, 54, minister

Jennifer, 43, coordinator

Joanne, 59, professor

Dustin, 21, student

Ari, 27, general contractor

Aurora, 40, massage therapist

Tiffani, 24, server

Bharat, 43, faculty at UTK

Stasia, 48, nurse

Anthony, 19, sales associate

Travis, 19

Shane, 28, student

 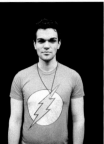 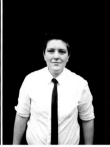 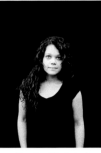 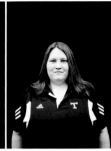

Laura, 22, personal trainer Amberly, 23, grad student Tyler, 23, student Lauren, 22, student Dorothy, 25, student Ashleigh, 25, bartender

 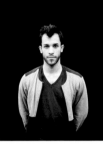 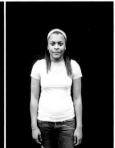

Victoria, 26, merchandiser Elizabeth, 25, campus worker Donna, 47, multimedia Michelle, 22, server Timothy, 25, theater lighting designer Chelsea, 21, student

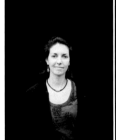 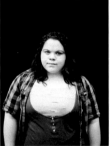

Kate, 27, lighting designer Vivian, 19, call center agent Andrew, 18, host at Texas Roadhouse Virginia, 18, student Shannon, 41, real estate Jeff, 35, filmmaker

Scott, 45, grad student Rusty, 35, HR

99

 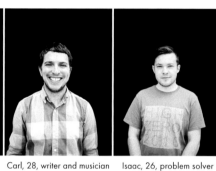

Matt, 33, festival organizer Kalindi, 20, barista Carl, 28, writer and musician Isaac, 26, problem solver Nick, 26, sales Brendan, 52, sports agent

Burton, 42, produce expert Eli, 19, student Jenny, 24, filmmaker Franky, 19, student Ian, 22, student Andrew, 24, botanist

 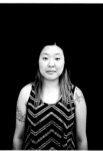 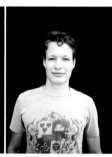 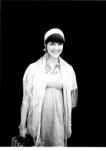 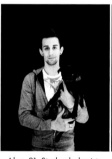

Jacob, 24, musician Christina, 26, eyewear Matty, 24, worker Golda, 21, artist Alex, 21, Starbucks barista Aaron, 22, artist

Trevor, 28, electrician Erica, 22, videographer Jeffrey, 21, student Jen, 37, assistant editor and musician Lauren, 25, DJ and promoter Scott, 25, producer, editor, and photographer

Katya, 26, editor, and Nina

Andi, 27

Nicholas, 20, artist

Bibi, 27, student

Elena, 30, artist

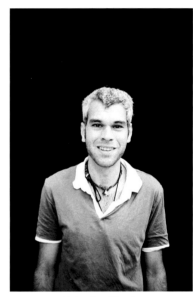

Christopher, 30, artist

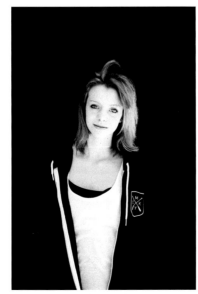

Deeda, 12, student

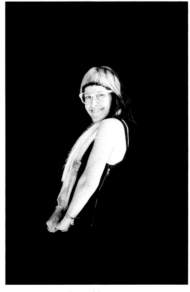

Tricia, 33, writer

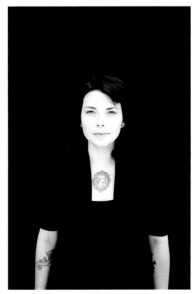

Anna, 23, server

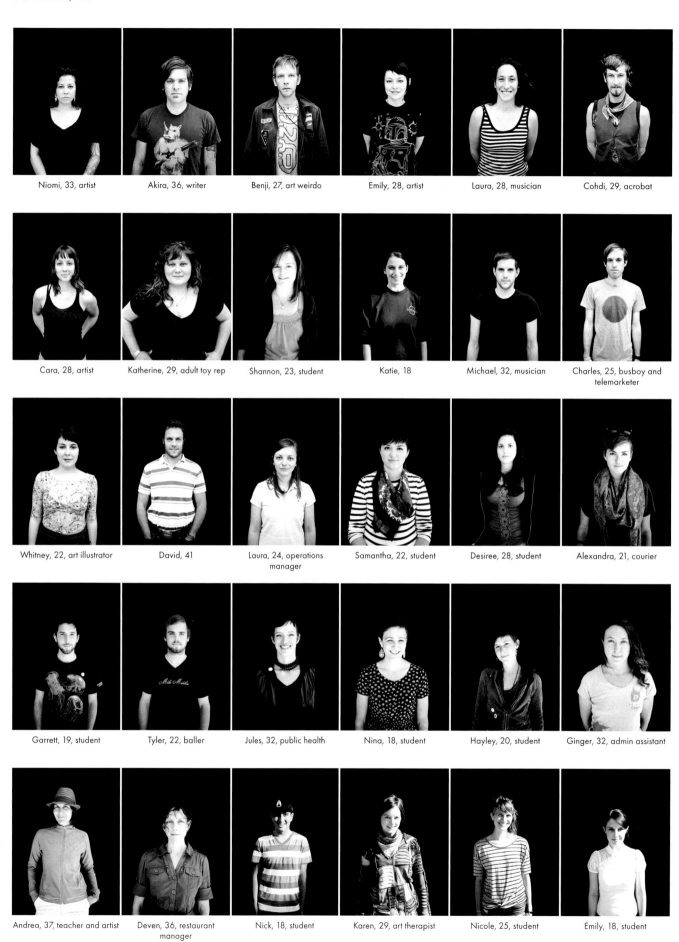

Niomi, 33, artist

Akira, 36, writer

Benji, 27, art weirdo

Emily, 28, artist

Laura, 28, musician

Cohdi, 29, acrobat

Cara, 28, artist

Katherine, 29, adult toy rep

Shannon, 23, student

Katie, 18

Michael, 32, musician

Charles, 25, busboy and telemarketer

Whitney, 22, art illustrator

David, 41

Laura, 24, operations manager

Samantha, 22, student

Desiree, 28, student

Alexandra, 21, courier

Garrett, 19, student

Tyler, 22, baller

Jules, 32, public health

Nina, 18, student

Hayley, 20, student

Ginger, 32, admin assistant

Andrea, 37, teacher and artist

Deven, 36, restaurant manager

Nick, 18, student

Karen, 29, art therapist

Nicole, 25, student

Emily, 18, student

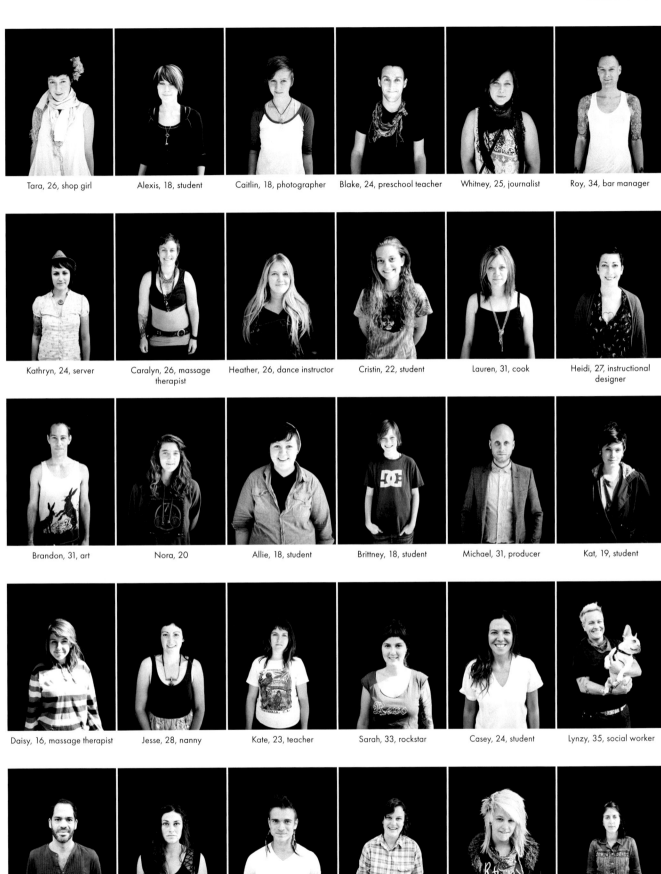

Tara, 26, shop girl Alexis, 18, student Caitlin, 18, photographer Blake, 24, preschool teacher Whitney, 25, journalist Roy, 34, bar manager

Kathryn, 24, server Caralyn, 26, massage therapist Heather, 26, dance instructor Cristin, 22, student Lauren, 31, cook Heidi, 27, instructional designer

Brandon, 31, art Nora, 20 Allie, 18, student Brittney, 18, student Michael, 31, producer Kat, 19, student

Daisy, 16, massage therapist Jesse, 28, nanny Kate, 23, teacher Sarah, 33, rockstar Casey, 24, student Lynzy, 35, social worker

Mauricio, 37, nonprofit Lea, 33, photographer Benjamin, 26, student Sophie, 17 Megan, 19, Goldmine Vintage Lauren, 19, student

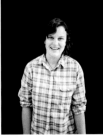

Camren, 27, event production

James, 18, student

Kyle, 18, pizza girl

Brett, 30, student

Natalie, 27, musician

Spekter, 37, motion graphics design

Alyosha, 20, student

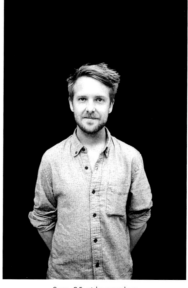

Sam, 25, videographer

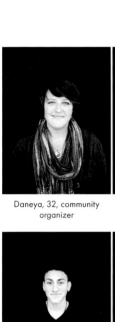

Daneya, 32, community organizer

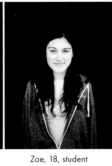

Zoe, 18, student

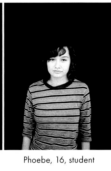

Phoebe, 16, student

Mallaury, 26, customer service

Ching Yuan, 33, kitchen manager

Janece, 23, graphic designer

Jesse, 21, bartender

Steven, 43, bar owner

Jorge, 27, bartender

Court, 35, operations manager

Heather, 33, nanny

Mandalyn, 22, US Air Force

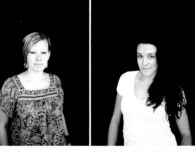

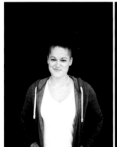

Kirsten, 25, ER and US Air Force

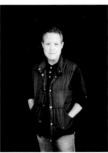

Matt, 57, speaker, trainer, and author

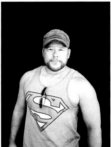

Drew, 40, blog writer

Mark, 43, computer engineer

Eli, 21, photographer

Paul, 44, accounting

Kristy, 31, photographer

Michael, 42, server

Cheryl, 36, clinical therapist

Shannon, 28, yoga teacher and doula, and Willow

Ben, 30, designer and drafter

Kyla, 26, photographer

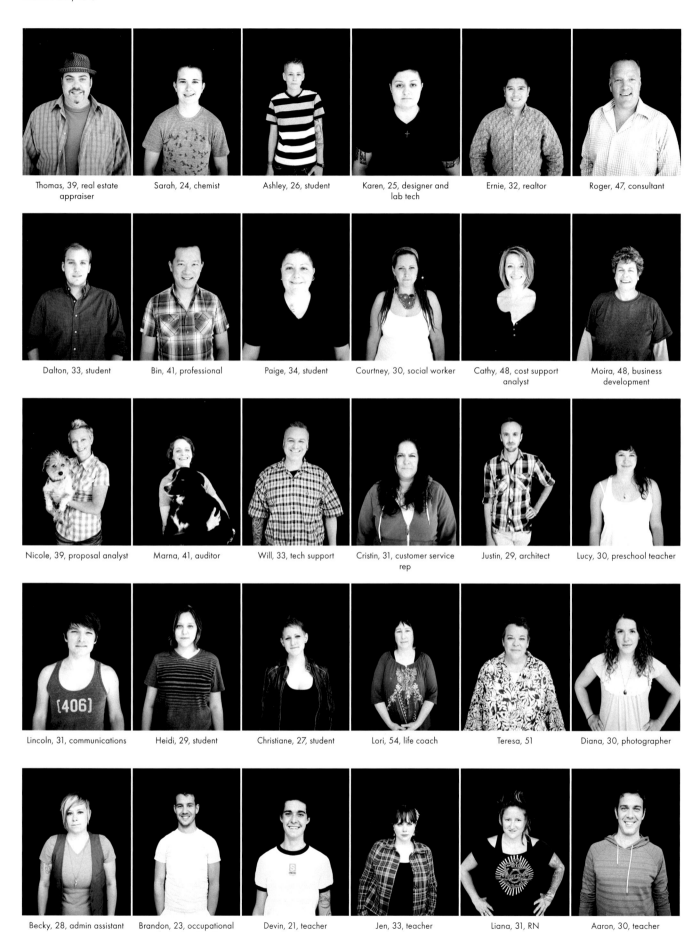

Thomas, 39, real estate appraiser

Sarah, 24, chemist

Ashley, 26, student

Karen, 25, designer and lab tech

Ernie, 32, realtor

Roger, 47, consultant

Dalton, 33, student

Bin, 41, professional

Paige, 34, student

Courtney, 30, social worker

Cathy, 48, cost support analyst

Moira, 48, business development

Nicole, 39, proposal analyst

Marna, 41, auditor

Will, 33, tech support

Cristin, 31, customer service rep

Justin, 29, architect

Lucy, 30, preschool teacher

Lincoln, 31, communications

Heidi, 29, student

Christiane, 27, student

Lori, 54, life coach

Teresa, 51

Diana, 30, photographer

Becky, 28, admin assistant

Brandon, 23, occupational therapy assistant

Devin, 21, teacher

Jen, 33, teacher

Liana, 31, RN

Aaron, 30, teacher

Corbin, 23, unemployed

Jazmyne, 21, baker and artist

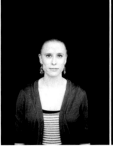
Catherine, 22, student

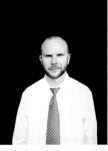
Alfredo, 36, ESL instruction

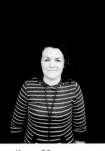
Kasey, 30, manager

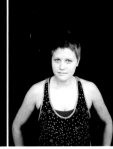
Kasey, 30, manager

Ryan, 31, photographer

Meghan, 32, costume designer

Brenda, 51, wardrobe director

Dustin, 37, minister

Matthew, 30, teacher

Jess, 36, barber

Deanna, 41, art teacher

Phoebe, 33, store manager

Jeff, 29, teacher

Jennifer, 22, student

Caitlin, 21, student

Emily, 22, student

Minka, 20, student

Katharine, 21, student

Johnny, 20, student

Eva, 21, student

Corley, 29, accountant and opera singer

Brian, 39, accountant

Brad, 40, director of operations

Taylor, 25, paraeducator

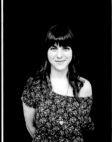
Amy, 30

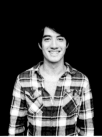
Bradley, 23, student

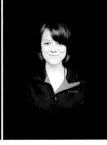
Kelly, 24, counselor

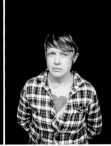
Robyn, 39, graphic design

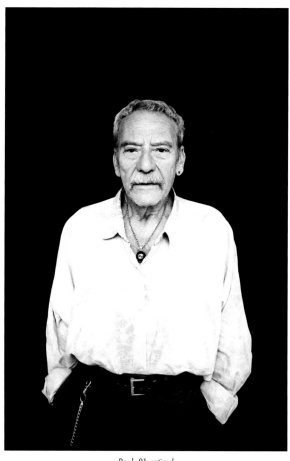

Paul, 81, retired

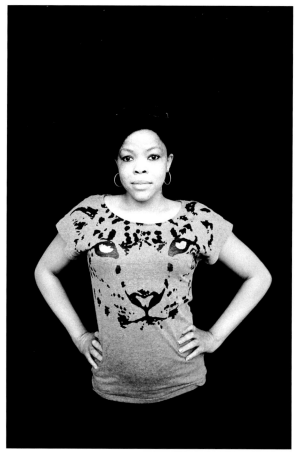

Ashley, 24, pimp

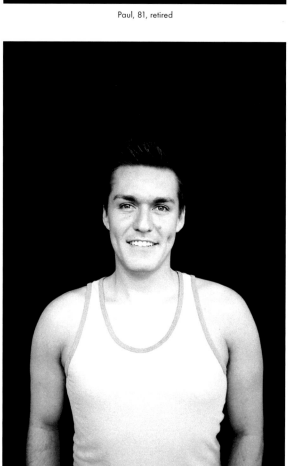

Shawn, 27, bartender

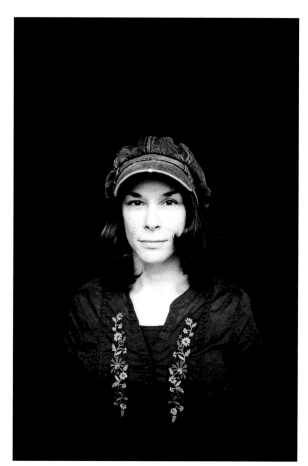

Sarah, 35, photographer

David, 25, government sales Richard, 30, healthcare Joshua, 26, advertising Ally, 34, inventory specialist Krista, 29, lab tech Adrienne, 31, teacher

Sean, 28, healthcare Carleen, 22, artist Devin, 21, Snap Glitter Alejandro, 31, librarian

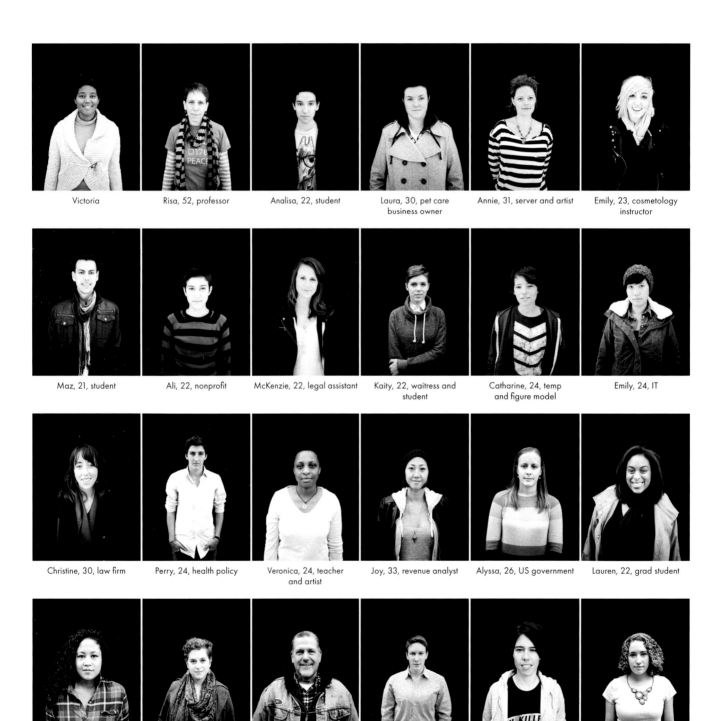

Victoria

Risa, 52, professor

Analisa, 22, student

Laura, 30, pet care business owner

Annie, 31, server and artist

Emily, 23, cosmetology instructor

Maz, 21, student

Ali, 22, nonprofit

McKenzie, 22, legal assistant

Kaity, 22, waitress and student

Catharine, 24, temp and figure model

Emily, 24, IT

Christine, 30, law firm

Perry, 24, health policy

Veronica, 24, teacher and artist

Joy, 33, revenue analyst

Alyssa, 26, US government

Lauren, 22, grad student

Kellyn, 26, lawyer

Ray, 24, student

Joseph, 64, psychotherapist and social worker

Anna, 22, legislative assistant

Sarah, 32, attorney

Jo, 28, PhD student

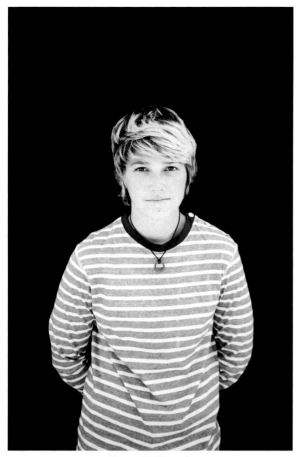

Gunner, 18, lifeguard

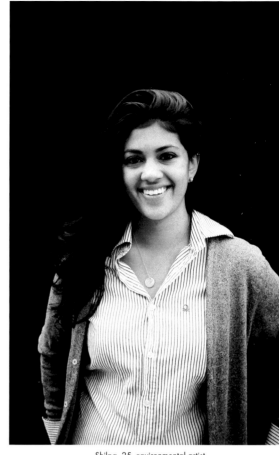

Shilpa, 25, environmental artist

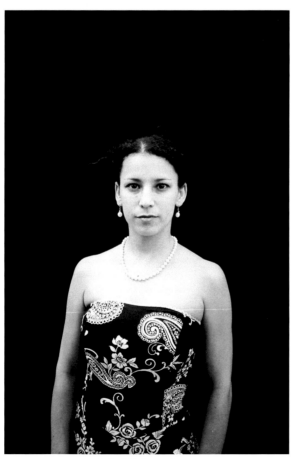

Jade, 27, ballroom dancer

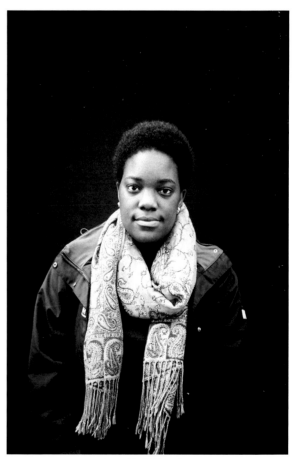

Dena, 22, ESOL teacher

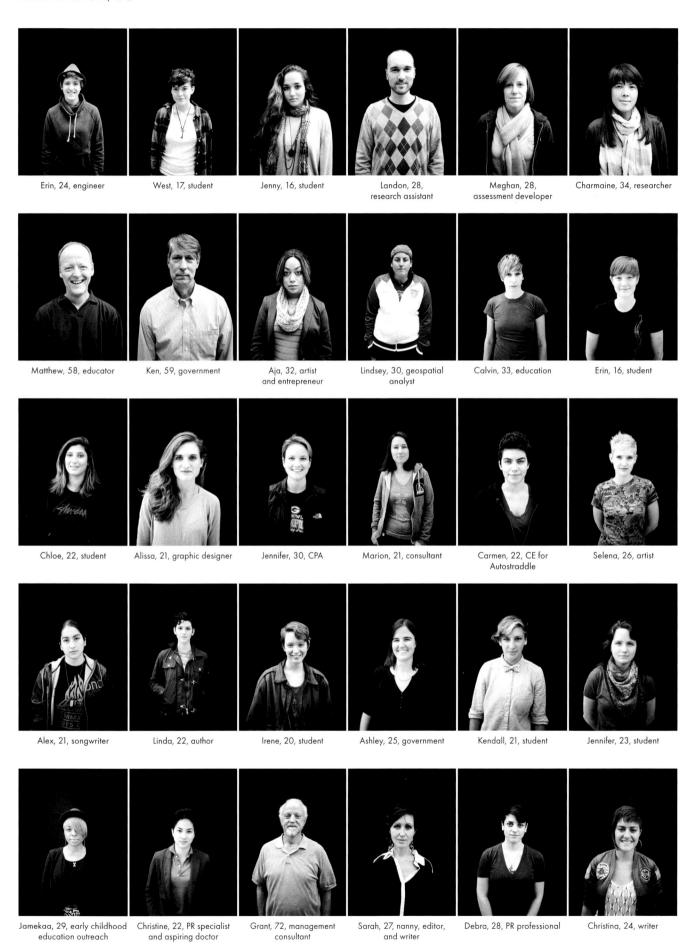

Erin, 24, engineer

West, 17, student

Jenny, 16, student

Landon, 28,
research assistant

Meghan, 28,
assessment developer

Charmaine, 34, researcher

Matthew, 58, educator

Ken, 59, government

Aja, 32, artist
and entrepreneur

Lindsey, 30, geospatial
analyst

Calvin, 33, education

Erin, 16, student

Chloe, 22, student

Alissa, 21, graphic designer

Jennifer, 30, CPA

Marion, 21, consultant

Carmen, 22, CE for
Autostraddle

Selena, 26, artist

Alex, 21, songwriter

Linda, 22, author

Irene, 20, student

Ashley, 25, government

Kendall, 21, student

Jennifer, 23, student

Jamekaa, 29, early childhood
education outreach

Christine, 22, PR specialist
and aspiring doctor

Grant, 72, management
consultant

Sarah, 27, nanny, editor,
and writer

Debra, 28, PR professional

Christina, 24, writer

Bruria, 17, student

Avonlea, 16, accounting intern

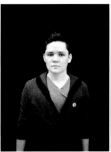

Nico, 29, fellowship advisor

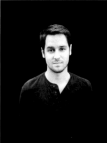

Cameron, 22, student

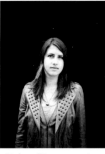

Lindsay, 23, arts organizer

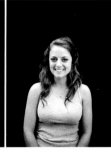

Jennifer, 21, student

Christine, 24, government

Lauren, 27, PETA facilities coordinator

Allison, 26, communications

Min, 22, student

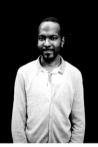

Desmond, 27, manager

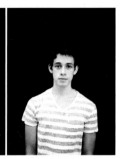

Steven, 18

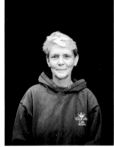

Stephanie, 59, retired special ed teacher

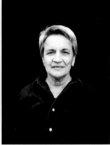

Lorraine, 66, psychotherapist

Deb, 60, editorial manager

Michelle, 31, student

2013

1,728–1,800	Oregon State University Corvallis, OR
1,801–1,910	Portland, OR
1,911–1,973	Stanford University Palo Alto, CA
1,974–2,015	Bay Area Youth Summit San Francisco, CA
2,016–2,096	NYC Dyke March New York, NY
2,097–2,218	NYC Pride New York, NY
2,219–2,251	Visalia, CA
2,252–2,312	Bakersfield Pride Bakersfield, CA
2,313–2,315	Berkeley, CA
2,316–2,335	Davis University Davis, CA

2,336–2,349	Redding, CA
2,350–2,440	Santa Barbara, CA
2,441–2,486	Chapman University Orange County, CA
2,487–2,505	Gay & Lesbian Elder Housing Los Angeles, CA
2,506–2,511	Google Gayglers San Francisco, CA
2,512–2,558	Youth Empowerment Summit San Francisco, CA
2,559–2,619	The Castro San Francisco, CA
2,620–2,644	Google Gayglers Mountain View, CA
2,645–2,652	National Center for Lesbian Rights San Francisco, CA

Lucy, 24, graduate teaching assistant

Rachel, 30, instructor

Erin, 24, student

Agustin, 22, student

Kirsten, 20, student

Kyia, 21, student

Lexie, 21, student

Melanie, 20, student

DJ, 24, grad student

John, 21, student

Shelby, 21, student

Kathleen, 19, student

Chris, 21, student

Sam, 22, student

Agne, 21, student and athlete

Tyfany, 19, student and military

Regina, 18, student

Nicole, 19, student

Stephanie, 27, graduate teaching assistant

Blake, 21, student

Katie, 20, student

Nick, 23, grad student

Jacob, 22, student

Kyle, 22, student

Hannah, 22, student

Stina, 18, student worker

Haley, 21, student

Marie, 20, student

Bryanna, 20, student

Jacky, 25, student

Brandi, 31, resident director

Kiah, 21, student

Justin, 21, student

Luke, 20, student

Jamie, 23, student

Roberto, 42, director

Kelsey, 24, residential
program specialist

Steve, 41, teaching assistant

Newmie, 22, cake diva

Nicole, 19, student

Taylor, 20, student

Liam, 26, deep sea diver

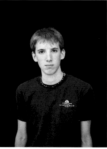

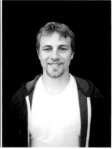

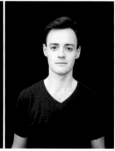

Jarod, 30, winemaker

Amanda, 21, fabric specialist

Alec, 19, student

Austin, 21, student

John, 25, student and server

Andrew, 23, grad student

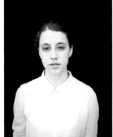

Sarah, 18, student

Jeff, 29, LGBTQ administrator

Emmet, 21, call center worker

Bryce, 20, student

Ayman, 20, student

Rose, 19

Mishal, 20, student

Chelsea, 22, student
and server

Rylan, 21, Pride Center

Audrey, 21, student

Erin, 21, student and barista

Jamie, 22, student

Leah, 29, grad student

George, 18, student

Adeline, 20, student

Mollie, 21, graphic designer

Breanne, 21, student

Brenna, 19, student

Brittany, 22, customer
service rep

Eric, 21, student

Megan, 20, student

Alexis, 21, student

Greg, 21, facilitator

Abel, 21, VP of
Northwest Polo Club

Charlie, 22, Pride Center

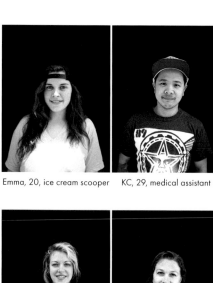

Emma, 20, ice cream scooper

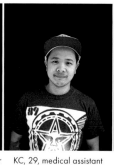

KC, 29, medical assistant

Kimberly, 24, server

Tyler, 25, student

Bria, 34

Princess Ryan, 24, mother

Kaija, 27, photographer

Mari, 39, artist and business owner

Sean, 24, social worker

Katie, 27, student and designer

Talor, 24, personal trainer

Sarah, 23, development specialist

Joel, 56, project manager

Rebecca, 32, unemployed

Ali, 27, camping specialist

Lauren, 32, artist

Emerald, 20, childcare worker

Meg, 35, retail

Kimberly, 25, food service

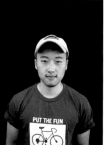

Chris, 24, food service

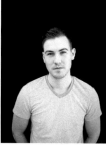

Josh, 25, higher education administrator

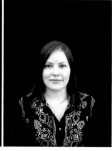

Heather, 28, doula

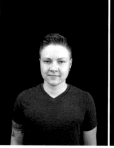

Cameron, 25, development coordinator

Wesley, 26, paraeducator

Seamus, 28, teacher

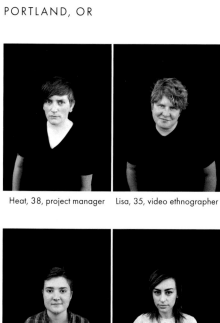

Heat, 38, project manager

Lisa, 35, video ethnographer

Nancy, 30, hairstylist

Milo, 28

Heather, 31, artisan baker

Alec, 24, creative director

Frida, 23, server

Bri, 23, makeup artist

Braylee, 25, makeup artist

Ian, 26, direct care worker

Mari, 26, cook

Joy, 26, cook

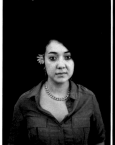
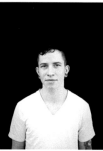
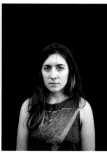

Loren, 31, aircraft mechanic

Saryn, 32, baker

Ginny, 23, delivery biker

Jackie, 23, student

Tim, 27, architect

Jesse, 22, architecture student

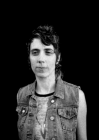
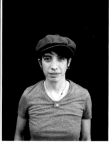
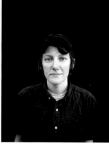
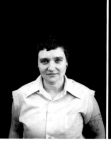
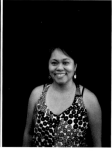

Nico, 25, vagabond

Leibel, 20, server

Hannah, 27, student

Margaret, 23, server

Dianna, 32, archaeologist

Britt, 33, insurance specialist

Cat, 31, graphic design

Gray, 42, art director

Dash, 34, customer service

Chris, 33, musician

Mikhiel, 35, writer

LaiLani, 37, indigenous
community organizer

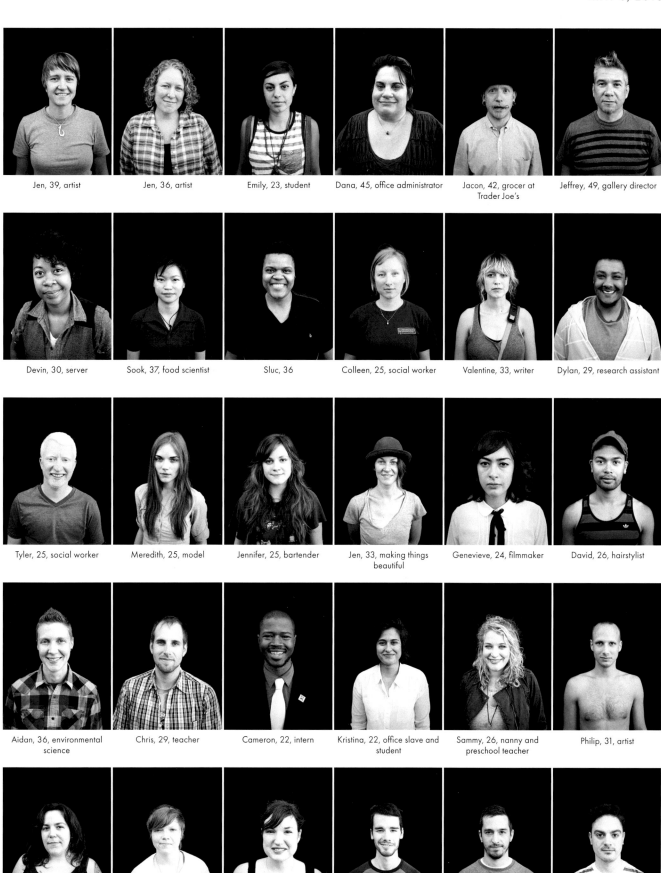

Jen, 39, artist Jen, 36, artist Emily, 23, student Dana, 45, office administrator Jacon, 42, grocer at Trader Joe's Jeffrey, 49, gallery director

Devin, 30, server Sook, 37, food scientist Sluc, 36 Colleen, 25, social worker Valentine, 33, writer Dylan, 29, research assistant

Tyler, 25, social worker Meredith, 25, model Jennifer, 25, bartender Jen, 33, making things beautiful Genevieve, 24, filmmaker David, 26, hairstylist

Aidan, 36, environmental science Chris, 29, teacher Cameron, 22, intern Kristina, 22, office slave and student Sammy, 26, nanny and preschool teacher Philip, 31, artist

Charlz Lynn, 29, student and biology researcher Marianna, 25, purchasing manager Rachel, 32, medical assistant Harrison, 24, baker Joshua, 24, barista Mark, 29, designer

Charles, 62, yoga teacher

Heather, 43, creative

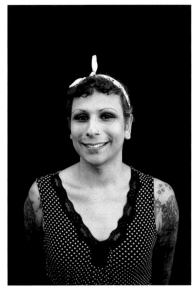

Natalie, 33, marketing

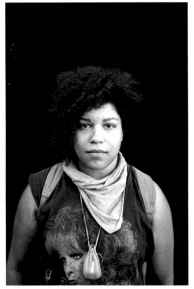

Israel, 24, farm muscles

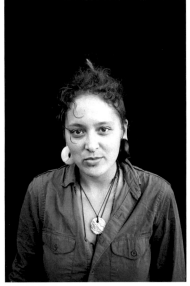

Ariah, 22, restaurant server

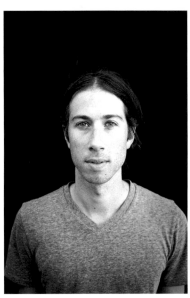

Peter, 29, musician

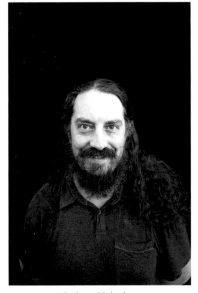

Zachary, 33, badass

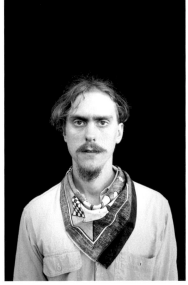

Nolan, 27, gardener

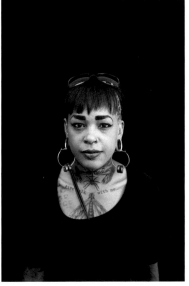

Raven, 25, server

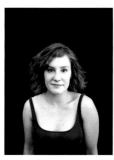

Kaitlyn, 24, project coordinator

Sam, 26, graduate research assistant

Jack, 31, aerialist

Samuel, 22, barista, student, and server

Caitlyn, 34, web developer

Stephanie, 26, graphic design

Jordanna, 22, midwifery student

Kaya, 24, nanny and student

Lindsay, 32, actor

Kimberly, 23, nanny

Maleah, 26, environmental tech

Rosevan, 24, nonprofit admin and dancer

Ryann, 31, hairdresser

Jon, 23, ice cream scooper

Galen, 24, nanny and artist

Roslynn, 33

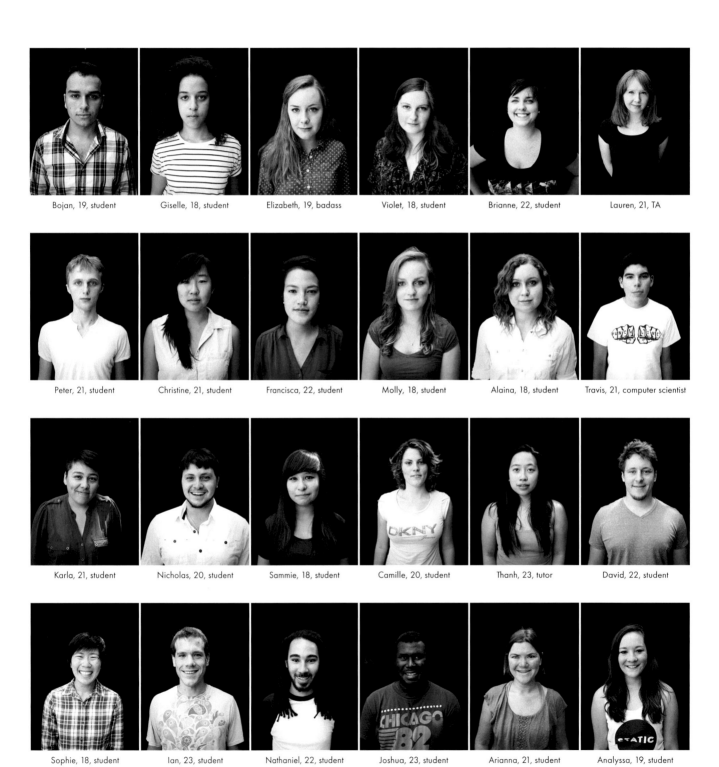

Bojan, 19, student

Giselle, 18, student

Elizabeth, 19, badass

Violet, 18, student

Brianne, 22, student

Lauren, 21, TA

Peter, 21, student

Christine, 21, student

Francisca, 22, student

Molly, 18, student

Alaina, 18, student

Travis, 21, computer scientist

Karla, 21, student

Nicholas, 20, student

Sammie, 18, student

Camille, 20, student

Thanh, 23, tutor

David, 22, student

Sophie, 18, student

Ian, 23, student

Nathaniel, 22, student

Joshua, 23, student

Arianna, 21, student

Analyssa, 19, student

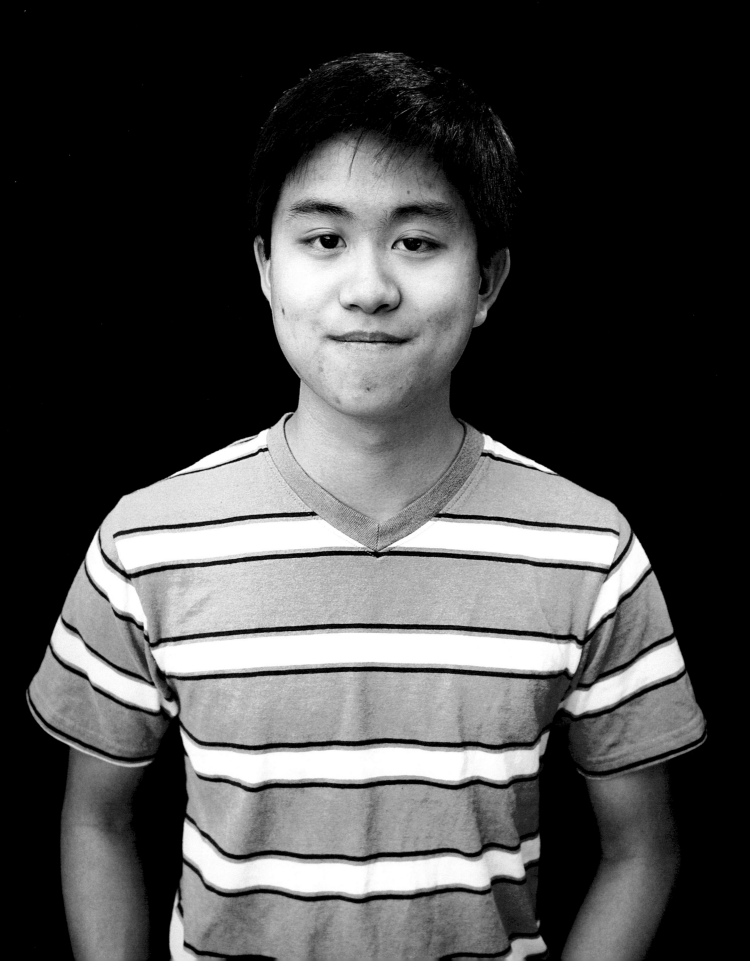

Ethan, 19, student

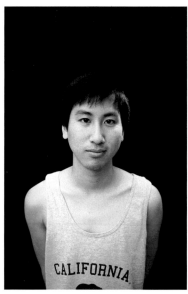

Thanh, 21, student

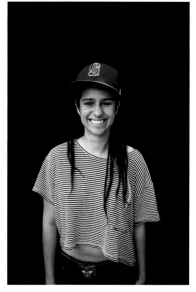

Vivian, 21, student

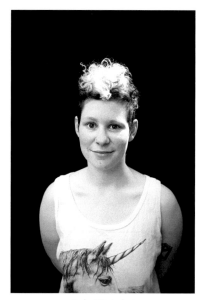

Carly, 20, student

Natasha, 20, spatial studies

Darcey, 19, student

Laura, 21, student

Anna, 21, lover

Alejandro, 20, student

Jonathan, 19, student

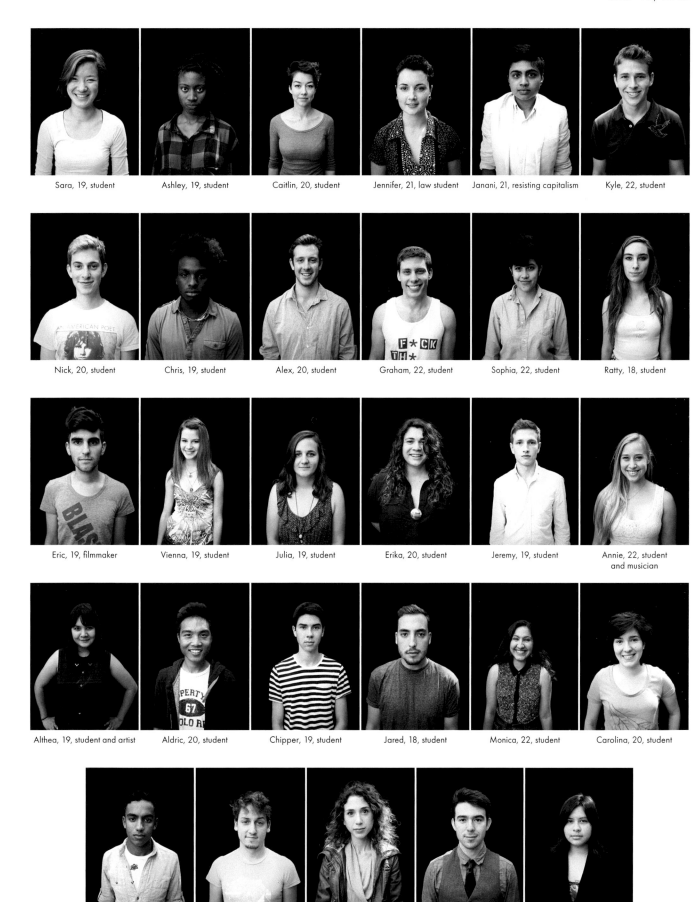

Sara, 19, student

Ashley, 19, student

Caitlin, 20, student

Jennifer, 21, law student

Janani, 21, resisting capitalism

Kyle, 22, student

Nick, 20, student

Chris, 19, student

Alex, 20, student

Graham, 22, student

Sophia, 22, student

Ratty, 18, student

Eric, 19, filmmaker

Vienna, 19, student

Julia, 19, student

Erika, 20, student

Jeremy, 19, student

Annie, 22, student and musician

Althea, 19, student and artist

Aldric, 20, student

Chipper, 19, student

Jared, 18, student

Monica, 22, student

Carolina, 20, student

Brandon, 18, student

Tyler, 25, student

Annie, 23, student

Andrew, 21, grad student

Jocelyn, 18, student

BAY AREA YOUTH SUMMIT
SAN FRANCISCO, CA
MAY 12, 2013

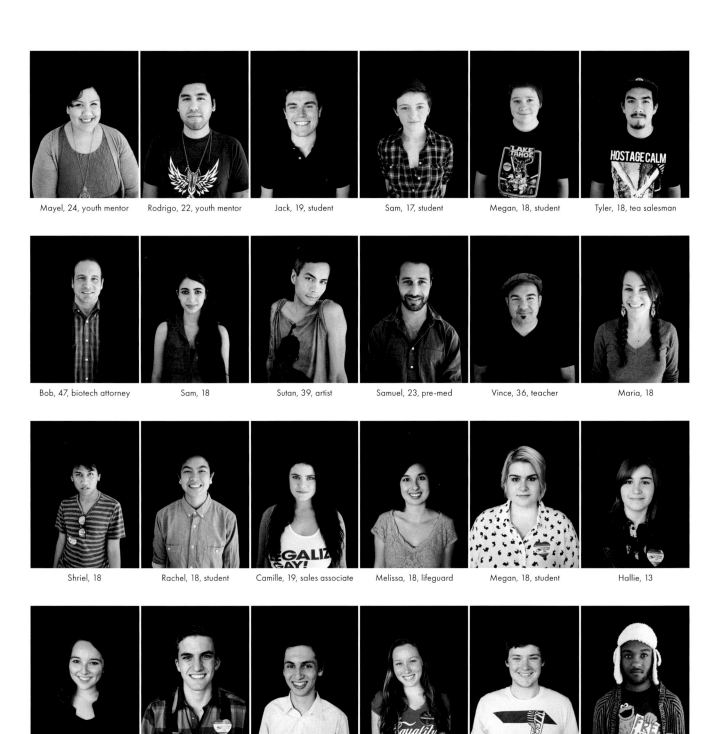

Mayel, 24, youth mentor

Rodrigo, 22, youth mentor

Jack, 19, student

Sam, 17, student

Megan, 18, student

Tyler, 18, tea salesman

Bob, 47, biotech attorney

Sam, 18

Sutan, 39, artist

Samuel, 23, pre-med

Vince, 36, teacher

Maria, 18

Shriel, 18

Rachel, 18, student

Camille, 19, sales associate

Melissa, 18, lifeguard

Megan, 18, student

Hallie, 13

Kira, 15, student

Michael, 20, unemployed

Eli, 18, student

Christy, 18, student

Walker, 19, unemployed

Logan, 18, student, activist,
and bakery assistant

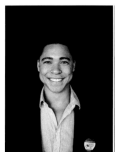

Deray, 19, student

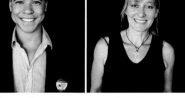

Eve, 52, mom

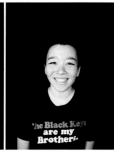

Rory, 18, student

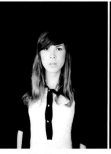

Eli, 17, student

Katherine, 16, student

Lindsey, 18, receptionist

Kalila, 17

Alex, 18, intern

Jonathan, 23, Bay Area Youth

Calliope, 22, teacher

Isabelle, 20, student

James, 61, retired

Ricky, 18

Jason, 19, student

Shannon, 46, community
organizer

Chris, 47, political consultant

Carl, 30, minister
and future teacher

Pelham, 34, artist

JUNE 26, 2013

IN *UNITED STATES V. WINDSOR*,
THE US SUPREME COURT DECLARES
SECTION 3 OF THE DEFENSE OF MARRIAGE
ACT TO BE UNCONSTITUTIONAL,
RULING THAT LEGALLY MARRIED SAME-SEX
COUPLES ARE ENTITLED TO FEDERAL RIGHTS
AND BENEFITS. IN A SEPARATE RULING,
THE COURT ALSO REFUSES AN APPEAL
BY SUPPORTERS OF PROPOSITION 8.

NYC DYKE MARCH
NEW YORK, NY
JUNE 29, 2013

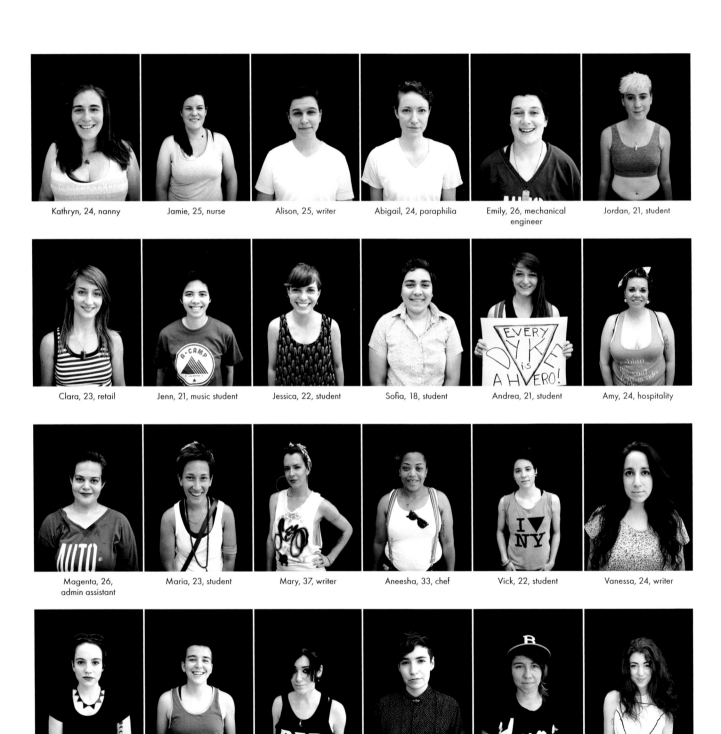

Kathryn, 24, nanny

Jamie, 25, nurse

Alison, 25, writer

Abigail, 24, paraphilia

Emily, 26, mechanical engineer

Jordan, 21, student

Clara, 23, retail

Jenn, 21, music student

Jessica, 22, student

Sofia, 18, student

Andrea, 21, student

Amy, 24, hospitality

Magenta, 26, admin assistant

Maria, 23, student

Mary, 37, writer

Aneesha, 33, chef

Vick, 22, student

Vanessa, 24, writer

Lucy, 24, receptionist

Laura, 21, student

Stef, 29, weirdo

Zia, 26, graphic designer

Stephanie, 26, account executive

Cat, 24, art director

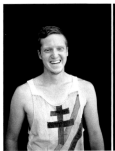

Jon, 21, student

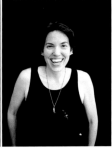

Sarah, 27, filmmaker

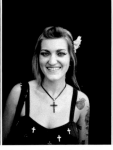

Jordan, 24, youth minister

Katie, 25, acupuncture student

Jen, 35, professor

Courtney, 24,
The OpEd Project

Emmet, 28, communications

Judy, 26, student

Michelle, 25, woodworker

Emily, 28, professor

A.D., 22, student

Kate, 19, student

Robin

Georgia, 31, dancer

Majda, 33, web developer

Julie, 26, writer

Tiffany, 26, actress

Chase, 24, operations
manager

Amira, 31, unemployed

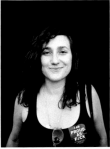

Shana, 33, attorney

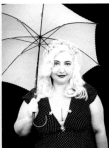

Rebecca, 32

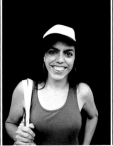

Rebecca, 34, social worker

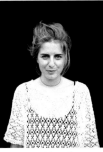

Kara, 23, student

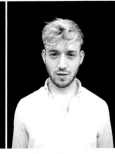

Ross, 22, writer

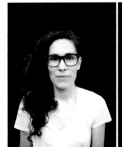

Lauren, 31, musician, artist,
and photo lab tech

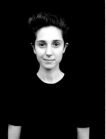

Jennifer, 25, co-founder
of VEER NYC

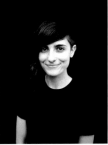

Allie, 25, co-founder
of VEER NYC

Jessica, 44, bureaucrat

Laura, 30, writer

Lynn, 24, podcast producer
and host

Lauren, 29, image management

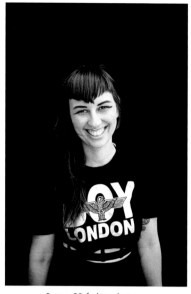

Becca, 29, fashion designer

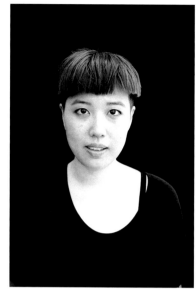

Stella, 27, chef

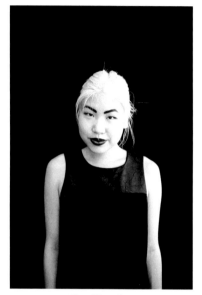

Ellen, 20, student

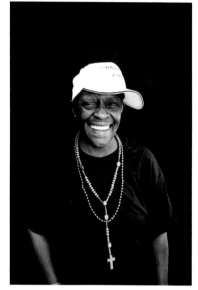

Jeannette

Veronica, 58

Kathryn, 21, student and nanny

Emily, 24, special needs professional

Mariah, 22, student and dancer

Erin, 26, writer

Laura, 32, hairstylist

Chelsea, 24, coordinator

Liza, 23, community organizer

Maya, 28, writer

Jessica, 27, arts administrator

Ryan, 31, teacher

Xena, 27, poet

Emilie, 25, social worker

Joy, 33, yoga teacher
and drama therapist

Jessica, 34, artist

Simone, 50, director

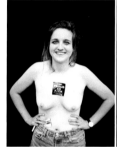

Lydia, 22, student

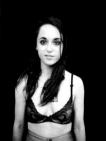

Ali, 23, student

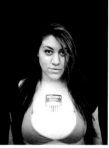

Ronit, artist

Julie, 56,
document processor

Mary, chef

Constance, 35,
real estate agent

NYC PRIDE
NEW YORK, NY
JUNE 30, 2013

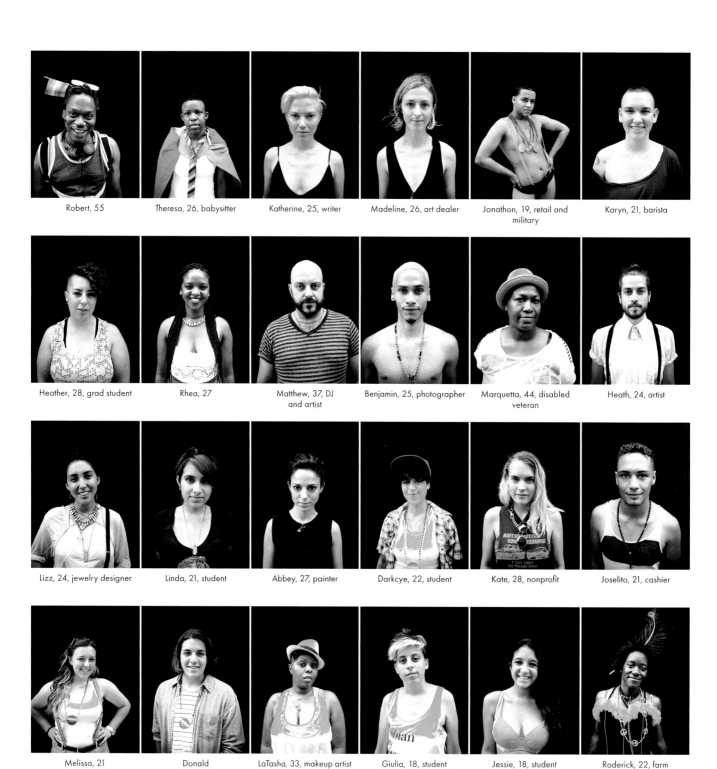

Robert, 55

Theresa, 26, babysitter

Katherine, 25, writer

Madeline, 26, art dealer

Jonathon, 19, retail and
military

Karyn, 21, barista

Heather, 28, grad student

Rhea, 27

Matthew, 37, DJ
and artist

Benjamin, 25, photographer

Marquetta, 44, disabled
veteran

Heath, 24, artist

Lizz, 24, jewelry designer

Linda, 21, student

Abbey, 27, painter

Darkcye, 22, student

Kate, 28, nonprofit

Joselito, 21, cashier

Melissa, 21

Donald

LaTasha, 33, makeup artist

Giulia, 18, student

Jessie, 18, student

Roderick, 22, farm
and barn intern

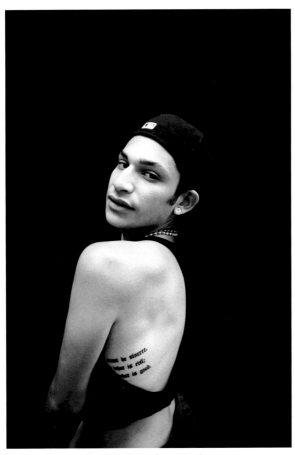

Christopher, 14, student and cashier

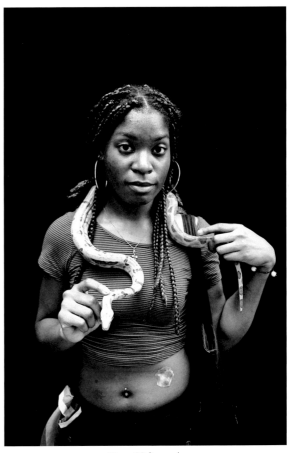

Kiana, 22, line cook

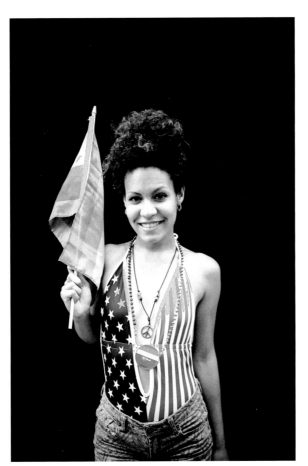

Alexis, 20, lifeguard

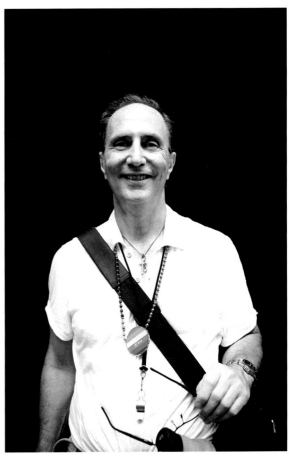

Randy, 53, RN

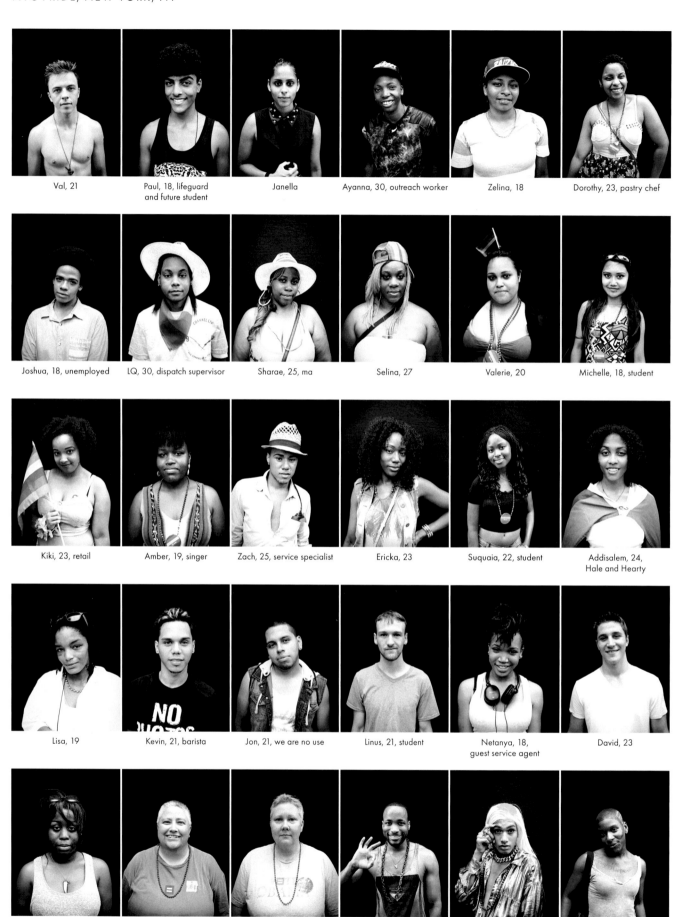

Val, 21

Paul, 18, lifeguard
and future student

Janella

Ayanna, 30, outreach worker

Zelina, 18

Dorothy, 23, pastry chef

Joshua, 18, unemployed

LQ, 30, dispatch supervisor

Sharae, 25, ma

Selina, 27

Valerie, 20

Michelle, 18, student

Kiki, 23, retail

Amber, 19, singer

Zach, 25, service specialist

Ericka, 23

Suquaia, 22, student

Addisalem, 24,
Hale and Hearty

Lisa, 19

Kevin, 21, barista

Jon, 21, we are no use

Linus, 21, student

Netanya, 18,
guest service agent

David, 23

Niaomi, 19

Cole, 43, social worker

Kat, 43, adult service
specialist

Larry, 27, lawyer
and student

Justin, 23, hairstylist

TC, 24, janitor

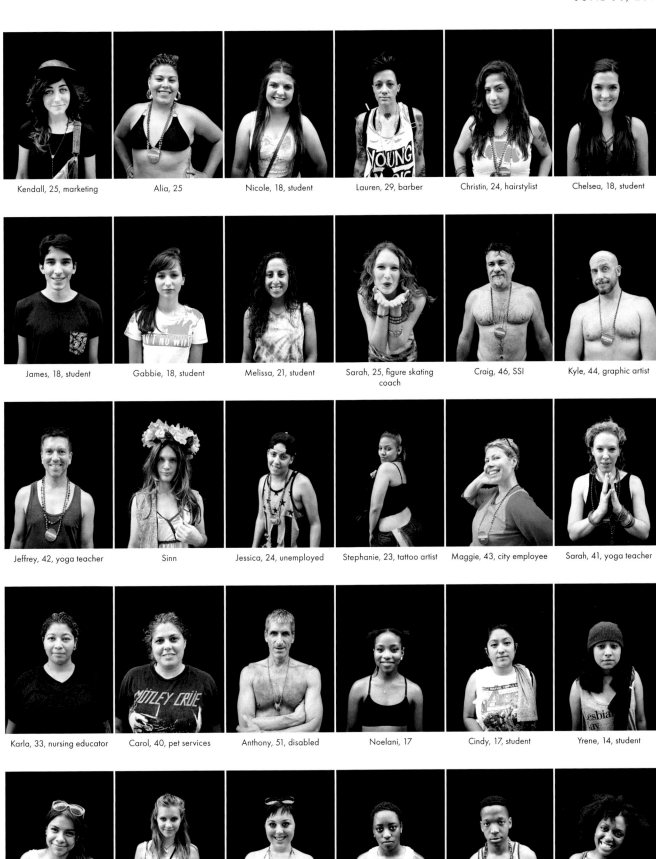

Kendall, 25, marketing

Alia, 25

Nicole, 18, student

Lauren, 29, barber

Christin, 24, hairstylist

Chelsea, 18, student

James, 18, student

Gabbie, 18, student

Melissa, 21, student

Sarah, 25, figure skating coach

Craig, 46, SSI

Kyle, 44, graphic artist

Jeffrey, 42, yoga teacher

Sinn

Jessica, 24, unemployed

Stephanie, 23, tattoo artist

Maggie, 43, city employee

Sarah, 41, yoga teacher

Karla, 33, nursing educator

Carol, 40, pet services

Anthony, 51, disabled

Noelani, 17

Cindy, 17, student

Yrene, 14, student

Arlent, 15, student

Arden, 20, student

Jessica, 28, nonprofit

Angel, 22, military

Michael, 22, student

Sierra, 22, teacher

Christylez, 33, Department of Health

Strawberry, 47, private dancer

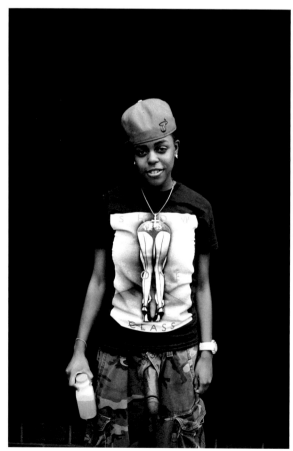

Naima, 18

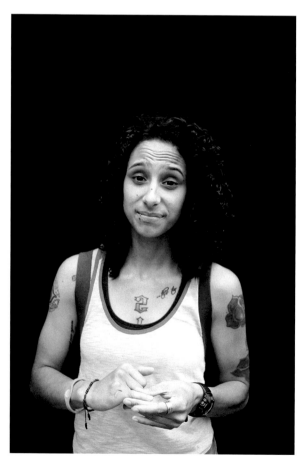

Shey, 22, security

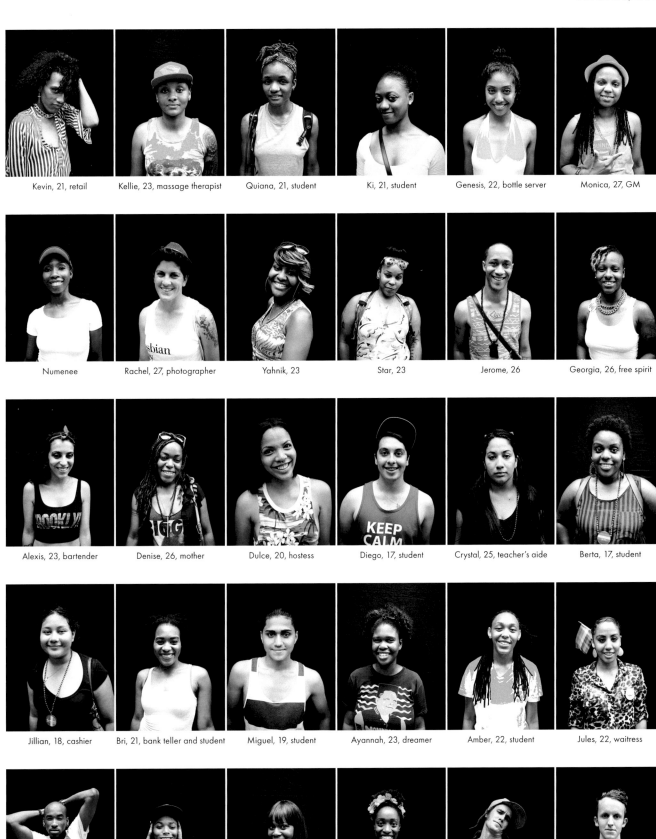

Kevin, 21, retail Kellie, 23, massage therapist Quiana, 21, student Ki, 21, student Genesis, 22, bottle server Monica, 27, GM

Numenee Rachel, 27, photographer Yahnik, 23 Star, 23 Jerome, 26 Georgia, 26, free spirit

Alexis, 23, bartender Denise, 26, mother Dulce, 20, hostess Diego, 17, student Crystal, 25, teacher's aide Berta, 17, student

Jillian, 18, cashier Bri, 21, bank teller and student Miguel, 19, student Ayannah, 23, dreamer Amber, 22, student Jules, 22, waitress

Aaron, 29, dancer and model Monsta, 22 Ebony, 23 Charnelle, 22, student Charlie, 28, writer Eamon, 21, student

VISALIA, CA
OCTOBER 18, 2013

Gary

John, 67, retired

Brock, 54, retired

Patricia, 43, ER registrar

Dena, 40, webmaster

Alex, 29, retail

Melissa, 29, state employee

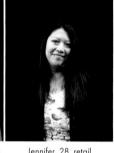

Jennifer, 28, retail

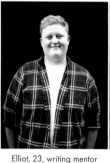

Elliot, 23, writing mentor

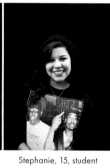

Stephanie, 15, student

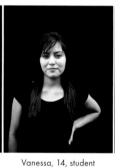

Vanessa, 14, student

Lanie, 62, Laniedad
notecards creator

Joan, 35, helicopter mechanic

Alicia, 24, student

Slade, 63, USDA

Ori, 42, art therapist

Jennifer, 44, housewife
and volunteer

Andrea, 29, security officer

Jackie, 19, student

Rim, 42, massage therapist

Sandy, 59, retired

Cheryl, 61, teacher

Jimmie, 56, 911 dispatcher

Ally, 20, student

142

Eric, 20, student

Dusty, 23, nanny

Casey, 20, student

Chelsea, 25, front desk supervisor

Alicia, 18

Anthony, 49, homemaker, and Lincoln

Brian, 50, marketing, and Lincoln

Melissa, 34, care provider

Crystal, 31, welder

BAKERSFIELD PRIDE
BAKERSFIELD, CA
OCTOBER 18, 2013

Enrique, 43, barista

Helen, 44, professor

Gricelda, 20, student

Casey, 22, student

Haley, 18

Jason, 31, hospitality

Cheri, 52, retired teacher

Jelissa, 18, student

Yolanda, 23, promo model

Donel, 54, psychologist

Lea Ann, 58, teacher

Billie-Joe, 26, bartender

London, 29, graphic designer

Elizabeth, 24

Jessica, 18, student

Kacey, 37, ASL interpreter

Steven, 27, transporter

Crystal, 19

Cory, 25

Tiny, 16, student

Tony, 52, retired

Sarah, 19, massage therapist

Rick, 55, buyer

Taj, 19

Joe, 53, handyman

Ali, 16

James, 17

Tina, 17, unemployed

Cody, 18, actor and comedian

Patty, 49, promotional sales

Robin, 52, preschool teacher

Caitlyn, 19, concierge

Maria, 20, freelance

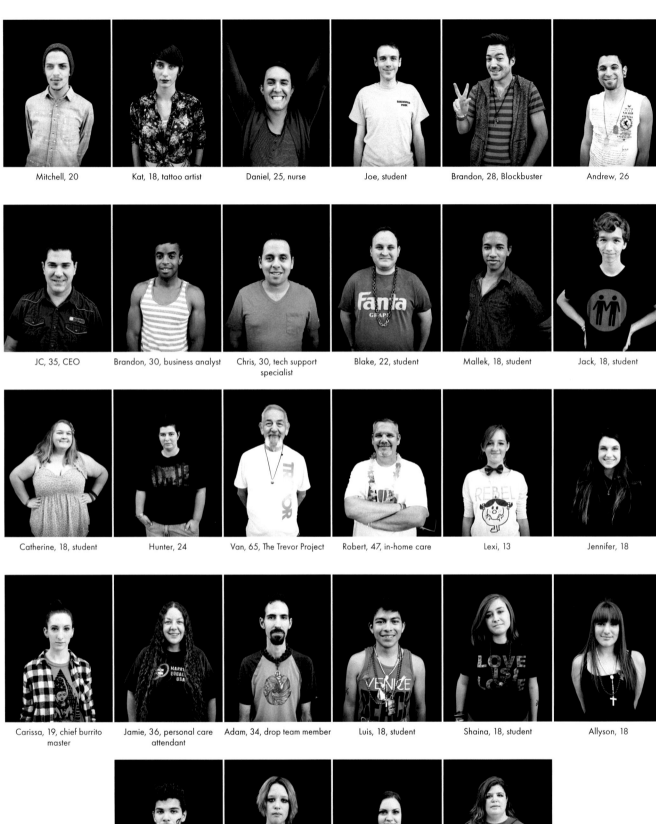

Mitchell, 20

Kat, 18, tattoo artist

Daniel, 25, nurse

Joe, student

Brandon, 28, Blockbuster

Andrew, 26

JC, 35, CEO

Brandon, 30, business analyst

Chris, 30, tech support specialist

Blake, 22, student

Mallek, 18, student

Jack, 18, student

Catherine, 18, student

Hunter, 24

Van, 65, The Trevor Project

Robert, 47, in-home care

Lexi, 13

Jennifer, 18

Carissa, 19, chief burrito master

Jamie, 36, personal care attendant

Adam, 34, drop team member

Luis, 18, student

Shaina, 18, student

Allyson, 18

Michael, 18, gardener

Harley, 13, horse trainer and photographer

Taylor, 19, burrito wrapper

Brandi, 37, phone sex operator

Holly, 21, barista and student

Leigh, 28, student

Libby, 30, student

DAVIS UNIVERSITY
DAVIS, CA
OCTOBER 20, 2013

Sam, 19, student

Jessica, 21, student

Christine, 23

Jason, 23, student

Olivia, 20, student

Josh, 21, dish boy and student

Dom, 24, student

Tanya, 19, student

LoLo, 22, unemployed

Elizabeth, 20, student

Rolin, 26, grad student

Jerome, 21, student

Marianne, 21, student

Jodie, 21, student

Manpreet, 21, student

Yesi, 22, student

Cherre, 30, postdoctoral
researcher

Natasha, 29, server
and student

Celeste, 30, print publishing

Seth, 13, school

David, 45, disabled

Skyla, 27, shipper receiver

Chase, 26, student
and welder

Julie, 49, marriage and
family therapist

Konner, 39, social worker

Kiana, 43, caregiver
and cashier

Frank, 73, retired political
consultant

Chelsea, 19, EMT student

Shannon, 34, social worker

Carrie, 35, community
organizer

Zoe, 49

Adri, 18, student

Barbi, 57, marriage and
family therapist

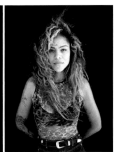

Morgann

SANTA BARBARA, CA

NOVEMBER 16, 2013

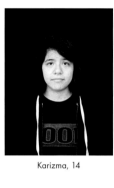

Karizma, 14

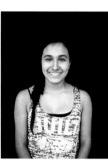

Destiny, 13

Richard, 62, waiter

Ana Maria, 31, photographer

Emily, 38, teacher
and mother

Jason, 25, development
director

Tyson, 26, events manager

Marco, 43, teacher

Jude, 65, retired

Gary, 53, contractor

Denny, 65, landscape
designer

Robert, 69, cosmetologist

John, 59, realtor

Barron, 16, high school

Olivia, 19, student

Jen, 43, pet dental hygienist

Isabel, 17, childcare provider

Steve, 25, ad sales

Justin, 20, assistant cook

Stacy, 30, social service
worker

Jill, 35, finance

Olivia, 17

Tina, 60, retail maven

Brad, 45, training
and development manager

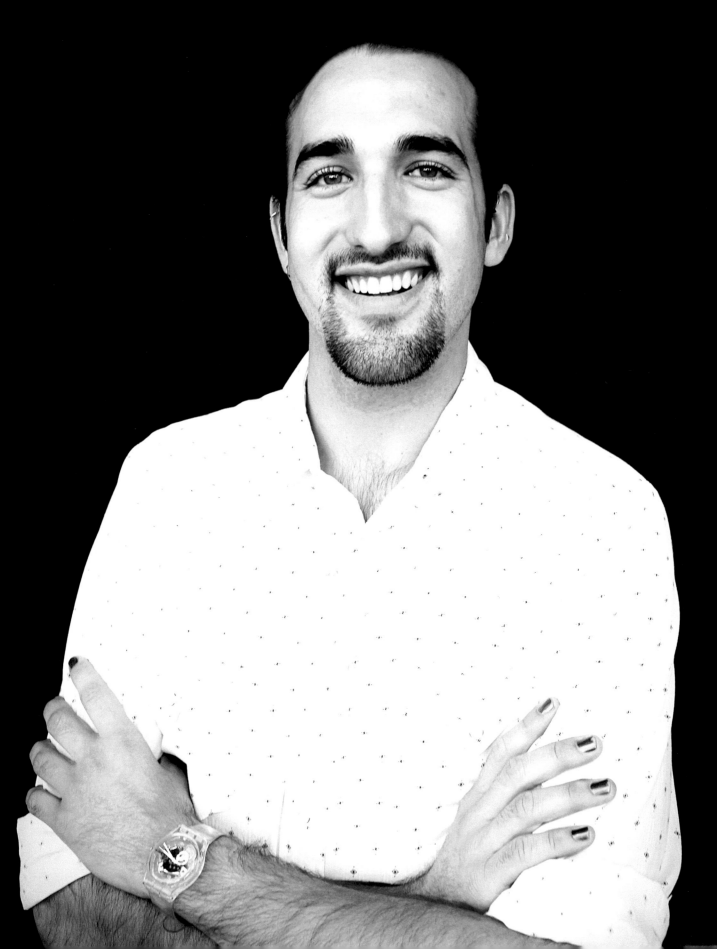

Tyler, 22, LGBTQ program coordinator

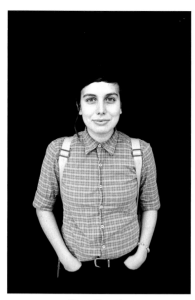

Oliver, 21, student

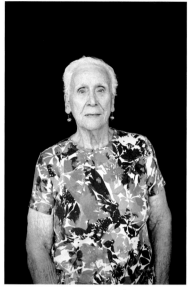

Janet, 83, retired

Aaron, 27, student advisor

Sherwin, 83, retired professor

Shredder, 26, EMT

Albert, 65, physician

Emma, 15, student

Maria Two Straps, 23, bartender

Courtney, 32, ad sales

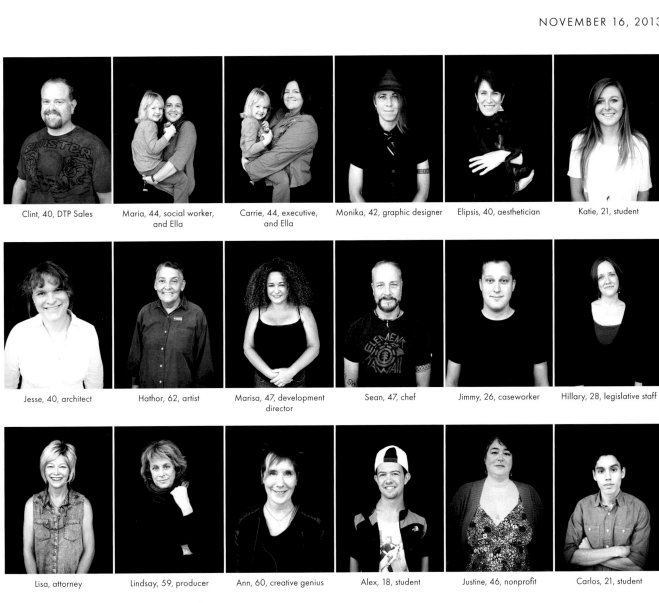

Clint, 40, DTP Sales

Maria, 44, social worker, and Ella

Carrie, 44, executive, and Ella

Monika, 42, graphic designer

Elipsis, 40, aesthetician

Katie, 21, student

Jesse, 40, architect

Hathor, 62, artist

Marisa, 47, development director

Sean, 47, chef

Jimmy, 26, caseworker

Hillary, 28, legislative staff

Lisa, attorney

Lindsay, 59, producer

Ann, 60, creative genius

Alex, 18, student

Justine, 46, nonprofit

Carlos, 21, student

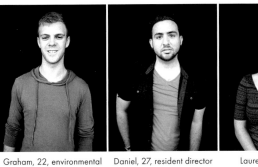

Graham, 22, environmental scientist

Daniel, 27, resident director

Lauren, 19, student

Gina, 51, fire inspector

Javier, 30, student

Ronald, 70, residential rentals

Halie, 21, student

Janelle, 28, grad student

Lillian, 27, PhD student

Forest, 20, student

Yasmin, 26, assistant resident director at UCSB

Lauren, 24, Trader Joe's

Trenton, 22, chef

David, 46, investment advisor

Pink, 36, chef

Pamela, 31, apartment manager

Adrienne, 29, customer service

Kelly, 28, McConnell's Ice Cream

Karl, 64, retired teacher

Michael, 54, RN

Terry, 64

Kitti, 49, drug and alcohol counselor

Robby, 47, media sales manager

Bryan, 43, manager

Todd, 24, theater manager

Christopher, 27, media consultant

Jaqueline, 30, filmmaker and student

Ashley, 19, student

Shira, 24, EMT

Cheri, 59, social justice educator

Jay, 41, buyer

Gloria, 30, homemaker

Danny, 25, bartender and student

David, 53, nonprofit director

Michelle, 34, executive chef

Mashey, 67, retired professor

Abby, 31, therapist

Meara, 31, nanny and student

Mary, 31, administrative services coordinator

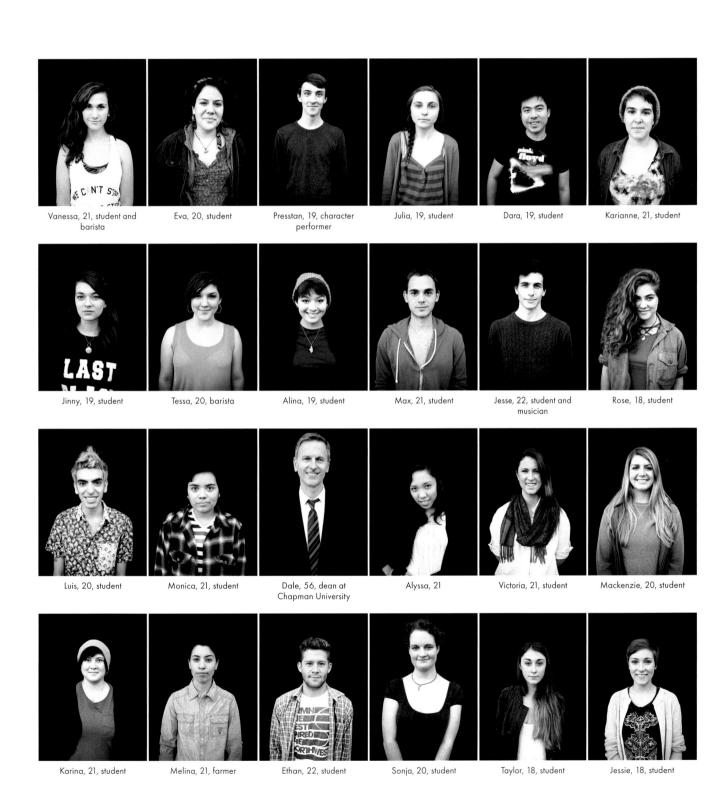

Vanessa, 21, student and barista

Eva, 20, student

Presstan, 19, character performer

Julia, 19, student

Dara, 19, student

Karianne, 21, student

Jinny, 19, student

Tessa, 20, barista

Alina, 19, student

Max, 21, student

Jesse, 22, student and musician

Rose, 18, student

Luis, 20, student

Monica, 21, student

Dale, 56, dean at Chapman University

Alyssa, 21

Victoria, 21, student

Mackenzie, 20, student

Karina, 21, student

Melina, 21, farmer

Ethan, 22, student

Sonja, 20, student

Taylor, 18, student

Jessie, 18, student

Casey, 21, student

Graeme, 21, student

Chad, 21, student

Julie, 24, research technician

Annie, 36, librarian

Robyn, 21, student

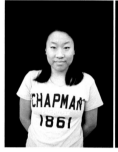
Kim, 20, student

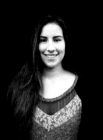
Kellianne, 21, student

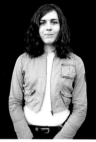
Chloe, 21, tutor

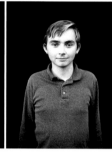
Jeff, 19, student

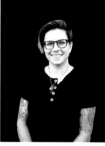
Lia, 36, professor and artist

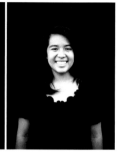
Amanda, 20, student

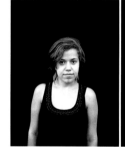
Victoria, 18, student

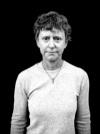
Tina, 48, musician

Michael, 62, professor

Claudine, 38, professor
of design

Alex, 21, student and retail

Alice, 18, student

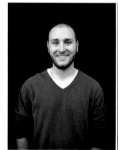
Leon, 18, diversity and equity
initiatives program

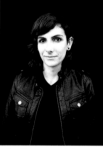
Sarah, 24, sound designer
and drama therapist

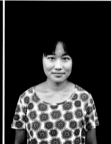
Sophia, 18, unemployed

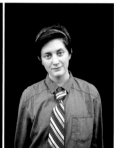
Stephanie, 21, costume
designer at Disneyland

Paul, 76, actor Beverley, 69, retired actor Andi, 68, retired Ed, 77, retired Roger, almost 70, retired John, 76 and aging, retired math teacher

 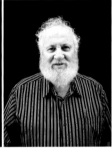 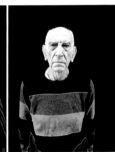

Bill, 70, artist Rosie, 72, retired Max, 67, retired Alice, 78, retired Melvin, 77, retired Neal, 85, actor

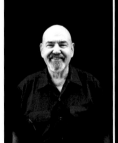 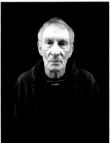

Bill, 74, retired contractor Bryant, 76, retired costumer at Warner Bros. Dick, 77, retired computer consultant Erika, 74, retired RN Yannek, 69, photographer, writer, and actor Gayle, 58, social worker

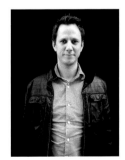

Brian, 53, fundraiser and writer

GOOGLE GAYGLERS
SAN FRANCISCO, CA
DECEMBER 1, 2013

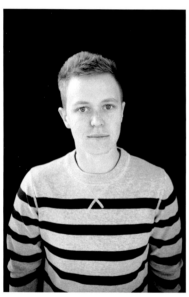

Anne, 24, business strategy

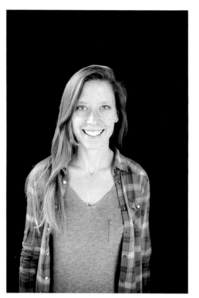

Natalie, 28, analyst

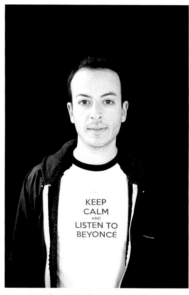

Jonathan, 24, administrative assistant

Jeff, 25, social ads

Bert, 39, manager

Jesse, 34, engineer

YOUTH EMPOWERMENT SUMMIT
SAN FRANCISCO, CA
DECEMBER 2, 2013

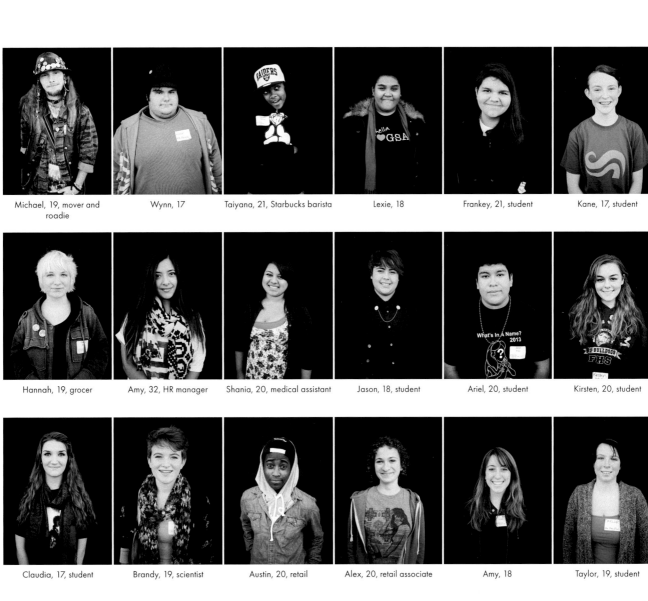

Michael, 19, mover and roadie

Wynn, 17

Taiyana, 21, Starbucks barista

Lexie, 18

Frankey, 21, student

Kane, 17, student

Hannah, 19, grocer

Amy, 32, HR manager

Shania, 20, medical assistant

Jason, 18, student

Ariel, 20, student

Kirsten, 20, student

Claudia, 17, student

Brandy, 19, scientist

Austin, 20, retail

Alex, 20, retail associate

Amy, 18

Taylor, 19, student

Molly Jean, 21, customer service rep at State Farm

Kendra, 19, assistant teacher

Jonathan, 18, student

Tenaya, 18, student

Jamie, 26, teacher

Cassie, 18

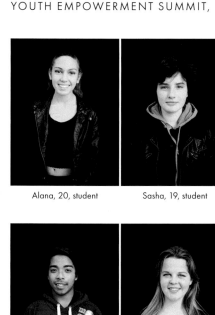

Alana, 20, student

Sasha, 19, student

Johnisha, 18

Felicia, 20, student

Claire, 19, student

Luka, 20, caregiver

Derrick, 18, server

Amoreena, 20, nurse assistant

Anya, 20, student

AJ, 20, college student

Cameron, 20, student

Watu, 22, alumni program associate

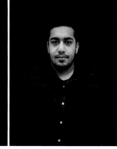
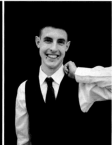
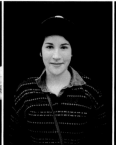
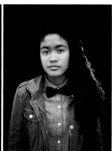

Isaias, 19, student

McKenna, 20, student

Sam, 18

Paul, 22, graduate research assistant

Nickolas, 19

Naphetta, 20, dog groomer

Pablo, 18, youth organizer

Edgardo, 18, student

Nick, 19, student

Ellery, 18, receptionist

Triss, 19, college student

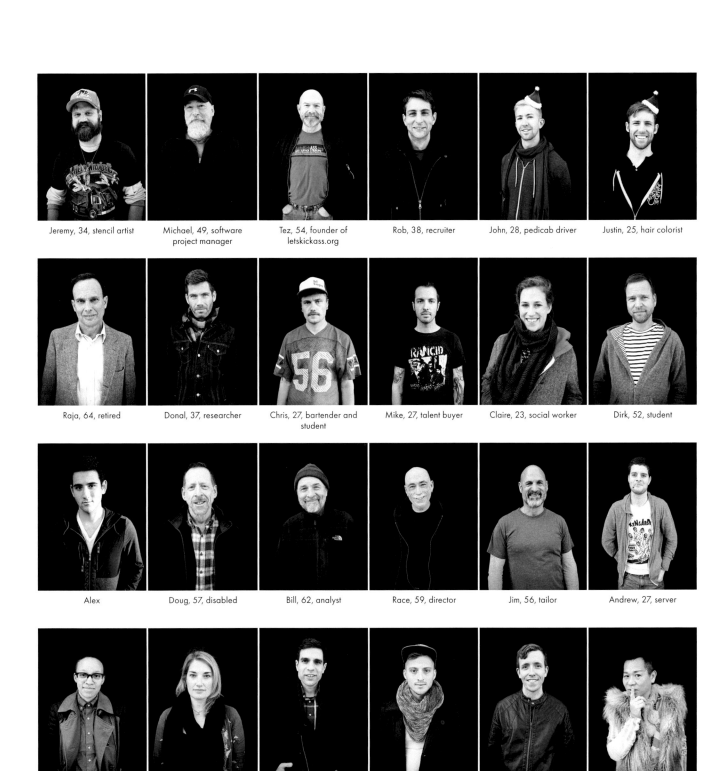

Jeremy, 34, stencil artist

Michael, 49, software project manager

Tez, 54, founder of letskickass.org

Rob, 38, recruiter

John, 28, pedicab driver

Justin, 25, hair colorist

Raja, 64, retired

Donal, 37, researcher

Chris, 27, bartender and student

Mike, 27, talent buyer

Claire, 23, social worker

Dirk, 52, student

Alex

Doug, 57, disabled

Bill, 62, analyst

Race, 59, director

Jim, 56, tailor

Andrew, 27, server

Alma, 27, occupational safety and health management

Chelsea, 33, massage therapist

Jonathan, 41, nurse practitioner and HIV consultant

Elliot, 25, higher education admin

Shaun, 24, teacher

Baby, fashion designer

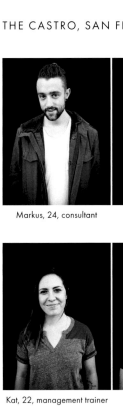

Markus, 24, consultant

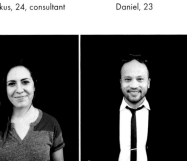

Daniel, 23

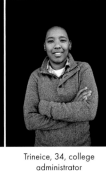

Michael, wholesale sales

Sergio, 90, linguist

Alida, 28, senior client manager

Tiffani, 30, grad student

Kat, 22, management trainer

John, 36

Trineice, 34, college administrator

Monica, 28, supervisor at Costco

Jenn, 32, musician

Maya, 36, graphic designer

Clayton, 22, marketing

Christopher, 24, property management

Bruce, 29, account executive

Zack, 27, teacher's assistant

KY, 24, trader

John, 27, student

Mikey, 32, musician

Suzanne, 27, law student

Cibelle, 27, importer

Miranda, 31, instructor

Katie, 34, soccer coach

Tyler, 25, sales executive

Alex, 22, business analyst

Frankie, 29, fabulous

Nuno, 34, sign language interpreter

Tina, 25, rehabilitation specialist

Joey, 28, actor

Marina, 30, nanny and teacher

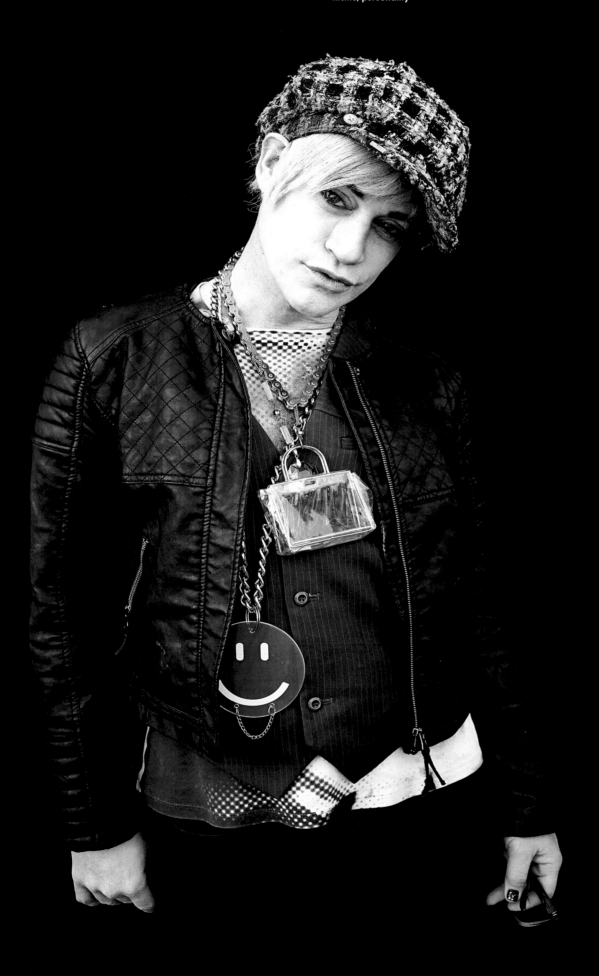

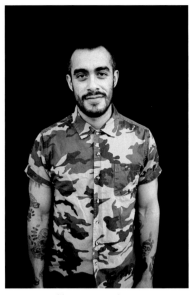

Pablo, 30, personal trainer

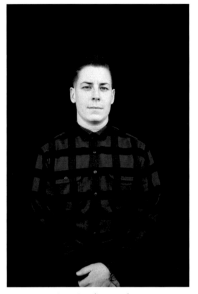

Sam, 31, photographer

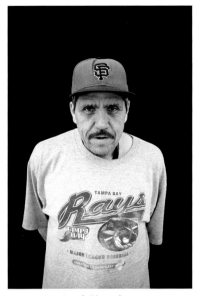

David, 58, machinist

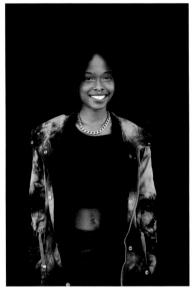

Portia, 27, student

Nate, 32, IT

Adam, 45, dental hygienist

GOOGLE GAYGLERS
MOUNTAIN VIEW, CA
DECEMBER 4, 2013

Evan, 23, people operations

Shannon, 31, recruiting support specialist

John, 46, stay-at-home dad

Jimmy, 28, legal assistant

Nick, 29, software engineer

Irene, 23, business solutions strategist

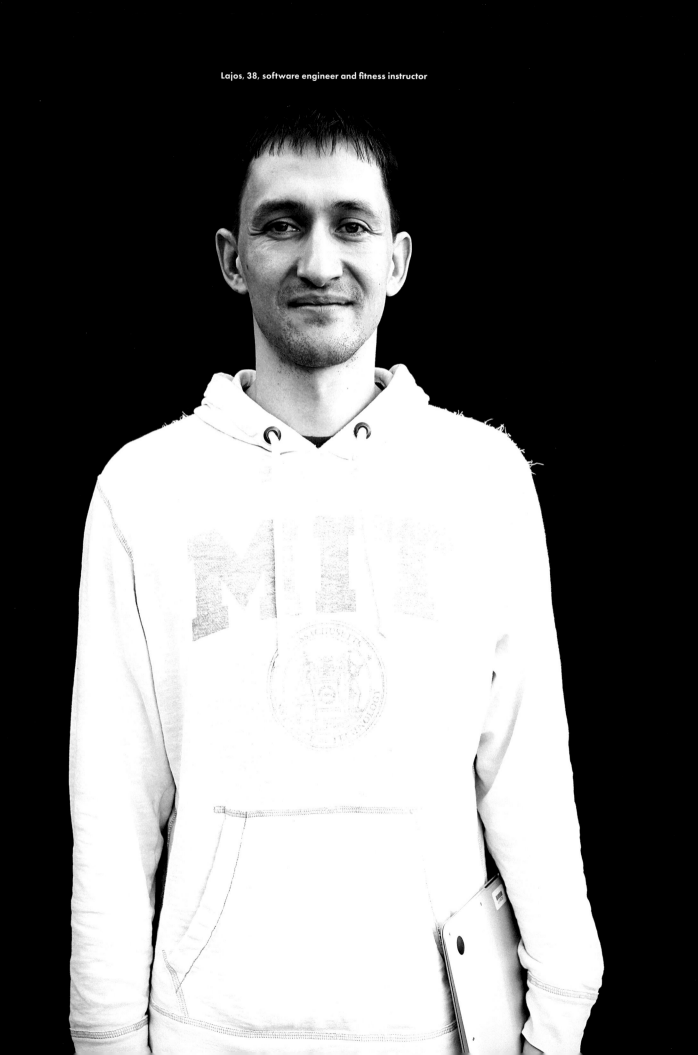
Lajos, 38, software engineer and fitness instructor

Jesus, 30, software designer

Cameron, 22, analyst

Ariel, 27, knowledge
base specialist

Phillipe, 37, software engineer

Kevin, 23, linguist

Aleks, 53, writer

Anna, 23, linguist

Mark, 51, software engineer

Heidi, 27, teacher

Bret, 23, account strategist

Jeff, 22, software engineer

Chloe, 22, software engineer

Michelle, 22, software
engineer

Cecilia, 50, finance

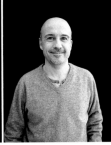

Mariano, 46, paralegal

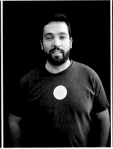

Francesco, 30, software
engineer

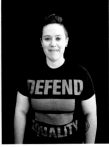

Liz, 26, dispatcher

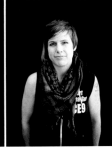

Skirt, 26, student
and teaching assistant

NATIONAL CENTER FOR LESBIAN RIGHTS
SAN FRANCISCO, CA
DECEMBER 4, 2013

Miji, 22, student

Christine, comms manager

Jaime, 31, lawyer

Danielle, 29, nonprofit

Aaron, 24, legal assistant

Sam, 27, lawyer

Billy, 29, accountant

Amy, 39, lawyer

2014

2,653–3,250	Creating Change Conference Houston, TX	
3,251–3,353	Fort Lauderdale, FL	
3,354–3,370	Boston University Boston, MA	
3,371–3,515	Five College Queer Gender and Sexuality Conference Hampshire College Amherst, MA	
3,516–3,561	Boston, MA	
3,562–3,617	Northern Michigan University Marquette, MI	
3,618–3,626	University of Utah Salt Lake City, UT	
3,627–3,727	The Power of One Conference Salt Lake City, UT	
3,728–3,867	Club Skirts Dinah Shore Weekend Palm Springs, CA	
3,868–4,016	Phoenix Pride Phoenix, AZ	
4,017–4,073	Gay–Straight Alliance Summit Bullis School Potomac, MD	
4,074–4,133	Davidson College Davidson, NC	
4,134–4,187	Vogue New York, NY	
4,188–4,464	Wythe Hotel Brooklyn, New York, NY	

4,465–4,621	Long Beach Pride Long Beach, CA
4,622–4,758	Des Moines Pride Des Moines, IA
4,759–4,958	LA Pride Los Angeles, CA
4,959–5,169	Nashville Pride Nashville, TN
5,170–5,338	Baltimore Pride Baltimore, MD
5,339–5,580	Sioux Falls Pride Sioux Falls, SD
5,581–5,826	Chicago Pride Chicago, IL
5,827–6,029	St. Louis Pride St. Louis, MO
6,030–6,233	Twin Cities Pride Minneapolis, MN
6,234–6,393	Pacific Pride Festival Santa Barbara, CA
6,394–6,638	Los Angeles, CA
6,639–6,774	Fort Wayne Pride Fort Wayne, IN
6,775–6,819	Pittsburgh Black Pride Pittsburgh, PA
6,820–6,937	Fargo-Moorhead Pride Fargo, ND
6,938–7,001	Kansas City, KS

7,002–7,255	Las Vegas Pride Las Vegas, NV
7,256–7,457	Pride Vermont Festival Burlington, VT
7,458–7,531	Dartmouth College Hanover, NH
7,532–7,572	Oberlin College Oberlin, OH
7,573–7,602	University of Delaware Newark, DE
7,603–7,808	South Carolina Pride Columbia, SC
7,809–7,845	Portland, ME
7,846–7,905	Rhode Island School of Design Providence, RI
7,906–7,945	Salisbury University Salisbury, MD
7,946–8,015	University of Louisville Louisville, KY
8,016–8,170	Virginia PrideFest Brown's Island, VA
8,171–8,227	New London, CT
8,228–8,254	Furman University Greenville, SC

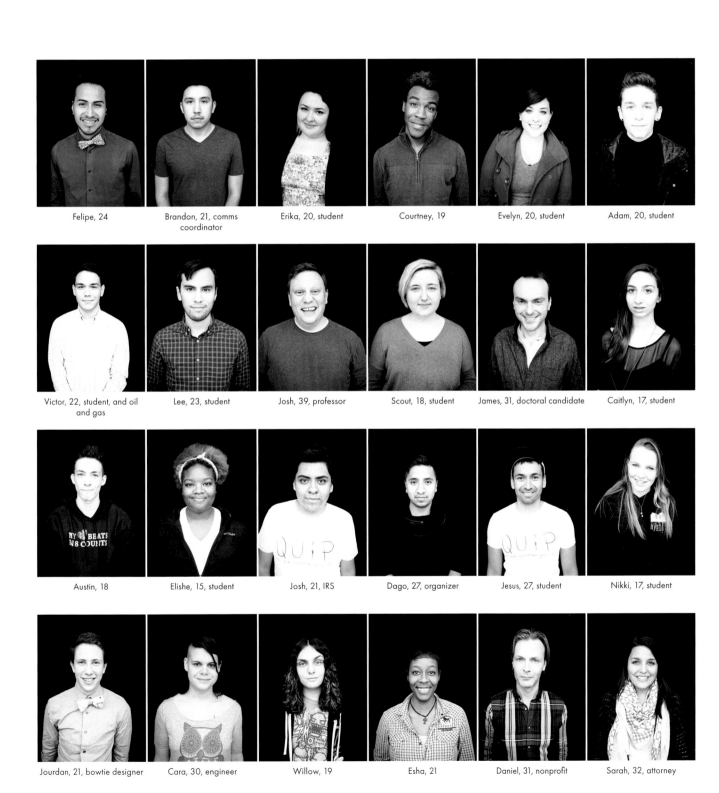

Felipe, 24

Brandon, 21, comms coordinator

Erika, 20, student

Courtney, 19

Evelyn, 20, student

Adam, 20, student

Victor, 22, student, and oil and gas

Lee, 23, student

Josh, 39, professor

Scout, 18, student

James, 31, doctoral candidate

Caitlyn, 17, student

Austin, 18

Elishe, 15, student

Josh, 21, IRS

Dago, 27, organizer

Jesus, 27, student

Nikki, 17, student

Jourdan, 21, bowtie designer

Cara, 30, engineer

Willow, 19

Esha, 21

Daniel, 31, nonprofit

Sarah, 32, attorney

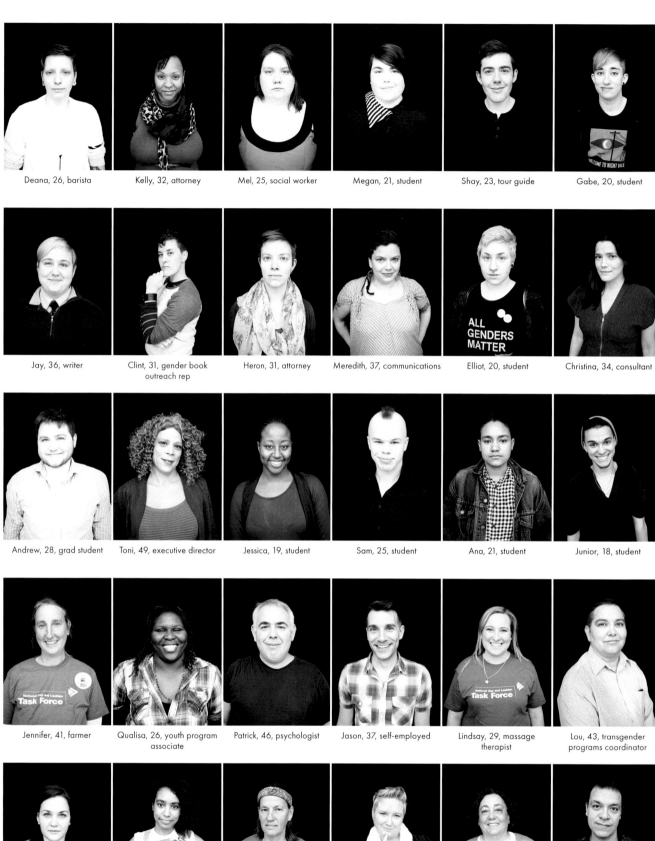

Deana, 26, barista

Kelly, 32, attorney

Mel, 25, social worker

Megan, 21, student

Shay, 23, tour guide

Gabe, 20, student

Jay, 36, writer

Clint, 31, gender book
outreach rep

Heron, 31, attorney

Meredith, 37, communications

Elliot, 20, student

Christina, 34, consultant

Andrew, 28, grad student

Toni, 49, executive director

Jessica, 19, student

Sam, 25, student

Ana, 21, student

Junior, 18, student

Jennifer, 41, farmer

Qualisa, 26, youth program
associate

Patrick, 46, psychologist

Jason, 37, self-employed

Lindsay, 29, massage
therapist

Lou, 43, transgender
programs coordinator

Sarah, 28, Time Out Youth

Karen, 19, college student
and queer organizer

Peggy, 54, farmer

Suezen, 32, grad student

Julie, 51, research

Joey, 39, journalist

Tigger, 23, model

Hektah, 22, program coordinator

Hope, 21, student

Nancy, 59, writer, performer, and comic

Jupiter, 20, admin assistant

Rachel, 32, business owner

Danisha, 19, retail associate

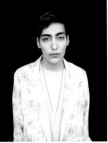

Jesus, 22, full-time student

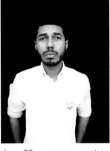

Jose, 22, programs associate

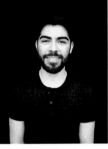

David, 19, student

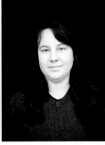

Julia, 26, student

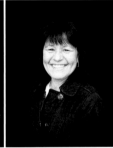

Yolanda, 56, social worker

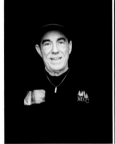

Georgie, 72, retired IRS

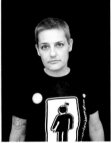

Smitty, 36, drag performer

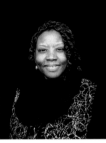

Diana, 60, researcher

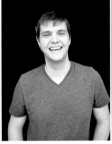

Patrick, 23, student

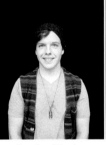

Brandon, 24, sales coordinator

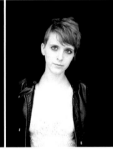

Katrina, 18, student

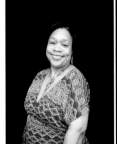

Gwen, 49, speaker

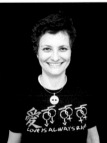

Claudia, 46, realtor

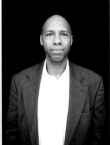

Kevin, 52, university administrator

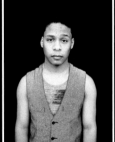

Jon Jon, 18, student and writer

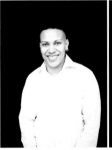

Renee, 20, student

Robb, 23, student

Amber, 25, activist

Sonya, 23, service and training

Eunice, 19, student

Shauntya, 27, education

Redd, 29, lead generator

Bridgett, 40, operations coordinator

Lucy, 21, student

Ariana, 41, director of transgender services

Kevin, 26, student

Brenda, 46, health educator

Leslie, 44, health educator

Gerald, 50, electrician

Michelle, 20, student

Valerie, 50, corrections officer

Jonathon, 21, youth advocate

Trenton, 21, security

Allison, 49, director of
LGBTA SRC

Victoria, 19, student

Emily, 21, student

Sarah, 19, student

Candace, 21, peer counselor

Kyle, 21, student

Mick, 19, media coordinator

Chris, 20, student

Ben, 22, student

Mat, 31, university student
supervisor

James, 20, student

Trayvontae, 19, IT

Boss, 19

JJ, 18, student

Michael, 20, student

Brett, 24, LGBTQ student
specialist

Ryker, 23, student

Margaret, 19, student

Dre, 18, student

Angela, 19, student

Lindsay, 24, higher ed

Erin, 22, organizer

Jesh, 20, student

Guillermo, 25, student

Sadiq, 32, optician

Georgia, 43

Dylan, 22, sexual health
research assistant

Helen, 26, student

Adena, 40, homemaker

Bella, 17, student Marco, 27, student Jim, 61, web designer Rey, 20, student Denicia, 18, student Sebastian, 26, policy analyst

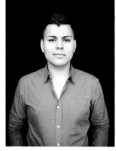
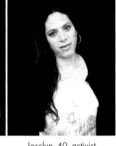
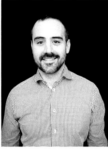

Carlos, 21, student Josclyn, 40, activist Jonathan, 36, photographer Adrian, 26, museum educator Sarah, 26, project coordinator Rebecca, 58, executive director

Steven, 25 Phoenix, 50, leader at Make the Road Jenny, 34, education manager Ricardo, 31, field organizer Irene, 29, social work Ikaika, 28, youth programs associate

Terry, 63, CEO Chris, 25, instructor Katie, 20, student Meredyth, 19, student Brad, 66, retired Robbie, 24, program assistant

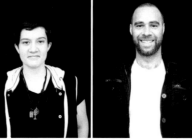
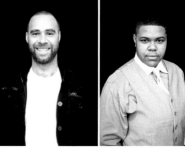

Tushar, 23, student Maure, 28, LGBT activism Owen, 31, program manager Jay, 16, stand-up comic Steven, 32, director of leadership and community resources Ashe, 31, human rights education activist

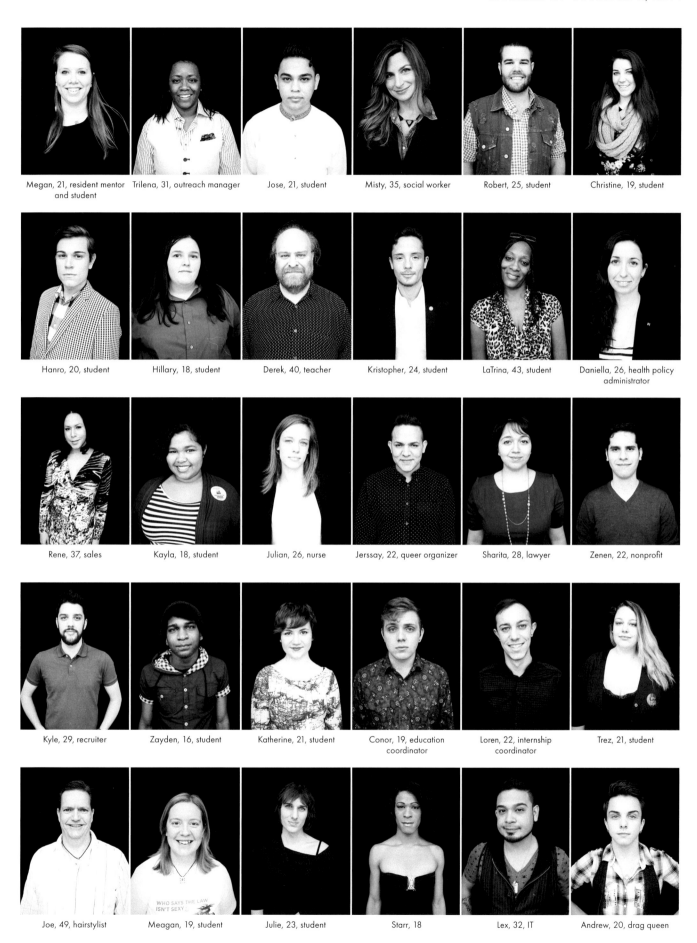

Megan, 21, resident mentor and student

Trilena, 31, outreach manager

Jose, 21, student

Misty, 35, social worker

Robert, 25, student

Christine, 19, student

Hanro, 20, student

Hillary, 18, student

Derek, 40, teacher

Kristopher, 24, student

LaTrina, 43, student

Daniella, 26, health policy administrator

Rene, 37, sales

Kayla, 18, student

Julian, 26, nurse

Jerssay, 22, queer organizer

Sharita, 28, lawyer

Zenen, 22, nonprofit

Kyle, 29, recruiter

Zayden, 16, student

Katherine, 21, student

Conor, 19, education coordinator

Loren, 22, internship coordinator

Trez, 21, student

Joe, 49, hairstylist

Meagan, 19, student

Julie, 23, student

Starr, 18

Lex, 32, IT

Andrew, 20, drag queen

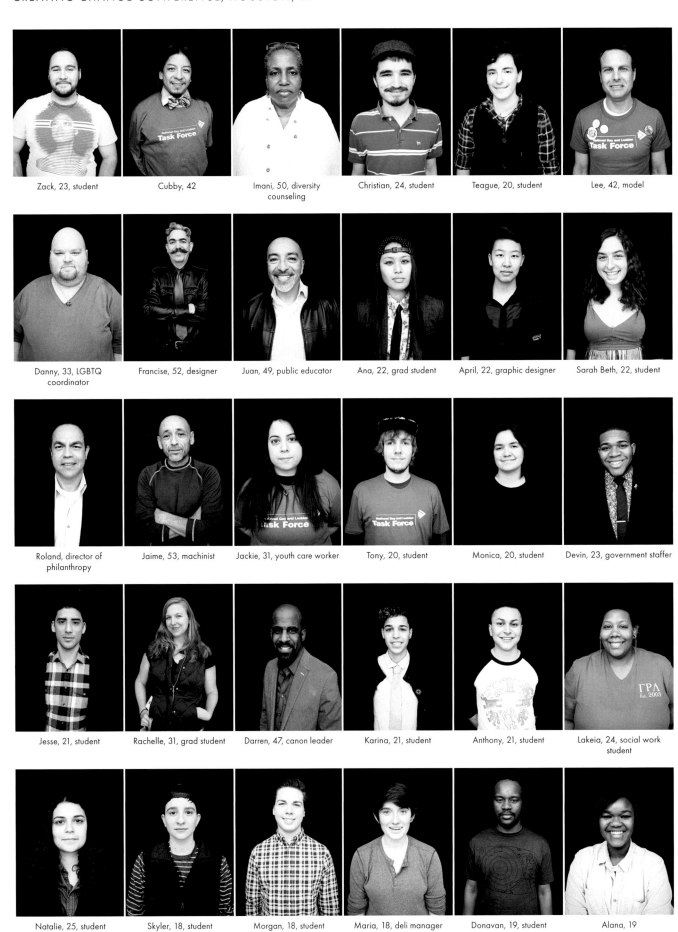

Zack, 23, student

Cubby, 42

Imani, 50, diversity counseling

Christian, 24, student

Teague, 20, student

Lee, 42, model

Danny, 33, LGBTQ coordinator

Francise, 52, designer

Juan, 49, public educator

Ana, 22, grad student

April, 22, graphic designer

Sarah Beth, 22, student

Roland, director of philanthropy

Jaime, 53, machinist

Jackie, 31, youth care worker

Tony, 20, student

Monica, 20, student

Devin, 23, government staffer

Jesse, 21, student

Rachelle, 31, grad student

Darren, 47, canon leader

Karina, 21, student

Anthony, 21, student

Lakeia, 24, social work student

Natalie, 25, student

Skyler, 18, student

Morgan, 18, student

Maria, 18, deli manager

Donavan, 19, student

Alana, 19

Torrey, 34, program coordinator

Christina, 52, CEO and publisher

Morgan, 24, student

Sammi, 19, student

Bridget, 19, student

Meghan, 20, student

Sarah, 20, student

BK, 49, professor of government

Dante, 52, filmmaker

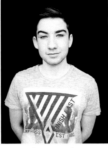
John, 18, student

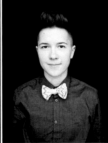
A. Lea, 23, self-employed

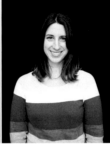
Molly, 34, higher education admin

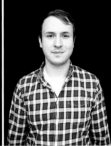
Anthony, 25, nonprofit management

Christian, 23, operation director

Benny, 21, café manager

Sam, 31, social services

Andie, 21, student

Antonia, photographer

Michelle, 53, bookkeeper

Jetta, 53, psychotherapist

Michael, 42, executive director

Chris, 33, nonprofit director

Jamie, 46, marketing

Kofi, 57, psychologist

Jordan, 23, student, activist, and writer

Emma, 18, student

Angel, 29, student and leader of MCC Trans Ministries

Jamill, 23, development coordinator

Julia, 27, mediator, grad student, and teacher

Emily, 34, program coordinator

Arielle, 27, law student

Ari, 19, student

Monica, 28, grad student

Karen, 28, law student

Amal, 33, structural engineer

Suzanne, 27, teacher and social worker

Tamisha, 29, director of diversity initiatives

Madeline, 21, student

E'lan, 21, youth advocate

Sin, 18, intern

Dominic, 21, student

Fiona, 36, TV producer and host

Cliffie, 40

Jeffrey, 42, social worker

Skyler, 30, social worker

Sarah, 31, social worker

Pierre, 48, finance accountant

Jessie, 28, PhD student

Kelly, 64, design

Liz, 62, chef

Samuel, 26, higher ed administrator

Oneal, 29, director of youth programs

Chelsea, 24, social justice educator

Ben, 19, student

Rob, 22, student

Jackie, 28, sexual and domestic violence advocate

Larry, 58, retired State of Texas government

Allie, 29, anti-violence trainer

Marquise, 33, media manager

Andy, 26, LGBT Center program coordinator

Abi, 16

Robyn, 27, unemployed

Nate, 21, organizer

Derwin, 23, youth organizer

Bishop Allyson, 42, pastor and bishop

Victoria, 24, GSA coordinator

Amira, 19, student

Yael, 21, student

Elizabeth, 21, student

Mary, 22, student

Linda, 26, student and barista

Guillermo, 21, coordinator

Shaily, 22, teacher and matchmaker

Dana, 31, adjunct professor

Ilene, 58, neuro feedback

Sandra, 45, writer

Esther, 40, master's student

Shauna, 47, LGBTQ project manager

Jessica, 22, student

Rory, 32, youth advocate

Jo, 56, metalworker and jeweler

Molly, 16, student

Darrin, 39

Vanessa, 30, program coordinator

Hector, 31, health educator

Justin, 24, law enforcement

Corey, 19, student

Sam, 21, student

Brittani, 28, musician

Mark, 30, communications

Gwenivere, 24, children's entertainment

Connor, 61, transgender services coordinator

Andrea, 48, LGBTQ civil and human rights advocate

Jonathan, 20, student

Russell, 42, nonprofit executive

183

Akil, 31, director of
youth programs

Rafael, 48, communications

Darnell, 24, student

Shane, 24, training
coordinator

Mark, 39, director of outreach

Paola, 41, caseworker

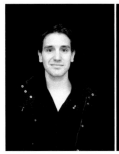
Sidney, 27, tech operator

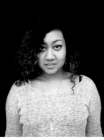
Biana, 21, student

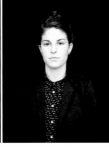
Amber, 21, student and artist

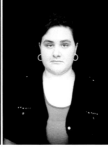
Kris, 18, student

Ricky, 23, events coordinator

Dwayne, 23, marketing

Diego, 57, PFLAG national
policy director

Timothy, 25, student

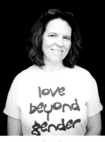
Kate, 45, legal secretary

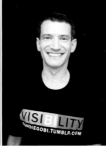
David, 44, accountant

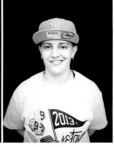
Bia, 27, sales associate

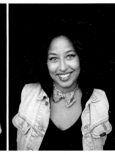
Nastassja, 21, student

Katie, 25, student

Candy, 62, retired

Debra, 60, spiritual director

Aiden, 25, student

Tristen, 21, actor

Abigail, 36, education

Sarah, 21, barista

Ashby, 38, social worker
and crisis service director

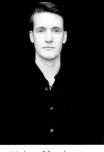
Nathan, 28, education
and LGBTQ activist

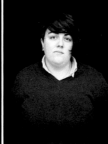
Boone, 22, student, barista,
and photographer

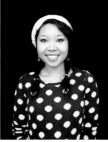
Deanna, 19, student

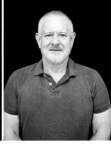
Bill, 62, architectural designer

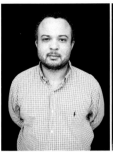

Christopher, 26, college instructor

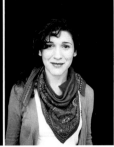

Rachel, 27, doula

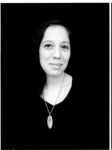

Hannabah, 27, student

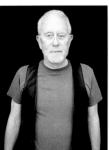

Lyle, 61, retired

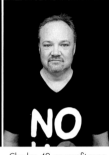

Charles, 49, nonprofit exec

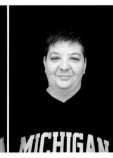

42, educator

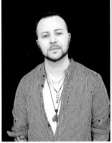

Courtney, 29, program coordinator

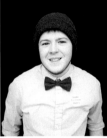

Lance, 19, student

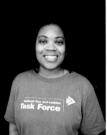

Apryll, 33, IT

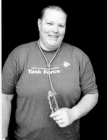

Sue, 42, police officer

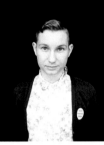

Alex, 21, sign language interpreter

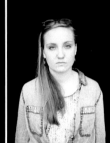

Bronte, 21, student, waitress, and activist

Kelly, 43, police officer

Dylan, 25, plumber

Ina, 41, radio talk show host

LaSherre, 26, grad student

Jim, 53, advocate

Melissa, 31, librarian

Daniel, 19, student

Shavailya, 41, contractor

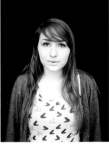

Fiona, 18, student

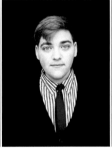

Michael, 19, student

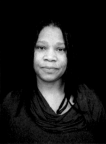

Seven, 48, nonprofit practitioner

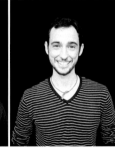

Stephen, 28, program coordinator

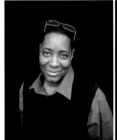

Terry Boi, 56, student manager and radio host

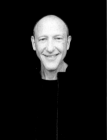

Tony, 58, retired

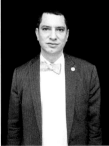

Jim, 48, director

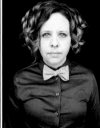

Shannon, 35, executive director

Abe, 37, writer

Mary, 52, consultant

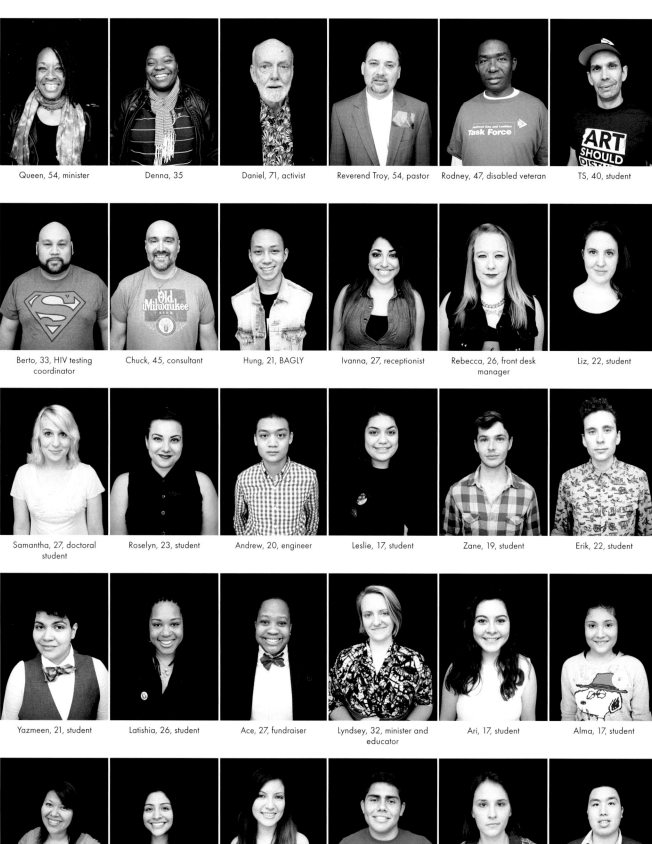

Queen, 54, minister

Denna, 35

Daniel, 71, activist

Reverend Troy, 54, pastor

Rodney, 47, disabled veteran

TS, 40, student

Berto, 33, HIV testing coordinator

Chuck, 45, consultant

Hung, 21, BAGLY

Ivanna, 27, receptionist

Rebecca, 26, front desk manager

Liz, 22, student

Samantha, 27, doctoral student

Roselyn, 23, student

Andrew, 20, engineer

Leslie, 17, student

Zane, 19, student

Erik, 22, student

Yazmeen, 21, student

Latishia, 26, student

Ace, 27, fundraiser

Lyndsey, 32, minister and educator

Ari, 17, student

Alma, 17, student

Emy, 31, college counselor

Carmen, 16, student

Gloria, 17, student

Busto, 16, student

Tracy, 29, lease analyst

Jon, 26, political organizer

Itzel, 30, high school math teacher

Dan, 62, tax auditor

Julian, 23, student

40, assistant manager at Hot Topic

Rob, 61, photo tech

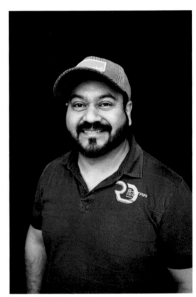

Chingon, 39, director of programs

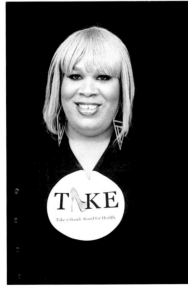

Neshia, 30, CNA

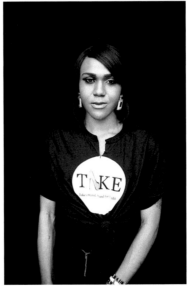

Ma'niyia, 26

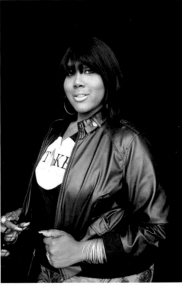

Domenique, 31, customer service

Nik, 20, student

J, 27, sheriff

Crystal, 57, medical

Rebecca, 44, clergy

Lauren, 21, retail

Rene, 29, wedding specialist

Savannah, 19, student

Yvonne, 72

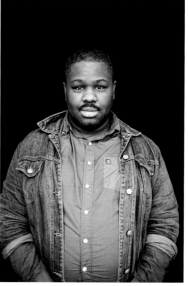

Jackie, 23, youth worker

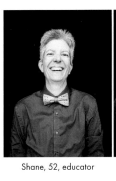

Shane, 52, educator

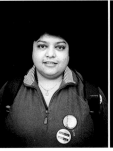

Jayati, 36, mortgage sales

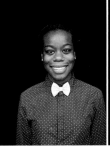

Tierra, 19, student

Ana, 20, student

Charlene, 24, community organizer

CJ, 22, student

Zizi, 25

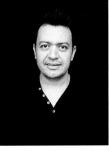

Edson, 36, counselor

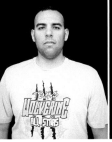

Edric, 28, student

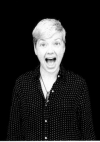

Amy, 41, attorney

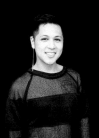

Victor, 26, student

Armando, 27, social worker

David, 25, Get Equal Texas organizer

Jennifer, 31, community organizer

Sarah, 36, playwright

Sarah, 32, editor and PhD student

Kim, 53, real estate

Rena, 23, unemployed student

Davian, 26, librarian

Guadalupe, 28, sociologist

Taylor, 20, student

Diana, 50, bus driver

Kat, 19, student

Sheri, 21, student

Chuck, 57, executive director of Equality Texas

Marissa, 24, independent contractor

Alex, 20, mentor in multicultural development

Logan, 22, youth worker

Kathryn, 21, student

Ed, 47, political science and public admin student

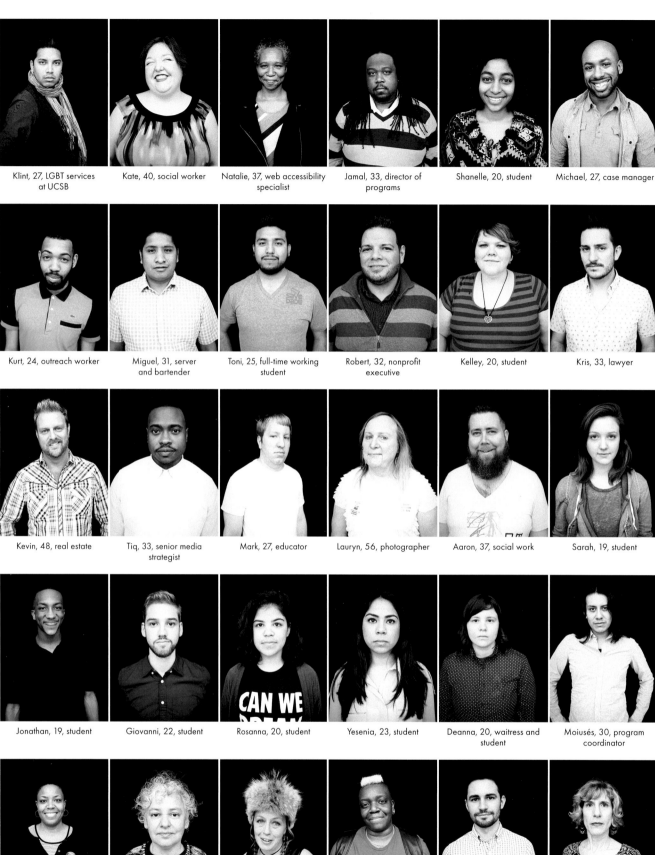

Klint, 27, LGBT services at UCSB

Kate, 40, social worker

Natalie, 37, web accessibility specialist

Jamal, 33, director of programs

Shanelle, 20, student

Michael, 27, case manager

Kurt, 24, outreach worker

Miguel, 31, server and bartender

Toni, 25, full-time working student

Robert, 32, nonprofit executive

Kelley, 20, student

Kris, 33, lawyer

Kevin, 48, real estate

Tiq, 33, senior media strategist

Mark, 27, educator

Lauryn, 56, photographer

Aaron, 37, social work

Sarah, 19, student

Jonathan, 19, student

Giovanni, 22, student

Rosanna, 20, student

Yesenia, 23, student

Deanna, 20, waitress and student

Moiusés, 30, program coordinator

Leisan, 36, higher education

Graciela, 53, director of Esperanza Peace and Justice Center

International Ms. Leather 2013, 38, mom and submissive

Q, 41, trainer and facilitator

Nathan, 27, federal policy advocacy at GLSEN

Lorraine, 51, director of LGBTQ Resource Center

Tye, 33, pharmacy

Tamika, 40, teacher

Renata, 36, policy director

Baby Face, 22, student

Michaela, 22, student

Randall, 34, engineer

Brian, 34, attorney

Tiffany, 35, business owner

Scott, 49, asset manager

Ahmed, 19, fashion editor

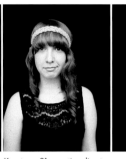

Kourtney, 21, creative director

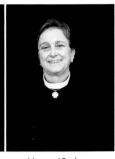

Nancy, 63, clergy

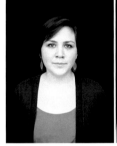

Amberose, 22, Pride Alliance

Jessica, 26, violence prevention educator

Andrea, 35, IT specialist

Ramon, 31

Jacqui, 51, finance

Jessica, 56, teacher

Rebecca, 28, college administrator

Heather, 21, college student

Guillermo, 20, student

Fat, 20, student

Sierra, 12

Katherine, 23, student

Matt, 18, student and artist

Geoffrey, 65, clergyperson

Kym, 46, information management

Gloria, 51, quality manager

Angie, 34, Amherst College Queer Resource Center

Nina, 28, residence director

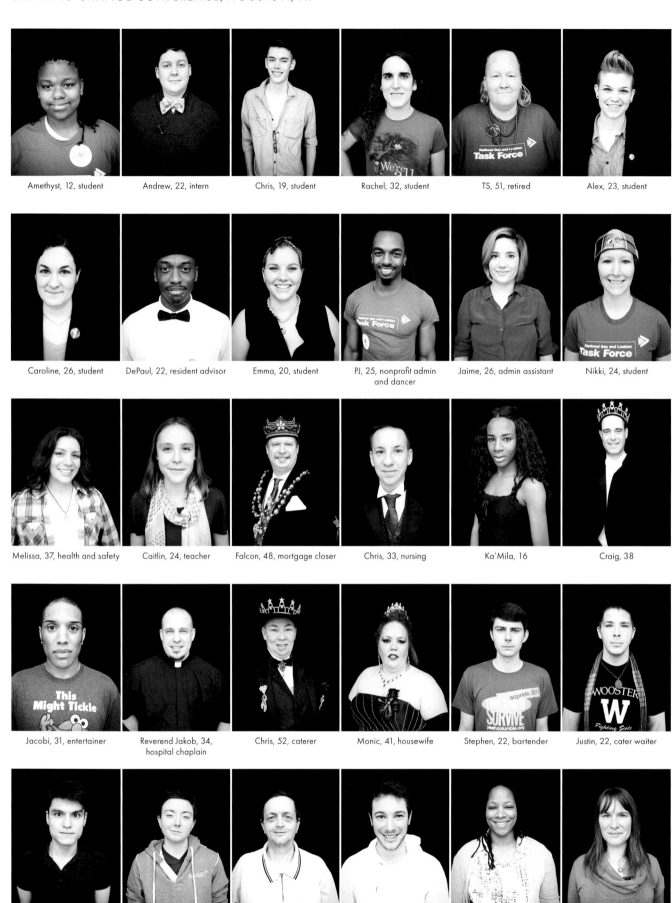

Amethyst, 12, student Andrew, 22, intern Chris, 19, student Rachel, 32, student TS, 51, retired Alex, 23, student

Caroline, 26, student DePaul, 22, resident advisor Emma, 20, student PJ, 25, nonprofit admin and dancer Jaime, 26, admin assistant Nikki, 24, student

Melissa, 37, health and safety Caitlin, 24, teacher Falcon, 48, mortgage closer Chris, 33, nursing Ka'Mila, 16 Craig, 38

Jacobi, 31, entertainer Reverend Jakob, 34, hospital chaplain Chris, 52, caterer Monic, 41, housewife Stephen, 22, bartender Justin, 22, cater waiter

Yuri, 21, bartender and manager Jason, 21, server Paul, 49, disabled Chris, 28, pharmacy technician Augie, 37, IT manager Andrea, 34, cartographer

Angie, 46, corrections officer

Maggie, 21, student

Anjeus, 60, reservation agent

Nicole, writer

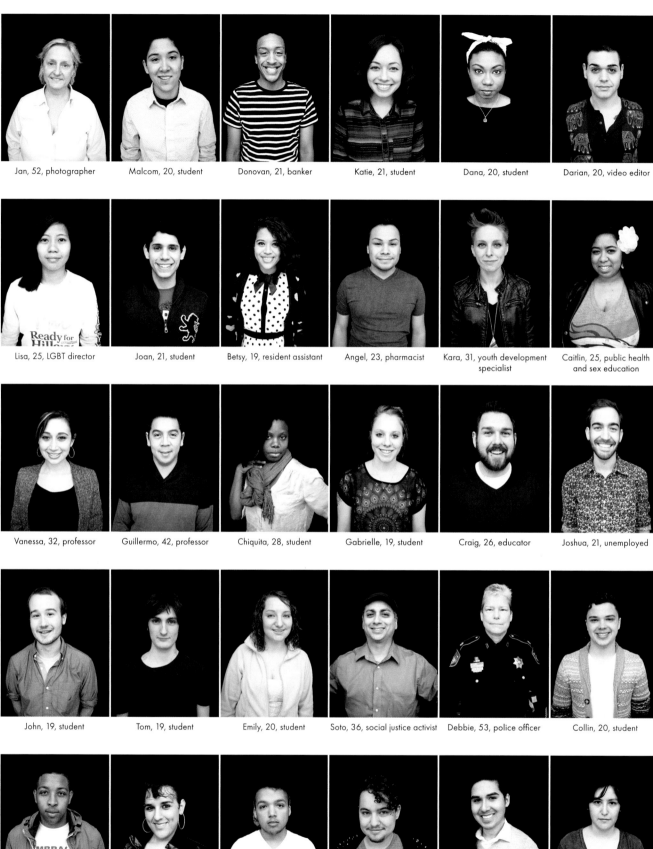

Jan, 52, photographer Malcom, 20, student Donovan, 21, banker Katie, 21, student Dana, 20, student Darian, 20, video editor

Lisa, 25, LGBT director Joan, 21, student Betsy, 19, resident assistant Angel, 23, pharmacist Kara, 31, youth development specialist Caitlin, 25, public health and sex education

Vanessa, 32, professor Guillermo, 42, professor Chiquita, 28, student Gabrielle, 19, student Craig, 26, educator Joshua, 21, unemployed

John, 19, student Tom, 19, student Emily, 20, student Soto, 36, social justice activist Debbie, 53, police officer Collin, 20, student

Andrew, 20, student Sam, 23, entrepreneur Hiram, 20, student Peter, 25, community organizer Danny, 29, community activist Issa, 23, artist

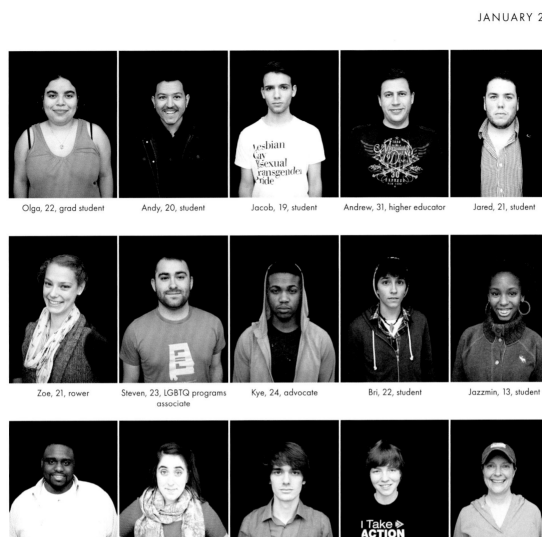

Olga, 22, grad student Andy, 20, student Jacob, 19, student Andrew, 31, higher educator Jared, 21, student Ann, 22, student

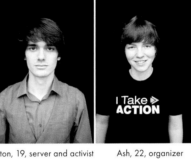

Zoe, 21, rower Steven, 23, LGBTQ programs associate Kye, 24, advocate Bri, 22, student Jazzmin, 13, student Ashley, 21, student

James, 30, mortgage customer service Christine, 24, general education teacher Preston, 19, server and activist Ash, 22, organizer Laura, 40, sign language interpreter Kristina, 32, social worker

KiKi, 40, entertainer Cleo, 24, teacher Kal, 22, facilitator Lee, 28, nurse Adela, 34, security Deanna, 46, staff support

Darius, 40, entertainment Ben, 26, graduate assistant and student Tesha, 20, student Corey, 28, director of the Hispanic Black Gay Coalition

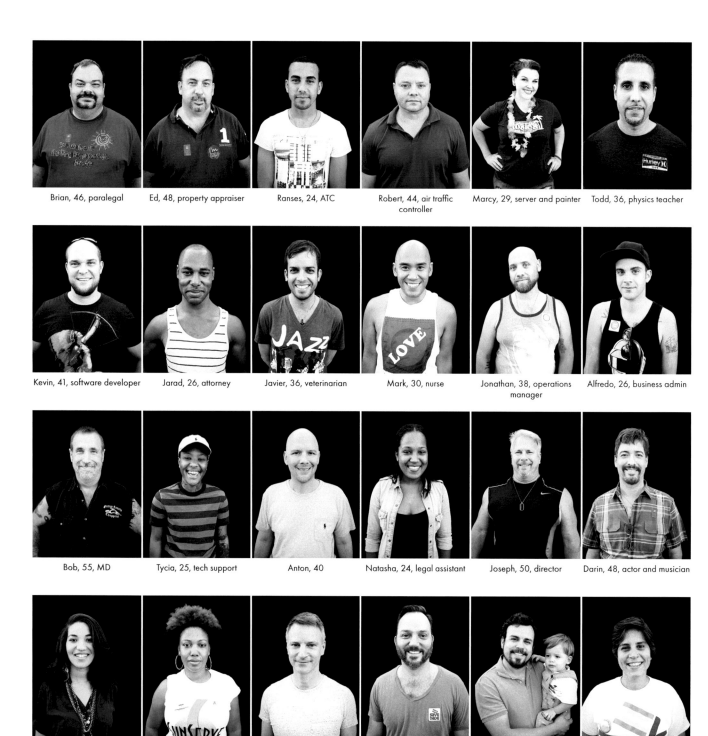

Brian, 46, paralegal

Ed, 48, property appraiser

Ranses, 24, ATC

Robert, 44, air traffic controller

Marcy, 29, server and painter

Todd, 36, physics teacher

Kevin, 41, software developer

Jarad, 26, attorney

Javier, 36, veterinarian

Mark, 30, nurse

Jonathan, 38, operations manager

Alfredo, 26, business admin

Bob, 55, MD

Tycia, 25, tech support

Anton, 40

Natasha, 24, legal assistant

Joseph, 50, director

Darin, 48, actor and musician

Stephanie, 27, attorney

Christina, 28, youth trainer and counselor

George, 49, sales trainer

Thomas, 42, teacher

Juan, 35, nonprofit

Charo, 30, organizer

Maria, 32, SAVE Dade director

Ifrain, 31, banker

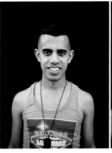

Nilber, 29, public health

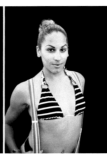

Ruby, 21, student

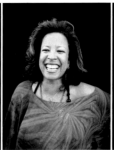

Robyn, 46, writer

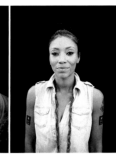

Radisha, 28, office manager

Ashlie, 27, makeup artist

Amanda, 26, Verizon sales rep

Jenn, 26, retail sales consultant

Caysie, 21, entertainer

Alan, 21, exotic dancer

Gwen, 56, veterinarian

Sam, 30, aircraft mechanic

Beverly, 57, accounting and HR

Jeffy, 50, maintenance engineer

Steven, 49, writer

Pinelopi, 33, student

Marlon, 23, dancer

Todd, 40, law

Mark, 53, retired

Kriztian, 26, manager

Jeff, 53, call center

Robert, 50

Joe, 54, hairdresser

Tracy, 51, police officer and deputy sheriff

Skylar, 16, student

Traybay, 32, dance instructor

Abigail, 23, fitness sales

Merio, 34, medical interpreter

Costilano, 34, manager

197

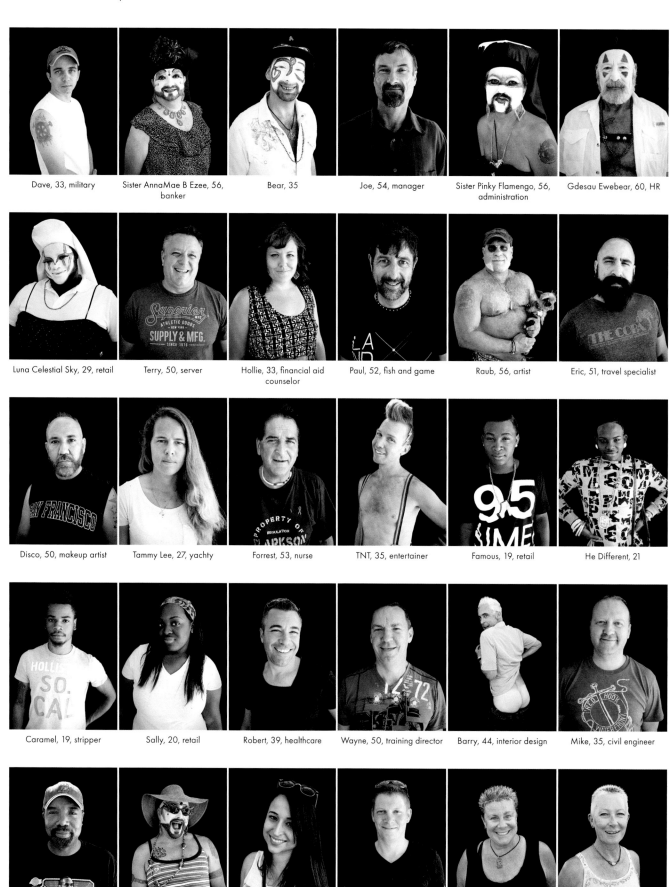

Dave, 33, military

Sister AnnaMae B Ezee, 56, banker

Bear, 35

Joe, 54, manager

Sister Pinky Flamengo, 56, administration

Gdesau Ewebear, 60, HR

Luna Celestial Sky, 29, retail

Terry, 50, server

Hollie, 33, financial aid counselor

Paul, 52, fish and game

Raub, 56, artist

Eric, 51, travel specialist

Disco, 50, makeup artist

Tammy Lee, 27, yachty

Forrest, 53, nurse

TNT, 35, entertainer

Famous, 19, retail

He Different, 21

Caramel, 19, stripper

Sally, 20, retail

Robert, 39, healthcare

Wayne, 50, training director

Barry, 44, interior design

Mike, 35, civil engineer

Don, 53, legal

Sister Ivanna Manda Lei, 52, quality assurance specialist

Roxy, 27, accounting

James, 33, grocery store assistant manager

GiGi, 52, retired FDNY lieutenant and paramedic

Sharron, 52, critical care nurse

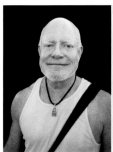 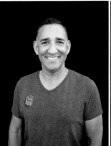

Chris, 60, investor Jeffrey, 48, flight attendant Benny, 25, engineer Martha, 21, Publix Brandee, 20, cashier at Publix David, 43, management

Jose, 34, retail Mark, 56, designer Jerry Grace, 50, banker Gary, 54, engineer Brett, 48, picker Jim, 42, bartender

 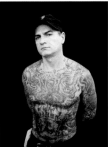 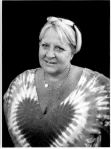 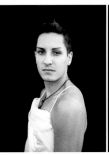 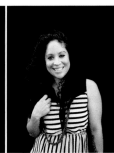

Jayla, 29, healthcare Amy, 29, journalist Jim, 48 Melissa, 47, accountant Anthony, 24, event planner Steph, 28

Arles, 45, flight attendant

Alexis, 20, student Rachel, 22, student Fiona, 21, student Marry, 20, working on it Kate, 32, curator Daniela, 19, tutor

Beatrice, 25, student Dylan, 19, student Celia, 21, student Samantha, 21, student Andrew, 21, student Sonia, 20, student

Jessie, 20, student Lindsay, 20, student Cara, 19, student Nai, 19, barista Declan, 20, student

FIVE COLLEGE QUEER GENDER
AND SEXUALITY CONFERENCE
HAMPSHIRE COLLEGE
AMHERST, MA
MARCH 7–8, 2014

Katherine, 21, student

Colleen, 22, student

Lucia, 24, massage therapist

Maura, 26, student

Andrew, 21, sandwich maker

Stephen, 20, canvasser

Lilly, 21, student

Dorothy Jane, 18, student

Charisse, 19, agriculture

Hayley, 24, education

Liya, 21, student

Robyn, 55, educator

April, 20, student and writer

Jennifer, 22, student

Rowan, 21, student

Knox, 21, barista and
starving artist

Devin, 23, sales associate

Maisie, 19, student

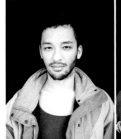
Dustin, 20, student

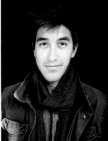
Daniel, 19, student

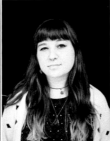
Sophie, 18

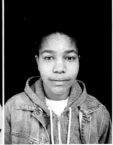
Kourtnie, 22, student

Nate, 20, student

Mati, 21, student

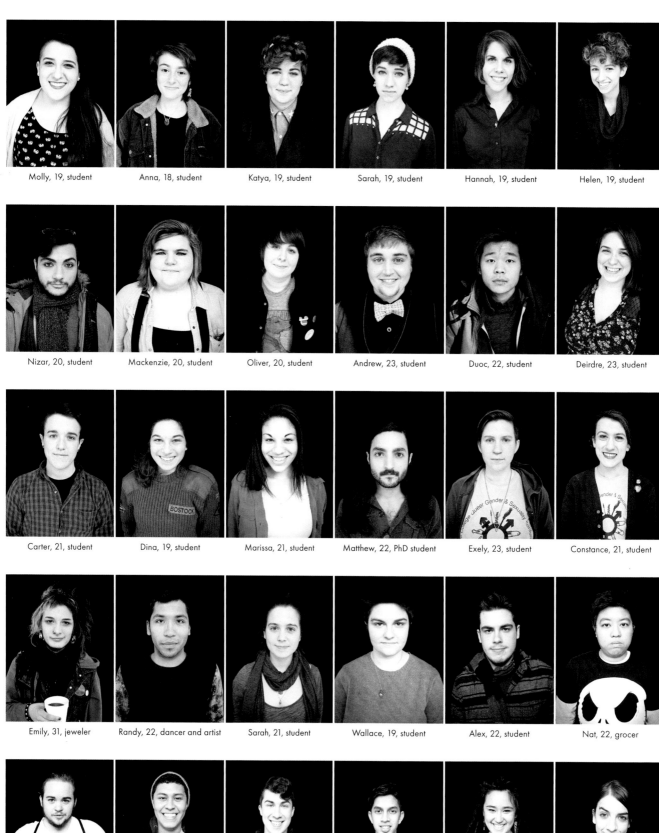

Molly, 19, student Anna, 18, student Katya, 19, student Sarah, 19, student Hannah, 19, student Helen, 19, student

Nizar, 20, student Mackenzie, 20, student Oliver, 20, student Andrew, 23, student Duoc, 22, student Deirdre, 23, student

Carter, 21, student Dina, 19, student Marissa, 21, student Matthew, 22, PhD student Exely, 23, student Constance, 21, student

Emily, 31, jeweler Randy, 22, dancer and artist Sarah, 21, student Wallace, 19, student Alex, 22, student Nat, 22, grocer

Teal, 25, poet Daniel, 20, student Michael, 20, nonprofit Sanjay, 18, student Maya, 20, event planner Jenna, 21, student

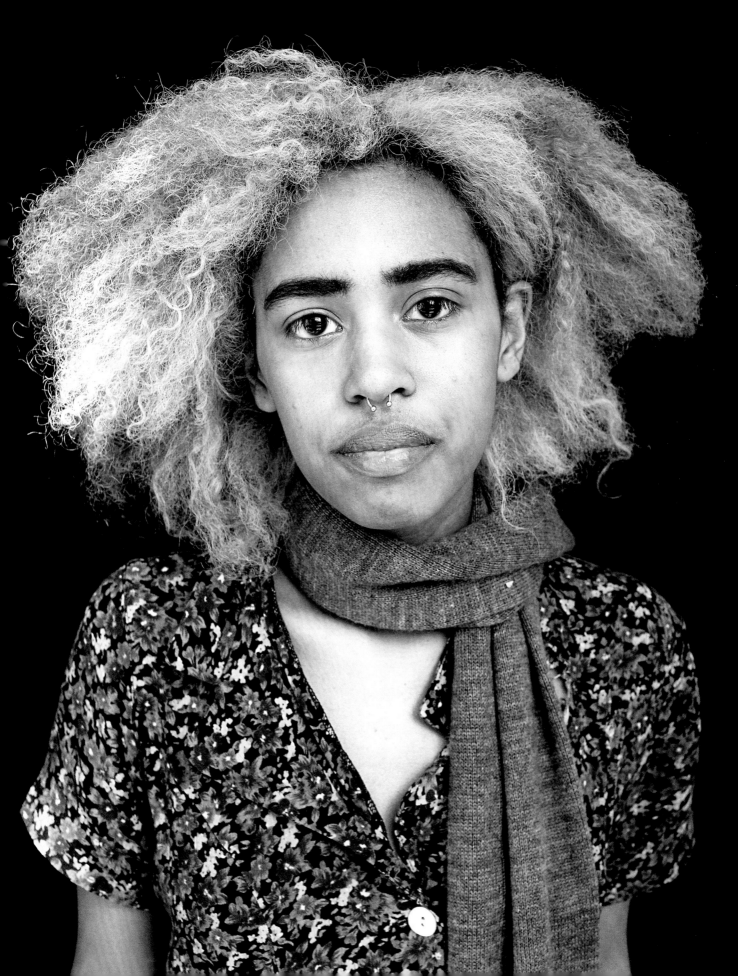
Violet, 19, student

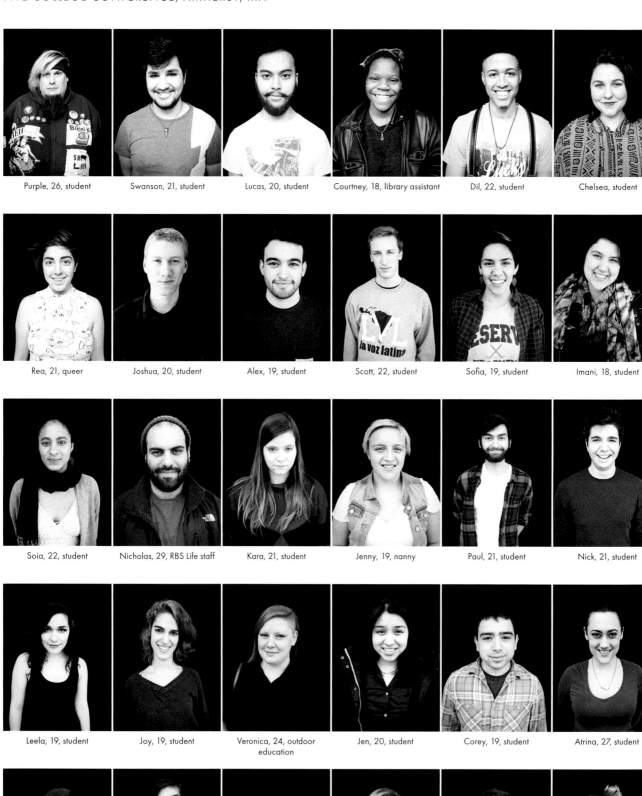

Purple, 26, student Swanson, 21, student Lucas, 20, student Courtney, 18, library assistant Dil, 22, student Chelsea, student

Rea, 21, queer Joshua, 20, student Alex, 19, student Scott, 22, student Sofia, 19, student Imani, 18, student

Soia, 22, student Nicholas, 29, RBS Life staff Kara, 21, student Jenny, 19, nanny Paul, 21, student Nick, 21, student

Leela, 19, student Joy, 19, student Veronica, 24, outdoor education Jen, 20, student Corey, 19, student Atrina, 27, student

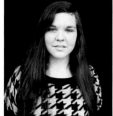

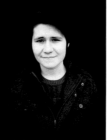
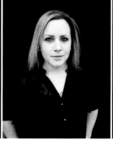
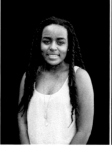
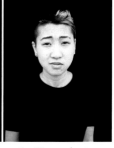

Maggie, 18 Katie, 18 Alex, 18 Jennifer, 28, mental health professional Austin, 18, student Jes, 23, sex educator and stand-up comedian

Laura, 20, student Frankie, 19, student Rebecca, 24, herbalist Aileen, 20, student Jaws, 37, trainer Jawn, 58, photographer

Jacob, 28, student Izzy, 18, student Jessa, 21, student Laura, 18, student Shawn, 27, crisis counselor Sean, 26, community bridger

Hanna, 18, student Kaitlyn, 20, student Sunny, 18, student Lindon, 20, student Tzi Tzi, 21, reslife intern Nicole, 19, student

Kam, 19, student Elliot, 24, data analyst Brandie, 27, nanny Amber, 26, senior program manager Adisa, 24, student Em, 19, student

Blake, 24, environmental educator Tones, 34, social worker and child and family therapist Amanda, 18, student Shan, 21, student Eva, 21, student Sarah, 20, student

Evan, 25, farmer

Brock, 23, personal trainer

DV, 21, student

Kat, 20, student

Kiri, 21, student

Victoria, 52, clinical therapist

Breana, 20, student

James, 21, student

Denton, 21, student

Noah, 21, mentor and student

Nessa, 22, waitress

Kym, 21, student

Jesse, 23, student

Laura, 23, file clerk

Kevin, 24, musician

Cherry, 22, artist

Justin, 22, student

Meg, 21, teacher

Alyssa, 18, student

Nataly, 20, student

Riley, 18, student

Sarah, 19, student

AR, 19, student

Omar, 22, student

Kevin, 20, student

Laura, 19, student

Neal, 22, student

Morgan, 18, student

Noah, 19, student

Gabriel, 21, unemployed college dropout

Melanie, 26, office manager Dani, 27, architectural design Shannan, 19, student Crystal, 19, student Juliana, 19, student Sean, 18, student

Molly, 22, student David, 22, student Ryan, 24, content creator Eileen, 28, case manager and doula Shannon, 27, lecturer and PhD student Mackenzie, 24, outreach specialist

Katie, 23, rowing coach Neema, 25, PhD student JG, 47, artist Bill, 46, TV producer Brian, 41, teacher Jonathan, 22

Noah, 23, software engineer Paul, 27, grad student Lane, 26, rowing coach Bryanna, 27, sales Melanie, 29, massage therapist and artist Audrey, 19, student

Sasha, 22, unemployed

Chanda, 25, lab tech

Jason, 38, hairstylist

Adam, 25, project manager

Iris, 25, recruiter

Mike, 30, music teacher

Will, 24, grad student

Paul, 32, musician

Claire, 34, database management

Lane, 25, special education teacher

Tiffy, 38, nurse, and Beatrix

Libby, 37, operation coordinator

Cory, 36, rowing coach

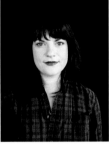

Emily, 34, event producer

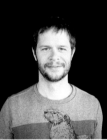

John, 36, farmer

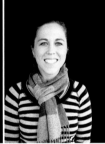

Sarah Hope, 30, musician and engineer

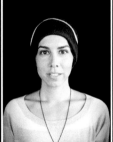

Monica

Wyndham, 24, nanny

Brynn, 30, elementary school teacher and artist

Megan, 28, professional equestrian

Jahna, 29, paramedic

Gonzalo, 24, student

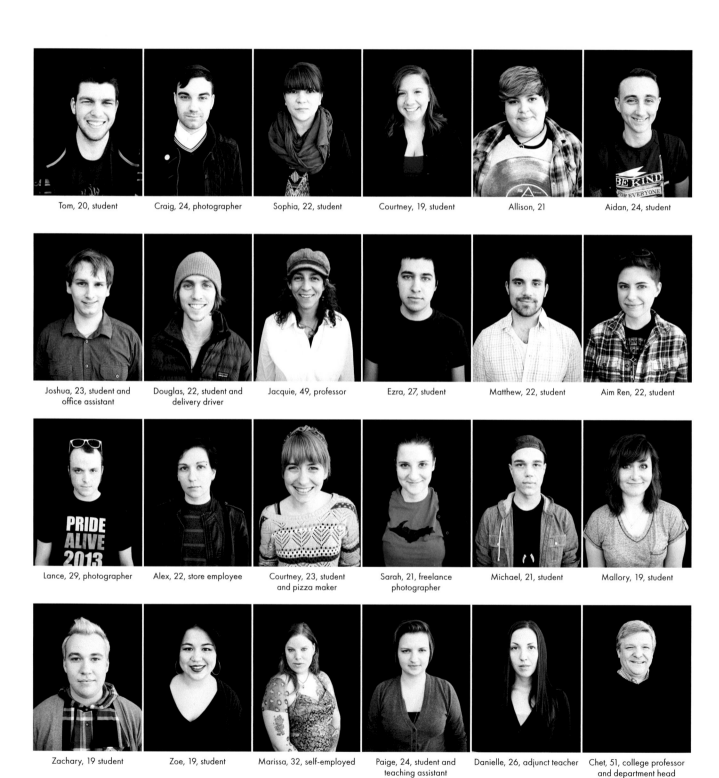

Tom, 20, student

Craig, 24, photographer

Sophia, 22, student

Courtney, 19, student

Allison, 21

Aidan, 24, student

Joshua, 23, student and
office assistant

Douglas, 22, student and
delivery driver

Jacquie, 49, professor

Ezra, 27, student

Matthew, 22, student

Aim Ren, 22, student

Lance, 29, photographer

Alex, 22, store employee

Courtney, 23, student
and pizza maker

Sarah, 21, freelance
photographer

Michael, 21, student

Mallory, 19, student

Zachary, 19 student

Zoe, 19, student

Marissa, 32, self-employed

Paige, 24, student and
teaching assistant

Danielle, 26, adjunct teacher

Chet, 51, college professor
and department head

Oscar, 18, student

Canyon, 7, songwriter

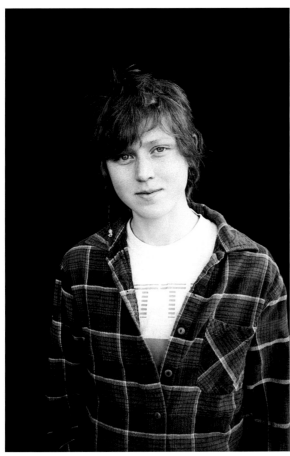

Laura, 20, climbing guide

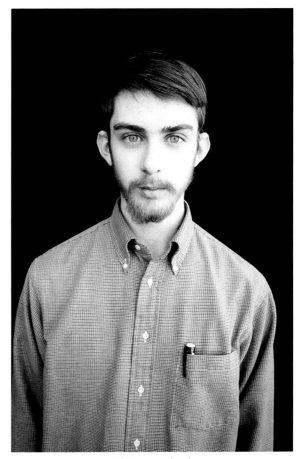

Jake, 19, unemployed

Caroline, 25, mom

Topher, 26

Jeanette, 16, high school
student

Maddie, 19, student

Bailee, 18, unemployed

Nina, 21, student

Joe, 25, student

Alyssa, 19, student

Tyler, 18, student

Alejandra, 27, student

Molly, 21, desk worker

Melissa, 19, student

Victoria, 21, student

Logan, 22, artist

Amanda, 25, designer

Kelly, 20, student

Allie, 19, student

Analicia, 22, student
and photographer

Betsy, 20, student

Grant, 20, burger technician

Kedzie, 19, student
and library page

Corryn, 23

Tracy, 43, professor

Simone, 43, student

Alisha, 20, student

Stephen, 19, student

Augustine, 20, student

Stafani, 22, interpreter
and student

Christen, 20, psychiatric technician

Molly, 22, student

Maria, 27, shipping manager

Sierra, 20, student

Stephanie, 25, registered nurse

Jaide, 26, barista

Alissa, 24, forest service

Gordon, 39, ski tech

Merissa, 21, student

Cherie, 33, student

Austin, 24, student

Charlotte, 18, student

Amee, 32, student

Rigo, 36, server

Debi, 25, photographer

Dana, 29, student

Jordan, 20, server

Justice, 18, student

Dani, 18, student

Moose, 29, CNA

Bo, 27, teacher

Cody, 20, research technician

Adrienne, 19, student

E-Rick, 18, student

Carmen, 20, banquet manager

Juli, 48, LGBT advocate

Nikki, 20, student

Dayna, 55, college administrator

Ricky, 22, student

Kate, 24, program coordinator

Georgie, 19, student

Ashton, 21, student

Joe, 50, higher education administrator

Dianne, 54, student

Cody, 20, student

Richele, 29, OA

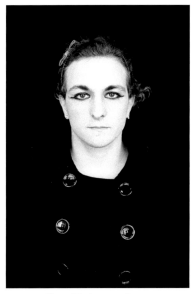

Kerry, 20, drag coordinator

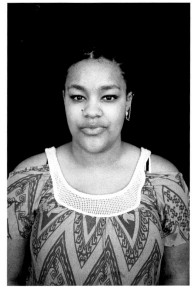

Airey, 18, student

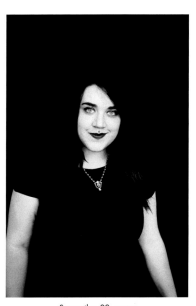

Samantha, 22, queer
and POC activist and chef

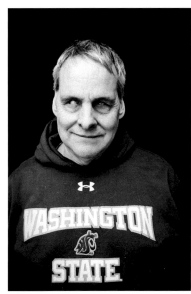

Dan, 61, coordinator

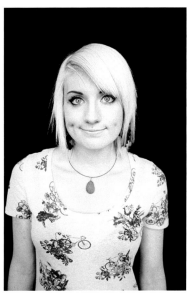

Cappy, 22, student

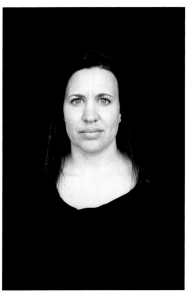

Shauna, 37, writing assistant

215

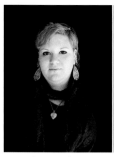

Helena, 21, physicist

J Mase, 29, poet

Eric, 19, student

Ali, 22, student

Haven, 32, nonprofit director

Nora Joan, 26, full-time gay farmer

Enzi, 30, youth worker

Jesus, 23, student

Natalie, 22, grad student

Rocky, 28, student

Brian, 22, student

Jackson, 21, student

Anna Lynn, 19, student

Lauryn, 21, student

Loren, 22, student

Ashley, 19, student

Kara, 20, peer educator

Brianne, 19, editor

Jordan, 20, student

Jake, 20, student

Amanda, 18, student

Tre, 20, sandwich artist

Kyle, 22, student

Latonya, 26, student relations

Annalee, 18, veterinary student

Nicole, 37, associate director of advertising

Jaz, 20, student and retail sales

Alisha, 25, CNA, guitar teacher, usher, and valet parker

Jacque, 26, program manager and college instructor

Tyler, 20, LGBT Resource Center

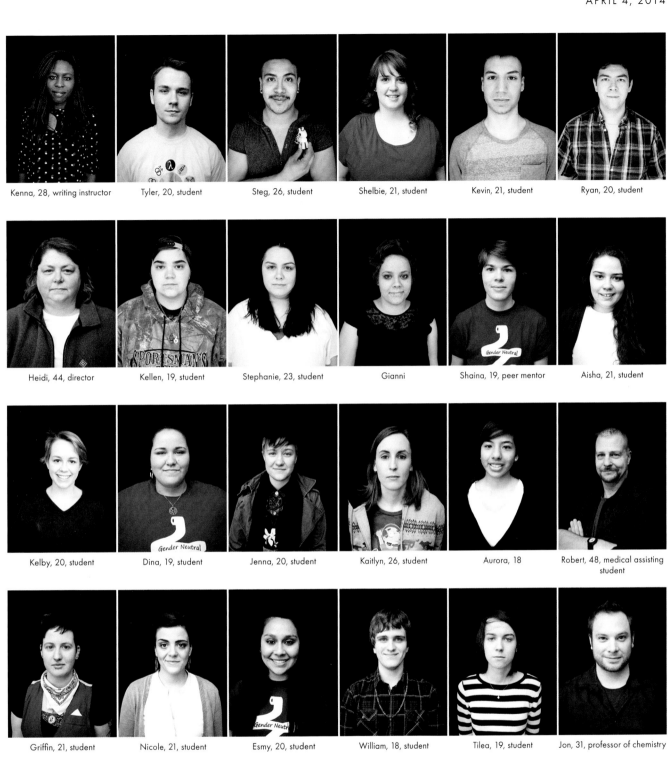

Kenna, 28, writing instructor

Tyler, 20, student

Steg, 26, student

Shelbie, 21, student

Kevin, 21, student

Ryan, 20, student

Heidi, 44, director

Kellen, 19, student

Stephanie, 23, student

Gianni

Shaina, 19, peer mentor

Aisha, 21, student

Kelby, 20, student

Dina, 19, student

Jenna, 20, student

Kaitlyn, 26, student

Aurora, 18

Robert, 48, medical assisting student

Griffin, 21, student

Nicole, 21, student

Esmy, 20, student

William, 18, student

Tilea, 19, student

Jon, 31, professor of chemistry

Karma, 26, diversity and equality program coordinator

Carol, 29, reading and writing college instructor

Jaimee, 28, assistant director of the Q Center at UW

Becca, 20, executive council member of the SLCC

Jen, 43, director of the Q Center at UW

Adam, 34, queer resource advocate

Curt, 39, administrator

Cass, 27, student government coordinator

DD, 25, unemployed

Penny, 32, IT

Jason, 21, student

Kilo, 39, teacher, activist, and father

Madison, 21, student

Alexander

CLUB SKIRTS DINAH SHORE WEEKEND
PALM SPRINGS, CA
APRIL 6, 2014

Fortune

Kylene, 26, radiologic
technologist

Katrine, 33, marketing

Elizabeth, 33, project
manager

Ashley, 43, executive
producer

Brenna, 25, sales

Ashley, 26, store manager

Stephanie, 27

Priscilla, 44, wine specialist

Stephanie, 28, chef

Helen, 30, teacher

Anna, 22, Amazon problem
solver

Lisa, 49, retired

Denise, 34,
stay-at-home mom

Love, 24, single mom

Peaches, 18

Trice, 29, unemployed

Ursula, 27, petroleum
engineer

Lupe, talent director

Kya, 21, dance instructor

Daisy, 26, IT tech

Danielle, 28, post-production
manager

Giuliana, 28, finance

Rosa, 25, dance

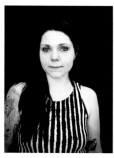

Trish, 30, editor

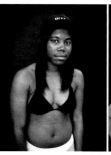

Taylor, 24, human resources

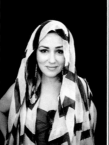

Rani, 41

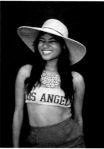

Chrissy, 24, sexiness

Bianca, 25, business

Gabrielle, 23, studio coordinator

Cassy, 35, engineer

Mitzie, 32, Edison administrator

Melissa, 34, nurse

Catherine, 27, customer service

V, corporate

Tameika, 27, chef

AJ, 23, student

Jackie, 30

Carol, 25, student

Melissa, 22, behavioral therapist

Raul, 23, student

Carolina, 25, student

Brittany, 26, child life specialist

Mary, 25, restaurant manager

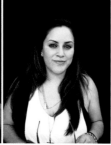

Ness, 24, VFX artist

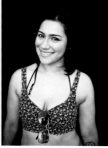

Lo, 25, hairdresser and photographer

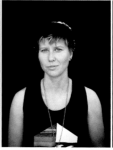

Blaire, 30, lawyer

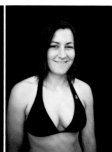

Lisa, 30, lawyer

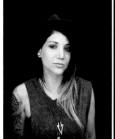

Suzy, 34, owner of detox center

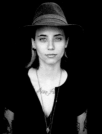

Jeny, 29, hairstylist

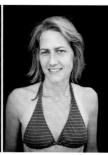

Christine, 43, licensed real estate professional

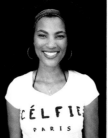

Kapri, 25, Pilates instructor and energy healer

Rez, 35, graphic designer

Brandi, 29, administrative assistant

Royce, 22, actor and singer

Katrina, 30, SharePoint designer

Jillian, 24, caregiver

Teddy, 26, student

Addie, 27, operator

Gemma, 23, kindergarten teacher

Shakira, 30, laborer

Gabriela, 24, musician

Ivy, 32, operations manager

Rhys, 31, social work

Allie, 23, engineer

T, 30, physical therapist

Shay, 25, project engineer

Johnny, 28, photographer

Hannah, 26, pedal cabby

Lauren, 23, bartender

Stephanie, 31, entertainer

Annie, 29, admin assistant

Melissa, 33, manager

Alysha, 26, security

Yasmin, 24, corrections officer

Myseisha, 25, general manager

Kaya, 23, auto slam operator

Janice, 33, bar owner and bartender

Cameo, 27, dispensing technician and pharmacy

Michael, 25, visual merchandiser and model

Gogo Mel, 33, makeup artist and gogo dancer

Lue, 26, porn star

Darn, 39, 1st AD

Sarah, 40, massage therapist

Florencia, 22, filmmaker

Arlene, 42, grip

Tracy, 22, bartender

Tiffany, 24, Saks

Mahadin, 37, bakery owner and actor

Jennifer, 28, marketing coordinator

T, 33, graphic designer

Cathy, 37, production coordinator

Lori, 43

Stacy, 43, student

Sai, 26, youth worker

Muzione, 30, massage therapist

Laurie, 30, computer science

Audrey, 24, student

Audrey, 23, insurance

Angel, 30, DJ

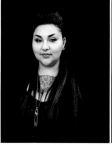

Alessa, 29, Club Tattoo

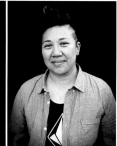

Kay, 36, energy technician

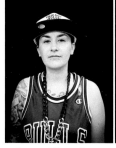

Deanna, 28, warehouse

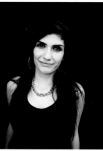

Marina, 22, retail

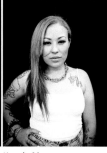

Kristah, 22, account executive

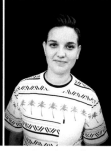

Sara, 27, retail

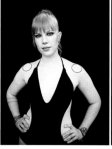

Dallas, 26, engineering technician

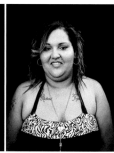

Raiiyn, 23, customer service rep

Nicole, 29, railroad safety

Edlin, 24, server

Erika, 24, server

Yuly, 30, student

Vanni, 30, teacher

Jay, 21, real estate

Joey, 25, hair

Morgan, 29, business owner

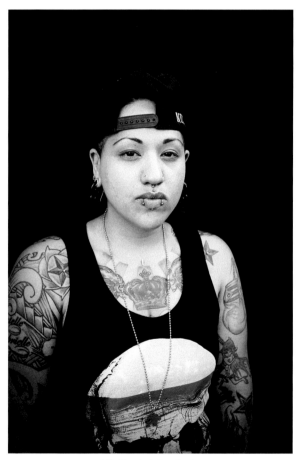

Nik, 31, private investigator

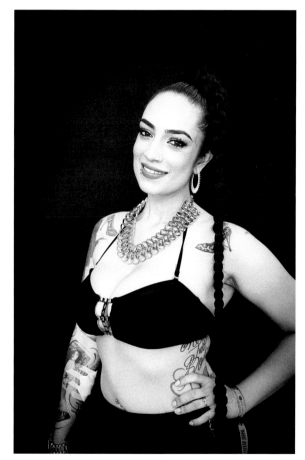

Holly, 27

Ashley, 26, porn star

Sonora, 41, actor

Nathalie, 33

Amy, 45, chef

Rossi, 55, massage therapist

Carolyn, 26, self-employed

Tristan, 24, air traffic controller

Alexis, 28, HR business partner

Emily, wedding planner

Jane, 23, sales

Teresa, 27, promotions

Jovan, 33, bartender

Stephanie, 25, student

Chelsea, 24, military

Brooke, 26, server

Amy, 36, director

Rolla, 34, filmmaker

Masha, 30, arts administrator

Kristy, 38, sales

Tracy, 33, TV development exec

Denna, 43, teacher

Aster, 25, nonprofit administrator and dancer

PHOENIX PRIDE
PHOENIX, AZ
APRIL 7, 2014

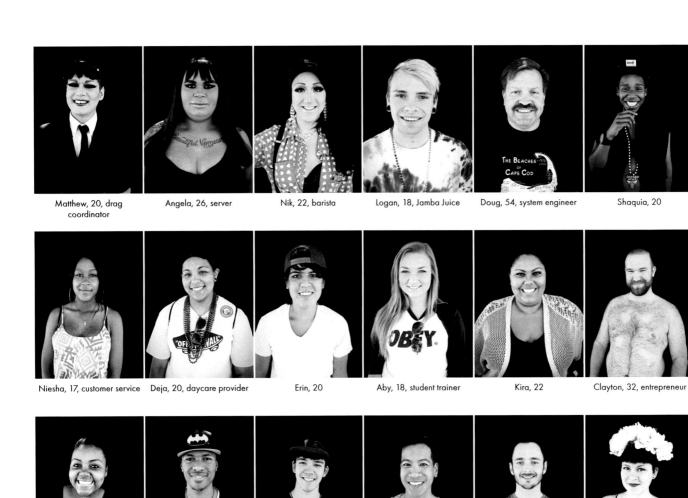

Matthew, 20, drag coordinator

Angela, 26, server

Nik, 22, barista

Logan, 18, Jamba Juice

Doug, 54, system engineer

Shaquia, 20

Niesha, 17, customer service

Deja, 20, daycare provider

Erin, 20

Aby, 18, student trainer

Kira, 22

Clayton, 32, entrepreneur

Precious, 20

Payton, 21, dancer

Bradly, 21, dance instructor

Paul, 47, flight attendant

Garrett, 27, manager

Taylor, 18, sales associate

Candice, 20, salesgirl

Janie, 19, line cook

Toni, 21, golf assistant pro

Sam, 22, server and student

Alex, 20, student

Eye, 26, employed

Steven, 18, service manager

Keri, 33, property manager

Christina, 29, property manager

Hannah, 8

Colby, 22, host at Texas Roadhouse

Zack, 28, porn star

Ara, 51, house painter

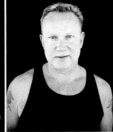

Jim, 54, sales

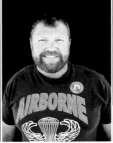

Billy, 36, business owner

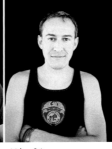

Mike, 34, process manager

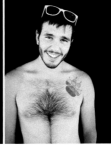

Andre, 22, bartender

Rich, 48, government

Sheldon, 35, general manager

Danny, 32, middle school art teacher

Shane, 22, Chase

Cassidy, 20, daycare teacher

Megan, 19, sandwich maker

Edward, 31, insurance

Sarah, 22, cashier

David, 36, manager

Lio, 29, banking

Dawn, 47, admin

Mark Anthony, 22, dancer

Kathy, 56, woodworker

Sister Gabby de Ankles, 42, electronics

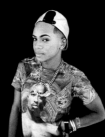

Trae, 21

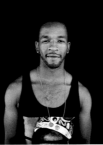

Nico, 23

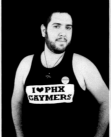

Paul, 27, customer care rep

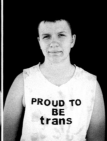

Connor, 18, student

Louis, 57

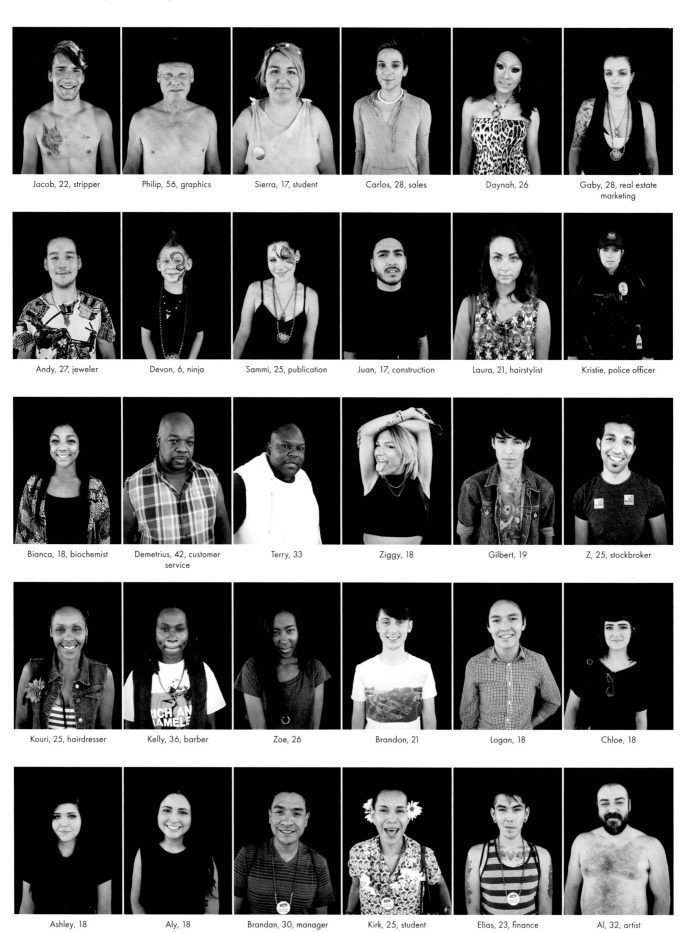

Jacob, 22, stripper

Philip, 56, graphics

Sierra, 17, student

Carlos, 28, sales

Daynah, 26

Gaby, 28, real estate marketing

Andy, 27, jeweler

Devon, 6, ninja

Sammi, 25, publication

Juan, 17, construction

Laura, 21, hairstylist

Kristie, police officer

Bianca, 18, biochemist

Demetrius, 42, customer service

Terry, 33

Ziggy, 18

Gilbert, 19

Z, 25, stockbroker

Kouri, 25, hairdresser

Kelly, 36, barber

Zoe, 26

Brandon, 21

Logan, 18

Chloe, 18

Ashley, 18

Aly, 18

Brandan, 30, manager

Kirk, 25, student

Elias, 23, finance

Al, 32, artist

Je'Mari, 22, dancer

Dion, 23, hairstylist

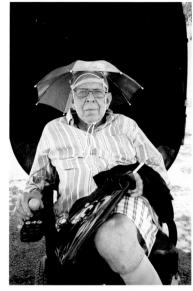

Searay, 79, retired

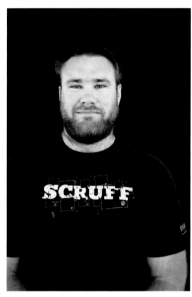

Gary, 26, social worker

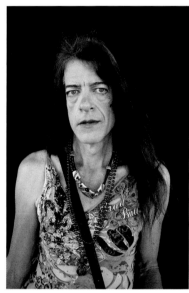

Vara, 51, retail

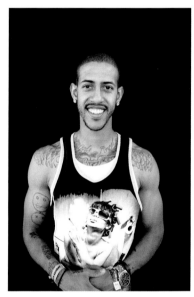

William, 23, big ballah baby

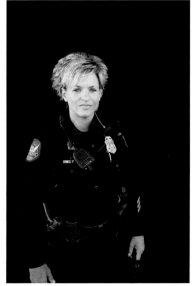

Chris, police officer

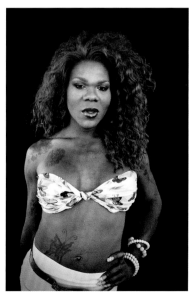

Sabhle, 34, hair

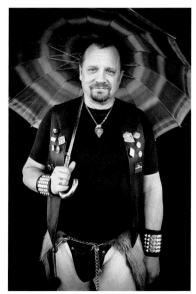

Donald, 46, paralegal

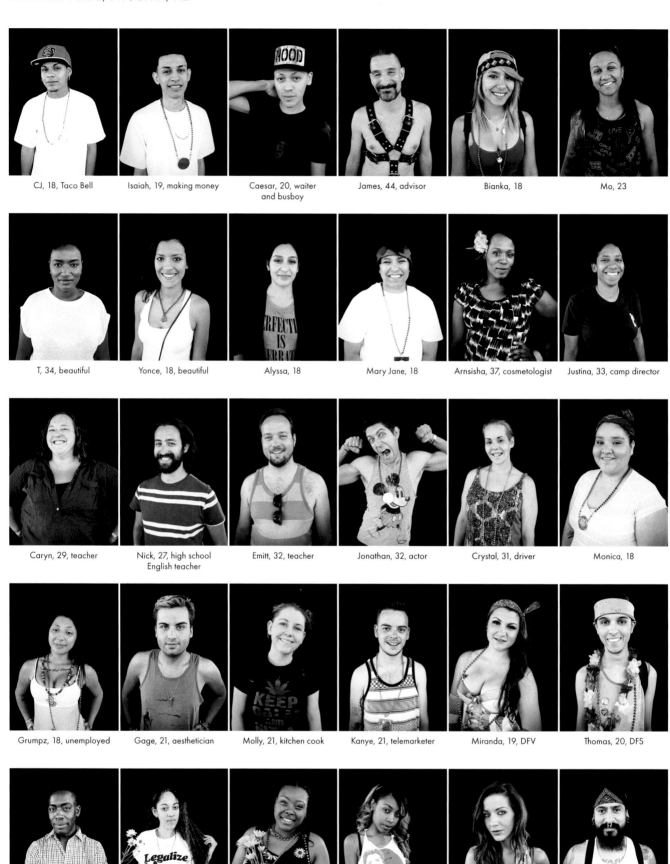

CJ, 18, Taco Bell | Isaiah, 19, making money | Caesar, 20, waiter and busboy | James, 44, advisor | Bianka, 18 | Mo, 23

T, 34, beautiful | Yonce, 18, beautiful | Alyssa, 18 | Mary Jane, 18 | Arnsisha, 37, cosmetologist | Justina, 33, camp director

Caryn, 29, teacher | Nick, 27, high school English teacher | Emitt, 32, teacher | Jonathan, 32, actor | Crystal, 31, driver | Monica, 18

Grumpz, 18, unemployed | Gage, 21, aesthetician | Molly, 21, kitchen cook | Kanye, 21, telemarketer | Miranda, 19, DFV | Thomas, 20, DFS

Ken, 36, server | Angela, 20 | Darienne, 20 | Tavia, 20 | Hay, 27, bartender | Rubez, 35, self-employed

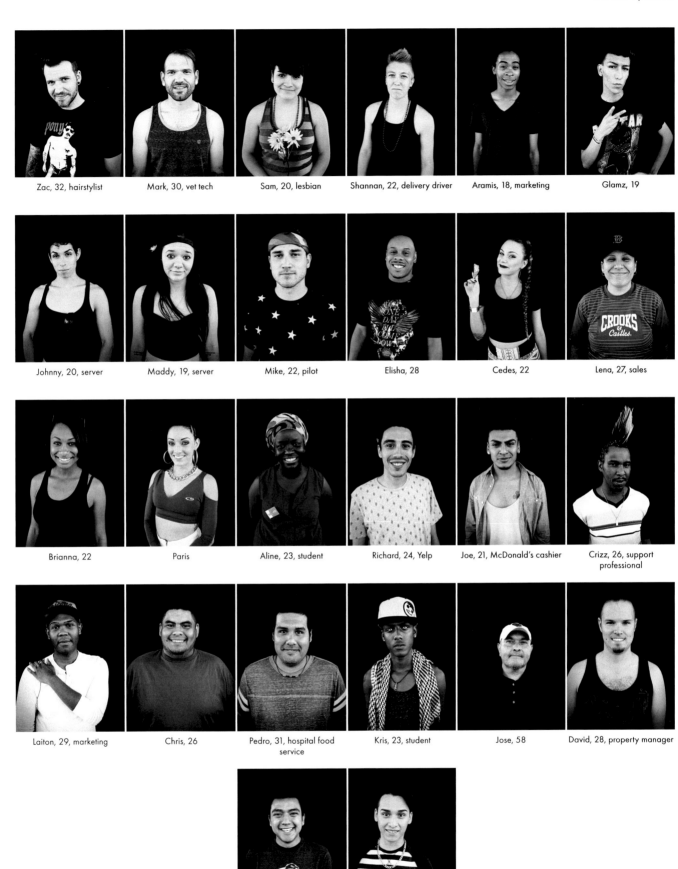

Zac, 32, hairstylist

Mark, 30, vet tech

Sam, 20, lesbian

Shannan, 22, delivery driver

Aramis, 18, marketing

Glamz, 19

Johnny, 20, server

Maddy, 19, server

Mike, 22, pilot

Elisha, 28

Cedes, 22

Lena, 27, sales

Brianna, 22

Paris

Aline, 23, student

Richard, 24, Yelp

Joe, 21, McDonald's cashier

Crizz, 26, support professional

Laiton, 29, marketing

Chris, 26

Pedro, 31, hospital food service

Kris, 23, student

Jose, 58

David, 28, property manager

Sergio, 18

Jose, 20

GAY-STRAIGHT ALLIANCE SUMMIT
BULLIS SCHOOL
POTOMAC, MD
APRIL 9, 2014

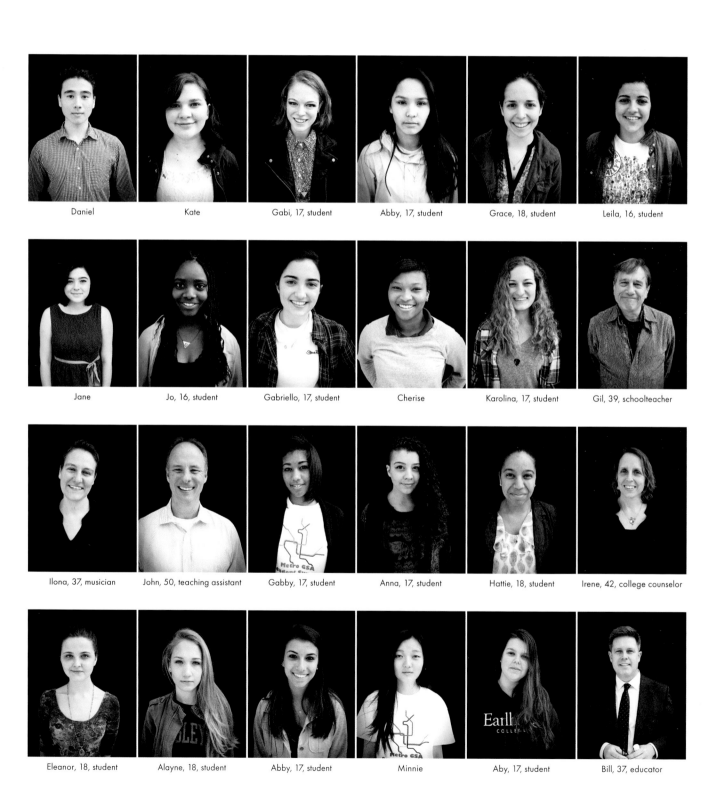

Daniel	Kate	Gabi, 17, student	Abby, 17, student	Grace, 18, student	Leila, 16, student
Jane	Jo, 16, student	Gabriello, 17, student	Cherise	Karolina, 17, student	Gil, 39, schoolteacher
Ilona, 37, musician	John, 50, teaching assistant	Gabby, 17, student	Anna, 17, student	Hattie, 18, student	Irene, 42, college counselor
Eleanor, 18, student	Alayne, 18, student	Abby, 17, student	Minnie	Aby, 17, student	Bill, 37, educator

Sibet, 18

Benjamin, 15, student

Justin, 15, student

Rosemary, 18, student

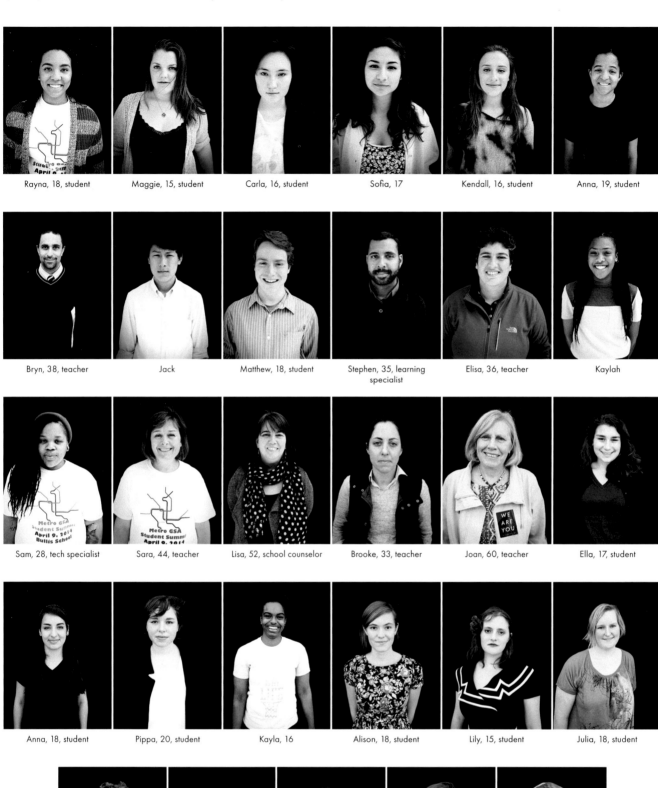

Rayna, 18, student

Maggie, 15, student

Carla, 16, student

Sofia, 17

Kendall, 16, student

Anna, 19, student

Bryn, 38, teacher

Jack

Matthew, 18, student

Stephen, 35, learning specialist

Elisa, 36, teacher

Kaylah

Sam, 28, tech specialist

Sara, 44, teacher

Lisa, 52, school counselor

Brooke, 33, teacher

Joan, 60, teacher

Ella, 17, student

Anna, 18, student

Pippa, 20, student

Kayla, 16

Alison, 18, student

Lily, 15, student

Julia, 18, student

Devon, 18, student

Ashfia, 18, student

Schuyler, 17, student

Madeline, 17

Hugh, 36, teacher and recording engineer

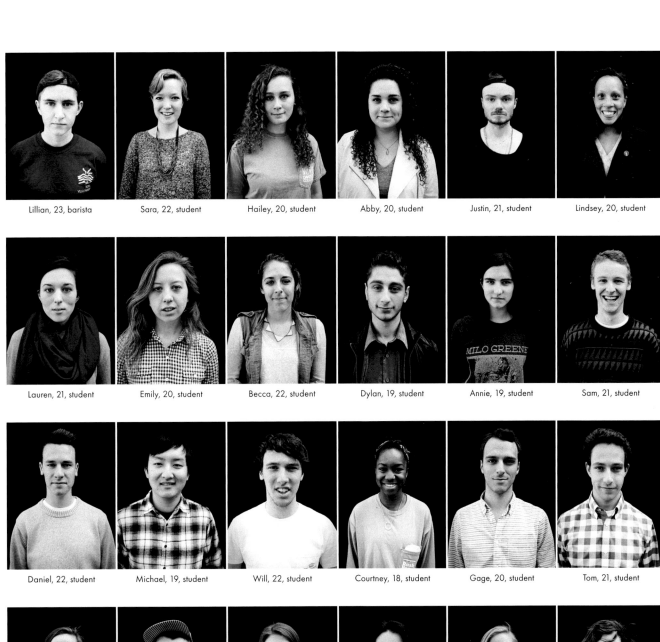

Lillian, 23, barista

Sara, 22, student

Hailey, 20, student

Abby, 20, student

Justin, 21, student

Lindsey, 20, student

Lauren, 21, student

Emily, 20, student

Becca, 22, student

Dylan, 19, student

Annie, 19, student

Sam, 21, student

Daniel, 22, student

Michael, 19, student

Will, 22, student

Courtney, 18, student

Gage, 20, student

Tom, 21, student

Carolyn, 22, student

Adam, 21, student

Kedra, 21, student

Jess, 19, student

Sarah, 21, student

Timmy, 23, student

Daniel, 19, student

Isabel, 20, student

Majo, 19, student

Ann, 21, student

Paige, 21

Holly, 20, student

John Michael, 19, student

Tory, 22, student

Ela, 20, student

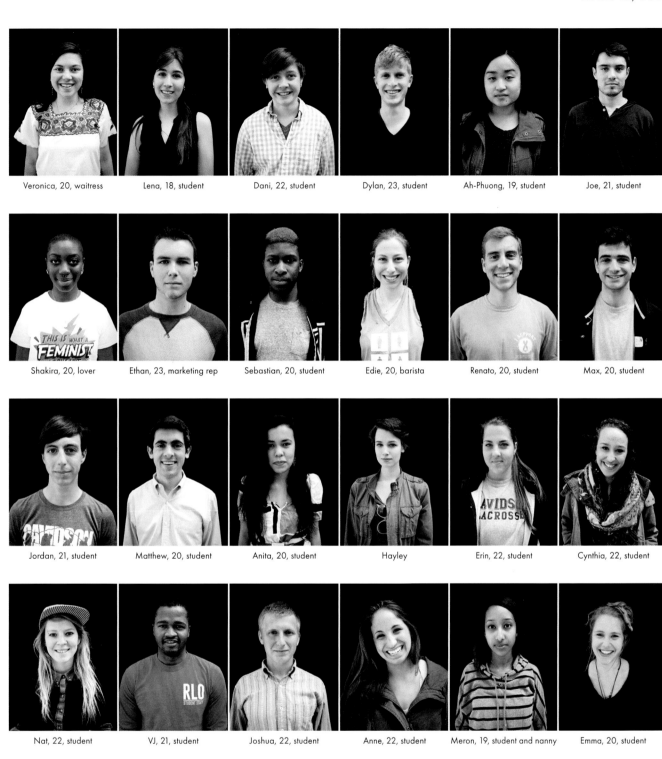

Veronica, 20, waitress Lena, 18, student Dani, 22, student Dylan, 23, student Ah-Phuong, 19, student Joe, 21, student

Shakira, 20, lover Ethan, 23, marketing rep Sebastian, 20, student Edie, 20, barista Renato, 20, student Max, 20, student

Jordan, 21, student Matthew, 20, student Anita, 20, student Hayley Erin, 22, student Cynthia, 22, student

Nat, 22, student VJ, 21, student Joshua, 22, student Anne, 22, student Meron, 19, student and nanny Emma, 20, student

Catie, 18, student Dora Mae, 19, student Emi, 18

MAY
2014

LAVERNE COX IS THE FIRST
TRANSGENDER PERSON TO BE
FEATURED ON THE COVER OF
TIME MAGAZINE.

VOGUE
NEW YORK, NY
MAY 8, 2014

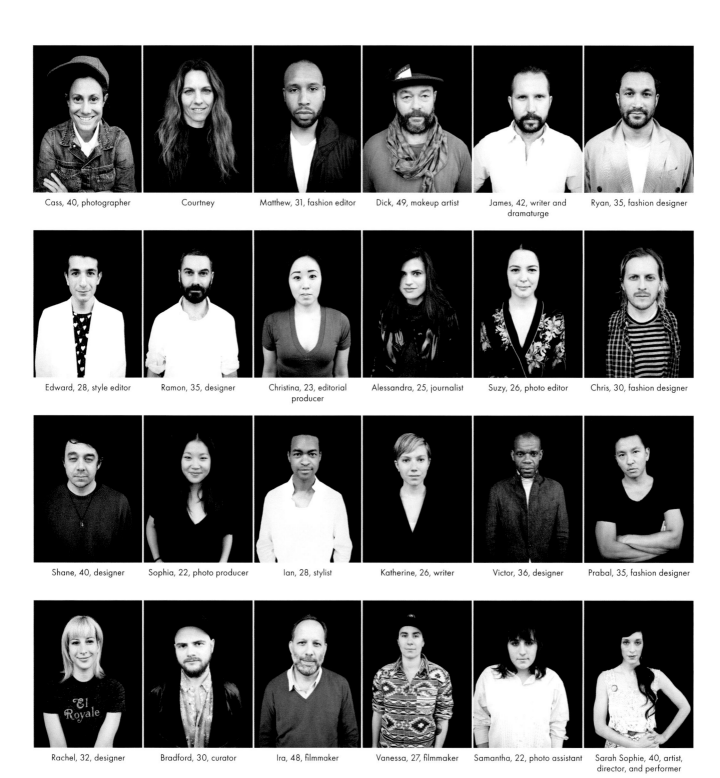

Cass, 40, photographer

Courtney

Matthew, 31, fashion editor

Dick, 49, makeup artist

James, 42, writer and dramaturge

Ryan, 35, fashion designer

Edward, 28, style editor

Ramon, 35, designer

Christina, 23, editorial producer

Alessandra, 25, journalist

Suzy, 26, photo editor

Chris, 30, fashion designer

Shane, 40, designer

Sophia, 22, photo producer

Ian, 28, stylist

Katherine, 26, writer

Victor, 36, designer

Prabal, 35, fashion designer

Rachel, 32, designer

Bradford, 30, curator

Ira, 48, filmmaker

Vanessa, 27, filmmaker

Samantha, 22, photo assistant

Sarah Sophie, 40, artist, director, and performer

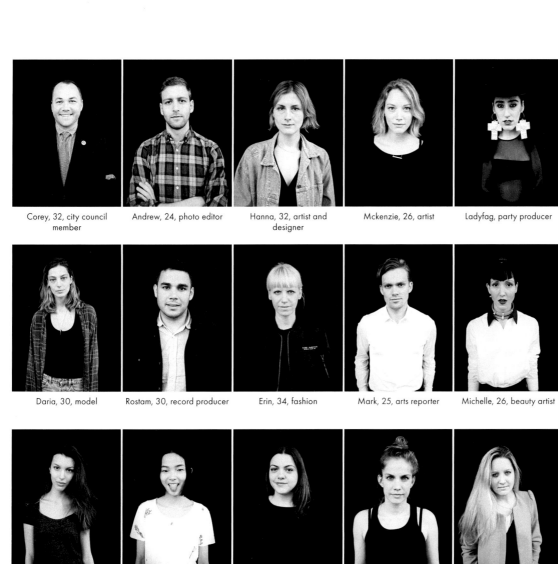

Corey, 32, city council member — Andrew, 24, photo editor — Hanna, 32, artist and designer — Mckenzie, 26, artist — Ladyfag, party producer — Adam, 32, fashion designer

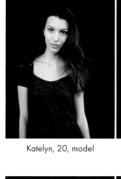 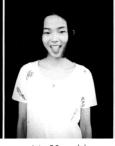 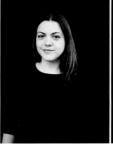

Daria, 30, model — Rostam, 30, record producer — Erin, 34, fashion — Mark, 25, arts reporter — Michelle, 26, beauty artist — Katlin, 21, model

Katelyn, 20, model — Juju, 25, model — Anne, 25, social media manager — Anna, 33, actress — Megan, 25, publicist — LP, 33, musician

Ruben, 24, photo researcher — Anthony, 22, graphic designer — Madeline, 26, manicurist — Adrian, 29, ballet dancer — Emma, 29, actor and designer — Chelsea, 26, market editor

 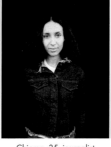 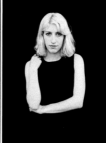 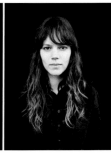

Jacky, 35, VP of brand and retail development — Azealia, 22, chef, exotic dancer, and artist — Christine, 47, former NY City Council member — Chioma, 35, journalist — Karley, 30, writer — Freja Beha, 28, model

WYTHE HOTEL
BROOKLYN, NEW YORK, NY
MAY 12, 2014

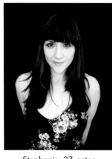
Stephanie, 27, actor

Jackie, 28, AAS administrator

Kathryn, 25, photographer

Georgina, 24, marketing events

Katherine, 24, nonprofit consulting

Daniel, 33, designer

Kristin, 33, everyone is gay

Jenny, 32, musician

Becca, 19, student

Caroline, 20, student

Richard, 62, retired lawyer and teacher

Renee, 28, filmmaker

Lauren, 24, spokesperson

Ashley, 22, student

Eyeris, 26, student

Sara, 39, DJ

Ussuri, 36, high school teacher

Dana, 34, French teacher

Kevone, 31, hypnotist

Marisa, 28, publicist

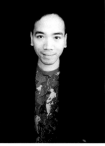
Cesar, 30, unemployed

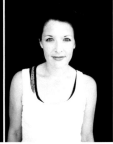
Darby, 30, dean of instruction

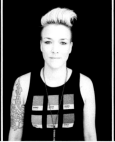
Megan, 27, manager and teacher

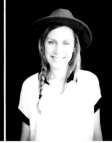
Liz, 26, assistant casting director and barista

AV, 48, artist

Ashley, 31, photographer

Kristen, 30, analyst
and advertising

Odelia, 16, student

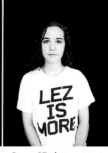

Diane, 27, photo assistant

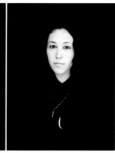

Ari, 24, executive assistant
to CEO

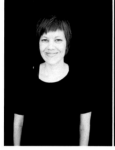

Sarah, 28, designer

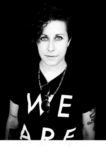

Anne, 26, production
manager

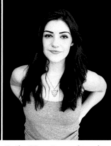

Emily, 23, writer and teacher

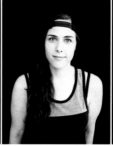

Becca, 22, grad student

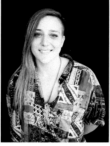

Courtnee, 20, photographer

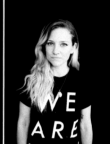

Alli, 26, art director

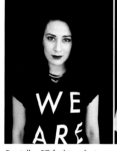

Daniella, 27, fashion designer

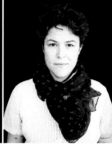

Erin, 34, nonprofit
executive director

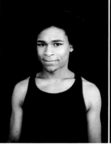

Dakaar, 23, liberal artist

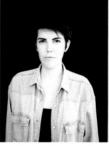

Heather, 29, nonprofit

Emily, 25, sales

Emi, 34, producer

Sebastien, 21

Thomas, 29, bartender

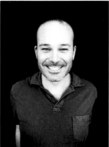

Anthony, 36, VP of
Lotus Productions

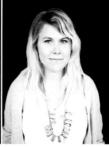

Kristi, 26, hair and
makeup artist

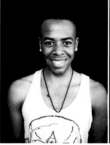

Justin, 22, server

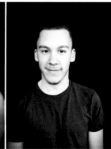

Carlisle, 21, student

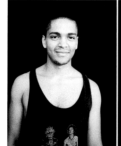

August, 21, server

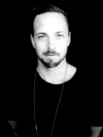

Cole, 27, photographer

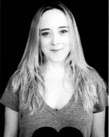

Kate, 31, events director

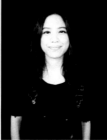

Michelle, 23,
Columbia University

Melissa, 23, production
manager

Awah-Lem, 23, student

Bobbi, 31, reporter and bartender

Zoe, 24, visual designer

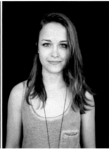
Nicole, 26, electrician

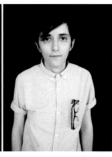
Sivan, 27, news editor

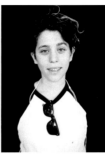
Maya, 24

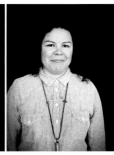
Sheena, 24, digital strategist

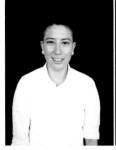
Kenji, 29, graphic design

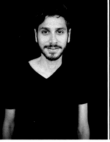
Mike, 31, grant maker

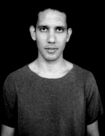
Carlos, 32, researcher

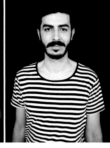
Juan Carlos, 29, architect

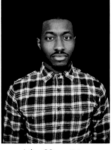
John, 23, musician

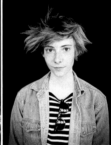
Grace, 18, student

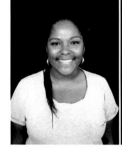
Destinee, 19, student

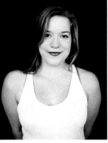
Carrie, 19, student

Barbara, 52, architectural drafter

Stacy, 44, Stonewall

Amber, DJ

Jesaca, 28, photo editor

Pippen, 28, teacher

Jodi, 31, engineer

Dalin, 28, hairstylist

William, 29, stylist

Chelsea, 24, shop assistant

Emily, 22, editorial assistant

Luke, 23, go-getter

Rachel, 30, business owner

Hutch, 25, ad sales manager

ChunkyLover79, 36, studio owner

Lane, 33, lawyer

Bunny, 31, artist

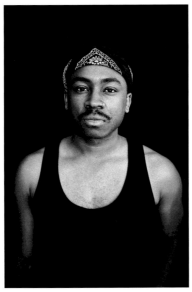

Marcus, 22, photo assistant and photographer

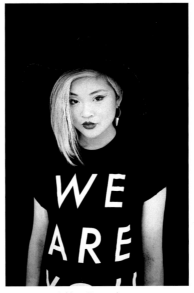

Ashley, 21, visual artist

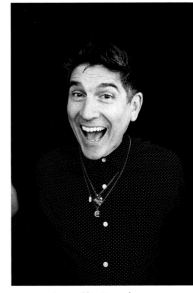

James, 59, writer and actor

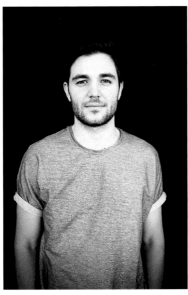

Stuart, 23, cinematographer

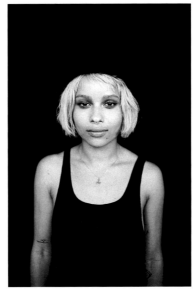

Zoe, 26, actor

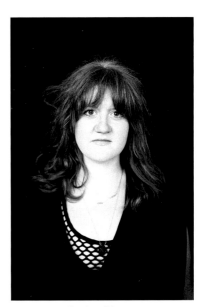

Caroline, 37, agent

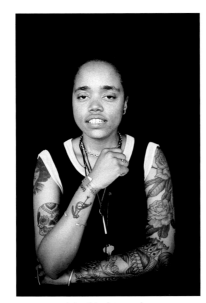

Anita, 26, photographer

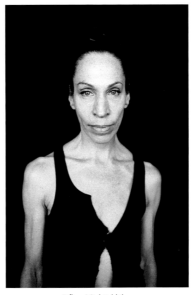

Rifka, 10, hitchhiker

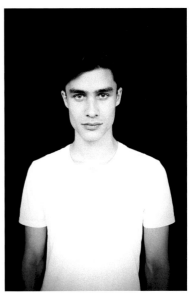

Lucas, 23, model

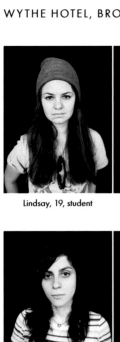

Lindsay, 19, student

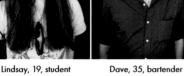

Dave, 35, bartender

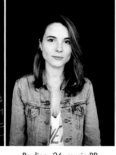

Nimrod, 31, filmmaker

Pauline, 26, music PR

Sandra, 33, multimedia specialist

Davina, 34, chef, bartender, and editor

Sam, 28, waitress

Johanne, 31, city planner and architect

Chauncey, 40, writer

Claire, 36, pastry chef

Amy, 23, personal assistant

Stuart, 53, musician

QiQi, 24, stylist

Anthony, 33, designer

Thomas, 23, host

Chris, 33, restaurant and All:Expanded

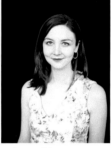

Jessica, 26, receptionist

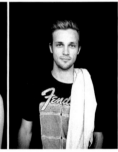

Scott, 28, model and designer

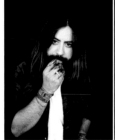

Jakob, 29, hair and makeup artist

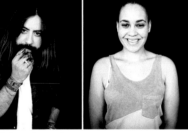

Mariana, 23, accountant

Adrienne, 22, student

Britt, 28, jewelry designer

Duncan, 30, filmmaker

Francesco, 37

Dolce, 29, teacher and student

Summer, 38, project manager and producer

April, 24, camera operator and photographer

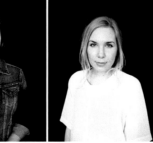
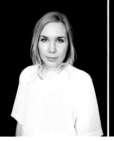

La Martelle, 23, design coordinator

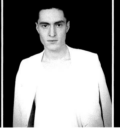

Harrison, 23, musician and designer

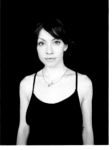

Alwyn, 29, studio manager, DP, and printing

Andreas, 20, stylist

Blake, 20, visual artist

Randi, 27, teacher

Khalid, 23, project manager

Moei, 30, office administrator

Emily, 33, photographer

Brian, 42, cinematographer

Dicapria, 29, artist

Lana, 31, digital imaging specialist

Jay, 37, IT

Jocelyn, 28, tech sales

Bridget, 34, producer

Thaddeus, 35, photo editor

Mel, 38, writer

Layla, 31, agent

Melissa

Andreas, 33, photographer

Eileen, 24, advertising

Brielle, 24, chocolatier

Lindsay, 29, video producer

Joelle, 39, photo archivist and editor

Dash, 25, professional dancer

Napoleon, 26, professional dancer

Adea, 27, professional dancer

Sarah, 28, project manager and music education

Dina, 25, artist, teacher, and healer

Greg, 31, photographer

Duff, 33, fashion designer

Erica, 32, writer

Nikki, 31, graphic designer

247

Sarit, 25, TV producer

Anna, 33, writer and bartender

Devan, 22, model and artist

Kristian, 33, hair and makeup artist

Dwayne, 20, artist

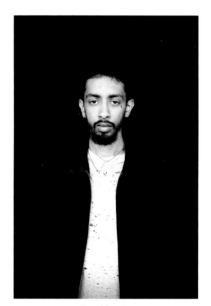

Ling, 22, artist

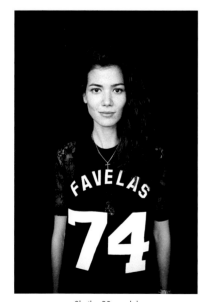

Sheila, 28, model

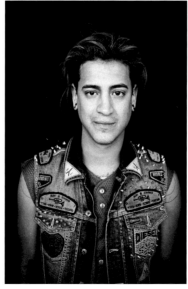

Prince, 26, fashion designer

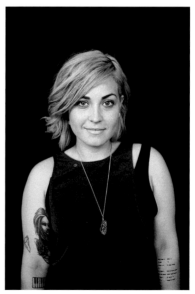

Remy, 26, hairstylist

Sarah, 24, unemployed

Sarah, 23, student

Justin, 34, public affairs

Alex, 28, photography

Melissa, 32, producer

Sarah, 25, teacher

Rebecca, 26, publicist

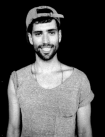
Bekim, 28, do stuff

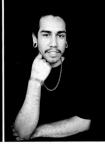
Berto, 22, hairstylist

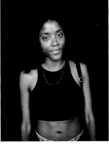
Chach, 22, actor and model

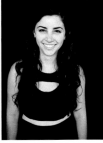
Simone, 23, organizer

Danielle, 22, education

Shay, 23, research assistant

Emery, 31, professional muse

Sarah, 29, writer

Steph, 27, product design

Katrin, 31, director
of events

Abigail, 32, artist

Rebecca, 26, writer

Jennifer, 30, creative
consultant

Morgan, 31, personal trainer

Laetitia, 34, art dealer

Ryan, 32, banking

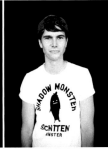
Ashley, 27, producer

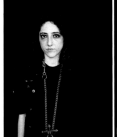
Lexx, 25, architect

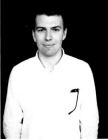
Jordan, 22, architect

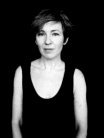
Vanessa, 38, architecture

Andrea, 29, writer and editor

Jane, 28, student

Roberto, 26, tech sales rep

Erica, 24, news

Aswini, 24, business

Mandy, 32, physical therapist

Katherine, 29, advertising

Pam, 30, artist

Natalia, 28, photographer

Nathan, 27, accessory designer

Brittany, 28, TV producer

Nadia, 32, video editor

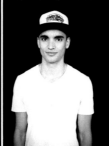

William, 23, painter

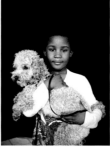

Aidan, 7

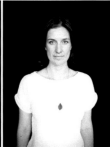

Fiona, 32, photographer

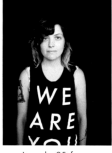

Amanda, 25, farmer

Clemens, 23, designer

Nina, 27, editor and director

Sonia, 33, marketing

David John, 25, sex worker

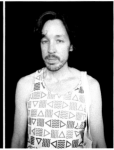

Early, 43, curator and producer

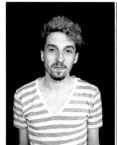

Tait, 24, student

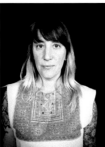

Merryl, 37, landscape

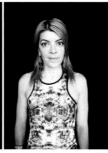

Jene, 35, jewelry designer

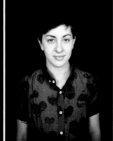

Jenna, 26, nanny

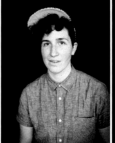

Emma, 28, tech startup executive

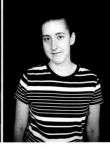

Becky, 25, teacher

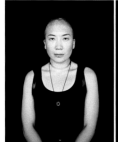

Yan, 28, designer

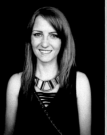

Ellen, 29, events and musician

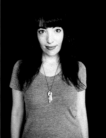

Allison, 30, co-founder of We Are the XX

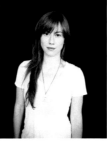

Kassidy, 28, co-founder of We Are the XX

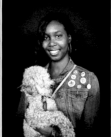

Rheanna, 23, student

Marti, 21, model, hostess, and screenwriter

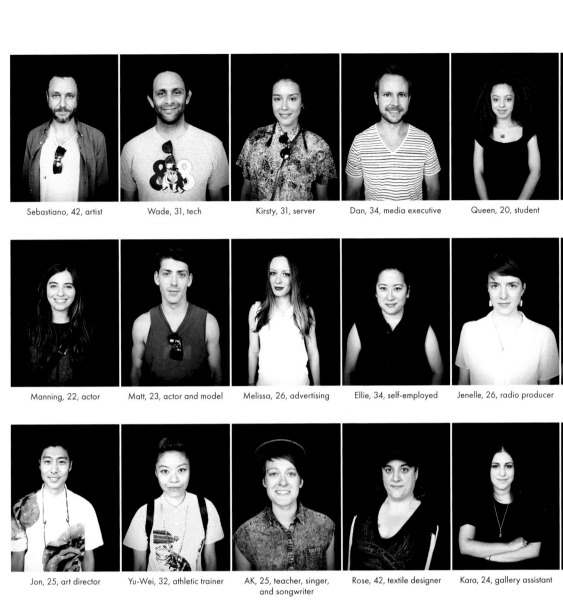

Sebastiano, 42, artist Wade, 31, tech Kirsty, 31, server Dan, 34, media executive Queen, 20, student Andrew, 41, doctor

Manning, 22, actor Matt, 23, actor and model Melissa, 26, advertising Ellie, 34, self-employed Jenelle, 26, radio producer Sam, 32, chef

Jon, 25, art director Yu-Wei, 32, athletic trainer AK, 25, teacher, singer, and songwriter Rose, 42, textile designer Kara, 24, gallery assistant Yolanda, 26, DJ

Katie, 25, bartender and student Mindy, 33, writer Antonia, 27, brand management Monica, 30, creative consultant Ludo, 23, filmmaker Max, 31, artist

Gala, singer, songwriter, and performer Abbey, 26, web designer and visual artist Camilo, 25, visual artist and ethnographer Nicholas, 27 Stuart, 32, journalist Alex, 29, strategist

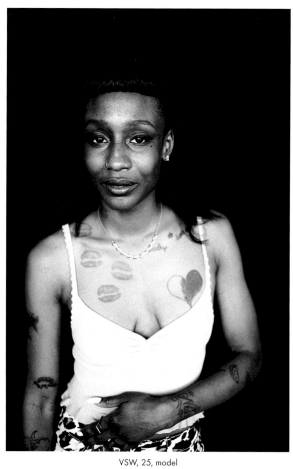

VSW, 25, model

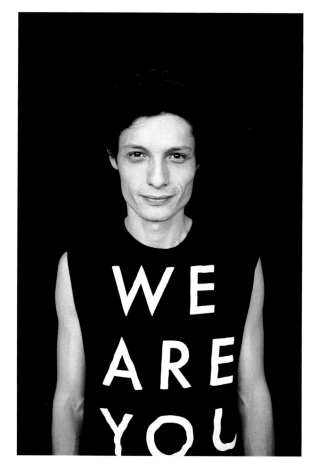

Juan, 27, actor

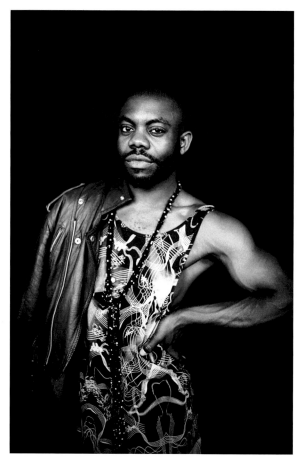

Coco, 30, designer

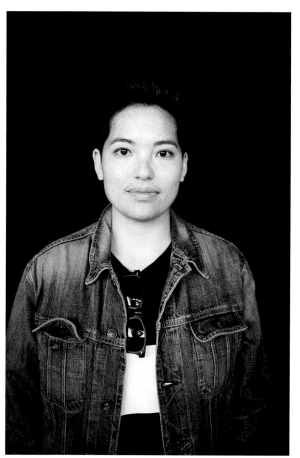

Stephanie, 30, project manager

Riya, 31, artist

Lara, 23, publicist

Laura, 29, performer

Abimbola, 24, musician

Sam, 28, talent producer

Jordan, 27, architect

Maritza, 25, model

Rachelle, 30, fashion
strategist

Alyssa, 19

Alexandra, 28, marketing

Rachel, 22, architect

Alex, 22, shipping
coordinator

Andy, 36, photographer

Maya, 24, AD coordinator

Jessica, 26, leathersmith

Vance, 31

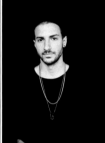

Robert, 26, artist

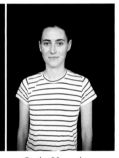

Cecile, 28, producer

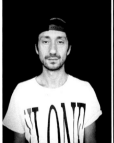

Jimmy, 34, musician

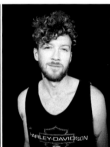

Simon, 26, musician

Diego, 67, curator

WE ARE NO ONE THING,

AND

NOTHING

FOREVER

LONG BEACH PRIDE
LONG BEACH, CA
MAY 19, 2014

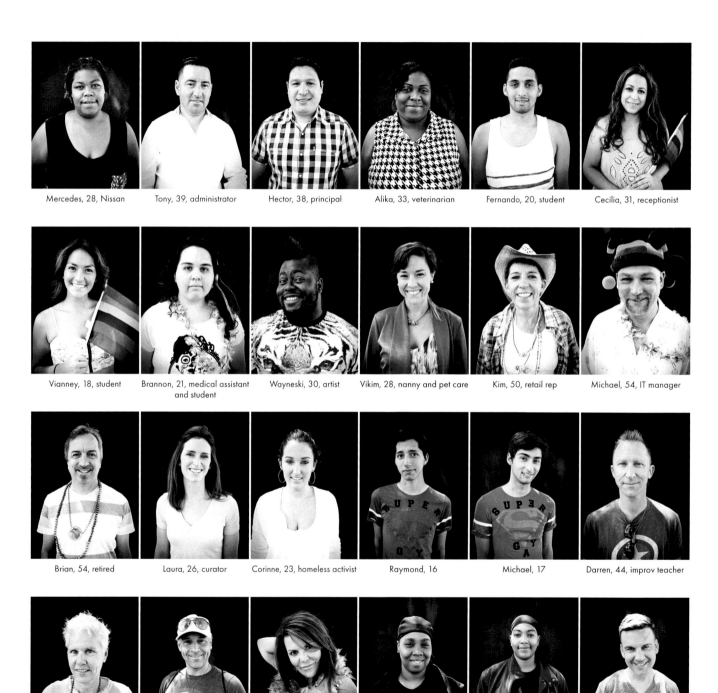

Mercedes, 28, Nissan

Tony, 39, administrator

Hector, 38, principal

Alika, 33, veterinarian

Fernando, 20, student

Cecilia, 31, receptionist

Vianney, 18, student

Brannon, 21, medical assistant and student

Wayneski, 30, artist

Vikim, 28, nanny and pet care

Kim, 50, retail rep

Michael, 54, IT manager

Brian, 54, retired

Laura, 26, curator

Corinne, 23, homeless activist

Raymond, 16

Michael, 17

Darren, 44, improv teacher

Nancy, 53, retired

Scott, 48, personal trainer

Deb, 59, RN and BSN

Kassandra, 28, logistics

Kristina, 25, author

Mark, 38, editorial stylist

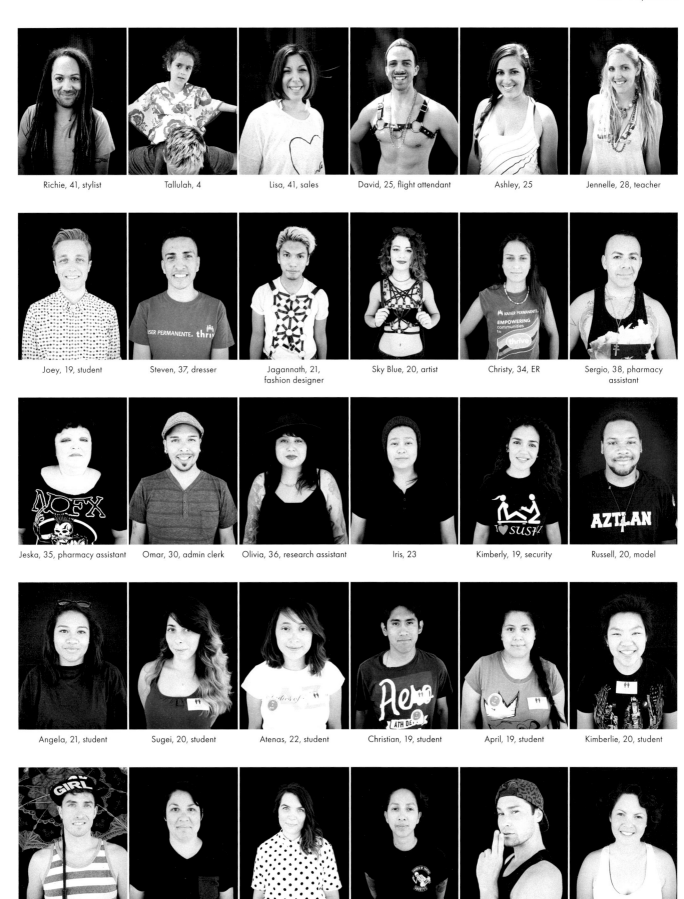

Richie, 41, stylist

Tallulah, 4

Lisa, 41, sales

David, 25, flight attendant

Ashley, 25

Jennelle, 28, teacher

Joey, 19, student

Steven, 37, dresser

Jagannath, 21,
fashion designer

Sky Blue, 20, artist

Christy, 34, ER

Sergio, 38, pharmacy
assistant

Jeska, 35, pharmacy assistant

Omar, 30, admin clerk

Olivia, 36, research assistant

Iris, 23

Kimberly, 19, security

Russell, 20, model

Angela, 21, student

Sugei, 20, student

Atenas, 22, student

Christian, 19, student

April, 19, student

Kimberlie, 20, student

Ross, 30, photographer
and photo editor

Jackie, 30, Trader Joe's

Bella, 21, cosmetology student

Erica, 29, Trader Joe's

Matthew, 31, retail

Jennifer, 26, US Marine

Nicole, 25, student

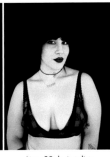

Lisa, 22, hairstylist

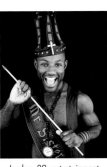

Jordan, 29, entertainment

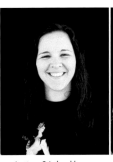

Justine, 26, healthcare

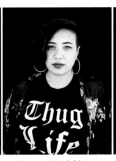

Saraya, 23, childcare provider

Sebastien, 25, core merchandiser

Martha, 26, public outreach

Jasmine, 27, activist and fundraiser

Devonte, 18, assistant

Rae, 22, canvasser

Jessica, 25

Keith, 56, doctor

Roni, 21, actor and singer

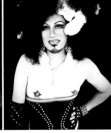

Jules, 36, server

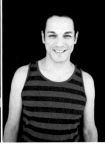

Santiago, 38, manager at Popeyes

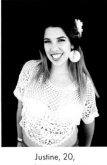

Justine, 20, assistant manager

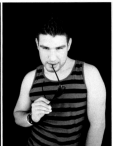

Albert, 28, property manager

Jesse, 24

Daniel, 20, student

Kerrie, 33, AVP

Jay, 30

Blake, 18, creative

Tyler, 21, nursing student

Danny, 23, student

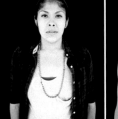

Stephanie, 20, Home Depot

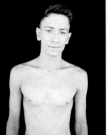

Thomas, 31, aesthetics

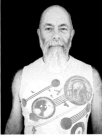

Joel, 52, artist

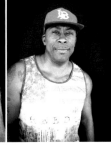

J, 37, sales

Cheyenne, 23, student

Jessi, 27, office administrator

Troy, 37, designer and artist

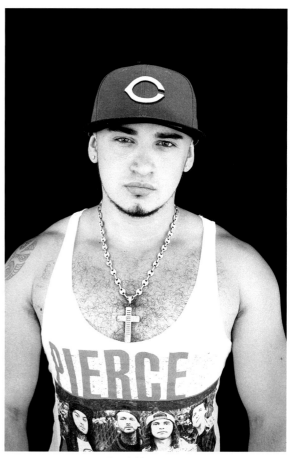

David, 28, engineer

Shawn, 28, tattoo artist

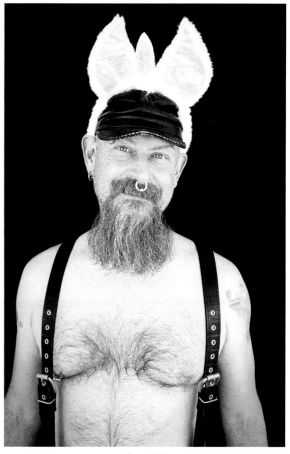

Chris, 47, IT

Robin, 25

Kevin, 28

Annelise, 18, waiter

Cesar

Giovanni, 26, guest services
lead

Sarai, 32, supervisor

Irene, 19, pizza maker

Cierra, 21, florist

Renee, 19

Jade, 25, banker

Kayla, 25, special ed
assistant

Rachael, 20, sales associate

Jason, 25

Leticia, 24, medical billing

Sarah, 17

Valerie, 27, PE department

Vanyce, 28, receptionist

Frankie, 26

Alisa, 24

Vanessa, 21, projectionist

Megan, 20

Monique, 26

Blayne, 23, creative director

Sarah, 22, server
and student

Renee, 19, paramedic student

Daniel, 18, pizza designer
at Little Caesars

Katie, 24, certificate
of analysis coordinator

Amy, 42, management
consultant

Amber, 25, student

Peter, 48, engineer
and actor

Bryan, 18, student

Steve, 67, NASA research director

Jenalyn, 32, engineer

Octavius, 42, fashion designer

Jamal, 43, director and choreographer

Miguel, 46, creative director

Chris, 33, therapist

Christopher, 29, student

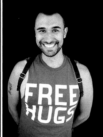

Anthony, 28, designer

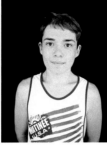

Dustin, 19, student

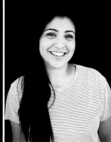

Jess, 21, sales

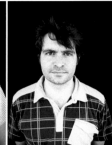

Christopher, 32, engineer

Lia, 24, inventory analysis

EJ, 22

Renee, 21

Jarod, 25, marketing

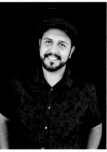

Chris, 26, retail

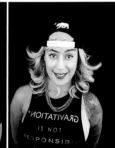

Yan-El, 35, sales manager

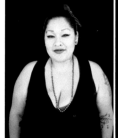

Maria, 30

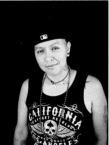

Yene, 33

Darlene, 32, nurse

Renee, 26, insurance

Bre, 21, self-employed

Gerrica, 21, karate instructor

Trayvon, 19, fitness instructor and circus artist

Emily, 19, baker

Miss Green, 23, logistics manager

Breanna, 20, logistics manager

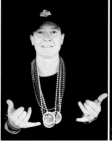

Rose, 49, security

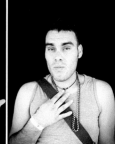

Praxidez, 21

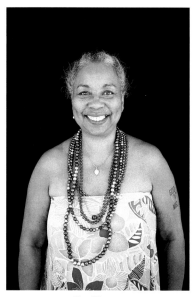

Sky, 57, artist

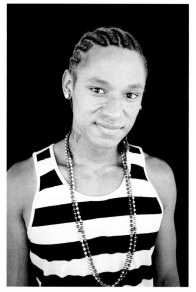

Chaz, 22

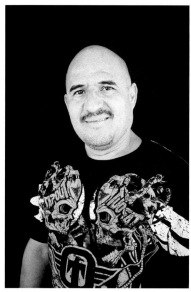

David, 41, GC

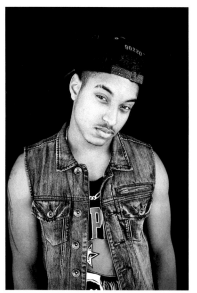

Marquise, 22, FedEx

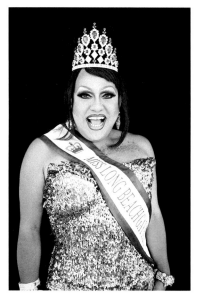

Isha, 32, makeup artist

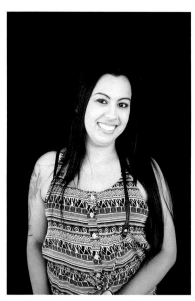

Valerie, 26

Aaron, 42, buyer

Ashton, 28, adult entertainment

Lisa, 24, self-employed

DES MOINES PRIDE
DES MOINES, IA
JUNE 7, 2014

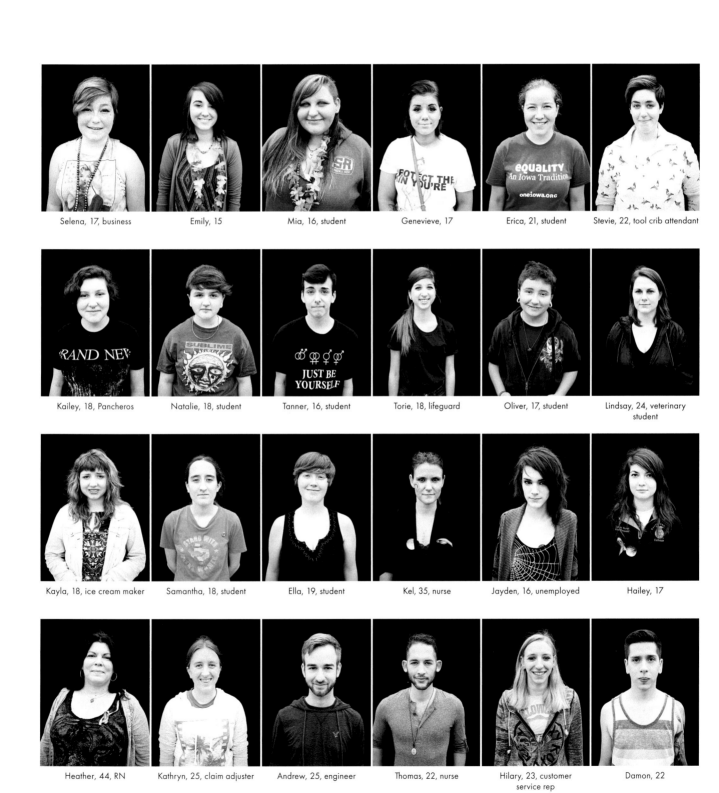

Selena, 17, business

Emily, 15

Mia, 16, student

Genevieve, 17

Erica, 21, student

Stevie, 22, tool crib attendant

Kailey, 18, Pancheros

Natalie, 18, student

Tanner, 16, student

Torie, 18, lifeguard

Oliver, 17, student

Lindsay, 24, veterinary student

Kayla, 18, ice cream maker

Samantha, 18, student

Ella, 19, student

Kel, 35, nurse

Jayden, 16, unemployed

Hailey, 17

Heather, 44, RN

Kathryn, 25, claim adjuster

Andrew, 25, engineer

Thomas, 22, nurse

Hilary, 23, customer service rep

Damon, 22

Chloe, 15

Jeff, 19, student

Dustin, 26, restaurant

Bruce, 48, warehouse

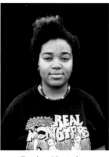
Tyesha, 19, student

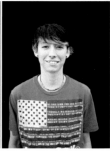
Ashley, 23

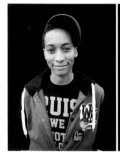
Kelly, 33

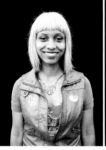
Cece, 31

Erin, 21, student

Marillane, 54, driver

Tosha, 51, trainer

Zack, 24, insurance salesman

Justin, 23, industrial chemist

Andrew, 24, med student

Jen, 44

Kelly, 54, state employed

Ronna

Robin, 55, VA hospital

Chad, 37, IT

Joseph, 35, wireless service tech

Cody, 23, loan adjuster

Toni, 23, supervisor

Tish, 18, customer service manager

Haley, 19

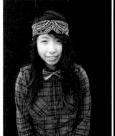
Thuy, 21, student

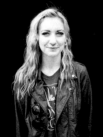
Makaela, 21, retail manager

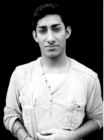
Daniel, 18, student

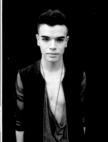
Jose, 19, student

Nicolas, 22, student

Nicholas, 23, makeup artist and hair whisperer

Shay, 18, writer

Sydnie, 43, truck driver

Tiffany, 25, carpentry

Tim, 25, club supervisor

Austin, 25, lead teacher

Emily, 23, transit driver

Jess, 19, student

Brian, 28, bus driver

Delores

Carycia, 23

Krystal, 25, barber

James, 26, sous-chef

Alexandra, 28, sales

Gianna, 24, Gorman's

Graci, 26, loan servicing
specialist

Brent, 28, student

Alee, 24, nurse

KP, 23, chef

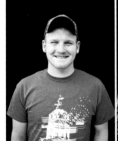

Timothy, 25, waiter

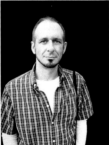

Robb, 39, retail management

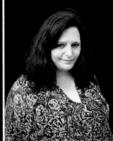

Teri, 45, preschool teacher

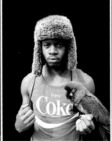

Edwin, 29, retail

Jacob, 24, retail

Kristina, 44, RN

Jonathan, 23, student

Erica, 27, retail

Lindsay, 26, waitress

Zandria, 23, CNA

Sonia, 22, human resources

Timothy, 28, Bed Bath
& Beyond

Crisis, 28, musician

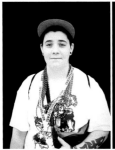

DJ, 22, manager

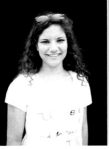

Madeline, 16, waitress

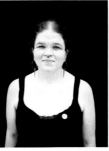

Kiva, 28, stay-at-home mom

Yolandi, 17, student

Twins, 36, picker

Jacob, 26, IT

Scott, 29, accounting

Jim, 53, communications

David, 34, hair and wigs

Andrew, 21, cook

Anna, 21, manager
at Happy Joe's

Colleen, 19, student

Alex, 18, student

Amy, 44, homemaker

Parker, 16

Tarrah, 16

Morgan, 15

Cal, 17, school

Jessica, 15, student

Abi, 18, CNA

Jordan, 27, surveyor

Christopher, 36, computer
engineer

Ashley, 30, hairstylist

Jeremy, 18, student

Jesse, 37, director of
new business operations

David, 58, retired firefighter

Sophia, 21, CNA

Tyler, 20, CNA

Kali, 19, cook at Pizza Hut

Britt-Wang, 23, cashier

Layce, 49, dietary aide

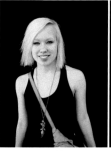

Melissa, 18, office assistant

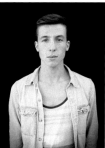

Nick, 19, student

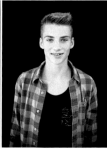

Austin, 18

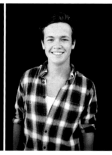

Carter, 18, lifeguard
and student

Amie, 29, internet director
at TV station

Jill, 28, patient care
coordinator

Stephanie, 24

Sam, 19

Sunshine, 21

Thomas, 29, fundraiser

Brigs, 20, cashier

Anna, 16

Cliff, 15

Rae, 27, insurance examiner

Jenna, 18, lifeguard

L'quesha, 18, checker

Jim, 49, motel night auditor

Destiny, 31, teacher

Ray, 55, factory worker

Logun, 20, student

Angie, 24, AmeriCorps
disaster relief

Jason, 23, dancer

Nick, 21, student

Damian, 21, occupations manager

Chassidy, 18, student

Steven, 20, student

Luis, 20, student

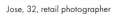
Jose, 32, retail photographer

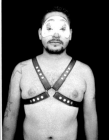
Fernando, 25, retail management

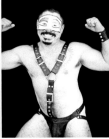
Bartholo, 42, architect

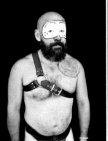
Stinky, 42, floral designer

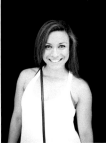
Hedy, 25, personal trainer

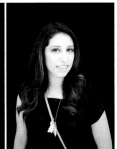
Yessenia, 24, case coordinator

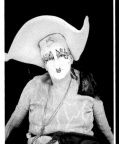

Sister Margaret, 72, retired

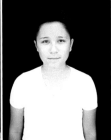
Kyla, 23, student

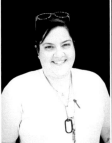
Mia

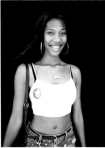
Chelsea, 20, student

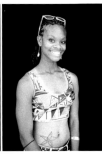
Charity, 23, student

Cherish, 18, student

Mitchell, 35, designer, creative director, and musician

Dominic

Kimberly

Stephanie, 34, freelance photographer

Steven, 53, animal rescue

Toby, 21, student

Josh, 20, sales associate

Phil, 25, engineer intern

Barry, 58

Kevin, 52

Alan, 52

Art, designer

Jackie, 24, café worker

Beauty, 44, raver
and harm reduction

Shawna, 22, vet tech

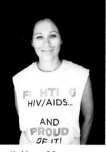

Kathleen, 30, groomer

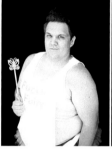

John, 27, server and
bartender

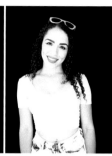

Jaweynn, 21, retail store
manager

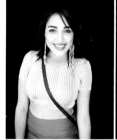

Steph, 25, host

Jackie, 25, TV host

Stephen, 26, retail

Kamesha, 32, physical
therapist

Joselito, 37, retail

Aaliyah, 29

Brian, 27, retail

Jose, 38, therapist

Philip, 23, sales associate

Abel, 24, sales manager

Nicole, 22, assistant

Ashley, 22, transportation

Liz, 23, student

Tyrone, 43, stylist

Toshira, 25, makeup artist

Hannah, 21, student

Jemma, 26

Kay, 34, self-employed

Scylis, 26, agent

Antoinne, 25, server

Cyhesha, 30, MIBC

Kevin, 26, marketer

Andrew, 32, art director

Bri, 24, comedian

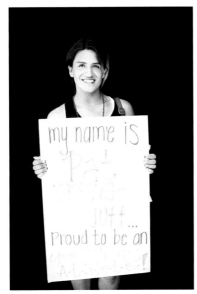

Pat, 18, student

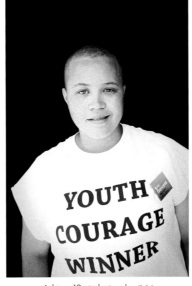

Ashton, 19, student and activist

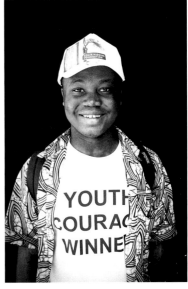

Jacques, 16, activist

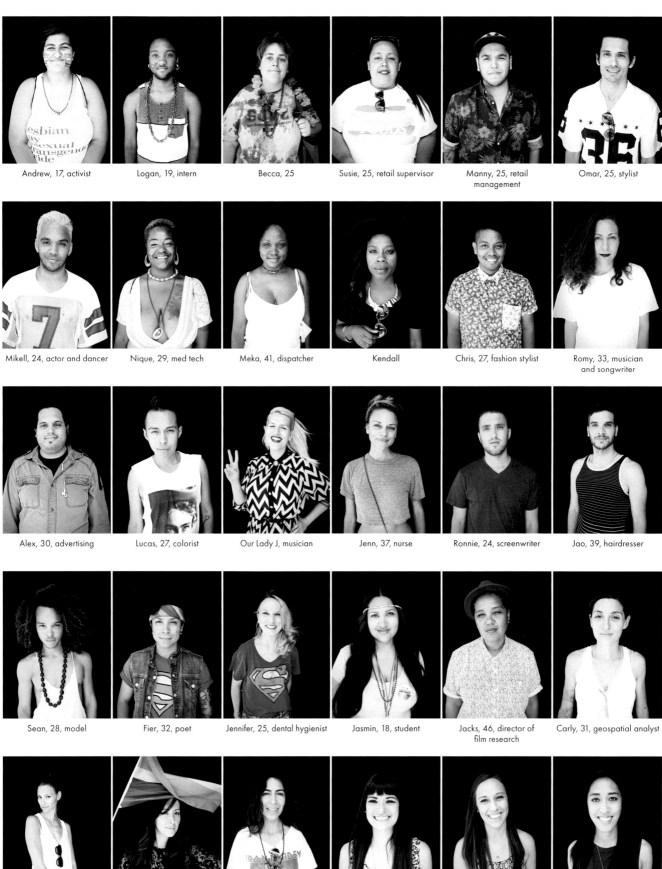

Andrew, 17, activist

Logan, 19, intern

Becca, 25

Susie, 25, retail supervisor

Manny, 25, retail management

Omar, 25, stylist

Mikell, 24, actor and dancer

Nique, 29, med tech

Meka, 41, dispatcher

Kendall

Chris, 27, fashion stylist

Romy, 33, musician and songwriter

Alex, 30, advertising

Lucas, 27, colorist

Our Lady J, musician

Jenn, 37, nurse

Ronnie, 24, screenwriter

Jao, 39, hairdresser

Sean, 28, model

Fier, 32, poet

Jennifer, 25, dental hygienist

Jasmin, 18, student

Jacks, 46, director of film research

Carly, 31, geospatial analyst

Theresa Joy, 31

Felicia, 33, superstar

Michelle, 37, nonprofit

Ashlyn, 26, teacher

Amber, 24, research manager

Rebecca, 25, digital analyst

JUNE 8, 2014

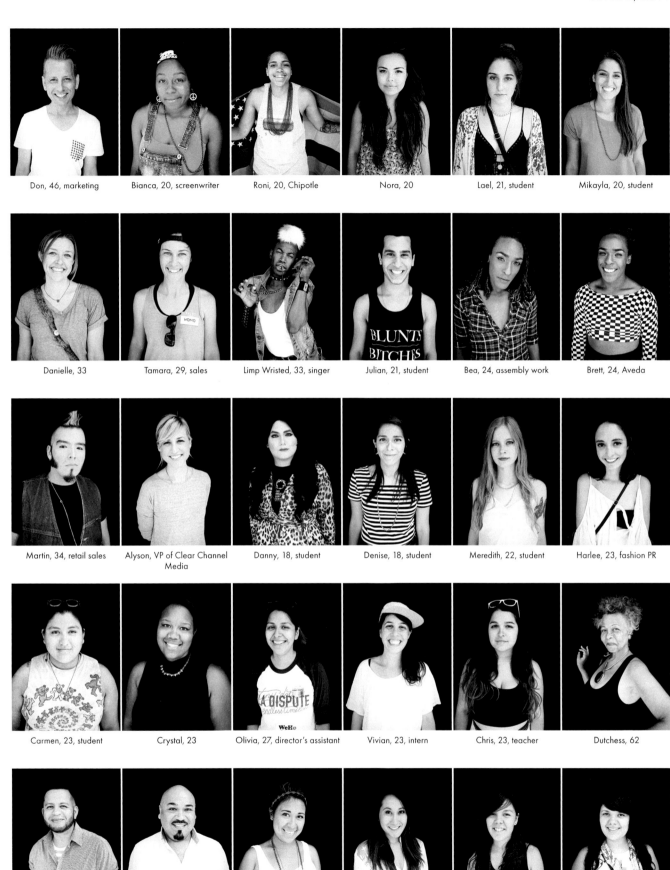

Don, 46, marketing

Bianca, 20, screenwriter

Roni, 20, Chipotle

Nora, 20

Lael, 21, student

Mikayla, 20, student

Danielle, 33

Tamara, 29, sales

Limp Wristed, 33, singer

Julian, 21, student

Bea, 24, assembly work

Brett, 24, Aveda

Martin, 34, retail sales

Alyson, VP of Clear Channel Media

Danny, 18, student

Denise, 18, student

Meredith, 22, student

Harlee, 23, fashion PR

Carmen, 23, student

Crystal, 23

Olivia, 27, director's assistant

Vivian, 23, intern

Chris, 23, teacher

Dutchess, 62

William, 35, lawyer

Oscar, 41, exports

Leana, 23, student

Stephanie, 21, student

Maydaly, 21

Karina, 19

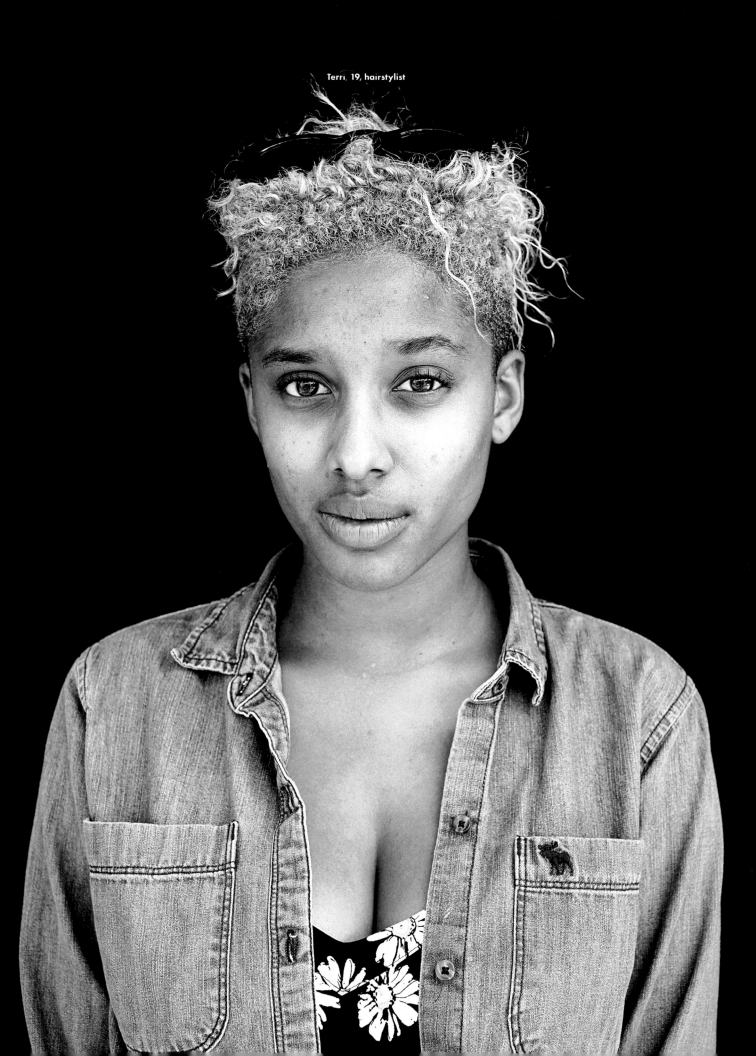

Terri, 19, hairstylist

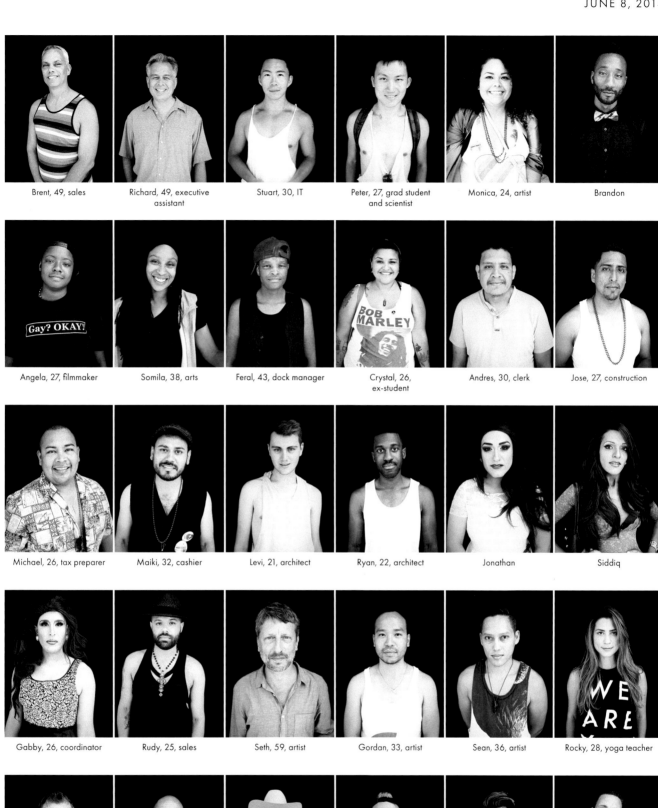

Brent, 49, sales

Richard, 49, executive assistant

Stuart, 30, IT

Peter, 27, grad student and scientist

Monica, 24, artist

Brandon

Angela, 27, filmmaker

Somila, 38, arts

Feral, 43, dock manager

Crystal, 26, ex-student

Andres, 30, clerk

Jose, 27, construction

Michael, 26, tax preparer

Maiki, 32, cashier

Levi, 21, architect

Ryan, 22, architect

Jonathan

Siddiq

Gabby, 26, coordinator

Rudy, 25, sales

Seth, 59, artist

Gordan, 33, artist

Sean, 36, artist

Rocky, 28, yoga teacher

Michael, 56, CEO

Chuck, 76, teacher

Tommy, self-employed

Matty, 25, makeup artist

Rene, 31, makeup artist

Ron, 45, server and bartender

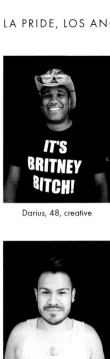

Darius, 48, creative

Dominique, 27, FX

Tiffani, 27, teacher

Jeramy, 26, media planner

Durant, 40, legal

Ricky, 31, office manager

Jose, 31, hairstylist

Thor, 48, self-employed

Max, 27, student and server

Jazmine, 17

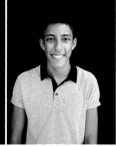

Mina, 18

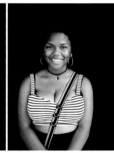

Nia, 17

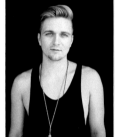

Dalton, 22, retail

Laura, 29, fashion stylist

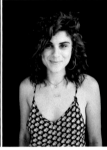

Natalia, 26, merchandiser

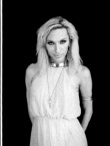

Staley, 28, creative director

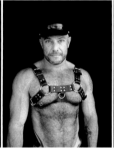

Marc, coach

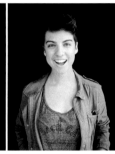

Lauren, 20, student

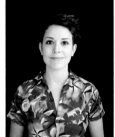

Christin, 21, animator

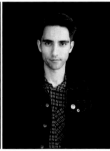

Yutaro, 33, sales clerk

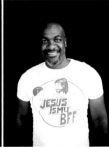

Corey, 37, writer

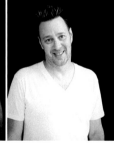

Jim, 51, TV production

Sarah Ann, 29, teacher

Genevieve, 29, coordinator

Jared, 23, production
assistant

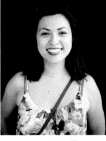

Lorena, 29, office

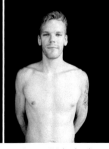

Aaron, 24, barback

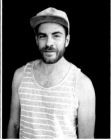

Carlos, 33, furniture design
and fabrication

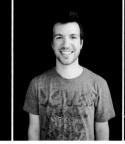

Justin, 24, marketing manager

Steven, 27, admin
support assistant

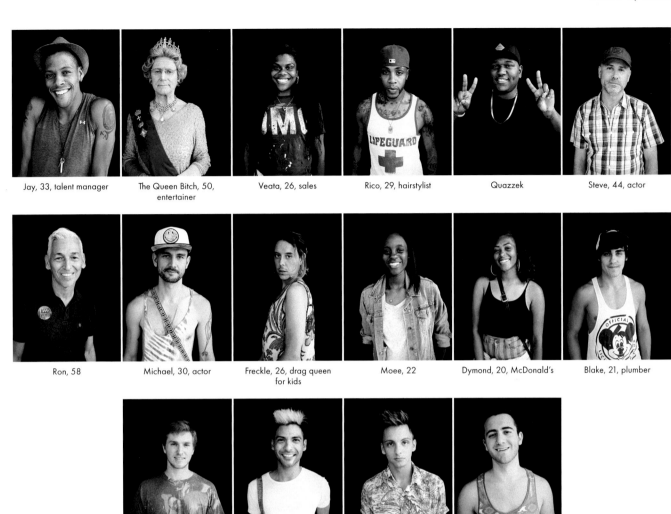

Jay, 33, talent manager

The Queen Bitch, 50, entertainer

Veata, 26, sales

Rico, 29, hairstylist

Quazzek

Steve, 44, actor

Ron, 58

Michael, 30, actor

Freckle, 26, drag queen for kids

Moee, 22

Dymond, 20, McDonald's

Blake, 21, plumber

Bobby, 22, barback

Mario, 25, hairstylist

Trevor, 23, queen

Matthew, 24, retail

NASHVILLE PRIDE

NASHVILLE, TN

JUNE 13, 2014

Little Josh, 22, housekeeper

Caitlyn, 20, self-employed

Stephen, 62, retired

Garry, 60, supervisor

Larry, 50, Department
of Affairs

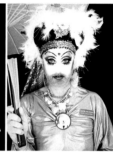

Sister Ann, 49, web editor
and sister

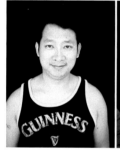

Latte, 36, production

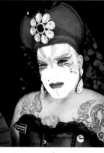

Sister Persefonee, 50,
accountant and sister

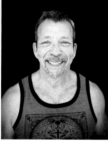

Mark, 51, metal

Chuck, 50, insurance

Nathan, 32, web designer

Daniel, 47, executive
admin assistant

Jason, 36, finance

Greg, 35, teacher

Brittany, 22, McDonald's

Brandon, 32, music director

Rick, 60, self-employed

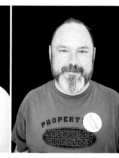

John, 44, charge
management

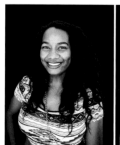

Amie-Lee, 20, hostess

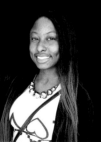

Briosha, 21, hostess

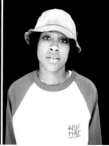

Jeseca, 21, artist management

Jeremy, 29, cytogenics
technologist

Cavalli Boi, 20,
Savannah's Candy Kitchen

Will, 22, videographer
and cashier

Lexi, 18, sales associate

Karli, 18, Old Navy

Arielle, 18

Corbin, 22, engineering

Brendaliz, 43, law enforcement

Kyle, 27, A&P mechanic

Bill, 25, mechanic

Mia, 23, teacher

Ashley, 24, medical assistant

Charles, 30, student

Charles, 30, healthcare

Chuck, 48, producer and host

Claudia, 31

Joseph, 30, State of Tennessee

Simon, 55, marketing director

Brent, 37, marketing

Jackie, 28, restaurant manager

Jill, 26, self-employed

Brendan, 28, hairstylist

Jeremy, 41, designer

Rachel, 22, filmmaker

Gabby, 24, social service worker

Brittany, 21, direct care worker

Jessica, 41, banker

Chantal, 26, hard-working mother

Raven, 25, data analysis

Deanna, 24, Daily's

Nicole, 36, truck driver

Roger, 38, accountant

Brad, 45, manager

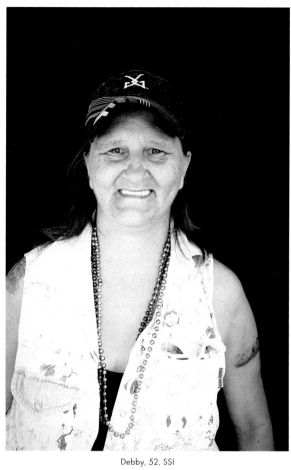

Debby, 52, SSI

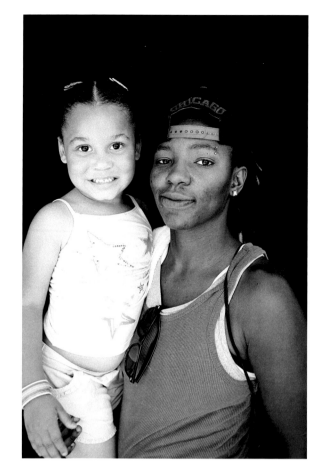

Lo, 36, cook

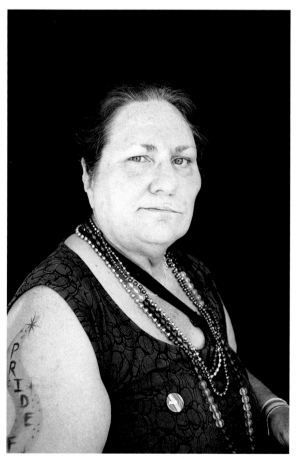

Anita Jo, 62, retired

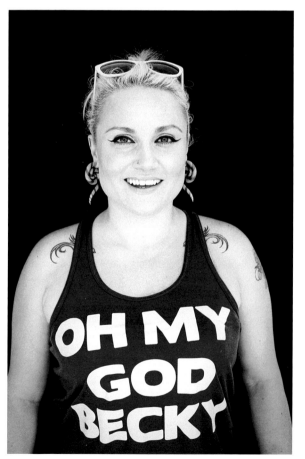

Tai, 34, X-ray technician

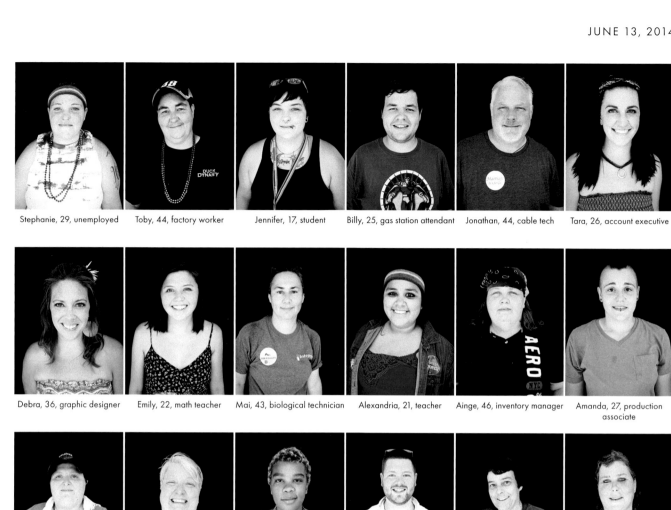

Stephanie, 29, unemployed Toby, 44, factory worker Jennifer, 17, student Billy, 25, gas station attendant Jonathan, 44, cable tech Tara, 26, account executive

Debra, 36, graphic designer Emily, 22, math teacher Mai, 43, biological technician Alexandria, 21, teacher Ainge, 46, inventory manager Amanda, 27, production associate

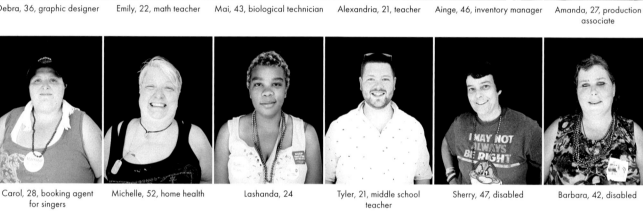

Carol, 28, booking agent for singers Michelle, 52, home health Lashanda, 24 Tyler, 21, middle school teacher Sherry, 47, disabled Barbara, 42, disabled

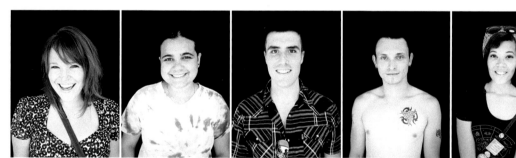
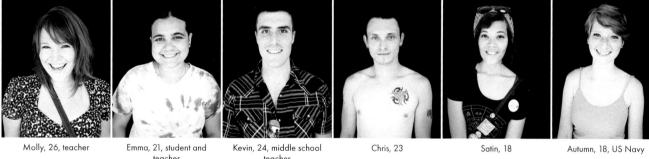

Molly, 26, teacher Emma, 21, student and teacher Kevin, 24, middle school teacher Chris, 23 Satin, 18 Autumn, 18, US Navy

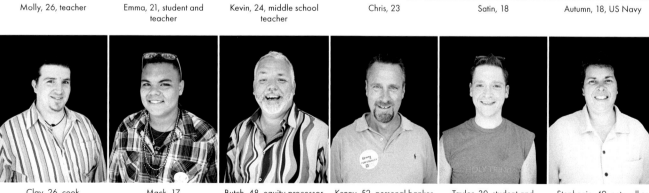

Clay, 26, cook Mack, 17 Butch, 48, equity processor Kenny, 52, personal banker Taylor, 30, student and barista Stephanie, 49, pet walker

Hayden, 22, food truck owner

Madelyn, info tech

Melissa, 19, student

Chukki, 53, personal trainer
and songwriter

Wendy, 43, marketing

Erika, 26, food service

Lauren, 22, admin worker

Christine, 25, dishwasher

Lexie, 22, underwriter

Kate, 25, insurance

Karla, 27, marketing
accountant manager

Janelle, 18

Julie, 48, shopping

Lisa, 47, art and photography
teacher

Erica Jo, 26, sales

Greta, 47, claims adjuster

Cynthia, 42, driver

Heather, 41, designer

Sam, 27, photographer

Princess, 17, Papa John's

Trenton, 32, graphic design

Brandan, 26, violin shop
owner

Audrey, 37,
pharmaceutical rep

Caroline, 25, retail

Mick, 31, X-ray technician

Rupie, 28, music promotion

Cynthia, 51, attorney

Rick, 40, operations lead

Alyssa Rose, 18

LP, 26, sales associate

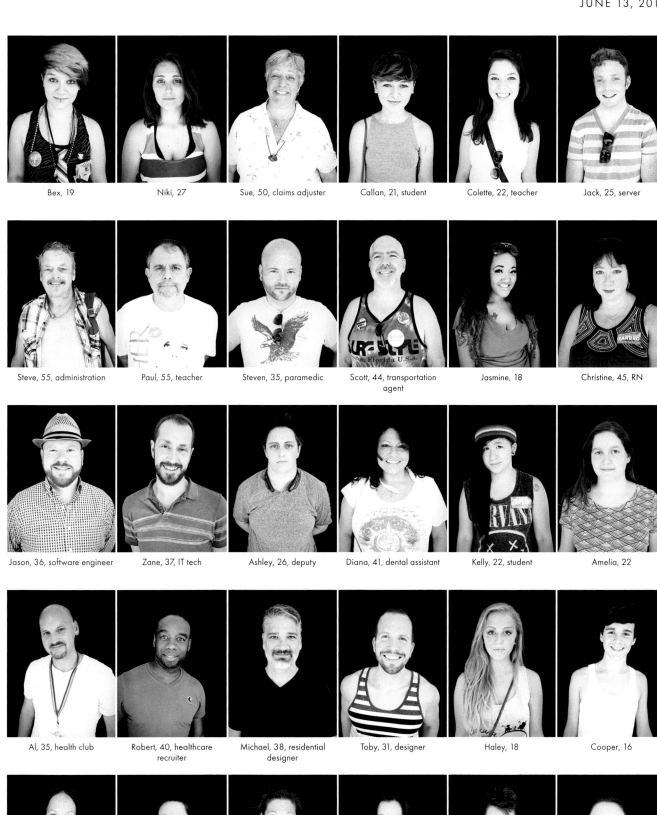

Bex, 19 Niki, 27 Sue, 50, claims adjuster Callan, 21, student Colette, 22, teacher Jack, 25, server

Steve, 55, administration Paul, 55, teacher Steven, 35, paramedic Scott, 44, transportation agent Jasmine, 18 Christine, 45, RN

Jason, 36, software engineer Zane, 37, IT tech Ashley, 26, deputy Diana, 41, dental assistant Kelly, 22, student Amelia, 22

Al, 35, health club Robert, 40, healthcare recruiter Michael, 38, residential designer Toby, 31, designer Haley, 18 Cooper, 16

 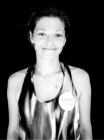 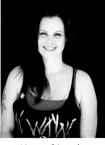 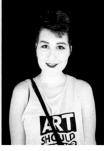 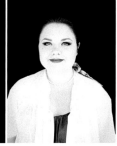

April, 33, stay-at-home mom Ashley, 24, middle and high school teacher Candie, 36 Megan, 26, student Maddie, 18, artist Courtney, 18, student

Kayla, 15

Morganne, 15

Abbey, 15

Shelby, 15

David, 19, landscape

Ty, 23

Joel, 42, healthcare
administration

Crystal, 37, asset protection

Patricia, 34, social work

Heather Nicole, 25, aircraft
mechanic

Denetria, 28, retail associate

Shaquille, 22, salesperson

Kristyne, 24, Amazon

Alyssa, 15, student

Jamie, 27, makeup artist

Whittley, 26, makeup artist

Josh, 17, stay-at-home

Chelsea, 16, student

Heather, 35, loan
servicing rep

Taylor, 24

Jocelyn, 25, student

Nick, 21, college student

Dustin, 20, server and sales
associate

Gia, 23, student

Yasmina, 25, photographer

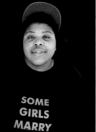

Drea, 24, PSS

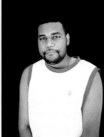

Michael

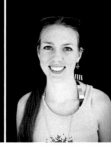

Judy, 28, teacher

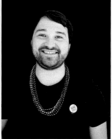

Devin, 22, IT consultant

Lu, 23, factory worker

Michelle, 48, factory worker

Tania, 40, self-employed

Sully, 42, barber

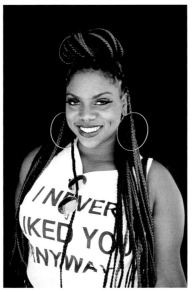

Brittany, 19

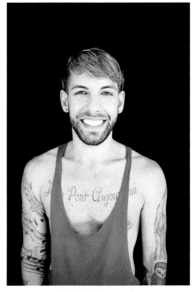

Caleb, 24, housewife

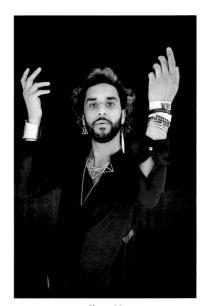

Chato, 28

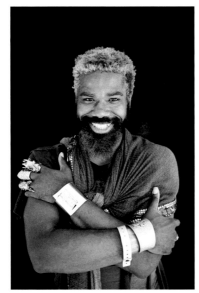

Phoenix Wisdom, 25, retired

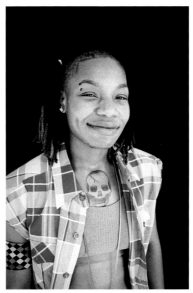

Christine, 28, server

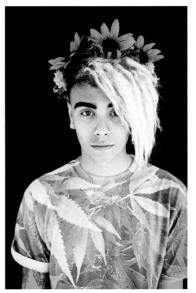

Javon, 18, cashier

Whitney, 22

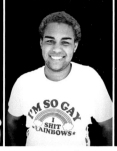

Trent, 19, student

Jade, 27, picker

Tahlia, 27, host and prep
at Hyde

Adrienne, 24, supply chain
analyst

Madeline, 20, student

Santiago, 23

Brandon, 25, general
manager

DeAndre, 26, tech

L, 19, host

Kelsey, 23, art historian

Sara, 22, student

Nicole, 31, US Army

Dazmine, 21

Nikki, 15

Jalen, 19, student

Caroline, 35, secretary

Gin, 43, pre-K teacher

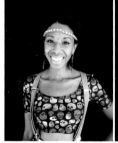

Timmery, 32, fashion show
producer

Darrius, 24, infrastructure
mobile support analyst

Malina, 33,
stay-at-home mom

Iris, 44, administration
assistant

Kayla, 22, Title III
programming assistant

Jessie, 31, security officer

BALTIMORE PRIDE
BALTIMORE, MD
JUNE 14, 2014

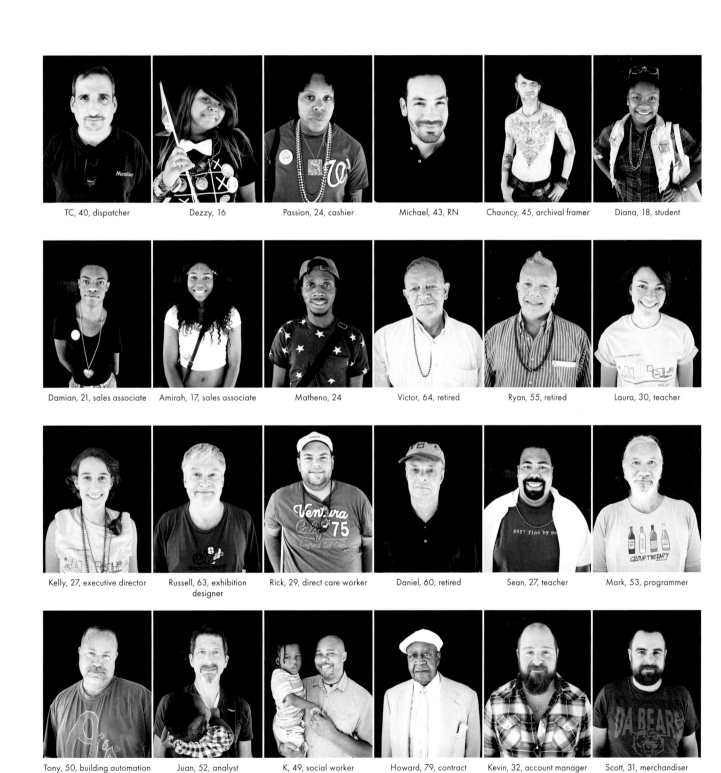

TC, 40, dispatcher

Dezzy, 16

Passion, 24, cashier

Michael, 43, RN

Chauncy, 45, archival framer

Diana, 18, student

Damian, 21, sales associate

Amirah, 17, sales associate

Matheno, 24

Victor, 64, retired

Ryan, 55, retired

Laura, 30, teacher

Kelly, 27, executive director

Russell, 63, exhibition designer

Rick, 29, direct care worker

Daniel, 60, retired

Sean, 27, teacher

Mark, 53, programmer

Tony, 50, building automation system operator

Juan, 52, analyst

K, 49, social worker

Howard, 79, contract administrator

Kevin, 32, account manager

Scott, 31, merchandiser

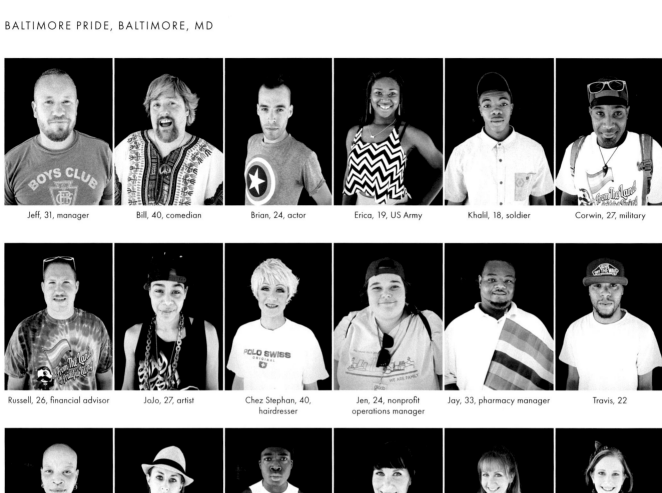

Jeff, 31, manager

Bill, 40, comedian

Brian, 24, actor

Erica, 19, US Army

Khalil, 18, soldier

Corwin, 27, military

Russell, 26, financial advisor

JoJo, 27, artist

Chez Stephan, 40, hairdresser

Jen, 24, nonprofit operations manager

Jay, 33, pharmacy manager

Travis, 22

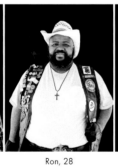
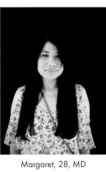
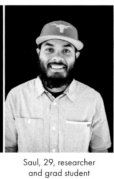
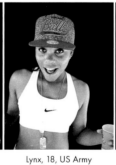

Cat, 41, jewelry designer

Mallory, 26, bartender

Micah, 19, designer

Jessica, 28, actress

Cathy, 28, actress

Jackie, 29, receptionist

Harry, 60, disabled

Ron, 28

Margaret, 28, MD

Saul, 29, researcher and grad student

Lynx, 18, US Army

Samantha, 22, US Army

Becca, 21, social work

Litta, 21, student

Kaila, 23, student

Ty, 23, student

Lincoln, 57

Kyle, 28, substitute teacher, actor, and playwright

Alexander, 21, student

Rahn, 20, self-employed painter

Al, 53, bartender

Mariah, 21, military

Stephanie, 24, Cosmos

Jess, 31, Sherwin-Williams manager

Kevin, 49

Tod, 48, executive assistant

Vanessa, 57, retired

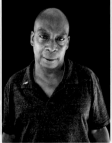

Gregory, 59

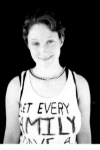

Maura, 18

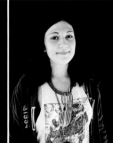

Madison, 14

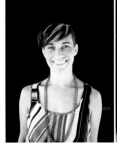

Julia, 24, nanny

Ricky, 50, receptionist

Amanda, 21, retail

Sarah, 26, retail

Renee, 37, social work

Kevin, 50, retired

Sonny, 50, addiction counselor

Jessica, 29

Dan, 28, HIV educator

Gigi, 22, student

Ashley, 23, clinical assistant

Cassie, 22, student

Kathy, 22, federal auditor

Sarah, 29, case management

Jennifer, 29, student and author

Kevin, 28, unemployed

Matthew, 55, unemployed

Jessi, 33, EMS

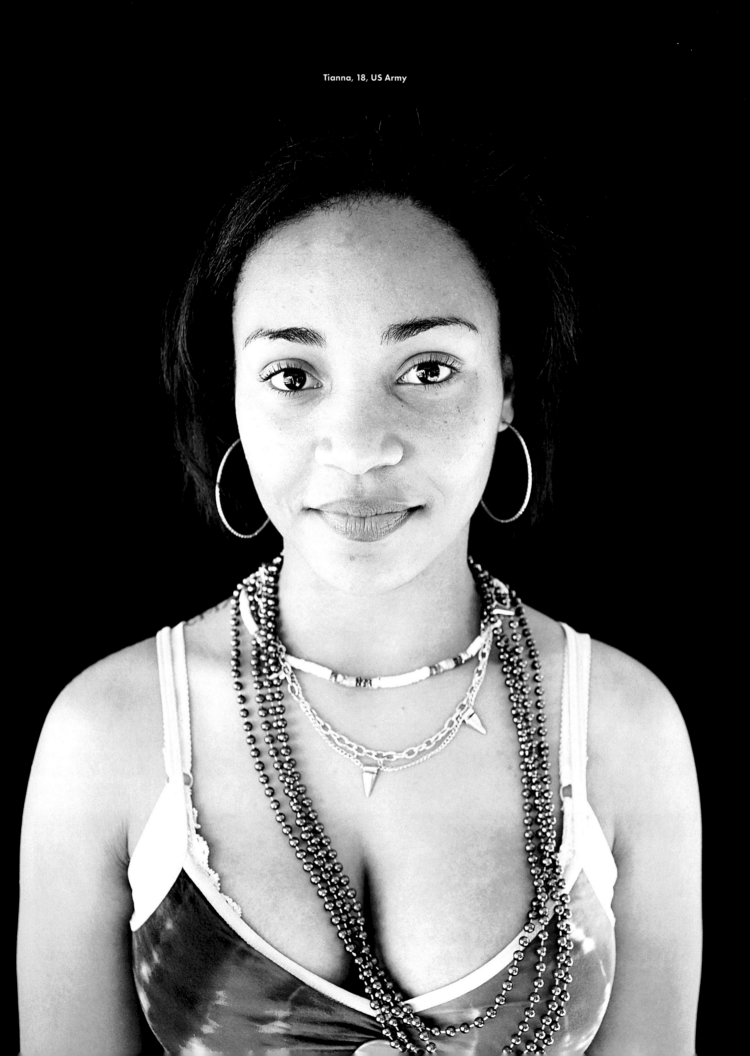

Tianna, 18, US Army

Ducky, 29, research coordinator

Tiffany, 37, labor

Avery, 20, student

Sara, 21, student

Jada, 19, student

Mandyjo, 35, sterile tech

Virginia, 32, military

Erick, 16, student

Nequa, 17, student

Justin, 17, student

Phoenix, 29, CMA

Jy, 25, corrections officer

Shannon, 33, musician

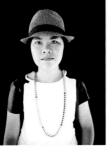

Onoh, 24

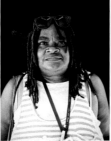

Susan, 63, artist

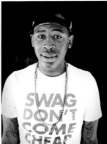

Mannie, 19, warehouse

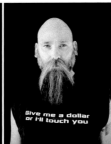

Sage, 49

Brian, 44, investment banker

Pierie, 21, biomedical engineer

Josh, 30, audiovisual technician

Matt, 28, electrical engineer

Jazmin, 23, nanny

John, 45, computer support

Rennie, 44, cabinetmaker

Nicole, 31, grant writing consultation

Sharon, 29, waitress

Ryan, 24, student

Shantyl, 42, manager

Shane, 22, self-employed

Nick, 23, teacher

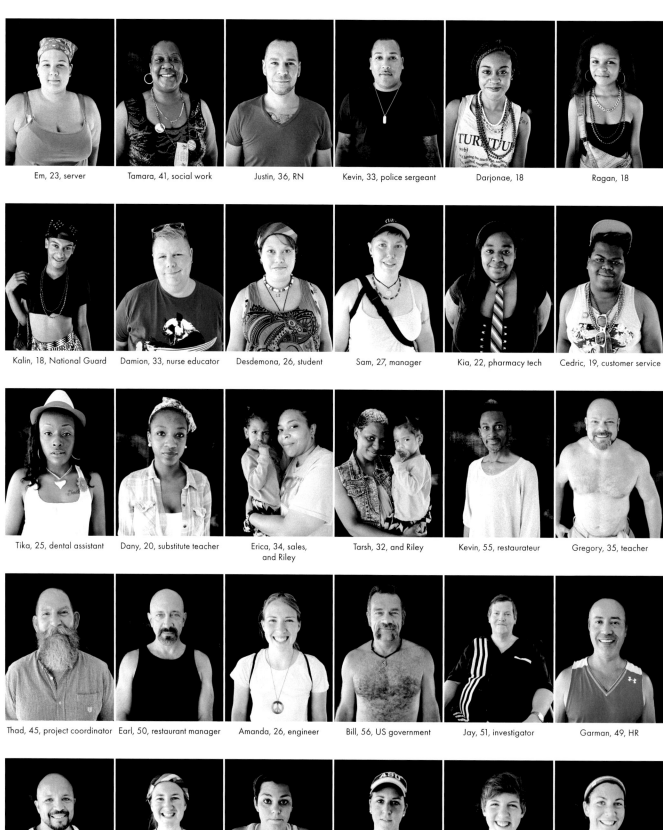

Em, 23, server | Tamara, 41, social work | Justin, 36, RN | Kevin, 33, police sergeant | Darjonae, 18 | Ragan, 18

Kalin, 18, National Guard | Damion, 33, nurse educator | Desdemona, 26, student | Sam, 27, manager | Kia, 22, pharmacy tech | Cedric, 19, customer service

Tika, 25, dental assistant | Dany, 20, substitute teacher | Erica, 34, sales, and Riley | Tarsh, 32, and Riley | Kevin, 55, restaurateur | Gregory, 35, teacher

Thad, 45, project coordinator | Earl, 50, restaurant manager | Amanda, 26, engineer | Bill, 56, US government | Jay, 51, investigator | Garman, 49, HR

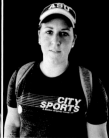

Bae, 44, HR | Sara, 27, environmental scientist | Kristen, 24, teacher | Nikki, 25, claims adjuster | Heather, 30, IT | Caitlin, 29, director of a Baltimore city school

Rob, 35, IT software consultant

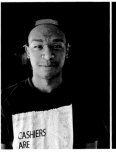
Aaron, 18, retail

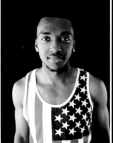
Kevin, 25, finance

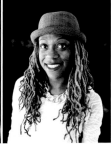
Nia, 26, teacher

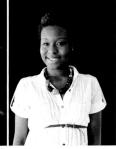
Kelsie, 23, investigator

Margaret, 18

Shari, 26, customer service rep

Malaika, 23

Deonya, 21

Alyssa, 21, student

Karli, 19, student

Taylor, 20, artist

Bryan, 19, artist

Jahniqua, 24, trainer

Machaela, 20, student

Tyrone, 53, colorist

Julie, 47, CEO

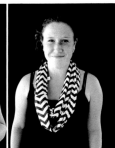
Mitzi, 16, student

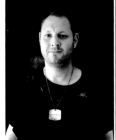
Andrew, 31, student

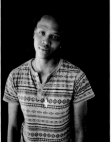
April, 28, FedEx package handler

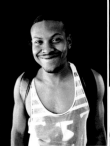
Mike, 25, Starbucks

Mike, 28

Challis, 32, hairstylist

Brazil, 31, concierge

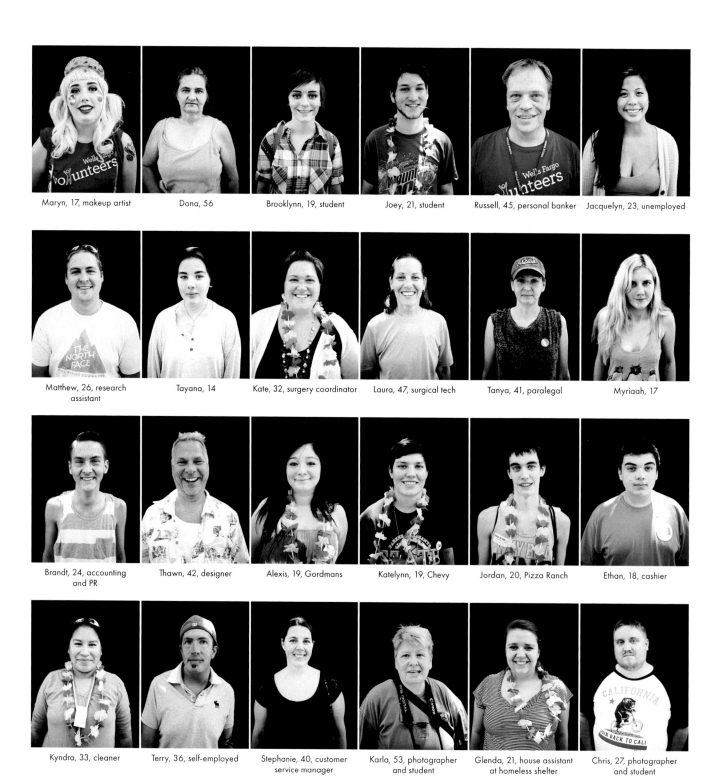

Maryn, 17, makeup artist

Dona, 56

Brooklynn, 19, student

Joey, 21, student

Russell, 45, personal banker

Jacquelyn, 23, unemployed

Matthew, 26, research assistant

Tayana, 14

Kate, 32, surgery coordinator

Laura, 47, surgical tech

Tanya, 41, paralegal

Myriaah, 17

Brandt, 24, accounting and PR

Thawn, 42, designer

Alexis, 19, Gordmans

Katelynn, 19, Chevy

Jordan, 20, Pizza Ranch

Ethan, 18, cashier

Kyndra, 33, cleaner

Terry, 36, self-employed

Stephanie, 40, customer service manager

Karla, 53, photographer and student

Glenda, 21, house assistant at homeless shelter

Chris, 27, photographer and student

Keara, 13

Becca, 19, retail

Josh, 17, student

Sarah, 17, student

Sammy, 14

Kristina, 18

Nicky, 16

Kristine, 21

Dakota, 18

Caelan, 16, community
volunteer

Carly, 18

Brian, 50, CNA

Dustin, 38, library technician

Aaron, 30, cheesemonger

Dan, 55

Sherry, 32, account
investigator

Jennifer, 31, Citibank

Rhonda, 46, underwriter

Christine, 54, retail

Terri Lynn, 53,
warehouse manager

Jason, 37, quality specialist

George, 55, customer
service rep

Mel, 64, social work

Kaitlyn, 21, factory worker

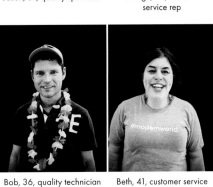

Amber, 20, factory

AJ, 29, horse trainer

Bob, 36, quality technician

Beth, 41, customer service

Jean, 59, customer service

Miriah, 31

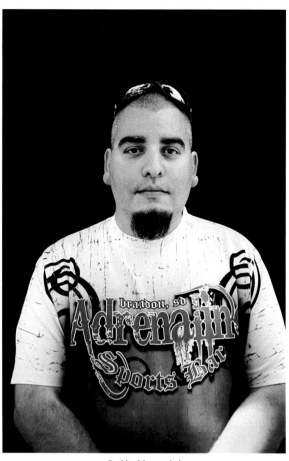

Gaddy, 30, gas clerk

Mya, 23, housekeeper

Giselle, 20, cosmetologist

Dale, 24, game developer

Megan, 29, personal assistant

Len, 20, artist

Tyler, 16, student

Dirk, 18, professor of rainbows

Alexis, 16, student

Brandon, 20, Hy-Vee

Nixxi, 17, student

Jamie, 24, CNC laser operator

Samantha, 20, robot operator

Nebu, 21, student

Joseph, 27

Preston, 36, bookkeeper

Kelley, 23, sales

Justin, 28, truck driver

Shane, 28, childcare provider

Shannon, 23, restaurant manager

Justin, 33, marketing

Jacob, 28, lawyer

Chris, 32, Federal Reserve Bank

Aaron, 39, assistant manager

Christopher, 30, training consultant

Alex, 29, lawyer

Ken, 48, dietitian

Joshua, 29, attorney

Andy, 25, teacher

Jayden, 44, clinical research manager

James, 38, sales

Ty, 23, financial advisor

Jenna, 21, student

Jacob, 19, collector

Justin, 25, architectural
designer

LaShay, 44, CNA
medical aide

James, 28

Sarah, 31, teacher

Kim, 25, education

Dennis, 61, customer service

Paul, 48, customer service

Jazmin, 24, bank teller

Nichole, 34, in-home care

Kay, 15, barista

Dylan, 22, fabricator

Kaitlin, 18, student

Brady, 16, student

Jake, 16, pizza maker

Zachary, 14, student

Deb, 44, manager

John, 28, disabled

Cole, 22, assembly

Samantha, 26, hospitality

Codey, 23,
software engineer

Amy, 30,
massage therapist

Sean, 30,
state employed

Becky, 30,
higher education

Chad, 32,
graphic designer

Pamela, 64, psychologist

Todd, 35, tech

Rony, 20, SAP tech

Thomas, 26, art director

Patrick, 34

Sarah, 29

Joey, 30, tech support

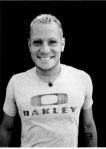
Nathan, 28, server

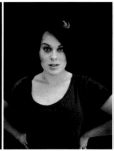
Elle, 24, advertising

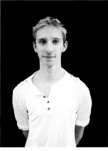
Charles, 20, entrepreneur

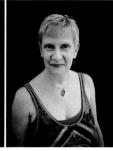
Gaye, 53, advertising

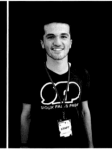
Adam, 20, Pier 1

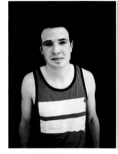
Jeff, 22, bartender

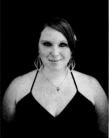
Cassandra, 28, army wife

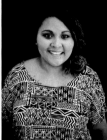
Mikayla, 19, daycare provider

Kathy, 43, healthcare management

Renee, 48, medical

Wayne, 29, surgical tech

Siggy, 45

Danielle, 22, student

Scott, 51, planner

Kaden, 11, student

Kim, 36, homemaker

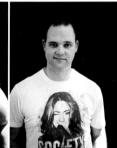
Chad, 28, customer service coordinator

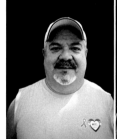
Terence, 57, collections

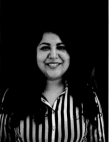
Gracie, 22, student

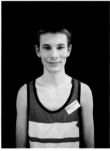
Logan, 19, server

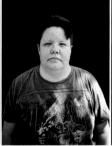
Victoria, 41, call center

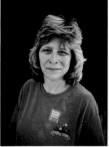
Melanie, 46, scientist

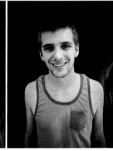
Tyler, 21, student

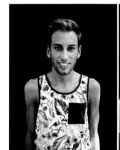
Jerome, 24, Showplace Wood Productions

David, 22, software developer

Charline, 39, nurse

Trish, 32

Bri, 19, McDonald's

Kristen, 21, fast food

Tera, 41, disabled

Elizabeth, 45, production worker

Marisa, 15

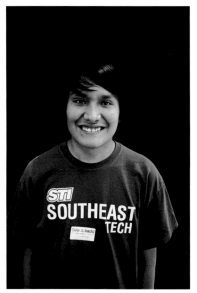

Charlie, 16

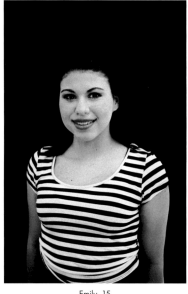

Emily, 15

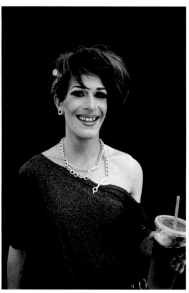

Porscha, 27, cosmetologist

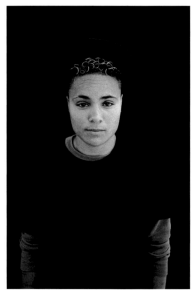

Danitra, 21, self-employed

Katie, 20, sales associate

Lawrence, 66, retired

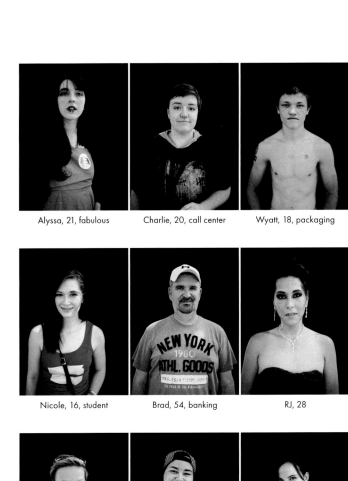

Alyssa, 21, fabulous

Charlie, 20, call center

Wyatt, 18, packaging

Dana, 18, invasive cardiologist

Kiya, 18, nursing

Danielle, 16, student

Nicole, 16, student

Brad, 54, banking

RJ, 28

Ashley, 18, writer

Tigger, 20, student

Becky, 30, retention

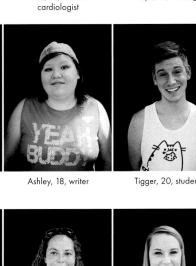

Brooke, 26, dental assistant

Brittany, 24, teacher

Meredith, 24, retail sales consultant

Nicole, 36, tech support

Kesha, 17, hostess

Kacie, 25, financial analyst

Sean, 43, schedule coordinator

Anthony, 33, manager

Nikki, 23, Wells Fargo

Stacy, 32, chef

Tiffany, 14, student

Doug, 34, tech

GR, 21, student

Jen, 38, manager

Noah, 7, kid

Raeann, 25, clinical research

Tarah, 28, accountant

Kylie, 23, welder

Adrielle, 23, research assistant

Kashala, 23, phlebotomist

Dana, 30, nurse

Amber, 25, property manager

Justin, 32, registered nurse

Crystal, 47, residential assistant

Heather, 27, banker

Amy, 34, manufacturing

Joshua, 43, sales manager

Darla, 51, library EA

Amanda, 32, RN

Michael, 32, professor

Tabitha, 30, assistant manager

Sandra, 50, safety coordinator

Jodie, 39, internal control analyst

Brooklyn, 28

D, 19, barista

Kristy, 48, motor carrier inspector

Steph, 48, truck driver

Kaila, 28

Maddie, 17, server

Kelsi, 19, waitress

Nick, 23, fraud investigator

Lauren, 24, production

Purgo, 19, cashier

Davie, 25, retail

Brett, 23, geneticist

Jennifer, 32, ACLU

Tai, 29, pharmacy tech

Samuel, 27, photographer

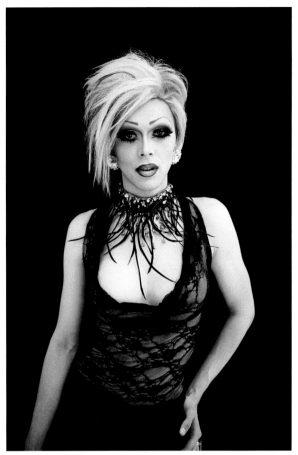

Ryan, 25, drag

Stephanie, 27, sander

Parker, 14, student

Yvonne, 53, construction

SIOUX FALLS PRIDE, SIOUX FALLS, SD

Eric, 31, agriculture

Kristina, 33, retail management

Wanda, 48, bar manager

Billy, 35, catering manager

Calita, 25, corrections officer

Amber Rose, 16, student

Sarah, 33

Vickie, 49, machine operator

Julie, 48, production associate

Makayla, 17, server at Holiday Inn

Shalina, 10

Val, 49, labor

Brad, 52, graphic designer

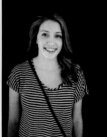

Amanda, 15

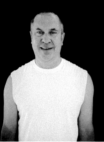
Michael, 45, owner and manager

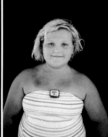
Katy, 11, student

Cassidy, 18, student

Allison, 18, student

Christine, 43, Curves

Alexis, 40, IT

Shaye, 30, bookkeeping assistant

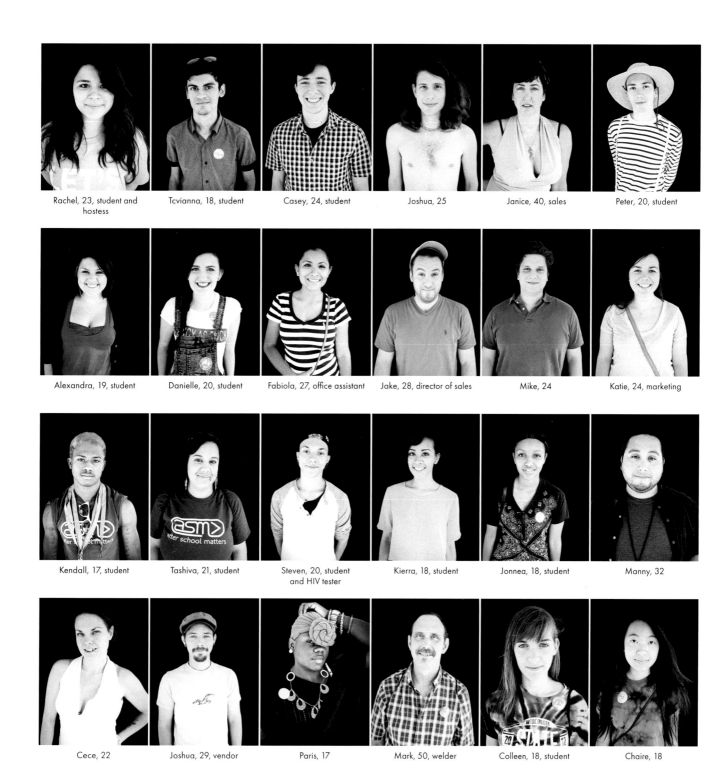

Rachel, 23, student and hostess

Tcvianna, 18, student

Casey, 24, student

Joshua, 25

Janice, 40, sales

Peter, 20, student

Alexandra, 19, student

Danielle, 20, student

Fabiola, 27, office assistant

Jake, 28, director of sales

Mike, 24

Katie, 24, marketing

Kendall, 17, student

Tashiva, 21, student

Steven, 20, student and HIV tester

Kierra, 18, student

Jonnea, 18, student

Manny, 32

Cece, 22

Joshua, 29, vendor

Paris, 17

Mark, 50, welder

Colleen, 18, student

Chaire, 18

Cesar, 41, education

Kim, 22, server

Juniper, 21, student and artist

Riley, 23, student

Joey D., 35, student

Joe, 39, mason contractor

Shan, 19, student

Tony, 72, retired and broke

Edward, 47, labor worker

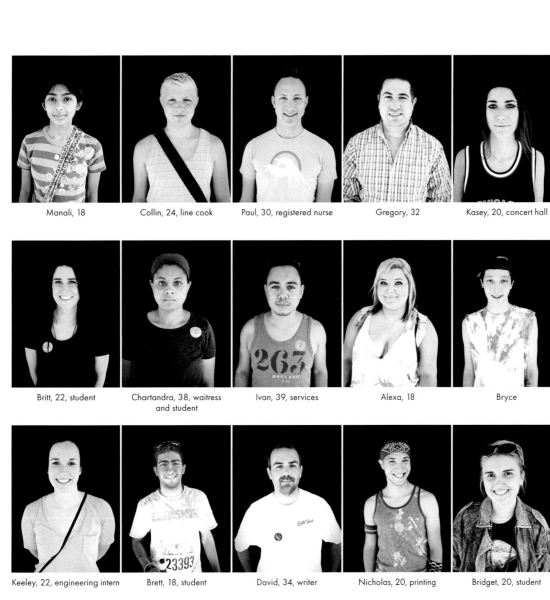

Manali, 18

Collin, 24, line cook

Paul, 30, registered nurse

Gregory, 32

Kasey, 20, concert hall

Kaitlin, 20, student

Britt, 22, student

Chartandra, 38, waitress and student

Ivan, 39, services

Alexa, 18

Bryce

Candace, 18

Keeley, 22, engineering intern

Brett, 18, student

David, 34, writer

Nicholas, 20, printing

Bridget, 20, student

Alexandrea, 25, nanny

Johnny V., 29, model and entertainer

Jose, 27, promo

Molly, 20, student

Drew, 27, retail management

Peter, 36, geologist

Matt, 39, office assistant

Kelsey, 21, merchandise coordinator

Kyle, 33, vet tech

Paul, 43, consultant

Alex, 18

Jim, 66, retired funeral director and embalmer

Matthew, 18

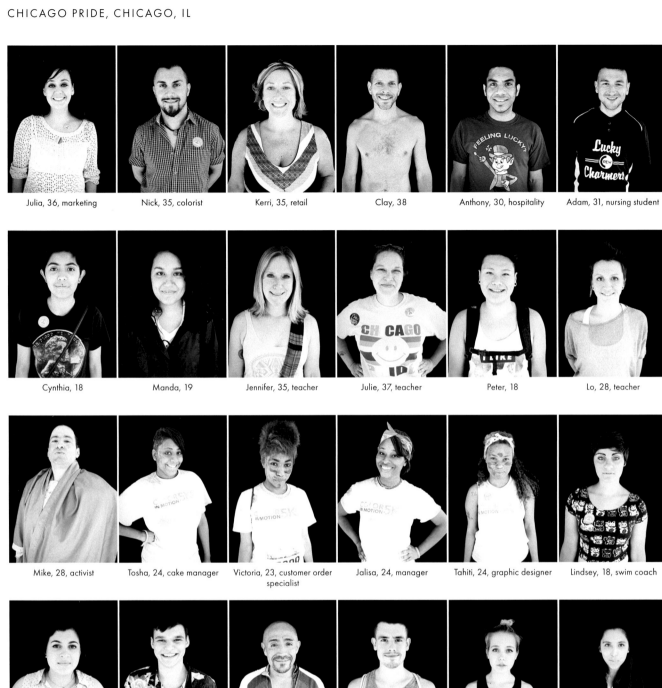

Julia, 36, marketing

Nick, 35, colorist

Kerri, 35, retail

Clay, 38

Anthony, 30, hospitality

Adam, 31, nursing student

Cynthia, 18

Manda, 19

Jennifer, 35, teacher

Julie, 37, teacher

Peter, 18

Lo, 28, teacher

Mike, 28, activist

Tosha, 24, cake manager

Victoria, 23, customer order specialist

Jalisa, 24, manager

Tahiti, 24, graphic designer

Lindsey, 18, swim coach

Marina, 17, student

Kyle, 19, student

Pedro, 50, trainer

Michael, 30, web designer

Lexie, 19, student

Mayra, 19, student

Cecilia, 19, student

Ryan, 38, marketing

Russ, 39, small business owner

Taylor, 20, student

Ellen, 45, therapist and addiction counselor

Matt, 21, student

Tyler, 24, designer

Raymond, 22, server

Quinn, 21

Alexandra, 21, student

Alex, 19

Juanita, 32, security

Eva, 37, manager

Wayne, talk radio

Adam, 28, CEO

Miss Foozie, 54,
character artist

Nuri, 33, graphic designer

Daytwon, 16

Marcia, 43

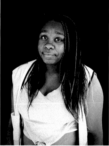

Tiana, 15

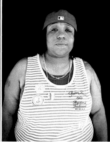

Tene, 31, customer service

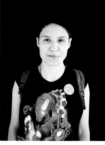

Wolf, 20, student

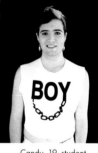

Candy, 19, student

Hung, 29, fitness instructor

Brad, 46, social work

Joe, 19, student

Eddie, 20

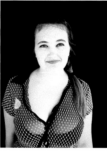

Katie, 20, camgirl

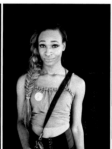

Darion, 20, Panera employee

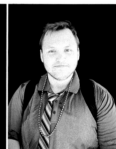

James, 23, engineer

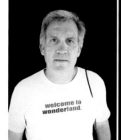

Dennis, 55, chef, assistant
manager, and photographer

Jiri, 43, compliance analyst

Israel, 43, carpentry

Kris, 25, US Navy

Nathan, 20, US Navy

Steven, 27, accountant

Meg, 24

Kash, 22, retail

Kyle, 23, front desk manager

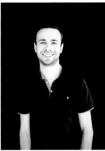

Nathan, 25, software consultant

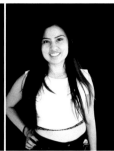

Monse, 18, shampoo girl

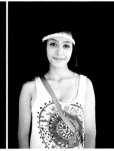

Maria, 18

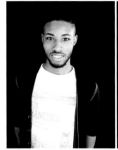

Carter, 20

Jeremy, 35, general manager

Kartan, 19, marketing assistant

Jon, 25, teacher

Vallery, 33, Trader Joe's

Perry, 51, education specialist

Julio, 38, program manager

Austin, 18, student

Eirann, 27, teacher

Joel, 58, marketing

Amber, 23, student

Henis, 19, student

Chris, 29, retail

Daniel, 31, production supervisor

Raina, 42, medical leave

Warren, 33, psychologist

Kim, 46, quality control

Ash, 24, student

Cody, 23, dancer

Kyle, 23, production assistant

Vinova, 20, student

Leah, 33, bartender

Joslyn, 29, at-home mom and wife

Trixie, 32, wine distributor and burlesque

Quiana, 37, machine operator

Jay, 14, library volunteer

Aron, 19, cook

Cristian, 20

Dee Jay, 22, dancer | Vicente, 21, teller | Ray, 25 | Dawn, 49, graphic designer | Andrea, 43, respiratory therapist | Kelly, 30, research fellow

John, 23, professional dancer | Cherise, 25, supervisor | Anita, 37, practice manager | Noria, 31, actor | Paola, 33, female impersonator | Justin, 20

Yudier, 29, student | Carlos, 47, RN | Pete, 22, coffee shop owner | AJ, 28, laser operator | Andrea, 26, advertiser | Daisy, 18

Adriana, 18, manager | Sergio, 48, lead | Justin, 24, bartender | Wanda, 46, housewife | AJ, 20, social network | Daisy, 23, legal assistant

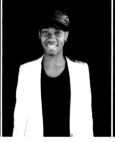
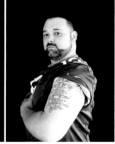

Mayra, 53, lead | Luis, 24, graphic designer | Marcel, 24, fashion creator | Drew, 22, retail | Blake, 22 | Doug, 33, customer service

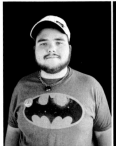

Kiefer, 22

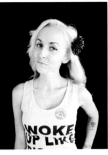

Nicole, 27, makeup artist

Shavonne, 28, student

Rob, 42, lawyer

Zach, 36, TV news producer

Joshua, 24, medicine

Sergio, 33, high school
English teacher

Justin, 30, anesthesiologist

Joe, 31, software engineer

Tywon, 28, restaurant
manager

Sen, 24, CSR

Alex, 20, student manager

Pheez, 23, rep

Jeremy, 26, nightclub security

Jose, 24, mechanic

Danny, 27, marketing

Cedric, 23, grower

Alex, 18, being cool

Erika, 25

Vanessa, 26

Caryn, 26, corporate
account manager

Lauren, 21, student

Katie, 31, DJ and musician

Jocelyn, 18, student

Sean, 26, student

Mitchell, 18, student

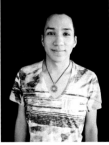

Carlos, 23, student

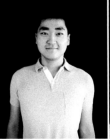

Lester, 23, student

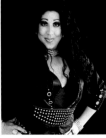

Anna, 32, marketing

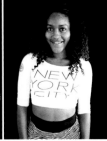

LaParis, 28,
life insurance agent

313

Lauren, 26, bartender

Miguel, 60, retired US Marine

Fernando, 27, ballet dancer

Durwynn, 29, Whole Foods

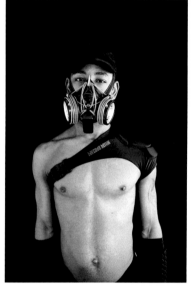

Slade, 29, bar staff

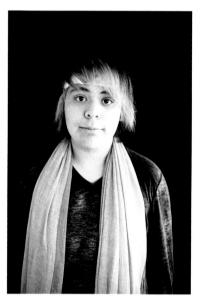

Steve, 15, student

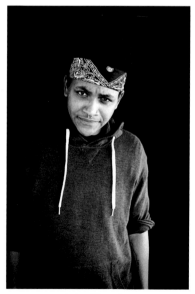

Amber, 22, student

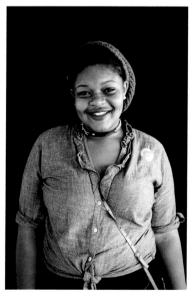

Keyaira, 18

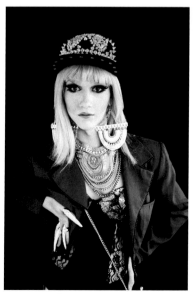

Tiffany, 20, sales advisor

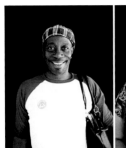

Lamont, 46, seminarian

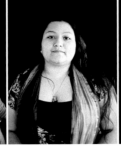

Medline, 22, student

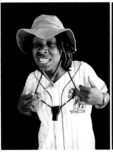

Oh Jay, 24, artist

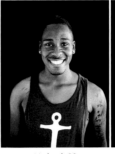

Michael, 22

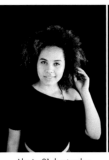

Alexis, 21, bartender
and student

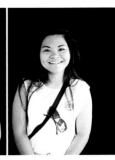

Alysa, 16, student

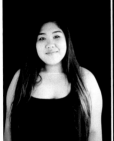

Irish, 16, student

Gustana, 18

Mandiego, 20, student

Leslie, 26

Jasmine, 18, intern

Jay, 20, server

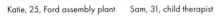

Katie, 25, Ford assembly plant

Sam, 31, child therapist

Nikoa, 40

Malice, 42, barber
and rapper

Hazel, 36, federal office

Carolina, 36, director
of personnel

Jola, 30, counselor

Jackson, 32, hairstylist

ST. LOUIS PRIDE
ST. LOUIS, MO
JUNE 28, 2014

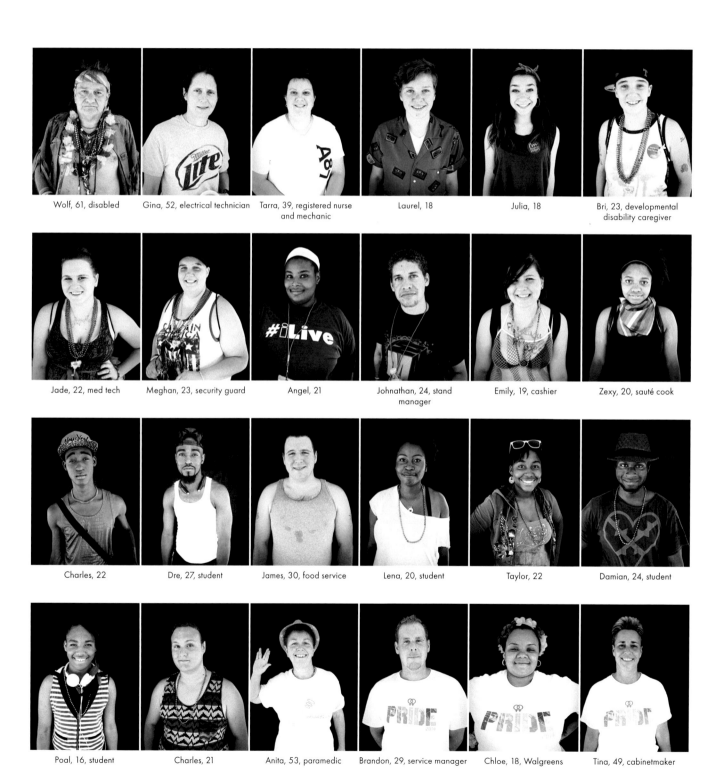

Wolf, 61, disabled

Gina, 52, electrical technician

Tarra, 39, registered nurse and mechanic

Laurel, 18

Julia, 18

Bri, 23, developmental disability caregiver

Jade, 22, med tech

Meghan, 23, security guard

Angel, 21

Johnathan, 24, stand manager

Emily, 19, cashier

Zexy, 20, sauté cook

Charles, 22

Dre, 27, student

James, 30, food service

Lena, 20, student

Taylor, 22

Damian, 24, student

Poal, 16, student

Charles, 21

Anita, 53, paramedic

Brandon, 29, service manager

Chloe, 18, Walgreens

Tina, 49, cabinetmaker

Virlinda, 46, cook

Dawn, 46, driver

Stuart, 29, restaurant
manager

Angel, 18, student

James, 22, pro pool

Tony, 50, IT

Timinika, 29, special
education teacher

Keke, 26, home health

Seth, 21

Chris, 20, photographer

Kelsie, 19, factory worker

TJ, 43, PCT

Quel, 40, CNA and
medical assistant

Nikki, 20, financial service
consultant

Chelsey, 21, Walmart

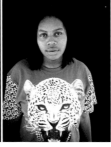

Erica, 20

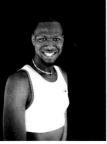

Michael, 24, Walmart

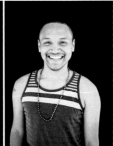

Donavan, 21, teller

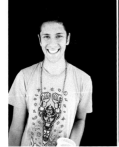

Dylan, 23, student

Jo, 16, student

Rita, 17, student

Desi, 19, sales associate

Autumn, 19, dispatcher

Amanda, 21, food service
worker

James, 27, visual
merchandiser and stylist

DJ, 29, correctional property
inventory manager

Josh, 27, developmental
disability support

Sean, 24, community support

Justin, 31, carpenter

Kasia, 29, waitress

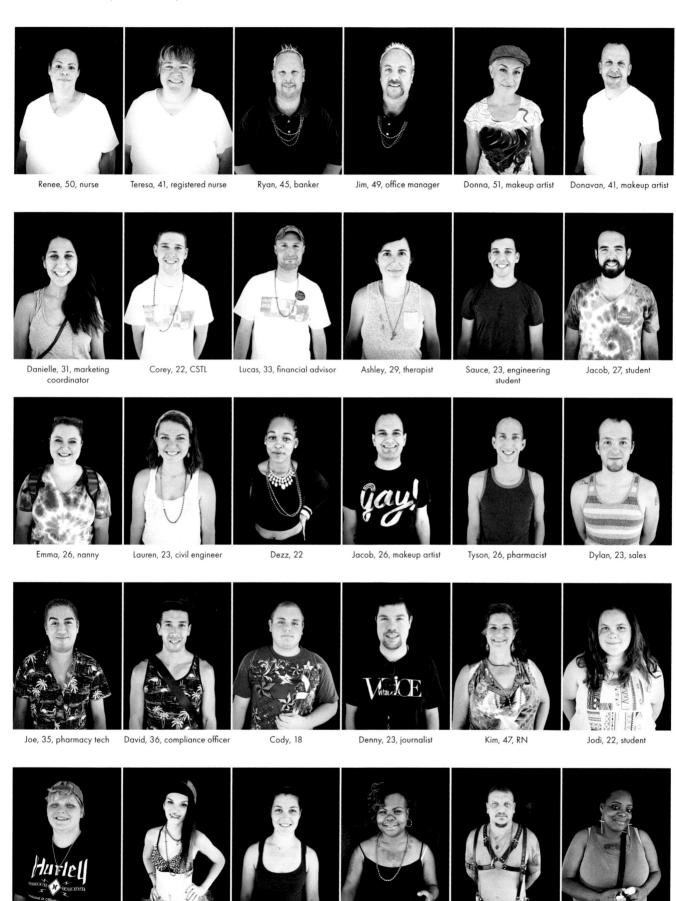

Renee, 50, nurse

Teresa, 41, registered nurse

Ryan, 45, banker

Jim, 49, office manager

Donna, 51, makeup artist

Donavan, 41, makeup artist

Danielle, 31, marketing coordinator

Corey, 22, CSTL

Lucas, 33, financial advisor

Ashley, 29, therapist

Sauce, 23, engineering student

Jacob, 27, student

Emma, 26, nanny

Lauren, 23, civil engineer

Dezz, 22

Jacob, 26, makeup artist

Tyson, 26, pharmacist

Dylan, 23, sales

Joe, 35, pharmacy tech

David, 36, compliance officer

Cody, 18

Denny, 23, journalist

Kim, 47, RN

Jodi, 22, student

Dominiche, 20, printer

Jessica, 17, student

Lucy, 22, environmental engineer

Rochelle, 32

Spiazx, 47

Chelle, 30, customer service rep

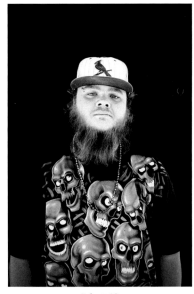

Robert, 19

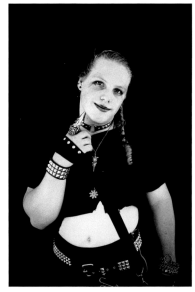

Lily, 20, student

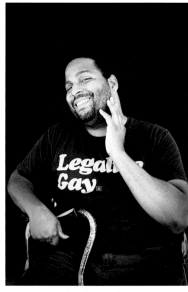

Leo, 32, psychic

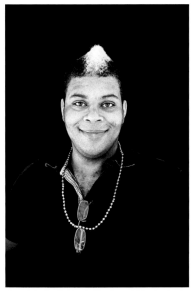

Sunshine, 29, shift manager

Houston, 17, student

Manda Lyn, 20

Jordan, 20, US Marine

Daniel, 30, chef

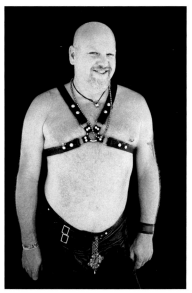

Ken, 50, state worker

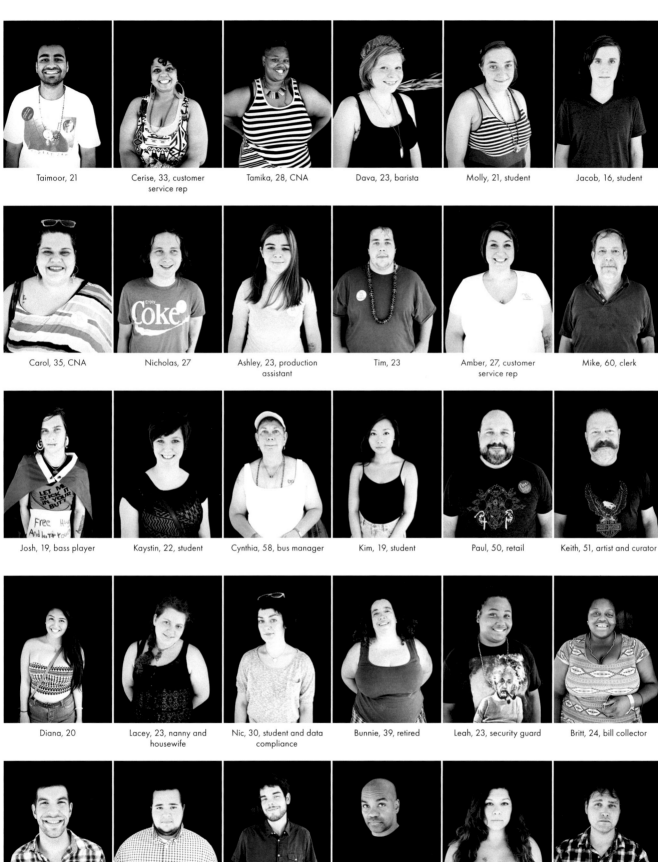

Taimoor, 21

Cerise, 33, customer service rep

Tamika, 28, CNA

Dava, 23, barista

Molly, 21, student

Jacob, 16, student

Carol, 35, CNA

Nicholas, 27

Ashley, 23, production assistant

Tim, 23

Amber, 27, customer service rep

Mike, 60, clerk

Josh, 19, bass player

Kaystin, 22, student

Cynthia, 58, bus manager

Kim, 19, student

Paul, 50, retail

Keith, 51, artist and curator

Diana, 20

Lacey, 23, nanny and housewife

Nic, 30, student and data compliance

Bunnie, 39, retired

Leah, 23, security guard

Britt, 24, bill collector

Andrew, 24, student

Michael, 24, student

Chris, 23, AmeriCorps

Arlander, 52, retail

Dachelle, 35, administrative assistant

Lee, 32, grad research assistant

Christopher, 26, EMT

Tiny, 41, data entry

Jonathan

Kam, 22, student

Monai, 27, manager

Abbie, 14, student

Brandon, 16, student

Kelsey, 23, student

Parker, 23, barista

Kayla, 23, student

Deedra, 25, security guard

Rachel, 23

Christopher, 26, customer service

Zack, 22

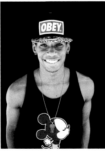

Matt, 23, sales associate

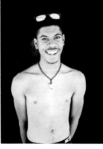

Eddie, 25, office assistant

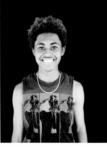

Cassandra, 24, hairstylist

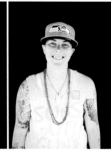

D, 25, student

Christina, 18

Alisya, 18, CNA

Cody, 19

Kerrion, 18, student

Paris, 18, retail specialist

Erin, 25, student

Christina, 42, retail manager and drag host

Kasey, 32, corrections officer

Mika, 24, nurse

Ash, 18, student

Allyson, 15, student

Lauren, 17, student

Kalen, 17, student

Travon, 16, sales rep

Dan, 19, carpenter

Andre, 26, US Navy

Duy, 21, student researcher

Envy, 19, customer assistance associate

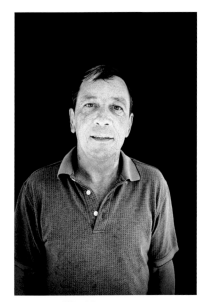

Mike, 55, press operator

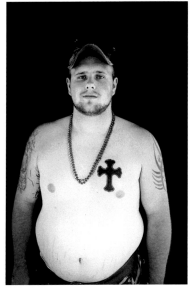

Matt, 20, US Army

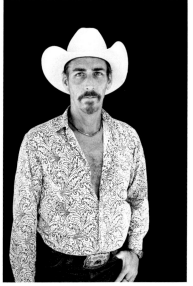

Jim, 50, educator

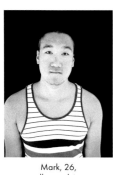

Mark, 26,
college advisor

John, 26,
architectural design

Sarah, 19,
server and student

Shane, 28, dairy manager

Tim, 25, retail

Kelsey, 23, waiter

Katie, 23, student

Geoffrey, 27, dancer

Anthony, 28, construction
laborer

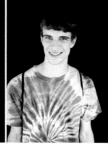

Bobby, 22, baker

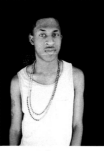

Cedric, 22

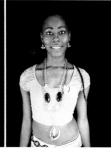

Jutakeiya, 21

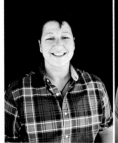

Bree, 30, law enforcement

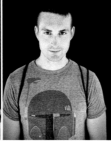

Zachary, 26, state trooper

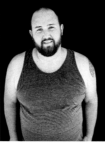

Timothy, 30, landscape
architect

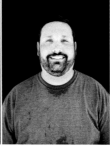

Rob, 40, account manager

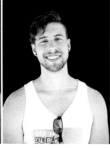

Logan, 21, student

David, 44, recruiter

Quindara, 19

Breyana, 20

Noah, 20, dancer

Des, 18, college student

Marquise, 18

Jane, 21, student

Kate, 22, student

Kelly, 32

Allie, 21, owner of
Arch Motorsports

Ruby, 24, student

Star, 24, student

Jen, 33, manual labor

Rose, 25, refiner Andy, 23, auto tech Leah, 18, Jack in the Box Justin, 19, student Michael, 30, baker Stefan, 21, server

Mark, 26, retail manager Jason, 31 Matt, 23, loan service Danny, 23 David, 23, teacher

TWIN CITIES PRIDE
MINNEAPOLIS, MN
JUNE 29, 2014

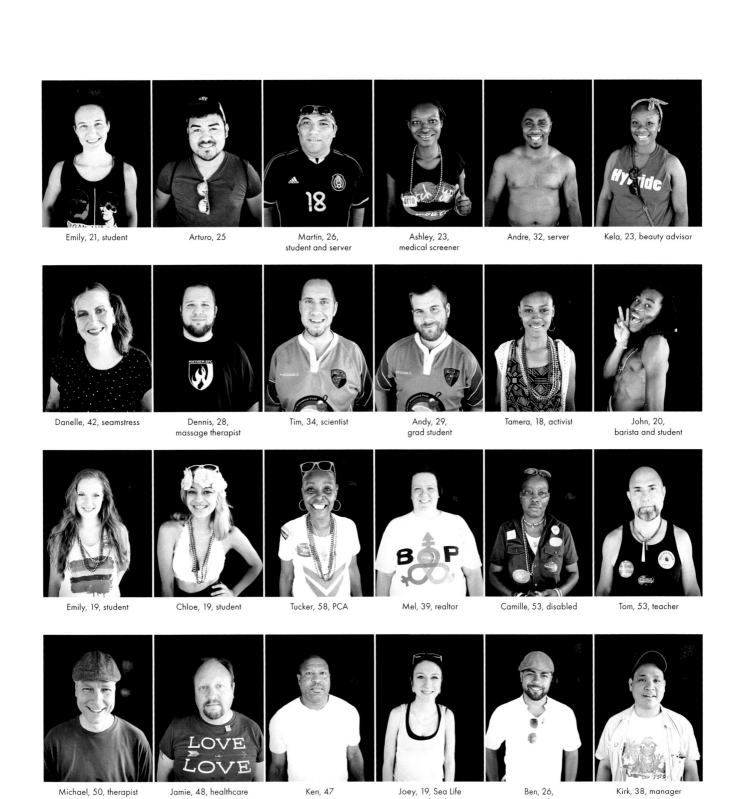

Emily, 21, student

Arturo, 25

Martin, 26,
student and server

Ashley, 23,
medical screener

Andre, 32, server

Kela, 23, beauty advisor

Danelle, 42, seamstress

Dennis, 28,
massage therapist

Tim, 34, scientist

Andy, 29,
grad student

Tamera, 18, activist

John, 20,
barista and student

Emily, 19, student

Chloe, 19, student

Tucker, 58, PCA

Mel, 39, realtor

Camille, 53, disabled

Tom, 53, teacher

Michael, 50, therapist

Jamie, 48, healthcare

Ken, 47

Joey, 19, Sea Life
employee

Ben, 26,
event coordinator

Kirk, 38, manager

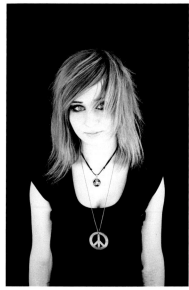

Claire, 18, student

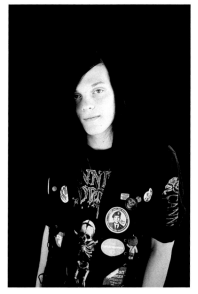

Joseph, 18, student

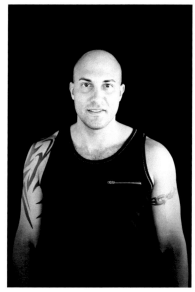

Michael, 33, corrections

Tina, 18, babysitter

Michelle, 23, and Khloe

James, 62, labor

Lucia, 52, police officer

Rachel, 22, piercer apprentice

Paige, 35, disabled

Jennifer, 41, personal trainer

Jaydee, 42, retail

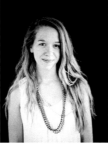

Elena, 20, student

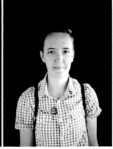

Katie, 22, student

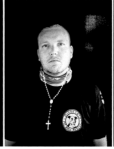

Tony, 26, disabled veteran

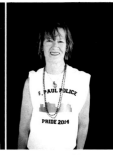

Jen, 54, physical therapist

Bob, 75, retired

Jen, 22, warehouse stocker

Kayla, 22, retail

Earl, 60, deli supervisor

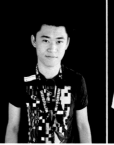

Vi, 21, rep

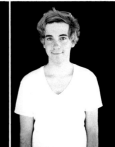

Nicholas, 18

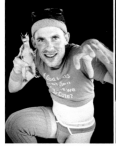

Clint, 31, molecular

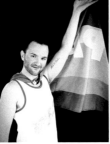

Steven, 31, hairstylist

Derek, 19, student

Annetta, 60, nurse

Mykenna, 53, software developer

Jordan, 17, cook

Christina, 17, student

Oliver, 18

Sophia, 14, daycare worker

Alicia, 18, sales associate

Erin, 19, sales associate

Morgan, 18, freelance digital artist

Stephanie, 18, archery coach and theatrical makeup

Brooke, 18, nursing home cleaning attendant

Alex, 18, Pizza Ranch

LeyLey, 15, student

Jennifer, 21, dental assistant

Ashley, 27, child and youth suport worker

327

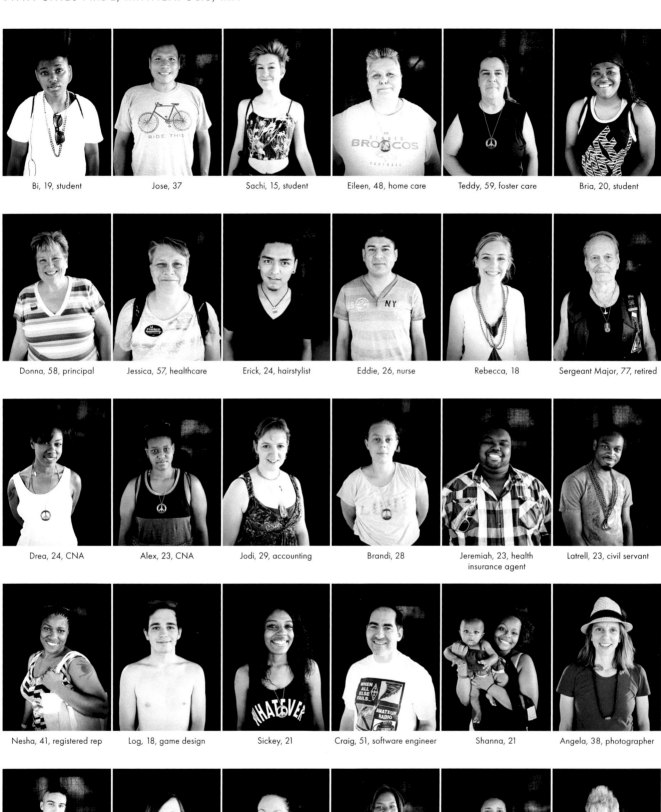

Bi, 19, student Jose, 37 Sachi, 15, student Eileen, 48, home care Teddy, 59, foster care Bria, 20, student

Donna, 58, principal Jessica, 57, healthcare Erick, 24, hairstylist Eddie, 26, nurse Rebecca, 18 Sergeant Major, 77, retired

Drea, 24, CNA Alex, 23, CNA Jodi, 29, accounting Brandi, 28 Jeremiah, 23, health insurance agent Latrell, 23, civil servant

Nesha, 41, registered rep Log, 18, game design Sickey, 21 Craig, 51, software engineer Shanna, 21 Angela, 38, photographer

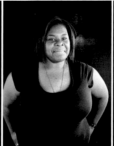
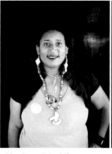
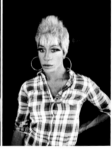

Brett, 20, GM at Jimmy John's Casey, 25, Cigna Behavioral Health Tesia, 24, student Kymmy, 23 Charlene, 24, shift manager Kamaree, 22, drag queen

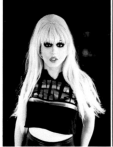

Bad Karma, 20,
drag entertainer

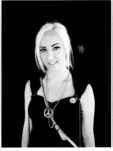

Bailey, 21

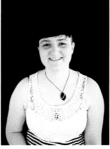

Mara, 19, student

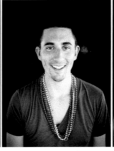

Alex, 24, vendor

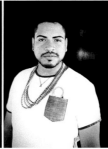

Travis, 25, marketing

Ashlee, 23, service advisor

Paige, 23, writer

Laresa, 25, sexual educator,
and Pella

Lucien, 18, host at Perkins

Rob, 31, Wells Fargo

Andres, 25

Alan, 21, teller, student,
and US Army

Sydney, 21, student

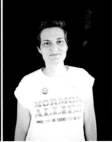

Beth, 35, bodywork therapist

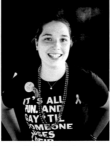

Jorja, 23, student

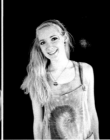

Marin, 19, barista and artist

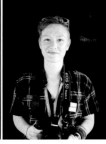

Rebecca, 28, photographer

Molly, 25, US Air Force
avionics specialist

Austin, 20, sales

John, 25, model

Emma, 39, fashion designer

Jamie, 68, retired

Liam, 18, student

Lucien, 18, student

Natalie, 18, project specialist

Josh, 39, student

McLean, 18

Ryan, 31, nonprofit education
and performer

Will, 23, arts

Joan, 26, Department
of Education

Jordan, 27, guitar player

Monique, 21, monitoring

Joshua, 28, unemployed

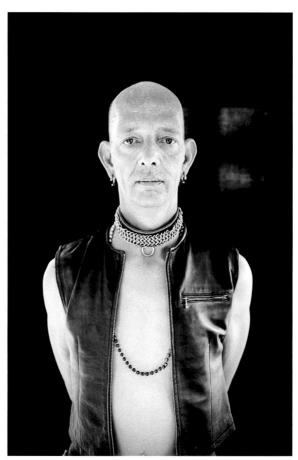

Jay, 43, CNA

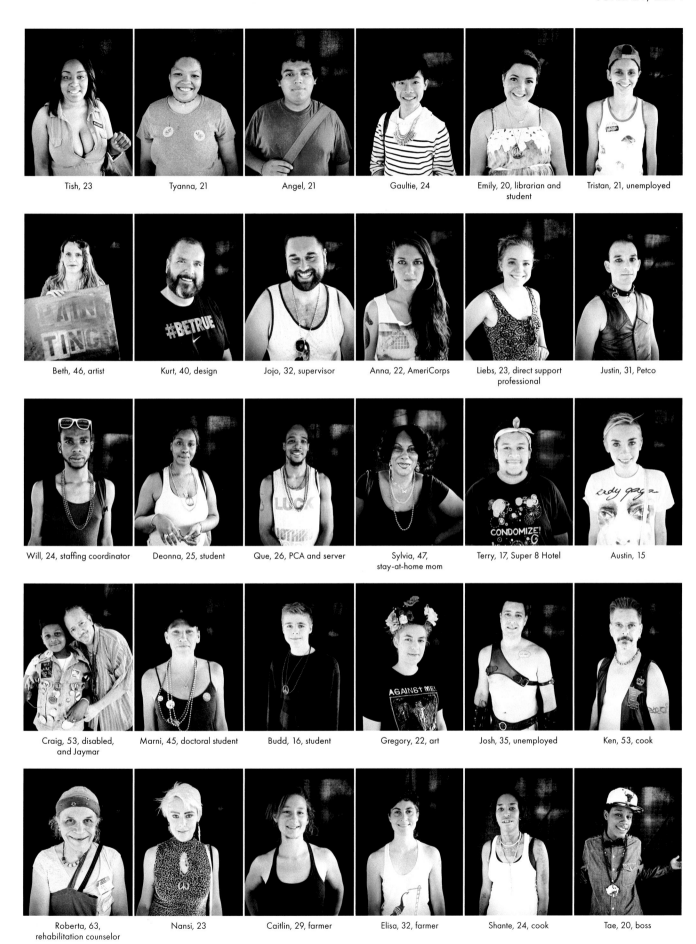

Tish, 23

Tyanna, 21

Angel, 21

Gaultie, 24

Emily, 20, librarian and student

Tristan, 21, unemployed

Beth, 46, artist

Kurt, 40, design

Jojo, 32, supervisor

Anna, 22, AmeriCorps

Liebs, 23, direct support professional

Justin, 31, Petco

Will, 24, staffing coordinator

Deonna, 25, student

Que, 26, PCA and server

Sylvia, 47, stay-at-home mom

Terry, 17, Super 8 Hotel

Austin, 15

Craig, 53, disabled, and Jaymar

Marni, 45, doctoral student

Budd, 16, student

Gregory, 22, art

Josh, 35, unemployed

Ken, 53, cook

Roberta, 63, rehabilitation counselor

Nansi, 23

Caitlin, 29, farmer

Elisa, 32, farmer

Shante, 24, cook

Tae, 20, boss

Tekesha, 23, registrar

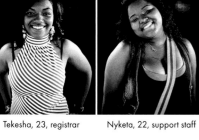
Nyketa, 22, support staff

Curtis, 36, chef

Matthew, 29, hairstylist

Eli, 26, photographer

Cole, 21, student and photographer

Mitchell, 20, resident assistant

Shannon, 33, assistant professor

Ngowo, 43, senior designer

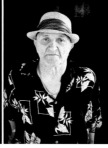
Joseph, 73, retired artist

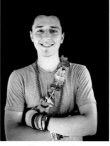
Alex, 20, student

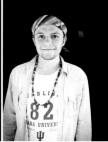
Avery, 21, student, researcher, and maid

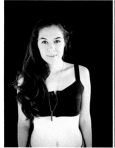
Daniel, 20, student

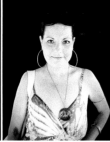
Nikki, 42, housemaker

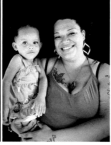
Capriece, 22, waitress, and Paris

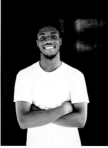
Shaw, 21, ride or die

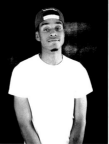
Artrail, 20, actor

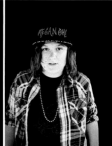
Megan, 19, subway artist

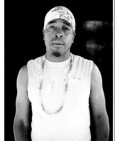
RTL, 36, restaurant manager

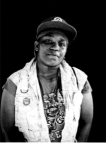
Kool-Aid, 24, PCA

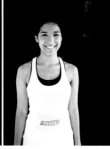
Sadie, 18, barista

Stephanie, 26

Bianca, 33

Brittany, 24, CSR

Izzy, 19, student

Samye, 20, independent contractor

Jovan, 25, claims examiner

Madeline, 22, overnight logistics

Asia, 21, sandwich artist

Thomas, 45

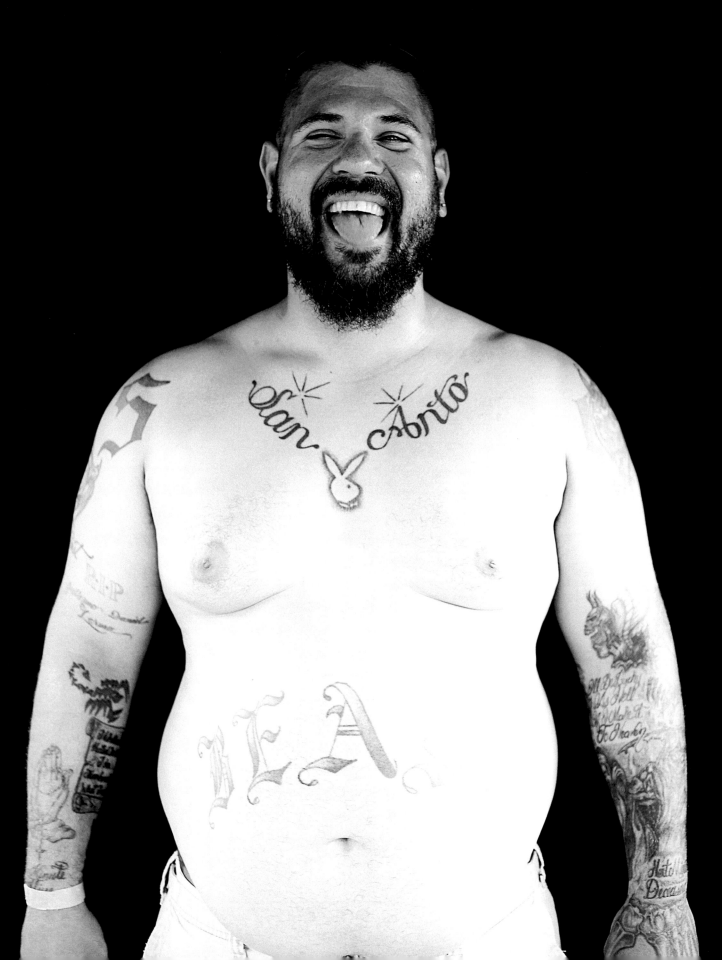

Matthew, 21, warehouse

Benjamin, 18, Dairy Queen

Reneka, 45, program coordinator

Thomas, 18, student

Lani, 18, student

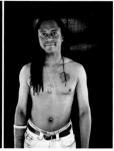

Derell, 39, sheet metal worker

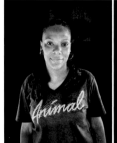

Maisha, 32, therapist

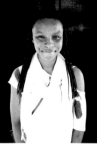

Kayla, 15

Brandon, 16

Nicole, 19, Quick Service

Shaun, 19, Quick Service

Liz, 19, student

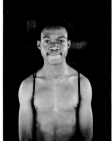

Keith, 18, student and pizza cook

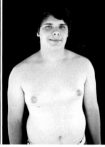

Brett, 18, student

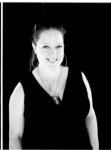

Tari, 36, administration assistant

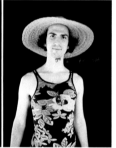

Deeps, 29, solderer

PACIFIC PRIDE FESTIVAL
SANTA BARBARA, CA
JULY 12, 2014

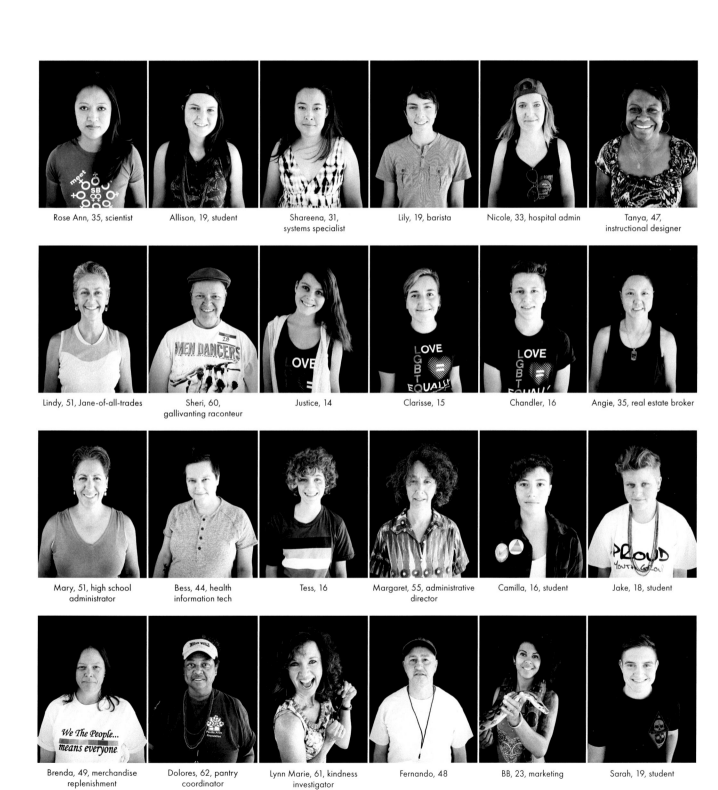

Rose Ann, 35, scientist

Allison, 19, student

Shareena, 31, systems specialist

Lily, 19, barista

Nicole, 33, hospital admin

Tanya, 47, instructional designer

Lindy, 51, Jane-of-all-trades

Sheri, 60, gallivanting raconteur

Justice, 14

Clarisse, 15

Chandler, 16

Angie, 35, real estate broker

Mary, 51, high school administrator

Bess, 44, health information tech

Tess, 16

Margaret, 55, administrative director

Camilla, 16, student

Jake, 18, student

Brenda, 49, merchandise replenishment

Dolores, 62, pantry coordinator

Lynn Marie, 61, kindness investigator

Fernando, 48

BB, 23, marketing

Sarah, 19, student

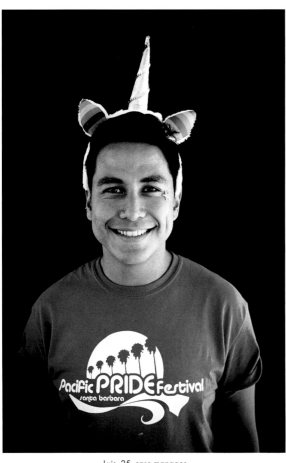
Luis, 25, case manager

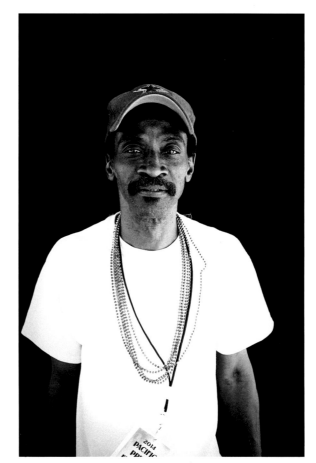
Lamar, 57, retired

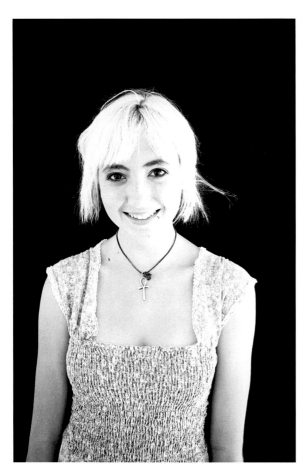
Landon, 15, student

Mimi, 49, fitness trainer

Karen, 23, student

Carter, 22, human being

Dan, 55, admin

Charlie, 18, programmer

Kat, 36, teacher

Donna, 46, manager

Adele, 70, retired

Leana, 26, assistant

Guillermo, 18, student

Tracy, 39, graphic design

Alexandra, 25, self-employed

Kevin, 21, student

Bobbie, 29

Larisa, 23, legal caseworker

Lindsay, 23, onboarding specialist

La Shara, 26, admin

Chuck, 18, hairstylist

Crystal, 28, manager

David, 54, actor and singer

Jordan, 25, engineer

Richard, 19

Julie, 50, high school administrator

Kati, 22, student

Alex, 21, student

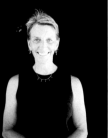

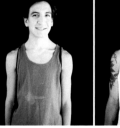

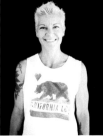

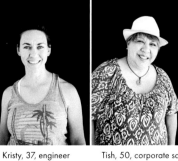

Jaime, 35, communications coordinator

Marilyn, 65, retired underwater photographer

Luis, 20, student

Karen, 44, learning and development

Kristy, 37, engineer

Tish, 50, corporate sales

337

Marian, 54, college administrator

Lauren, 34, environmental scientist

Amber, 25, brand ambassador manager

Barbara, 66, small business owner

Jadi, 56, assistant house manager

Kristina, 32, yoga teacher

Sonia, 47, massage therapist

Star, 23, student and musician

Emmie, 23, PhD student

David, 18, winery

Celie, 32, realtor

Tina, 47, self-employed

Michelle, 43, photographer

Carlos, 38

Jessica, 18, student

Diego, 18, student

Chandra, 47, retail

Amber, 20, student

William, 78, retired artist

Dustin, 18

Sarah, 29, security

Sam, 24, retail manager

Jen, 31

Tanya, 40

Gary, 46, program manager

NayNay, 27, brand ambassador manager at Uber

Dustin, 36, electrical coordinator

Lisa, 34

Zarah, 34, undergraduate advisor

Claudia, 28, front office manager

Mario, 19

Matthew, 20, student and pizza cook

Lynne, 7

Kim, 56, organic farmer

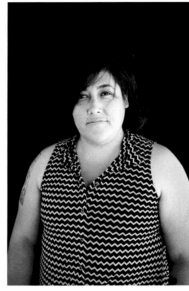

Xochitl, 35, program director

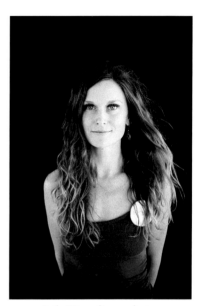

Emily, 27, recycling coordinator

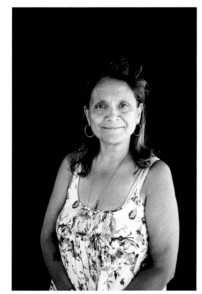

Edie, 61, doctor

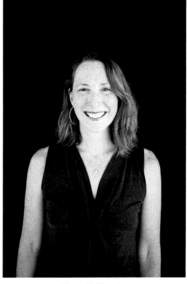

Ellen, 49, librarian

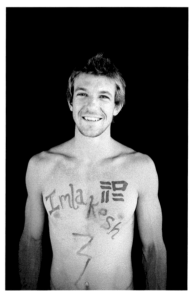

Tarza, 25, acrobat

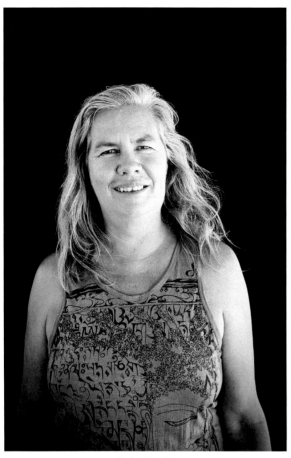

Linda, 55, artist

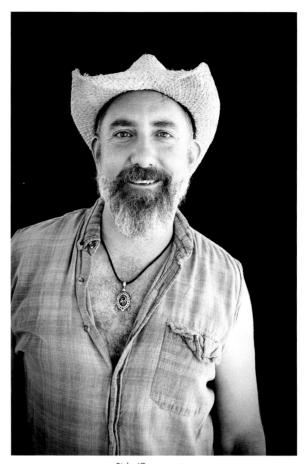

Rick, 47, prop master

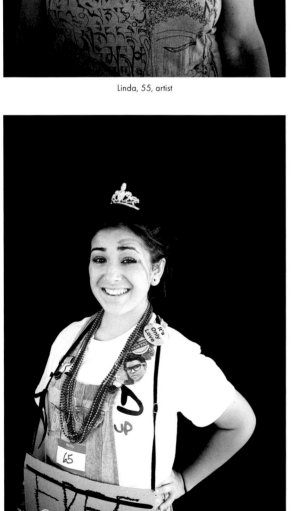

Alana, 16, student

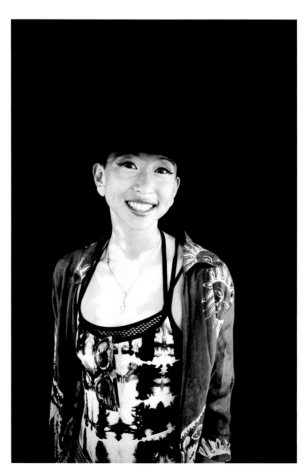

Gabrielle, 23, graphic designer

Charlie, 29, couponpal.com

Taylor, 18, student

Andrea, 34, admin assistant

Lauren, 29, life skills coach

Samantha, 37, teacher

Yadira, 32, career service consultant

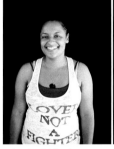

Stooky, 24, food assistant

Nicole, 36, driver

Monique, 32, sales and customer service

Jan, 57, dental hygienist

Bengly, 15, student

Shannon, 22, dietitian

Tania, 47, professor

Natalie, 15, student

Jaqued, 46

LP, 54, plumber

Stephanie, 47, supervisor

Bianca, 21, student

Cheryl, 50, direct support professional

Lisa, 46, cartoonist

Lincoln, 29, educator

Chris, 38, education

Bernie, 64, spiritual coach

Gary, 56, counselor

Kirsten, 47, analyst

Andrew, 18, student

Ian, 23, visual communicator

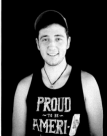

Trevor, 19, barista

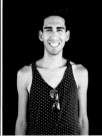

Daniel, 22, waiter

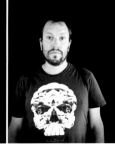

Skip, 45, consultant

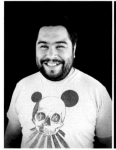

Luis, 37, administration

Hannah, 23, superfood company

Mollie, 20, student

Carissa, 24, superfood chemist

Kashmire, 24, student

Liz, 39, loafer

Kemara, 18

Chief, 25, development assistant

Michelle, 32

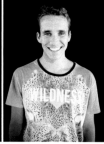

Luc, 23, education

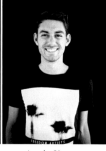

Jacob, 21, server and manager

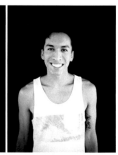

Jacob, 20, Dollar Tree manager

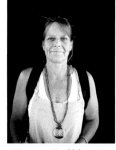

Mariann, 48, phlebotomist

Jodi, 43, cosmetologist

Ramona, 51, sales

Jasmine, 21, retail

Brittany, 19, student

Jesus, 29

Twilight, 38, IT trainer

Erica, 39, air traffic controller

Kim, 53, college advisor

George, 47, research adminstration

Ryne, 24, delivery specialist

David, 43, adjunct professor

Jessi, 23, nurse

Dani, 23, botanist

Daniel, 52, accountant

Eli, 40, administration

Iris, 31, health coach

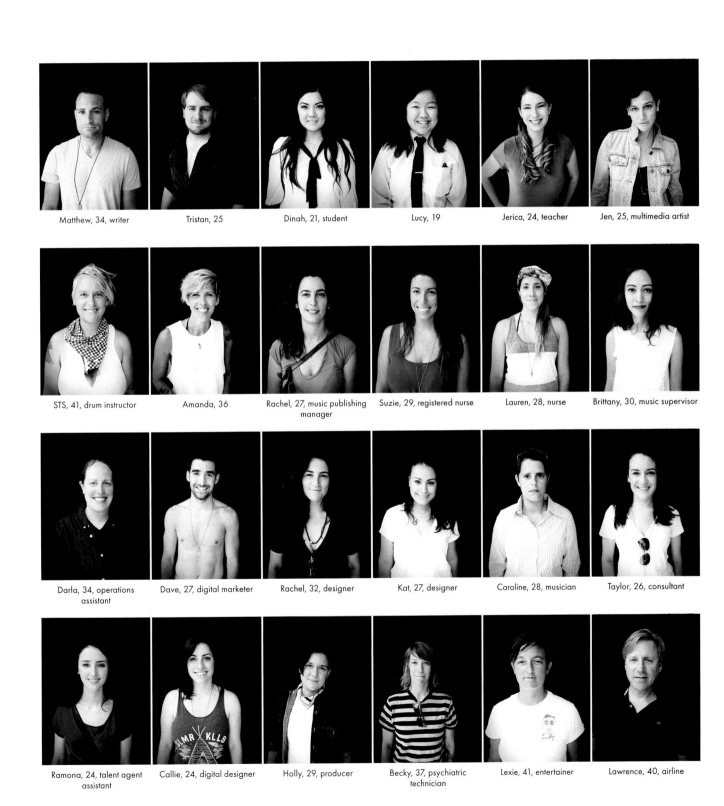

Matthew, 34, writer

Tristan, 25

Dinah, 21, student

Lucy, 19

Jerica, 24, teacher

Jen, 25, multimedia artist

STS, 41, drum instructor

Amanda, 36

Rachel, 27, music publishing manager

Suzie, 29, registered nurse

Lauren, 28, nurse

Brittany, 30, music supervisor

Darla, 34, operations assistant

Dave, 27, digital marketer

Rachel, 32, designer

Kat, 27, designer

Caroline, 28, musician

Taylor, 26, consultant

Ramona, 24, talent agent assistant

Callie, 24, digital designer

Holly, 29, producer

Becky, 37, psychiatric technician

Lexie, 41, entertainer

Lawrence, 40, airline

Ryan, 41, choreographer

Vince, 58, freelance illustrator

Abby, 26, artist

Natalie, 29, social services

Andrew, 36, musician

Mark, 36, publicist

Vera, 30, DJ

Patrice, 24, dance instructor

Chris, 36, lender

Frankie, 39, real estate

Julianna, 38, principal

Mars, 31, video editor and colorist

Jimmy, 28

Memphis Mayhem, 32, physical therapist

Lorena, 23, filmmaker

Nora, 38, massage therapist

Caitlin, 28, stand-up comic

Leslie, 31, actor

Patrick, 33, realtor

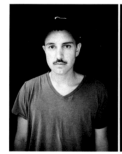
Oliver, 28, community outreach

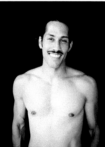
Blas, 27, digital media

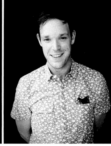
Ethan, 24, actor

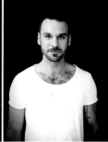
Michal, 34, stress specialist

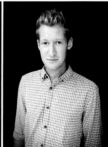
Andy, 24, photographer

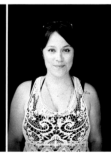
Natalie, 24, marketing company owner

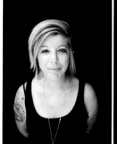
Kaili, 29, care provider

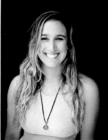
Carly, 27, provider

Stacey, 24, service rep

Kaitlyn, 26, counselor

Nas, 25

Cece, 26, dancer

345

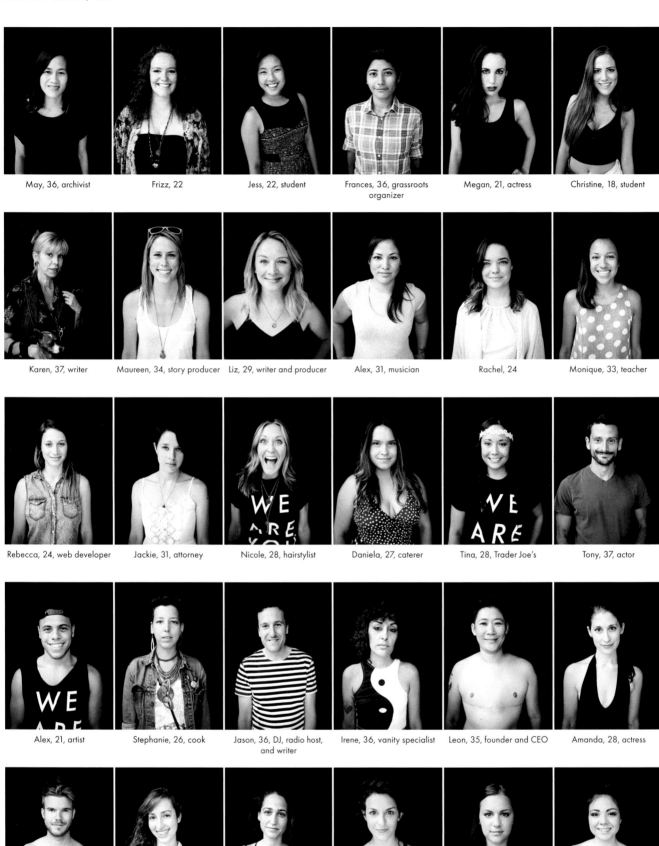

May, 36, archivist

Frizz, 22

Jess, 22, student

Frances, 36, grassroots organizer

Megan, 21, actress

Christine, 18, student

Karen, 37, writer

Maureen, 34, story producer

Liz, 29, writer and producer

Alex, 31, musician

Rachel, 24

Monique, 33, teacher

Rebecca, 24, web developer

Jackie, 31, attorney

Nicole, 28, hairstylist

Daniela, 27, caterer

Tina, 28, Trader Joe's

Tony, 37, actor

Alex, 21, artist

Stephanie, 26, cook

Jason, 36, DJ, radio host, and writer

Irene, 36, vanity specialist

Leon, 35, founder and CEO

Amanda, 28, actress

Ryan, 28

Clarissee, 29, production coordinator

Honey, 32, therapist

Maggie, 25, account executive

Catt, 21, event manager

Ashley, 21, US Forest Service

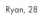
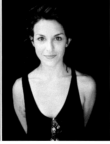

Diana, 21, student

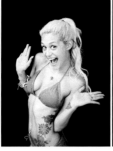

Kristina, 21, event planner

Stephanie, 25,
tour marketing manager

Lee, 24, grad student

James, 30, business analyst

Neara, 26, musician

Liz, 37, writer and creator

India, 28, music manager

Dina, 35, editor

Michelle, 31, artist

Sujey, 30, assistant

Rene, 24, bartender

Delma, 23, waitress

Brittany, 29,
Camp No Counselors

Rocky, 24, model

Britenelle, 28, account
manager

Nic, 28, producer

Nicole, 24, writer

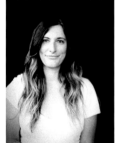

Heather, 37, editor

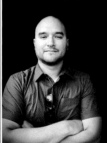

Daniel, 34, producer

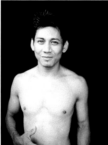

Carlos, 34, accounting

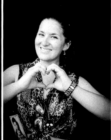

Holland, 21, cashier
and student

Delia, 31, studio manager

Nicol, 34, writer
and comedian

Katy, 25, entertainment
management

Alexandra, 22, associate
creative director

Charlene, 33, casting,
artist, and painter

Jae

Isabelle, 40, admin

Saa, 40, musician

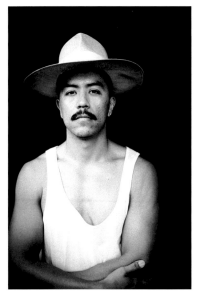

Adrian, 33, artist

Jodi

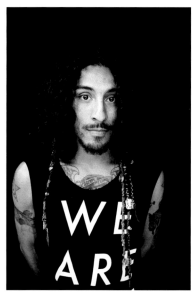

John, 30, concierge

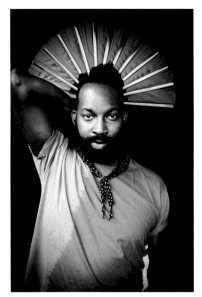

Maurice, 33, florist

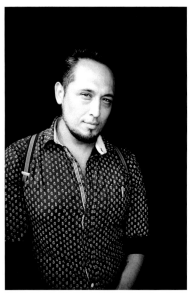

Carlos, 32, law

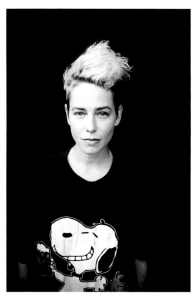

Amber, 35, artist, designer, and poet

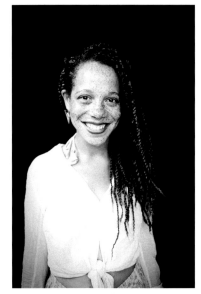

Hope, 26, dreamer

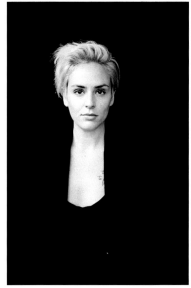

Laurel, 29, sales

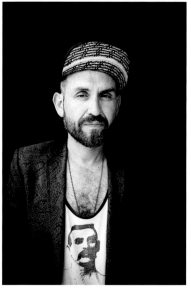

Johnny, 38, stylist

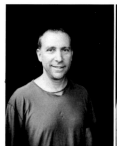

Brian, 50, driver
and musician

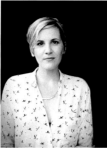

Amara, 30, director
and producer

Hollie, 31, self-employed

Raja, 36, stylist

Alex, 35, fashion sales

Trey, 34, president
at Gents

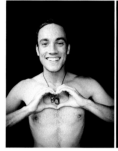

Janice, 28, sales

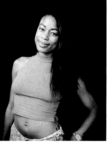

Valerie, 33, makeup artist

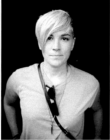

Katie, 30, director

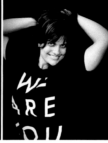

Shellie Jo, 38, dog walker

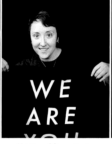

Kristina, 32, engineer

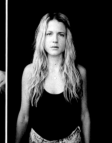

Lauren, 26, paralegal

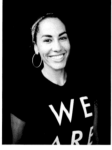

Stephanie, 27, personal
assistant

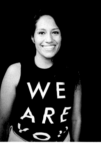

Genna, 27, photographer

Haven, 33, production

Carey, 29, behavioral
therapist

Stephanee, 25, personal
assistant

Kate, 28, server

Cameron, 29, writer and
director

Julie, 24, marketing
professional

Katie, 24, digital things

Jessica, 34, boss

Candice, 34, software
engineer

Blaine, 32

Sondra, 26, bartender
and instructor

Susan, 33, artist

Stephanie, 23, graphic
designer

Rachel, 26, production
assistant

Emily, 28, social worker

Naomi, 27, fashion designer

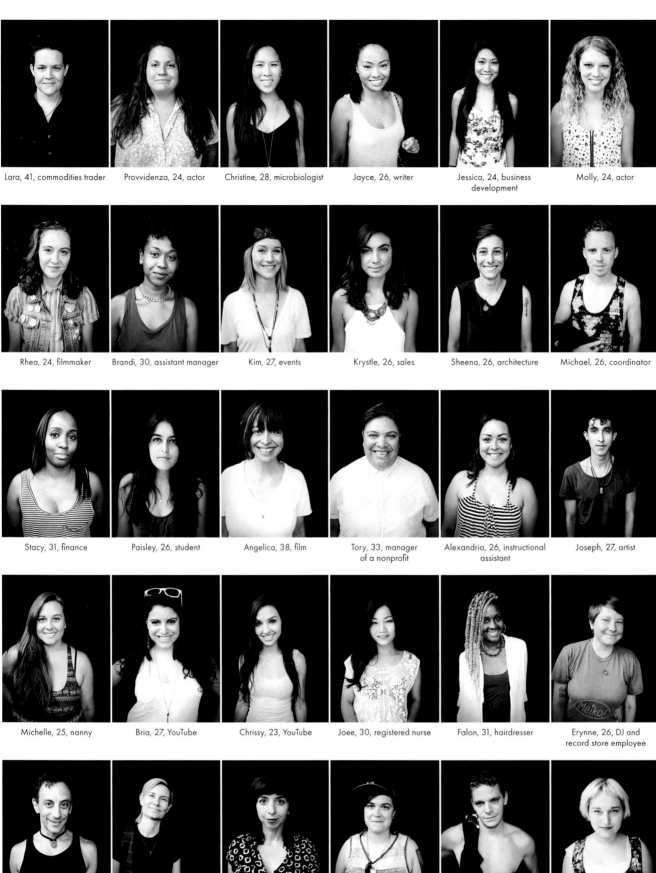

Lara, 41, commodities trader

Provvidenza, 24, actor

Christine, 28, microbiologist

Jayce, 26, writer

Jessica, 24, business development

Molly, 24, actor

Rhea, 24, filmmaker

Brandi, 30, assistant manager

Kim, 27, events

Krystle, 26, sales

Sheena, 26, architecture

Michael, 26, coordinator

Stacy, 31, finance

Paisley, 26, student

Angelica, 38, film

Tory, 33, manager of a nonprofit

Alexandria, 26, instructional assistant

Joseph, 27, artist

Michelle, 25, nanny

Bria, 27, YouTube

Chrissy, 23, YouTube

Joee, 30, registered nurse

Falon, 31, hairdresser

Erynne, 26, DJ and record store employee

Eric, 44, costume and fashion designer

Vanessa, 41, queer party promoter

Gina, 24, playwright and director

Nicole, 34, licensing manager

Chase, 25, coordinator

Keely, 21, writer, assistant, and bookseller

Christian, 24, badass

Timmy, 23, designer

Lauren, 40, stylist

Nicole, 29, student

Javon, 22, athlete

Tay, 28, art director

Mishann, 32, case management

Marina, 25, fashion design student

Lucky, 34, filmmaker

351

Ashley, 28, community development specialist

Mary, 27, actor

Velvet, 28, customer service

Donnie, 28, VIP host

Alli, 26, staff reporter for Us Weekly

Bestat, 28, assistant

Sarah, 28, architect

Larissa, 26, student affairs

Alex, 25, production

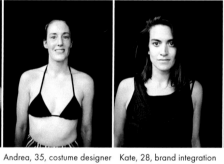

Emily, 26, sales

Lilly, 27, marketing

Allyce, 33, art director

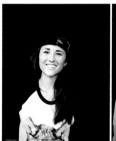

Stevie, 26, YouTube

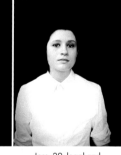

Sarah, 30, creative director

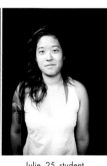

Jennifer

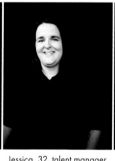

Andrea, 35, costume designer

Kate, 28, brand integration director

Debbie, 30, mental health worker

Kylene, 26, radiologic technologist

Jess, 29, legal and grad student

Julie, 25, student

Jessica, 32, talent manager

Jeannette, 21, student

Erin, 31, graphic artist

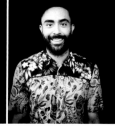

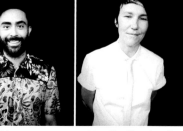

Chelsea, 23, fine jewelry designer

Caitlin, 26, student

Deven, 36, restaurant server

Jose, 26, management

Lisa, 41, self-employed

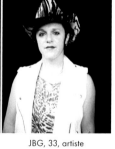

JBG, 33, artiste

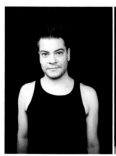

Ernesto, 36, office manager

Christopher, 39, actor

Laurie, 30, project manager

Chantell, 24, student

Flor, 37, director of digital

Jesus, 25, dancer

Dani, 30, entertainment
attorney

Pegah, 27, volunteer

Hattie, 24, student

Jolyon, 23, student

Jason, 33, art director

Justin, 32, writer

Sara, 32, stylist

Rachel, 31, creative executive

Romina, 35, film and
video editor

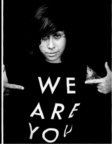

Nabedi, 33, musician

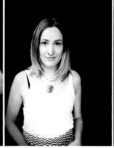

Nicole, 29, student

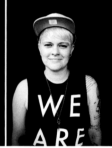

Leah, 30, stylist

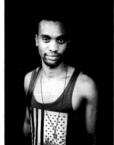

Jordan, 25, marketing
manager

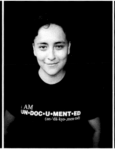

Sandra, 32, photographer

Maggie, 31, musician
and actress

Dez, 26, psychotherapist
and grant writer

FORT WAYNE PRIDE
FORT WAYNE, IN
JULY 26, 2014

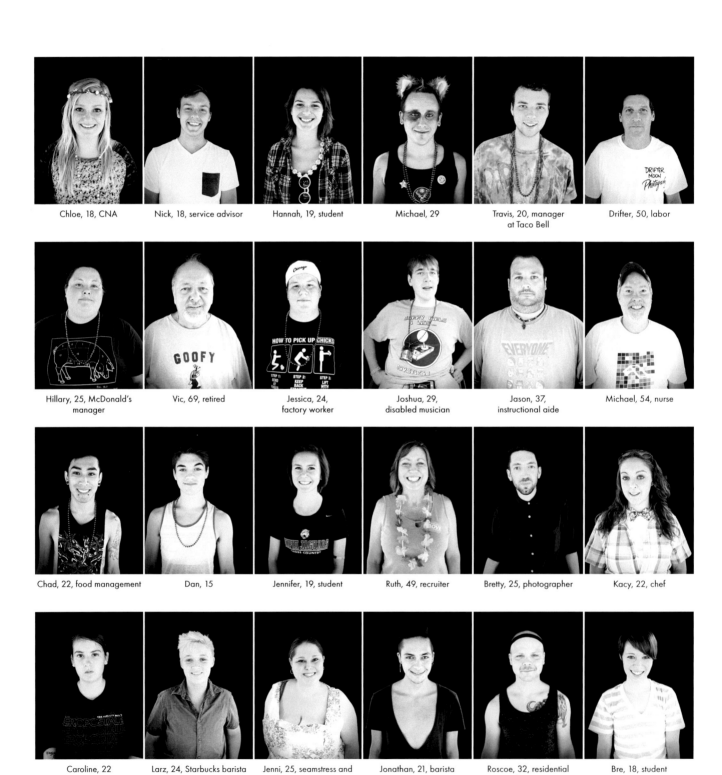

Chloe, 18, CNA

Nick, 18, service advisor

Hannah, 19, student

Michael, 29

Travis, 20, manager
at Taco Bell

Drifter, 50, labor

Hillary, 25, McDonald's
manager

Vic, 69, retired

Jessica, 24,
factory worker

Joshua, 29,
disabled musician

Jason, 37,
instructional aide

Michael, 54, nurse

Chad, 22, food management

Dan, 15

Jennifer, 19, student

Ruth, 49, recruiter

Bretty, 25, photographer

Kacy, 22, chef

Caroline, 22

Larz, 24, Starbucks barista

Jenni, 25, seamstress and
historic interpreter

Jonathan, 21, barista

Roscoe, 32, residential
director

Bre, 18, student

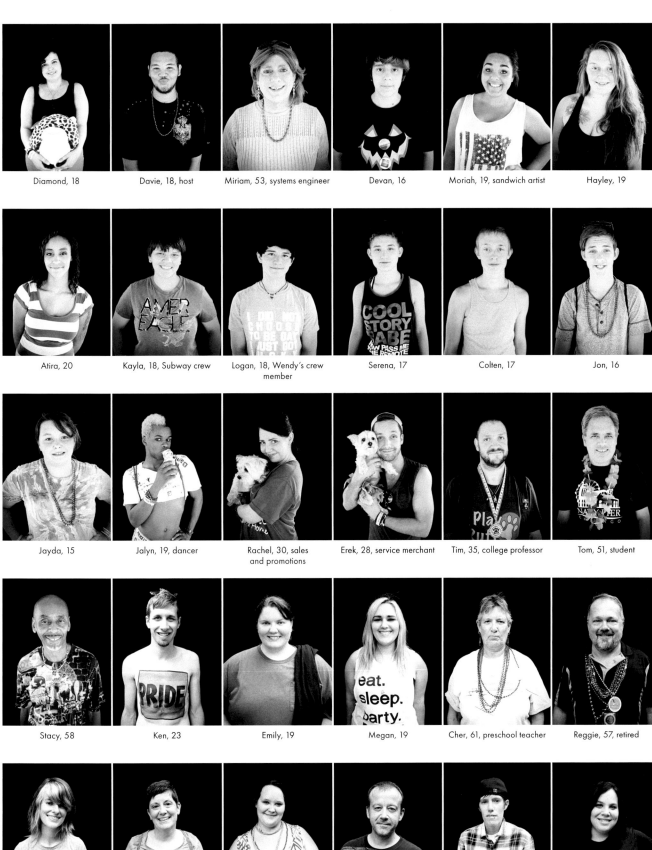

Diamond, 18

Davie, 18, host

Miriam, 53, systems engineer

Devan, 16

Moriah, 19, sandwich artist

Hayley, 19

Atira, 20

Kayla, 18, Subway crew

Logan, 18, Wendy's crew member

Serena, 17

Colten, 17

Jon, 16

Jayda, 15

Jalyn, 19, dancer

Rachel, 30, sales and promotions

Erek, 28, service merchant

Tim, 35, college professor

Tom, 51, student

Stacy, 58

Ken, 23

Emily, 19

Megan, 19

Cher, 61, preschool teacher

Reggie, 57, retired

Aimee, 27, artist

Cassy, 54, pharmaceutical tech

Shawna, 27, published author

Bob, 45, factory worker

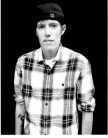

Angie, 32, soybean processing

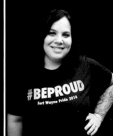

Jennifer, 26, patient care

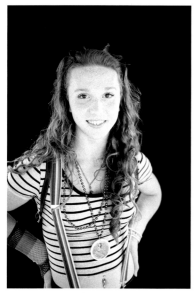

Maddy, 18, student

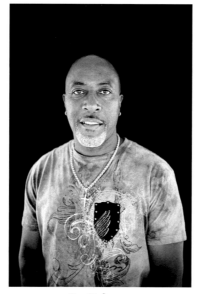

Tim, 54, fireman

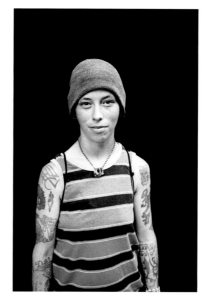

Margo, 31, manager

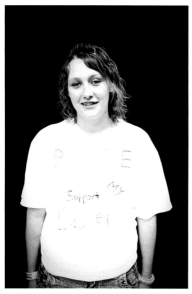

Anna, 21, mom

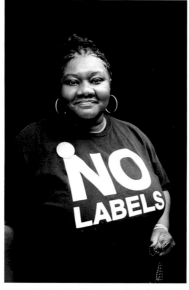

Patricia, 44, AIDS outreach worker

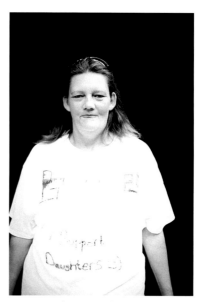

Beth, 41, stay-at-home mom

Lee, 39, factory

Kodi, 15, high school student

Garrett, 17, cashier

Cat, 25, forklift driver

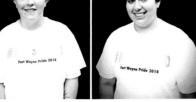
Ashley, 22, forklift driver

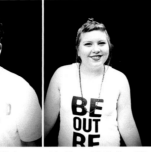
Maddison, 19, McDonald's

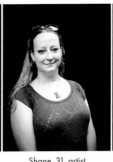
Shane, 31, artist

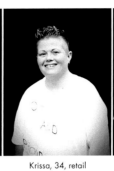
Krissa, 34, retail

Kim, 42, retired

David, 61, photographer

Alyssa, 26, chef

Mirah, 18, waitress

Tiesha, 26, advertising

Felicia, 21, intern

Bailee, 22, social worker

Lexi, 17

Krissy

Bug, 15

Melissa, 38, quality

Katie, 22, server

Amanda, 21, student

Wesley, 18, college

Anita, 43, clinical support

Jen, 42, verifier

Cabe, 17, cashier

Nikki, 26, clerk

Jackie, 28, youth professional

Amanda, 30, merchandise
supervisor

Danielle, 18, student

Teo, 18, student

Xander, 18

Michael, 23, student

Abby, 18, student

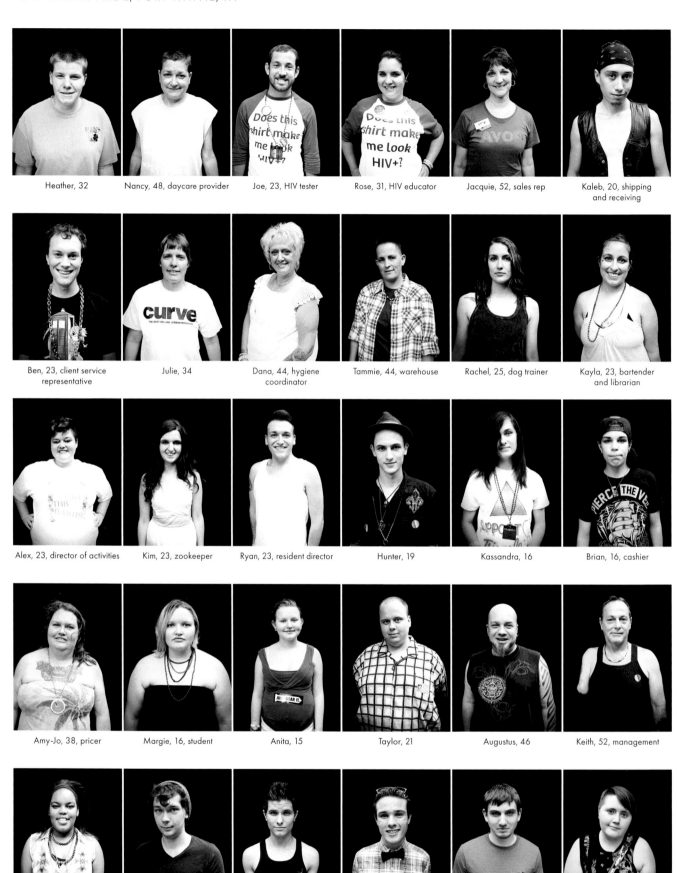

Heather, 32

Nancy, 48, daycare provider

Joe, 23, HIV tester

Rose, 31, HIV educator

Jacquie, 52, sales rep

Kaleb, 20, shipping and receiving

Ben, 23, client service representative

Julie, 34

Dana, 44, hygiene coordinator

Tammie, 44, warehouse

Rachel, 25, dog trainer

Kayla, 23, bartender and librarian

Alex, 23, director of activities

Kim, 23, zookeeper

Ryan, 23, resident director

Hunter, 19

Kassandra, 16

Brian, 16, cashier

Amy-Jo, 38, pricer

Margie, 16, student

Anita, 15

Taylor, 21

Augustus, 46

Keith, 52, management

Mary, 17

Adam, 21, manager

Michael, 23, server

Ryan, 18, McDonald's

TJ, 20, cashier

Erin, 22

Amy, 20, student

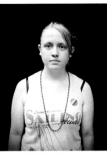

Caitlin, 22, student

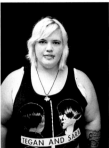

Ashley, 21, student

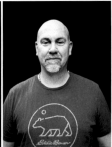

Randy, 49, management

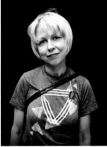

Bridgett, 36, salon owner
and hairstylist

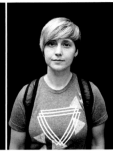

Stephanie, 28, sales
consultant

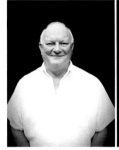

Michael, 68, retired

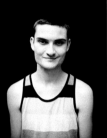

Blake, 19

Keky, 39, theater director

Isabel, 15, student

Angie, 43, home
healthcare aide

Kimberly, 40, pharmacy tech

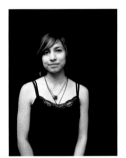

Jessie, 18

PITTSBURGH BLACK PRIDE
PITTSBURGH, PA
JULY 27, 2014

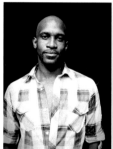

Ira, 31, ballet dancer

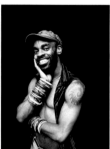

Martel, 32, dancer

Fats, 60, wife

Cindy, 44, CNA

PA, 24

Asia, 35, pharmacy tech

Bee, 38, cook

Maria, 25, makeup artist

Ashley, 24, nurse assistant

Solomon, 24, CNA

Jazmine, 45, driver

Denise, 53, retired

Latausha, 31, caretaker

Jay, 54, corporate manager

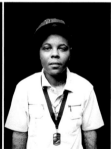

Yo, 32

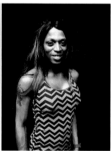

Tiarah, 28, cosmetologist

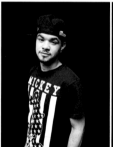

Drew, 23, caregiver

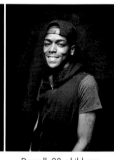

Darnell, 28, childcare professional

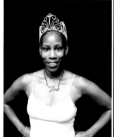

Lois, 37, self-employed

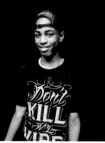

Jahmar, 25, dancer

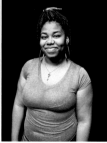

Aubre, 19

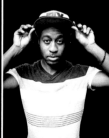

Moton, 33, manager

Taray, 39, department manager at Walmart

Kimberly, 49, health unit coordinator

Douglas, 59, registered nurse

Ryan, 23, student and barista

Booder, 28, school bus driver

Vinay, 21, manager, and Taye

AJ, 24, line cook

Diane, 45

Vannie, 22, food and beverage

Sedrah, 32, nurse

Jennifer, 48, warehouse

Leah, 23, server

Courtney, 33, engineer

Flip, 52, lead HAB aide

Flecia, 51

Prin, 25, inbound tech support

TJ, 31, medical assistant

Chrissy, 31, hairstylist

Britney, 24, home health aide

Shaun, 25, sales and marketing

Alya, 21, hairstylist

Sean, 21, boss

Brittney, 25, massage therapist

FARGO-MOORHEAD PRIDE
FARGO, ND
AUGUST 16, 2014

Adam, 22, RN

Marissa, 28, HR manager

Heather, 37, social worker

Bobbie, 25, editor

Janis, 62, state director

Garrett, 22, student

Matt, 30, community organizer

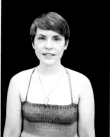

Angela, 21, student

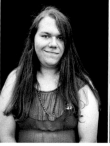

Dee, 22, environmental services

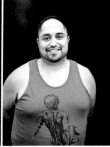

Tony, 26, lead teller

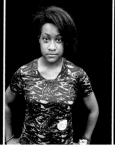

Jade, 17, Burger King cashier

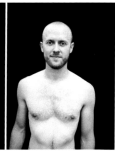

Jared, 28, system administrator

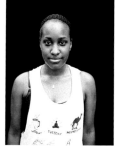

Asia, 21, assistant manager

Jack, 65, quality control

Amanda, 33, social worker

Christina, 38, sales management

Heather, 28, courier

Nicole, 21, student

Carrie, 29, insurance

Rochelle, 25, RN

Jill, 35, nurse

Joshua, 32, state representative

Kyle, 27, student

Dean, 55, mental health

Crystal, 25, postal service

Lindsay, 28, biller

Elizabeth, 28, workflow coordinator

Cheyenne, 28, receptionist

Geneva, 22, librarian

Sylvia, 37, scheduling assistant

Bruce, 25, cashier

Kendrick, 27

Christopher, 32

Michael, 28, pharmaceutical

Christopher, 42, fragrance specialist

Ryan, 21, warehouse worker

Tansy, 22, entomology research assistant

Heather, 23, student

Vel, 78, retired

Jess, 21, supervisor at KFC

David, 29, retail management

Jake, 41, healthcare

Casey, 26, vanguard

Maria, 18, student

Scott, 38, engineer

Autumn, 19, market researcher

Topher, 25, student and school aide

Heather, 23

Ray, 54, professor

Cindy, 59, university lecturer

Lee, 59, pharmacist

Christopher, 43, store manager

Patrick, 22, pharmacy tech

Kelley, 23, warehouse manager and US Army Reserve

JE, 62

Thomas, 22, student

Paul, 24, delivery driver

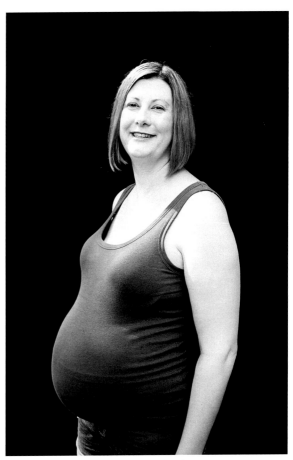

Celeste, 38, social worker

Anthony, 27, makeup artist

Garrett, 22, bartender and student

Kevin, 41, stylist

Kevin, 50, maintenance

Brandon, 25, phlebotomist

Wayne, 46

Beth, 41, graphic designer

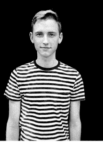
Josh, 20, barista

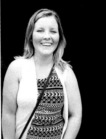
Caitlyn, 20, barista

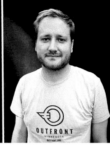
Chris, 34, political director

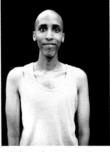
Mohamed, 21, AmeriCorps mentor

Sera, 13, student

Allan, 61, security officer

James, 33, purchasing manager

Brian, 52, computer and IT

Rhea Ann, 35, accounting services

Chad, 22, student

Barbara, 36, UPS

Justin, 33, general manager

Anthony, 32, CDL driver, nurse, and LXMO

Matthew, 29, student

Amber, 29, daycare provider

Joshua, 23, student

Erik, 20, banker and sales

Johnny, 32, cook and server

Paulo, 35, illustrator

Kodi, 25, night audit

Grace, 21, biologist

Calvin, 43, publishing, editor, and newspaper

Annie, 32, volunteer coordinator and editor

Day, 37, writer

Jessy, 16, student

Ashlee, 24, process technician

Hayley, 26, arborist

Robert, 24, Walmart

Angel, 31, travel nurse

Jaren, 30, mailman

Nyx, 39, food service

Yuki Raven, 20, food service

Kadance, 32, professor

Anita, 53, teacher

Kate, 23, student

Christine, 42, transcriptionist

Jess, 31, substitute teacher

Anthony, 19, cleaners

Dane, 33, temp

Stacey, 30, health insurance

Shari, 34, claims processor

Debbie, 52

Jenn, 39, nursing home activities

Bender, 26, photographer

Shana, 29, nurse

Annie, 34, caregiver

Jomo, 37, manager

Lilyan, 28, web programmer

Emily, 27, foster parent

Katie, 18, student

Danny, 17, student

Ashley, 14, student

Sheri, 47, musician

Amber, 25, manager

Michael, 48, social work

Jonathan, 29, education

Trisha, 26, substitute teacher

Amy, 33, child therapist

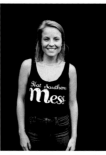
Vyonne, 30, social work

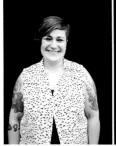
Adria, 36, health services manager

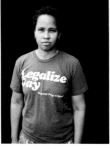
Kristin, 36, attorney

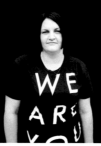
Charly, 27, mental health

Candace, 29, social worker

Dina, 27, military and veteran

Emily, 29, cell phone tower tech

Katie, 35, teacher

Jaime, 36, training specialist

Emily, 22, law student

Mackenzie, 23, bartender

Heather, 41, kitchen manager

Ray, 51, electrician

Krishna, 28, track and field coach

Jessica, 27, forensic specialist

Erica, 24, crime scene investigation

Rebecca, 34, police officer

Conor, 36, office manager

Victoria, 30, education and outreach coordinator

Diane, 34, health worker Mirella, 22, student Jenna, 24, student Danielle, 37, graphic designer Gina, 36, retail management Beth, 32, bartender

Ellie, 16, student Libby, 14, student Shannon, 27, QA associate Julie, 48, mom Roze, 23, student Jennifer, 23, software developer

Kristen, 33, teacher Craig, 34, art handler Emily, 40, artist Lindsey, 35, victim services coordinator Abigail, 29, recording technician Amy, 34, federal government contractor

Danuta, 24, advertising George, 33, engineer John, 46, engineering Patrice, 27, photographer Mattie, 16, student Julie, 51

Kate, 35, customer service Kristy, 30, probation officer Luis, 44, artist Kimberly, 29, teacher Sarahlynn, 32, receptionist Blue, 34, loan assistant

Aaron, 33, karaoke host

Peggy, 31, designer

Reid, 15

Rachel, 35, interior painter

John, 59, pharmacist
and pastor

David, 31, industrial designer

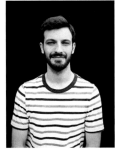

Mitchell, 27, field service
engineer

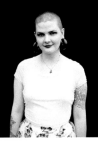

Palmer, 24, dominatrix
and sex worker

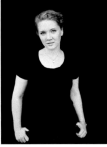

Christie, 24, marketing
and vet tech school

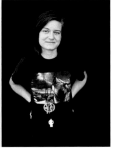

Gillian, 27, urban gardening
lab instructor

LAS VEGAS PRIDE
LAS VEGAS, NV
SEPTEMBER 6, 2014

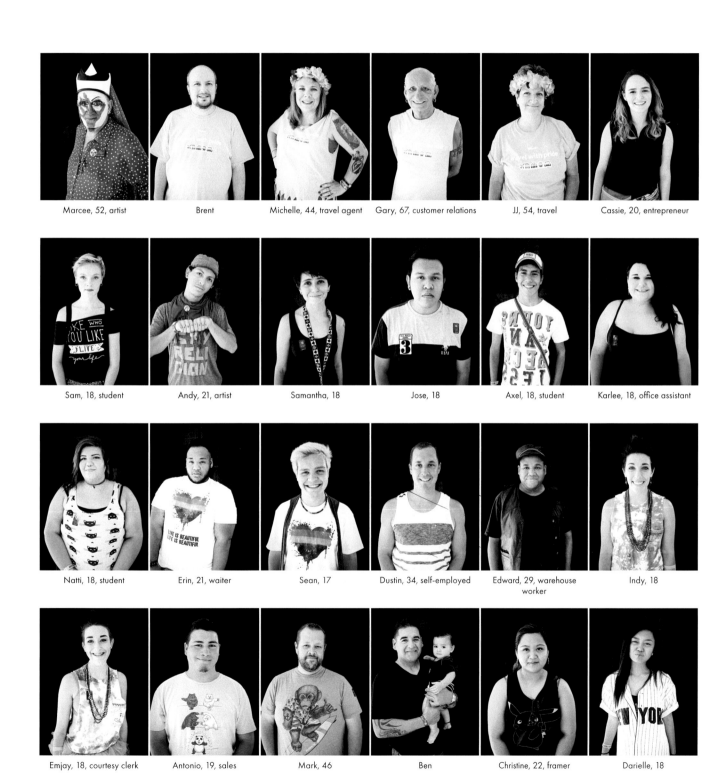

Marcee, 52, artist Brent Michelle, 44, travel agent Gary, 67, customer relations JJ, 54, travel Cassie, 20, entrepreneur

Sam, 18, student Andy, 21, artist Samantha, 18 Jose, 18 Axel, 18, student Karlee, 18, office assistant

Natti, 18, student Erin, 21, waiter Sean, 17 Dustin, 34, self-employed Edward, 29, warehouse worker Indy, 18

Emjay, 18, courtesy clerk Antonio, 19, sales Mark, 46 Ben Christine, 22, framer Darielle, 18

Matthew, 20, call center rep

Todd, 38, self-employed

Summer, 35, medical assistant

Wayne, 41, entertainer

Nev, 18, cashier

Morgan, 17

Reilly, 17

Jamie Lee, 52, student

David, 56,
school bus driver

Brandon, 18,
sales associate

Alex, 24,
patient services rep

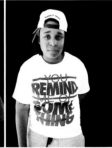

Lynette, 24,
security guard

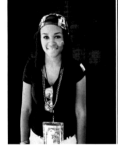

Chanelle, 18, pizza server

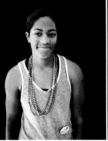

Lonah, 18, Downtown
Disney CSA

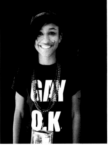

Tracey, 18, CSA

Jaleesa, 25, special aide

Cindy, 25, CrossFit coach

Sergio, 29, community center

Leonardo, 46, owner
and hairstylist

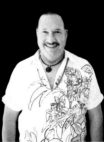

Michael, 55, retired

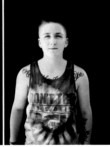

Kylie, 20

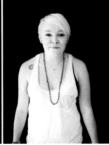

Lachelle, 19, CNA

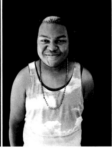

Manee, 18

Khellie, 20, surgical tech

John, 30, server

Kaitlyn, 22, receptionist

Nathan, 24, server

Tara, 41, mortgage processor

Christina, 43, mortgage
processor

Shadi, 14

Sister Tillie, 45, self-employed

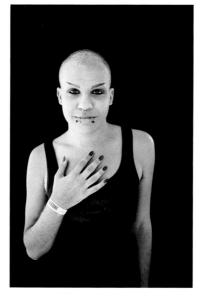

Salem, performing arts

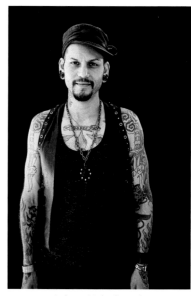

Anthony, 38, leathersmith

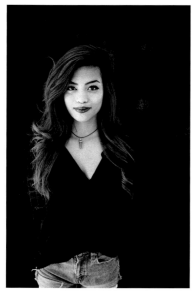

Alyssa, 17, student

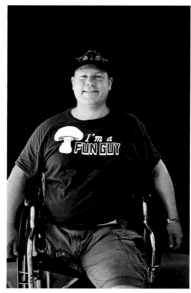

Alexander, 44, sales

Patricia, 55, disabled

Craig, 49, disabled

Sir Jim, 57, customs broker

Sister Loosy, 50, retired

Alicia, 18

Jon, 25, tanning salon manager

Daniel, 21, security

Monte, 25, music, rap, and singing

Jessie, 19, piercer

Jessica, 28, bartender
and artist

Taylor, 56, retired

Griselle, 28, structural
engineer

Scott, 25, designer

EJ, 27, stage manager

Avery, 16, lifeguard

Mo, 18, NSC

Jordan, 20, barista and singer

Nico, 25, resort agent

Deacon, 50, leatherworker
and tailor

David, 37, administrator

Dee, 23, assistant manager

Santos, 36,
HIV test counselor

Ramon, 21,
massage therapist

Gina, 22, student

Lauren, 25, interior designer

Jessica, 26, biller

Kristin, 28, engineer

Stephen, 28, student

Karissa, 15, student

Brena, 21, sales

Courtney, 25, medical
assistant

Stephanie, 23, sales

Macy, 23, vet tech

Samantha, 27, construction

Myshele, 21, US Army

Taylor, 23, insurance

Kyle, 34, vet tech

Autumn, 41, sales

Christina, 21, insurance agent

Leah, 24, athletic trainer and student

James, 29, cashier

Heather, 30, office manager

Megan, 21, manager

Darryl, 49, RN

Danny, 54, customer service

Abby, 27, manager

Zee, 23, self-employed

Shaun, 48, showroom consultant

Denny, 67, retired

Johnnie, 19, lifeguard

Matthew, 18, Subway crew

Paula, 47, student

Lucas, 18, student

Miriam, 25

Esmeralda, 25, safety

Randy, 23, timeshare phone operator

Jarred, 26, electrician

Michelle, 43, senior analyst

Devon, 14

Krissy, 41, merchant teller

Angelique, 27, accounting

Rian, 28, financial advisor

Valerie, 25, clerk

Christina, 27, sales rep

Ophelia, 27, underwriter and burlesque

Jeffrey, 28, drag king

Dom Zo Zo, 16

Mark, 48, sales

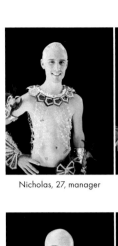

Nicholas, 27, manager

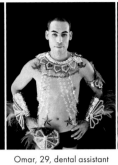

Omar, 29, dental assistant

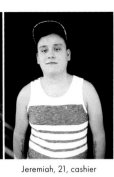

Jeremiah, 21, cashier

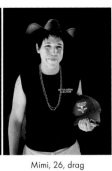

Mimi, 26, drag

Paul, 32, entertainer

Michael, 18

Gary, 21, bartender and realtor

Kenny, 36, computer technician

Xavier, 38, health educator

Robert, 37, teacher

Christina, 27, retail

Robert, 57, retired

Detrick, 32, manager

David, 49, billing

Dany, 27, sales associate

Juan, 17

Holly, 16

Karina, 15

Tania, 16

Kayla, 18, student

Ree, 20, student

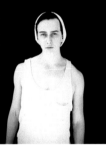

Justin, 19, student

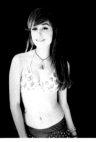

Kyla, 17, student

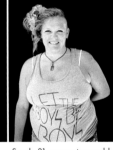

Sarah, 31, accounts payable

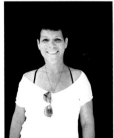

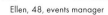

Ellen, 48, events manager

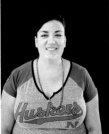

Paige, 24, 911 dispatcher

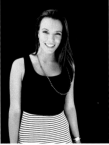

Samantha, 22, model

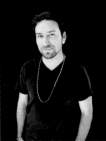

Damien, 37, server and host

Carlos, 25, sales

Tess, 50, coach operator

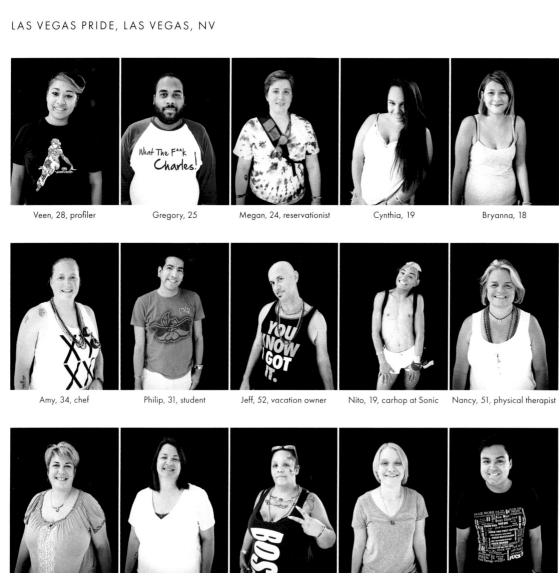

Veen, 28, profiler

Gregory, 25

Megan, 24, reservationist

Cynthia, 19

Bryanna, 18

Buffy, 42, admin

Amy, 34, chef

Philip, 31, student

Jeff, 52, vacation owner

Nito, 19, carhop at Sonic

Nancy, 51, physical therapist

Elizabeth, 49, RN

Wendy, 43, teacher

Kathryn, 47, teacher

Fannie, 34,
stay-at-home mom

Deanna, 18, student
and babysitter

Raul, 18, student

Wade, 39, gemologist

Eric, 40, trainer

John, 52, surveillance

Deborah, 49, nurse

Sam, 17, student

Dakota, 16, student

Chris, 17, student

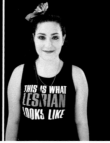

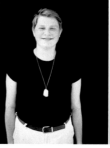

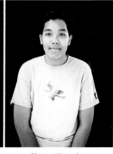

Paula, 49, senior manager

Rhonda, 42, corporate
travel consultant

Liz, 42, supervisor

Karen, 42, social worker

Heather, 24, rental lab
technician

Katelynn, 23

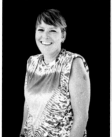

Steven, 23, insurance agent, and Alissa, 4

Kevin, 28, driver and manager, and Alissa, 4

Keri, 43, retired

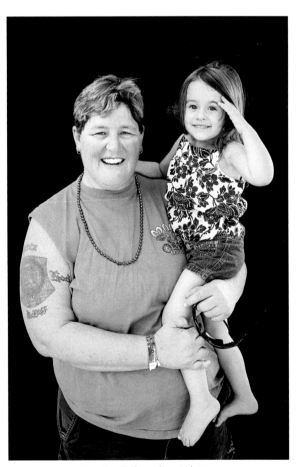

Mary Ann, 51, flow voltage technician

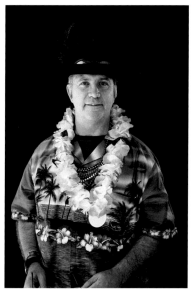

Timothy, 54, retired US Marine

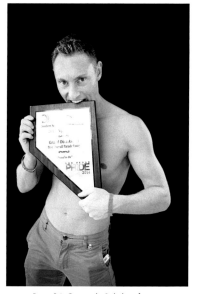

Ross, 34, Cirque du Soleil performer

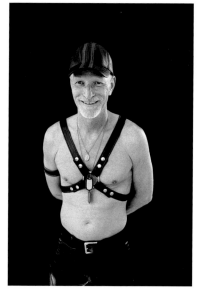

Kerry, 53, travel counselor

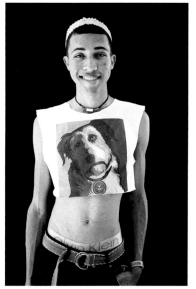

Tyler, 18, college student

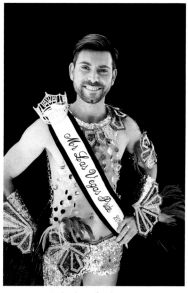

Michael, 38, food service

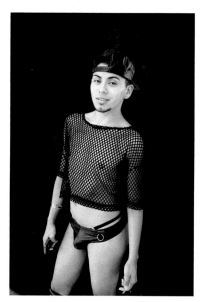

Jay, 23, makeup artist

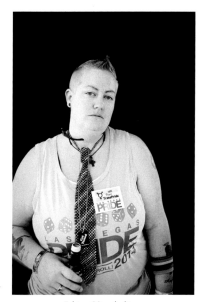

Tobias, 28, cab driver

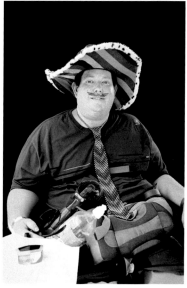

George, 34, disabled

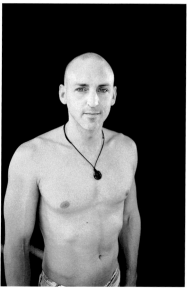

Benoit, 36, performer

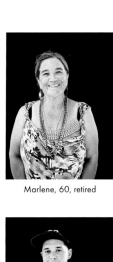
Marlene, 60, retired

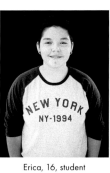
Erica, 16, student

Chris, 43, cage cashier

Nuna, 30, CSIZ

Emily, 18, student

Ajay, 30

Colby, 23, US Air Force

Cody, 21, server

Jerry, 42, specialist

Lee, 71, retired

Jonathan, 22, actor

Sam, 30, housewife

Katie, 20, retail

Jennifer, 21, cashier

Vicky, 28, bank manager

Chelsei, 18, student

Samantha, 15, student

Krystyna, 18, student

Brennon, 19

Courtney

Brittany, 22, retail

Jaclyn, 24, student

Heather, 26, office assistant

Jaiden, 28, historian and artist

David, 20, administrative assistant

Sarah, 34, marriage and family therapist

Jennifer, 40, administrative assistant

Alex, 19, dispatcher and operations

Craig, 46, teacher

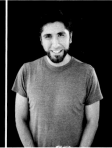
Miguel, 39, teacher

381

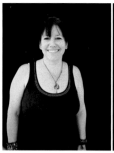

Joanna, 48, graphic designer and teacher

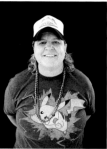

Cherie, 48, medical

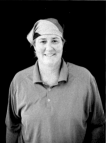

Denise, 47, receiver

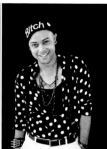

Jermajesty, 27, fashion

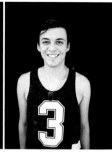

Juan, 21, student

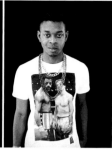

David, 22, retail

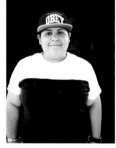

Claudia, 22, student

Shareece, 22, Dodger Stadium

Dan, 52, education

Daniel, 55

Brendan, 42, banker

Paul, 36, baker

Lani, 40, customer service rep

Tiffany, 30, customer service

Wanda, 33, grad student

Gary, 63, designer

Kristov, 18

Tobi, 18

Brian, 26

Jonathan, 29

Robert

Marie

Mateo, 31, hairstylist

Brandon, 29, bartender

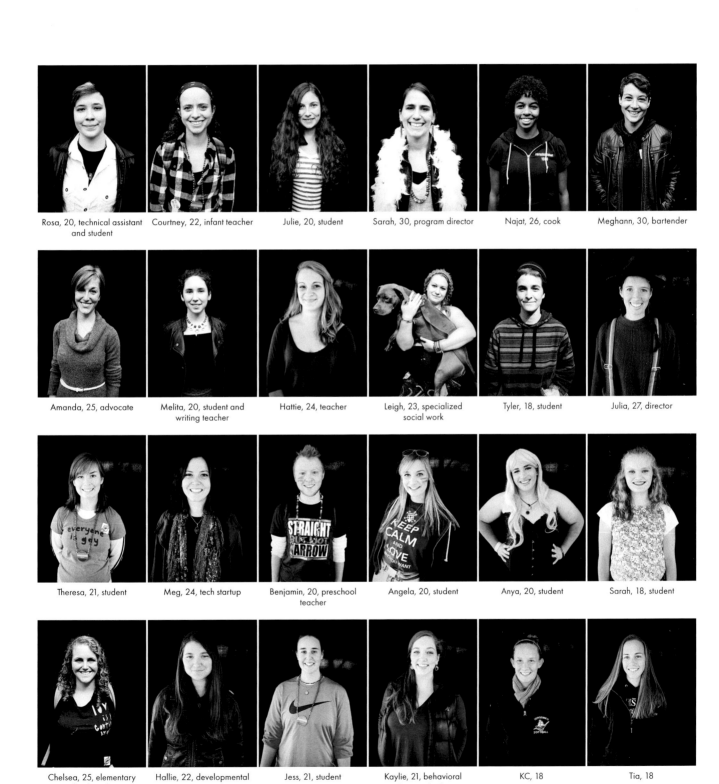

Rosa, 20, technical assistant and student

Courtney, 22, infant teacher

Julie, 20, student

Sarah, 30, program director

Najat, 26, cook

Meghann, 30, bartender

Amanda, 25, advocate

Melita, 20, student and writing teacher

Hattie, 24, teacher

Leigh, 23, specialized social work

Tyler, 18, student

Julia, 27, director

Theresa, 21, student

Meg, 24, tech startup

Benjamin, 20, preschool teacher

Angela, 20, student

Anya, 20, student

Sarah, 18, student

Chelsea, 25, elementary school teacher

Hallie, 22, developmental services

Jess, 21, student

Kaylie, 21, behavioral interventionist

KC, 18

Tia, 18

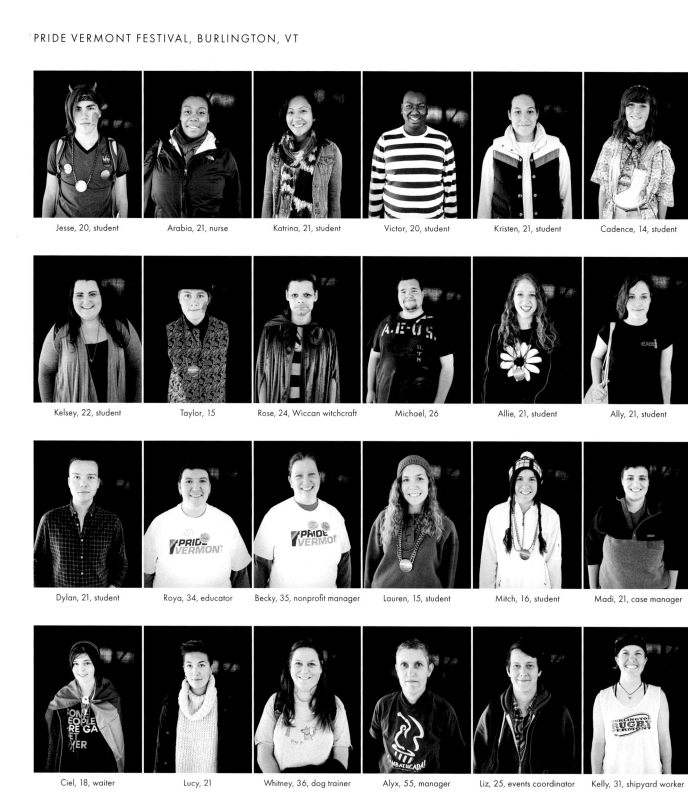

Jesse, 20, student Arabia, 21, nurse Katrina, 21, student Victor, 20, student Kristen, 21, student Cadence, 14, student

Kelsey, 22, student Taylor, 15 Rose, 24, Wiccan witchcraft Michael, 26 Allie, 21, student Ally, 21, student

Dylan, 21, student Roya, 34, educator Becky, 35, nonprofit manager Lauren, 15, student Mitch, 16, student Madi, 21, case manager

Ciel, 18, waiter Lucy, 21 Whitney, 36, dog trainer Alyx, 55, manager Liz, 25, events coordinator Kelly, 31, shipyard worker

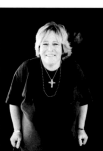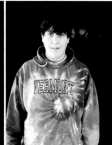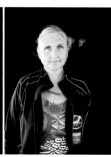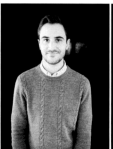

Jennifer, 31, dentist Lisa Ann, 50, peer support Shannon, 41, toddler teacher Maike, 58, professor Ryan, 25 Kaia, 15, student

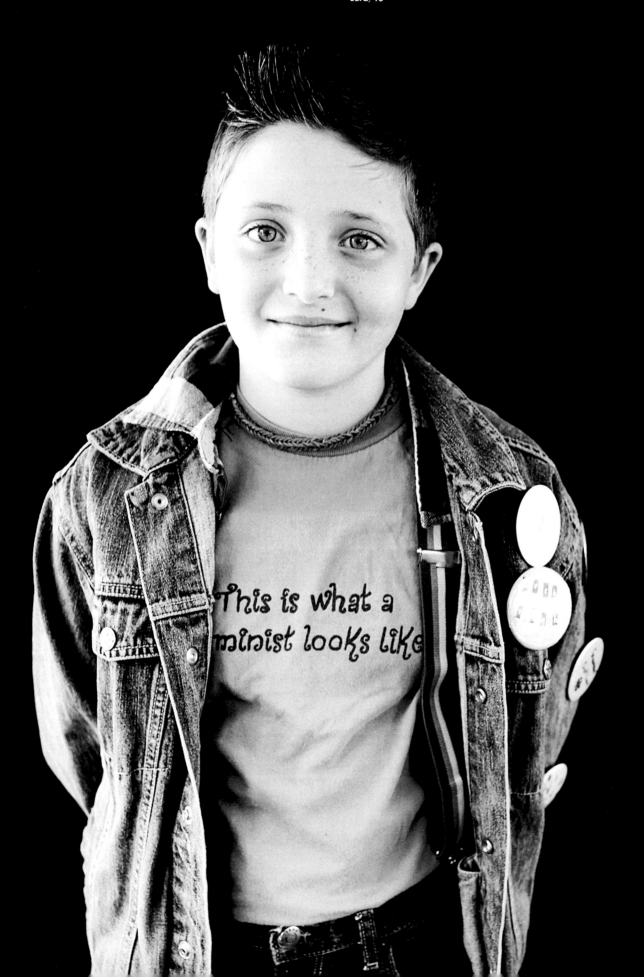

Ezra, 10

Javier, 29, immigration officer

Rinker, 20, binder

Nicholas, 28, actor

Ami, 26, grad student

Miles, 27, social worker

Aurora, 27, homeless shelter assistant

Damian, 19, cashier

Stephen, 18, DRA

Bryn, 31, environmental analyst

Leea, 18, student

Jada, 35, teacher

Jan-Luis, 20, student

Jill, 34, physician assistant

Lucas, 23, digital specialist

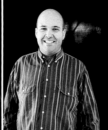

Drew, 31, school bus driver

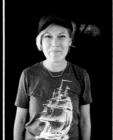

Heather, 40, psychotherapist

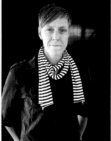

Imogen, 41, sales

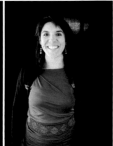

Bess, 28, medical assistant

Claire, 39, development

Cori, 32, counselor

Jan, 60, financial service

Pippi, 28, owner and retail

Sam, 17, student

Cherie, 19, drag queen

Aasha, 25, retail

Aurora, 20, student and deli associate

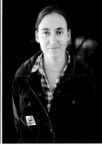

Annie, 30, teacher

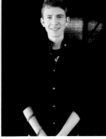

Alex, 20, student

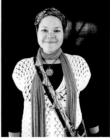

Jennifer, 44, higher education student affairs

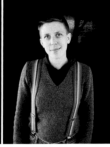

Dana, 27, graphic designer, baker, and admin

Jacob, 22, student

Jonathan, 22, student

Michelle, 25, counselor

Alicia, 33, operation specialist

Meesh, 34, chocolate packager

Caroline, 20, youth outreach coordinator

Saer, 19, student

Emma, 18, college student

Carly, 18, college student

Kelly, 18, student

James, 33, waiter

Henry, 21, student

Sunshine, 28, ICU vet tech

Valerie, 23, grad student

Emily, 23, microbiologist

Amanda, 30, respite worker

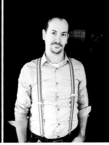
Josh, 33, program supervisor

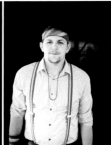
Justin, 32, prep cook

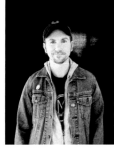
Cole, 34, independent scholar

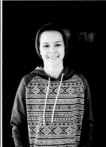
Randi, 18, student

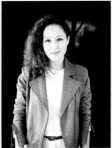
Isabella, 18, student

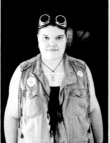
Erin/Erik, 21, student

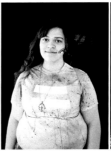
Mina, 21, student

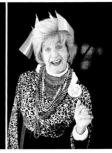
Amber, 58, performer

Emiry, 34, mental health and addiction counselor

Randy, 18, student

Emma, 26, media analyst

Emily, 29, digital marketing

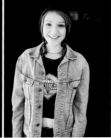
Jamie, 18, student

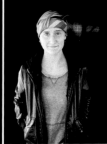
Sophie, 18, student

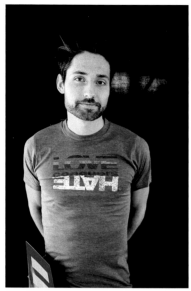

Justin, 25, Special Olympics Vermont

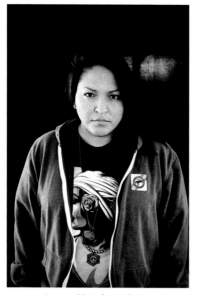

Latricia, 29, student and artist

Micah, 30, Outright Vermont

Robella, 45, newspaper carrier

Alma, 9, student

Karl, 31, carpenter

Ryan, 19, student

Luci Furr, 34, chef

Leonard, 59

Cat, 23, dogs

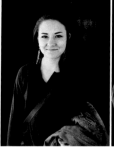

Emily, 21, dog handler

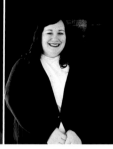

Amanda, 21, hairstylist receptionist

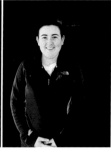

Rebecca, 20, assistant housekeeper

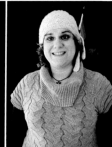

Bridget, 25, software engineer

Jamie, 28, doggy daycare

Van, 57, student

Rebecca, 26, videographer

Sven, 16, student

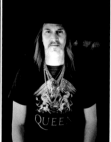

Shakey, 50, retired cook

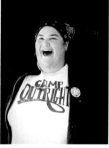

Aris, 38

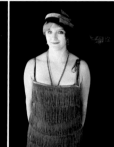

Innocent Ivy, 26, cashier

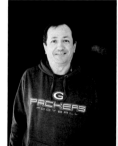

Gary, 46, blogger

Shawn, 39, chef

Donny, 38, graphic design

Sadie, 18, sales associate

Aly, 19

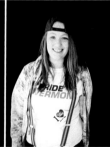

Katherine, 21, student

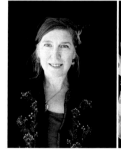

Cecile, 51, seamstress

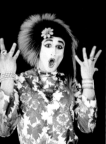

Major Force, 29, retail

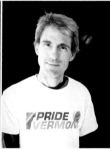

JD, 46, writer

Gregg, 37, engineer

Erika, 33, distributor

Sarah, 30, firmware engineer

Merrique, 26, bank teller and burlesque dancer

Aeshna, 29, town planner and belly and burlesque dancer

Becky, 36, sustainability professional

Alexa, 28, cabaret producer

Philip, 32, chef and general manager

Grace, 19, student

Emily, 20, student

Gibson, 44, PM

Nikki Champagne, 20, student

Matthew, 49, computer programmer

Marissa, 34, software engineer

Amy, 24, insurance agent

Shyshy, 21

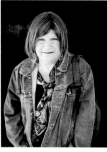

Brenda, 57, customer service

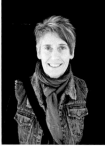

Laurie, 49, astrologer

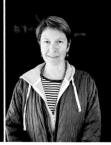

Nan, 58, early educator

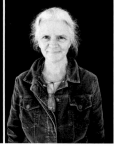

Mary, 60, paralegal

Kate, 62, librarian

Nick, 27, behavioral interventionist

Liz, 28, timber framer

Adam, 18

Orion, 16

Doris, 24, research assistant

Maya, 42, engineering

Tacy, 19, Job Corps

Ann, 20

Lee, 26, herbalist

Sebastian, 24, direct service

Elijah, 24, cook

Keith, 14

Jelly, 14, babysitter

Helen, 14

Joshua, 21

Rachel, 27, environmental educator

Vincent, 23, dog behavioralist and illustrator

Alissa, 24, early educator

Elaine, 18, student

Samantha, 20

Nicholas, 23

Tucker, 22, glassblower

Jon, 30, federal government

Chaz, chef

Ernie, 54, sales consultant

Laura, 25, homeless
shelter staff

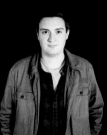

Will, 16, student

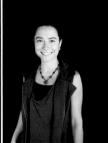

Michal, 28, yoga

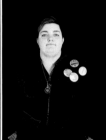

Jake, 22, student

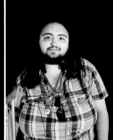

Galen, 28, artist
and volunteer

Skittlez, 30, hotel and food

Randy, 58, realtor

Micalee, 32, teacher

Charles, 61, retired

Kim, 46, executive director

Amber, 31, librarian

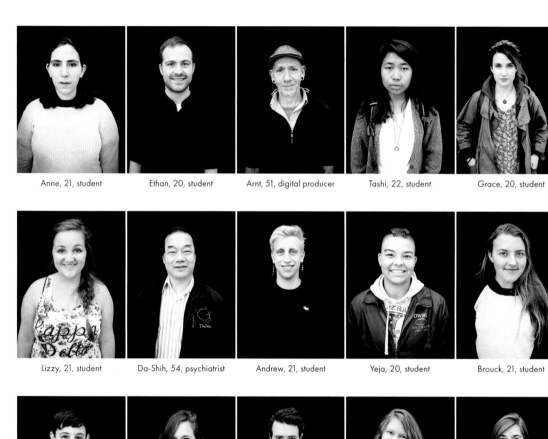

Anne, 21, student
Ethan, 20, student
Arnt, 51, digital producer
Tashi, 22, student
Grace, 20, student
Shiella, 31, higher education admin

Lizzy, 21, student
Da-Shih, 54, psychiatrist
Andrew, 21, student
Yeja, 20, student
Brouck, 21, student
Kerry Anne, 20, student

Mick, 20, student
Emily, 21, marketing manager
Jimmy, 20, student
Kristina, 19, student
Tatjana, 18, student
Catherine, 22, student

Kevin, 29, student
Ruben, 18, student
Chan, 22, student
Ellen, 21, student
Michelle, 27, associate director of CGSE
Olivia, 18, student and Sunday school teacher

John, 52, librarian

Brian, 54, psychologist

Kevin, 19, student

T, 22, student

Stephanie, 22, project manager

Connie, 21, student

Luke, 20, student

Jennifer, 21, student

Murgatroyd, 18, student

Mel, 24, student

Joe, 18, student

Nick, 19, student

Derrick, 29, college administrator

David, 20, student

Kelsey, 19, student

Selome, 19, student

Gerben, 21, student

Julia, 19, student

Terren, 18, student

Matt, 23, photo instructor

Larissa, 18

Singer, 20, student

Mau, 19, student

Emily, 20, student

Emma, 21, student

Lee, 22, student

Zac, 20

Yujin, 22, student

Gaby, 20, designer and student

Melina, 20, student

Alanna, 40, event director

Sophie, 20, student

Ian, 24, med student

Kelsey, 19, student

Anthony, 23, student

Arielle, 24, student

Larissa, 32, assistant dean

Joe, 26, physician

Robert, 27, student

Amber, 19, student

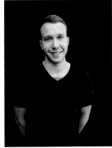

Max, 22, student

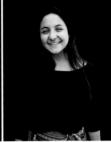

Elise, 18, student

Erin, 21, student

Chris, 21, student

Mark, 50, administration

Simone, 20, student

Troy, 20, student

Jeffrey, 62, childcare
administrator

Gabby, 19, student

Michael, 20, student

OBERLIN COLLEGE

OBERLIN, OH

SEPTEMBER 17, 2014

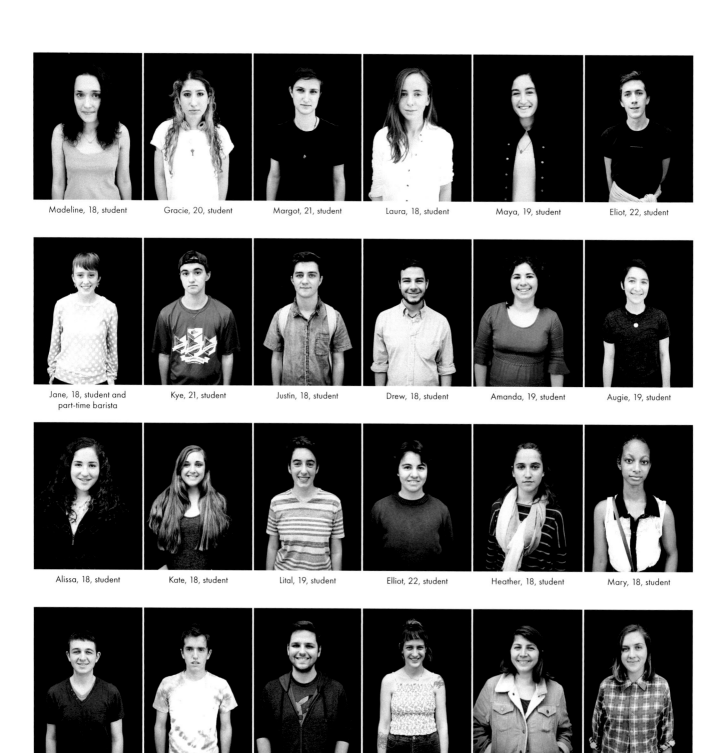

Madeline, 18, student Gracie, 20, student Margot, 21, student Laura, 18, student Maya, 19, student Eliot, 22, student

Jane, 18, student and part-time barista Kye, 21, student Justin, 18, student Drew, 18, student Amanda, 19, student Augie, 19, student

Alissa, 18, student Kate, 18, student Lital, 19, student Elliot, 22, student Heather, 18, student Mary, 18, student

Alex, 18, student Michael, 18, student Carlos, 18, student Sophie, 21, student Paris, 21, student Sara, 21, student

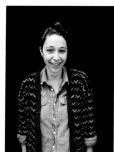
Sarah, 21, student

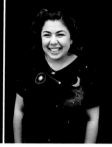
Olivia, 20, student

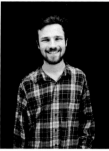
Nicholas, 19, student

Talia, 18, student

Quinn, 20, student

Kasey, 20, student

Sophie, 19, student

Theo, 19, human being

Rory, 18, student

Laurel, 19, student

Anna, 19, student

Della, 19, student

Claire, 18, student

Tom, 18, student

Katie, 19, student

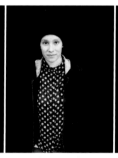
Ruby, 19, student

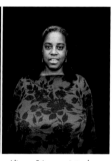
Alison, 54, associate dean
and director

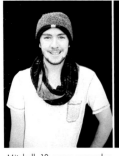
Mitchell, 18, camp counselor

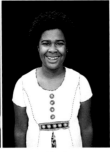
Micah

Katie, 19, student

Nicolette, 18, student

Duck, 18, student

Bailey, 19, student

Harry, 18, student

Sabrina, 21, student

Travis, 19, student

Stephen, 19, student

Hayley, 19, student

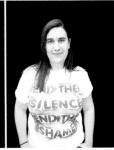
Alex, 20, student

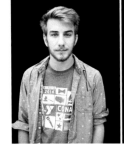

Eric, 18, student

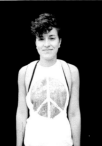
Maggie, 20, student

Michael, 61, realtor

Mike, 51, realtor

Freddie, 61, policy analyst

Tom, 49, husband

Bob, 60, program manager

Chris, 32, program manager

Greg, 58, DOT

Mark, 56, property manager

Lou, 46, systems analyst

John, 53, computer
programmer

Tyler, 20, student

Aisling, 18, student

Thomas, 53, security engineer

Michael, 65, retired insurance broker

Barry, 60, associate professor

Michael, 48, business owner

SOUTH CAROLINA PRIDE
COLUMBIA, SC
SEPTEMBER 20, 2014

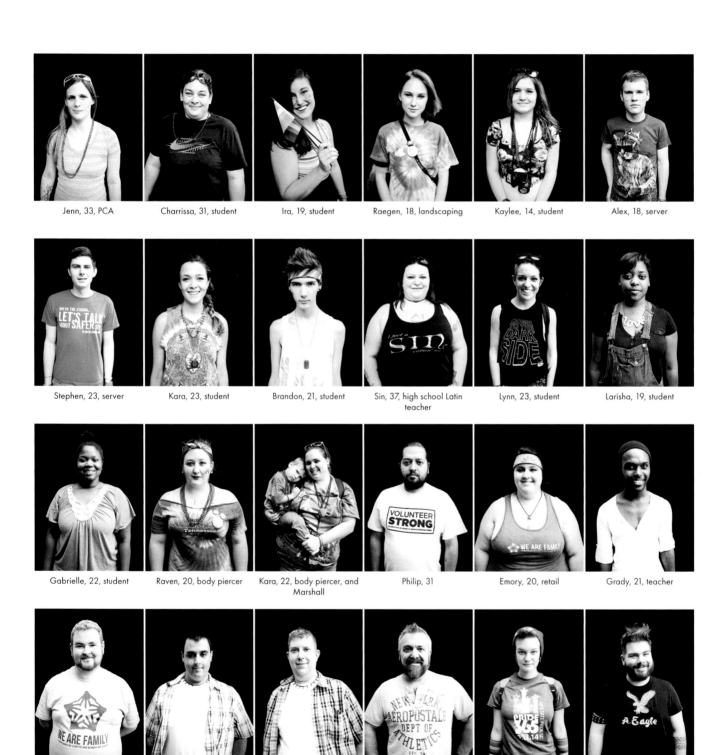

Jenn, 33, PCA

Charrissa, 31, student

Ira, 19, student

Raegen, 18, landscaping

Kaylee, 14, student

Alex, 18, server

Stephen, 23, server

Kara, 23, student

Brandon, 21, student

Sin, 37, high school Latin teacher

Lynn, 23, student

Larisha, 19, student

Gabrielle, 22, student

Raven, 20, body piercer

Kara, 22, body piercer, and Marshall

Philip, 31

Emory, 20, retail

Grady, 21, teacher

Michael, 21, benefits administrator

Michael, 22

Bruce, 30, CMA

AL, 47, retail management

Jinx, 18

Richard, 25, cosmetology instructor

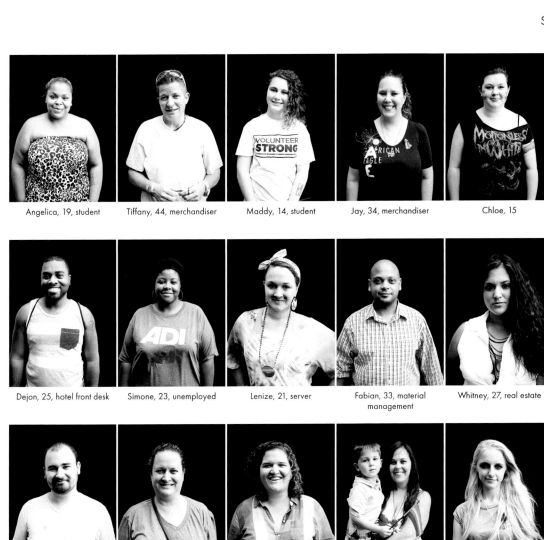

Angelica, 19, student

Tiffany, 44, merchandiser

Maddy, 14, student

Jay, 34, merchandiser

Chloe, 15

Jenny, 25, dance instructor and writer

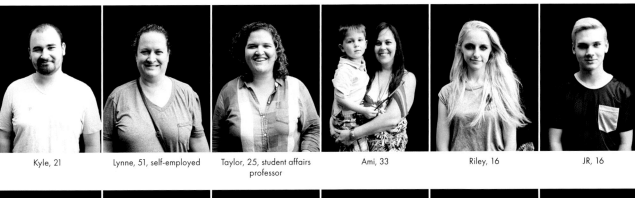

Dejon, 25, hotel front desk

Simone, 23, unemployed

Lenize, 21, server

Fabian, 33, material management

Whitney, 27, real estate

Jon, 23

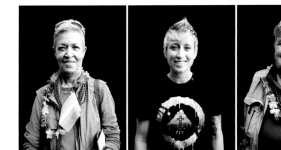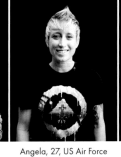

Kyle, 21

Lynne, 51, self-employed

Taylor, 25, student affairs professor

Ami, 33

Riley, 16

JR, 16

Barbara, 66, retired

Angela, 27, US Air Force

Jo, 63, retired

Leanna, 25

Amy, 26, grad student

Kyle, 26, data analyst

Brandon, 28, forecast analyst

Kali, 19, student and delivery driver

Brian, 26, admin

Anton, 27, student

Joshua, 24, admin specialist

Cannon, 19, student

Suziee, 18, student

Trell, 19, student

Garrett, 19

Nikki, 18

Will, 33

Bridget, 18

Sen, 28, student

Britt, 24, contract coordinator

James, 34, scientist

Kevin, 27, US Navy

Laura, 24, ABA therapist

Crystal, 24, bartender

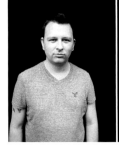

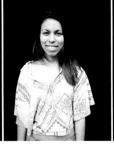
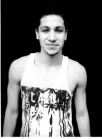
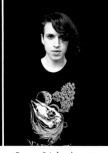

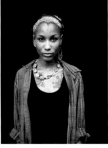
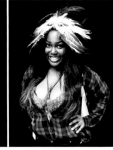

Daniel, 27, contract coordinator

Mary, 24, producer

Danny, 21, server

Emory, 24, food service and artist

Kestrel, 24, cosmetologist

Monica, 16, Zumiez

Ashley, 29, vet tech

Katie, 26, server

Matt, 32, artist

Ro, 18, server

Mallory, 19, student

Denton, 25, barista

Alexandra, 20, student

Gabriela, 20, student

Buckley, 19, cook

Miles, 19, barista

Zach, 18, student

Leigh, 26, café specialist

402

Brandis, 33

Patricia, 23, student

LA, 23, student

Quavo, 18

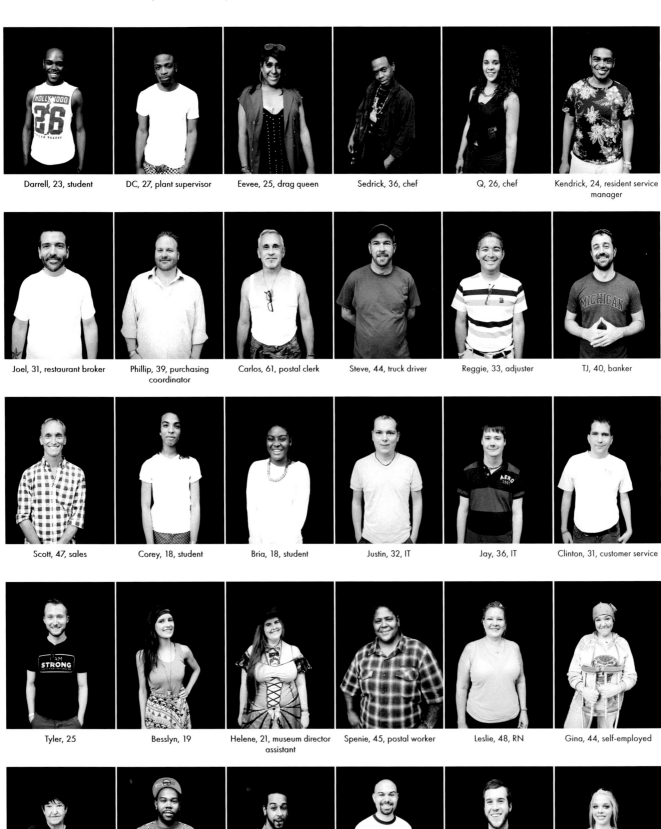

Darrell, 23, student DC, 27, plant supervisor Eevee, 25, drag queen Sedrick, 36, chef Q, 26, chef Kendrick, 24, resident service manager

Joel, 31, restaurant broker Phillip, 39, purchasing coordinator Carlos, 61, postal clerk Steve, 44, truck driver Reggie, 33, adjuster TJ, 40, banker

Scott, 47, sales Corey, 18, student Bria, 18, student Justin, 32, IT Jay, 36, IT Clinton, 31, customer service

Tyler, 25 Besslyn, 19 Helene, 21, museum director assistant Spenie, 45, postal worker Leslie, 48, RN Gina, 44, self-employed

Mary, 67, disabled Reno, 28, supervisor Bradley, 25, wardrobe stylist Judd, 33, self-employed Jesse, 22, singer-songwriter Lauryn, 21, bartender

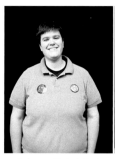

Rebecca, 31, technical
support

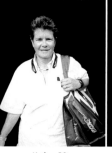

Kathy, 50,
pool technician

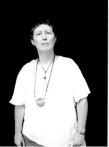

Laura, 54,
mortgage specialist

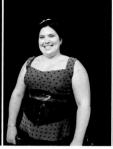

Robin, 32,
massage therapist

Allie, 18

Dominique, 21, musician
and writer

Jeffrey, 50, radiologic
technologist

Gary, 50, INS

Chuck, 34, network engineer

Don, 67, retired

Robert, 57, engineer

Tremanti, 19

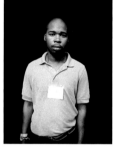

Freddy, 26, AIDS and
HIV board

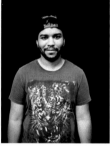

Christian, 25, professional
dancer

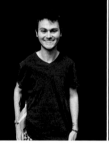

Frankie, 21, therapist
and student

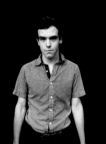

John, 19, business owner

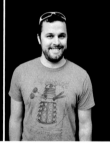

Kyle, 24, tech support

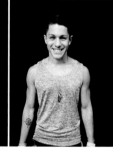

John, 18, student

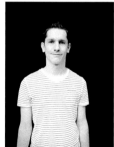

Justin, 25, chemist

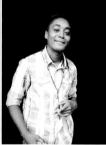

Brittnay, 28, front desk

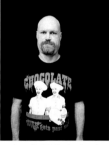

Joseph, 52, high school
librarian

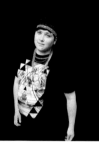

Evan, 20, CNA

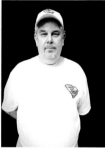

Bob, 50, food service industry

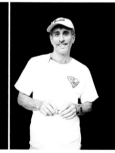

Carlos, 55, interpreter
and translator

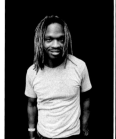

Jarvis, 26, community health
specialist and youth peer

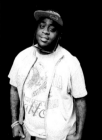

Sushii, 28, owner

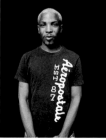

Bobby, 24, flight attendant

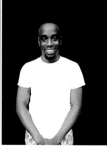

Tre, 25, medical assistant

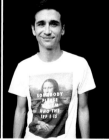

Rodman, 25, student

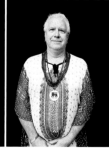

Bryan, 56, dental assistant

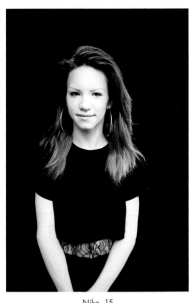

Niko, 15

Andre, 15

G

Jacece, 21

Paul, 49, engineer

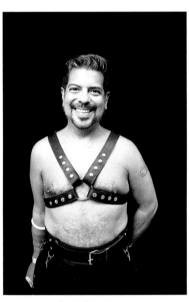

Don, 43, spa owner

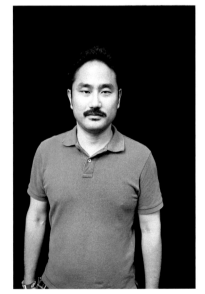

Kunio, 38, professor

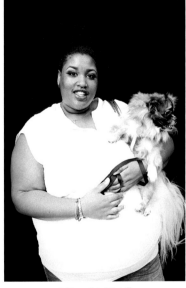

Brittany, 24, CS staff

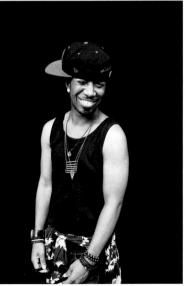

Braxton, 31, teacher

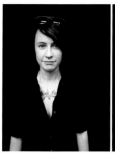

Ashley, 25, bartender

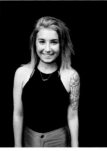

Taylor, 21, bartender

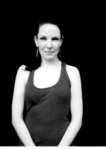

Sarah, 30, fundraiser

James, 29, financial advisor

James, 26, dental hygienist

Neil, 31, marketing

Michael, 36, RN

Makayla, 18

Krista, 24, student

Amanda, 23, student

Kevin, 27, server

Cole, 29, respiratory
consultant

Phillip, 40, social media
strategist

Karen, 40, technical writer

Eric, 44, electrician

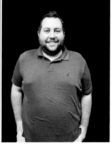

Ryan, 30, logistics manager

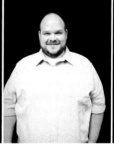

David, 38, auditor

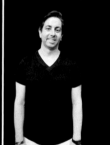

Daniel, 38, professor

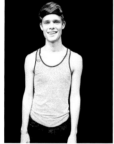

Andrew, 24, ultrasound
technician

Sarah, 27, nurse aide

Cenedra, 27, cashier

Madeline, 19, server

Hannah, 19, student

Ashley, 24, bartender

Rachel, 22

Angela, 42, RN

Megan, 20

Stann, 51, sales

Michael, 59, retired

Mary, 17

Echo, 23, manager

Juli, 28, Lowe's

Jen, 27, medical

Tina, 27, manager

James, 21, military

Ben, 28, manager

Sara, 24, EMS EMT

Michael, 26, customer service

Joshua, 24, EMT

Armando, 20, security officer

Hope, 21, student

Bri, 21, student

Will, 28, marketing

Doug, 47, purchasing agent

Tony, 20

Charlie, 19, English student

Megan, 20, server

Kat, 18

Alyssa, 17

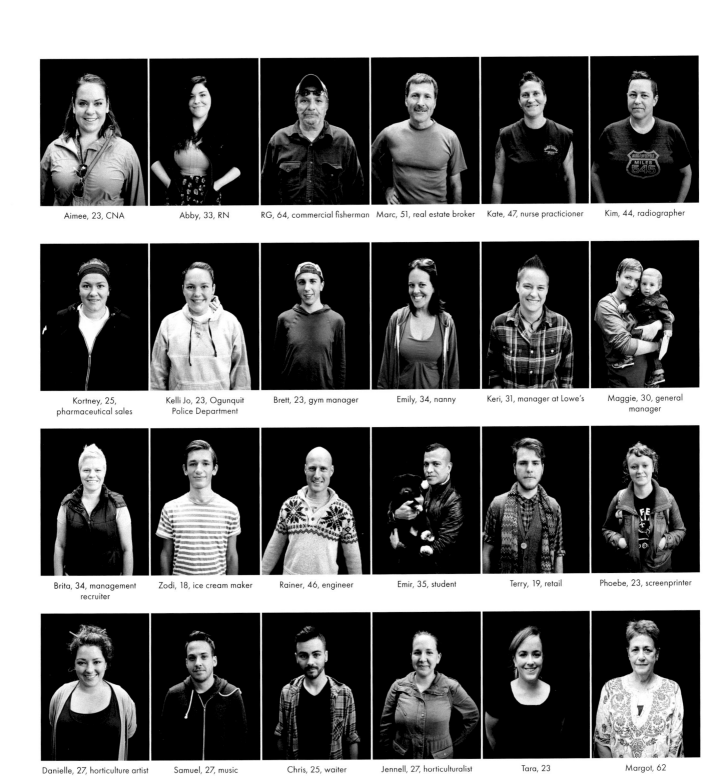

Aimee, 23, CNA

Abby, 33, RN

RG, 64, commercial fisherman

Marc, 51, real estate broker

Kate, 47, nurse practicioner

Kim, 44, radiographer

Kortney, 25, pharmaceutical sales

Kelli Jo, 23, Ogunquit Police Department

Brett, 23, gym manager

Emily, 34, nanny

Keri, 31, manager at Lowe's

Maggie, 30, general manager

Brita, 34, management recruiter

Zodi, 18, ice cream maker

Rainer, 46, engineer

Emir, 35, student

Terry, 19, retail

Phoebe, 23, screenprinter

Danielle, 27, horticulture artist

Samuel, 27, music

Chris, 25, waiter

Jennell, 27, horticulturalist

Tara, 23

Margot, 62

Jacob, 22, Portland Radio Group

Robyn, 27, designer

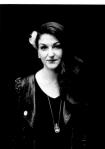

Renee, 25, bartender and musician

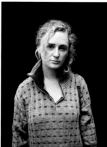

Wendy, 24, server

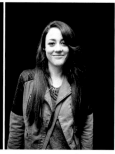

Maggie, 24, student and retail

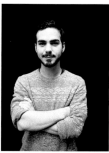

Justin, 24, student

Scott, 32, physician assistant

Peter John, 25

Lucy, 32, marketing researcher

Robert, 33, Sea Bags

Nate, 39, groundskeeper

Samuel, 19, student and artist

Marissa, 19, retail

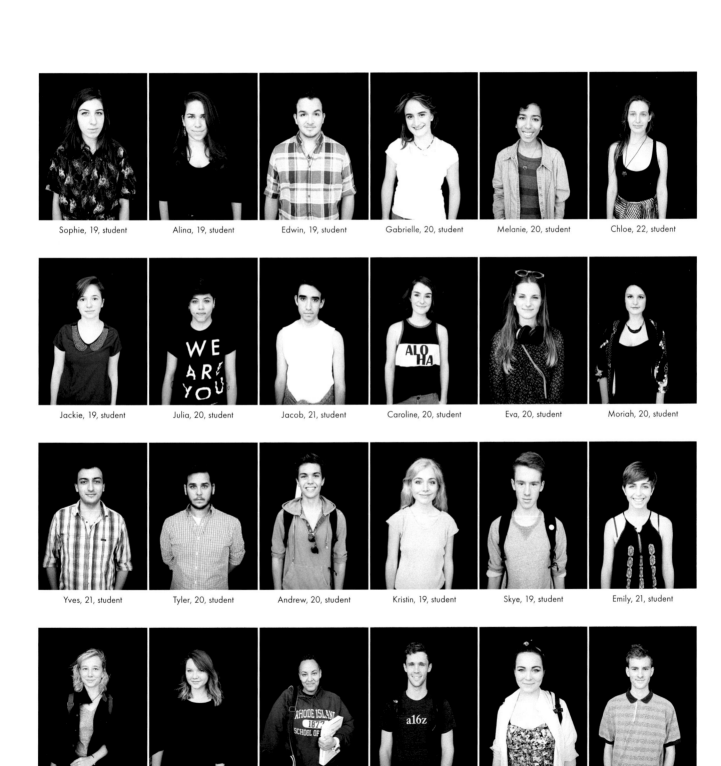

Sophie, 19, student Alina, 19, student Edwin, 19, student Gabrielle, 20, student Melanie, 20, student Chloe, 22, student

Jackie, 19, student Julia, 20, student Jacob, 21, student Caroline, 20, student Eva, 20, student Moriah, 20, student

Yves, 21, student Tyler, 20, student Andrew, 20, student Kristin, 19, student Skye, 19, student Emily, 21, student

Rachel, 20, student Zoe, 19, student Nafis, 36, artist Brian, 21, student Emma, 19, student Andrew, 23, student

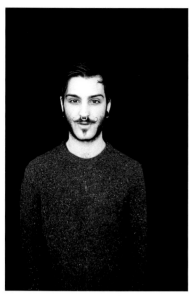

Vincent, 21, student

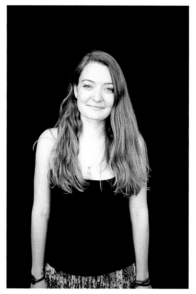

Abby, 21, student

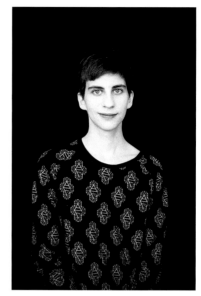

B-Twon, 20, student

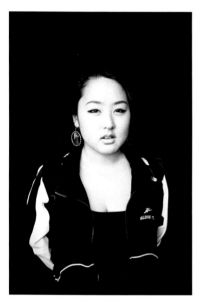

Tomi, 20

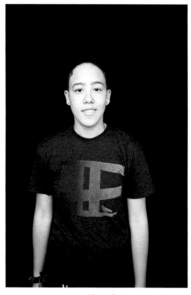

Izzy, 19, student

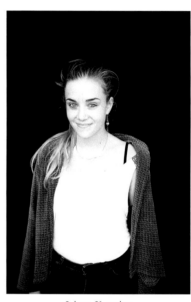

Selena, 21, student

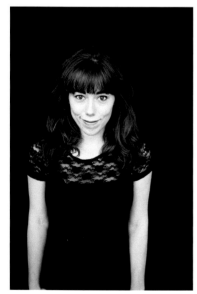

Lauren, 21, librarian

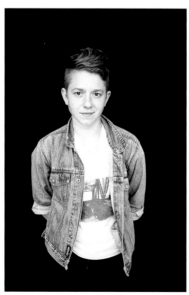

Lizzie, 19, student

Mariah, 19, student

Katie, 21, student

Pamela, 30, student

Evan, 21, video journalist

Selene, 18, student

Aescwyn, 21, student

Thomas, 19, student

Elizabeth, 19, student

Tate, 22, student

Katherine, 22, student

Kate, 27, student

Amelia, 21, student

Regan, 21, student

Natasha, 19, student

Colin, 21, student

Andrea, 20, student

Evangeline, 21, student

Ryan, 21, student

Anny, 22, educator

Aiden, 20, student

Leah, 21, student

Lo, 21, student

Marina, 19, student

Liliana, 19, student

Ashleigh, 21, student

Linnea, 19, student

Julia, 27, grad student

Midori, 20, student, food
service, and library tech

413

Emily, 19, student

Fiji, 22, cashier

Kiani, 19, student

Katie, 18, student

Pear, 18, student

Sam, 26, student

Paige, 21, student

Avery, 21, student

Kendal, 18, student

Faith, 23, student

Brittney, 19, student

Jenna, 20, resident assistant

Morgan, 20, student

Allison, 21, student

Kris, 18, student

Mary, 19, student

Kaley, 19, student

Sarah, 19, student

Amanda, 22, student affairs
professional

Alec, 18, student

Jay, 18, student

Alison, 21, student

Sarah, 21, student

Celeste, 24, coordinator
and grad student

Kam, 19, student

Darby, 18, student

Joanne, 17

Alex, 20, student

Teresa, 20, student

Tango, 20

Rebecca, 20, K-8 teacher
and student

Rachel, 20, student and RA

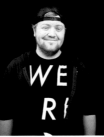

Zach, 20, student

Chelsey, 21, student

Eren, 17, student

Manny, 18, student

Scrappy, 22, student

Sarah, 21, student

Helen, 19, student

Patricia, 22, farmhand,
musician, and artist

Brigid, 19, student

Jenn, 37, grad student

Juniper, 21, student

Jordan, 21, food service

Ginny, 19, student

Kay Kay, 27, student

Shannon, 20, host

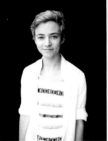

Kaleb, 18, student

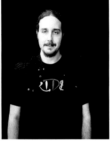

Jamie, 35, English teacher

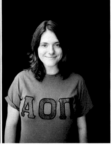

Anna, 19, manager

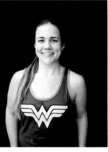

Mallory, 28, student

Valerie, 22, student and
librarian

Emma, 22, student

Andrea, 21, student

Lisa, 46, LGBT Center director

Erin, 23, grad student

Crystal, 19, UPS package
handler

Chris, 20, student

Celes, 26, student

Jacob, 18, student

Katy, 26, LGBT Center staff

Hilton, 21, customer service

Brittany, 26, student and
youth counselor

Hunter, 20, sales associate
and marketer

Jerusha, 22, student

Sierra, 18, student

Devan, 18, package handler

Laurel, 23, student
and professor

Ben, 20, LGBT Center
ambassador

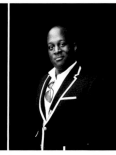

Joey, 31, program coordinator

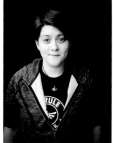

Jessica, 20, student

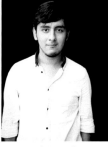

Axel, 21, student

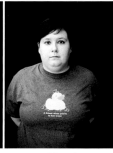

Jen, 25, student

Megan, 19, student

Margaret, 66, retired

Jasie, 30, PhD student

Johni, 20, Nike store

Sebastian, 22, student

Andrea, 28, pharmacy tech

Jayden, 26, doctoral student

Lauren, 43, nonprofit
consultant

Regina, 47, professor

Tony, 26, student

Yene, 29, lab scientist

Ashley, 23, student

Donnie, 20, online
entertainment

Rachel, 25, graduate assistant

Jacob, 26, grad student

Ariana, 18, student

Mallie, 21, student

Craig, 18

AJ, 30, LGBT Center staff

Madeleine, 21, student

Madison, 18, lab assistant

Nolan, 25, student

Femmy MacQueen, 39, humanities instructor

Kaila, 34, associate professor

Dave, 27

Catherine, 21, student

Clay, 24, student

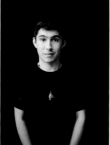

Chamberlin, 20, student

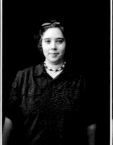

Leigh Ann, 35, skills trainer

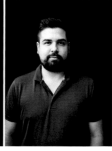

Nicholas, 29, student

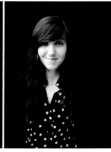

Kandace, 19, UPS

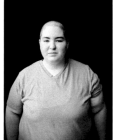

MC, 23, Humane Society
adoption counselor

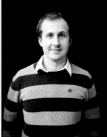

Sam, 18, student

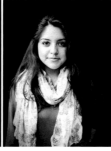

Lorena, 22, student

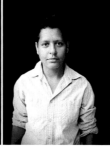

Tania, 22, student

Ana, 21, student

Emma, 20, student

VIRGINIA PRIDEFEST
BROWN'S ISLAND, VA
SEPTEMBER 27, 2014

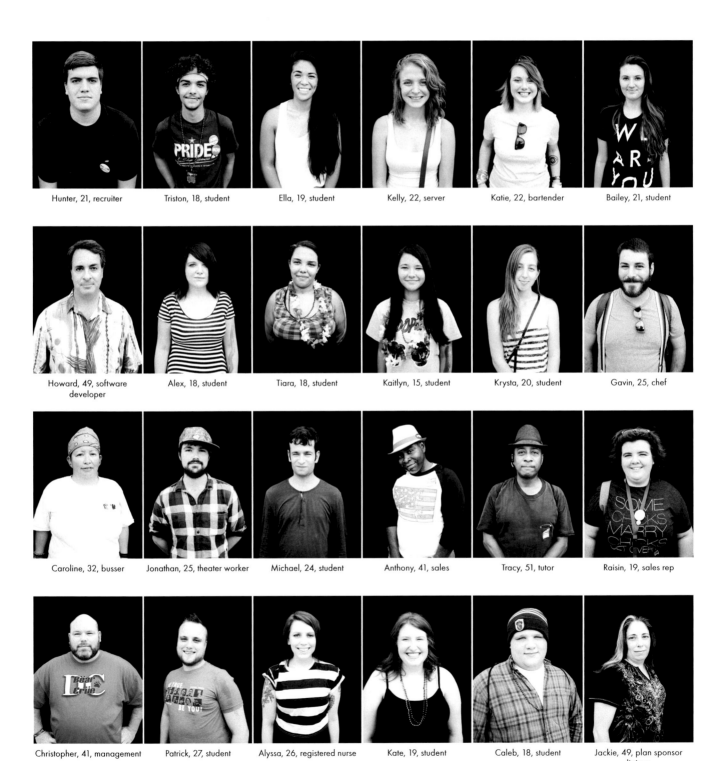

Hunter, 21, recruiter

Triston, 18, student

Ella, 19, student

Kelly, 22, server

Katie, 22, bartender

Bailey, 21, student

Howard, 49, software developer

Alex, 18, student

Tiara, 18, student

Kaitlyn, 15, student

Krysta, 20, student

Gavin, 25, chef

Caroline, 32, busser

Jonathan, 25, theater worker

Michael, 24, student

Anthony, 41, sales

Tracy, 51, tutor

Raisin, 19, sales rep

Christopher, 41, management

Patrick, 27, student

Alyssa, 26, registered nurse

Kate, 19, student

Caleb, 18, student

Jackie, 49, plan sponsor liaison

Elanor, 24, graphic designer

Brennon, 21, student

Kathi, 19, student

Gabby, 20, cashier

Gina, 19, server

Dan, 19, student

Andrea, 29, Walmart

Vik Star, 28, line cook

M Star, 25

Tyler, 25, delivery driver

Diane, 53, retail management

Tye, 28

Kayla, 25, manager at kennel

Anna, 30, fire performer

Izzy, 29, stay-at-home parent

Sam, 8

Michelle, 37, insurance

Natalie, 28, pet store

Ash, 26, pet store

Eliana, 20

Camille, 19

Liz, 20, student

Zucco, 21

Shawn, 21, student

Joshua, 21, student

Jordan, 18, student

Scott, 31, dispatcher
at Comcast

Luis, 28, driver

Taylor, 16, student

Riley, 16

Levi, 30, kennel tech

Davonte, 22, student and IT tech

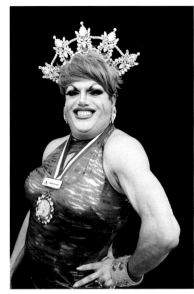

Natasha, 32, Empress of the Imperial Court

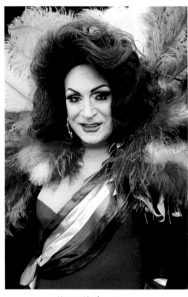

Kerry, 61, drag queen

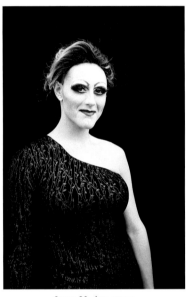

Stacy, 20, drag queen

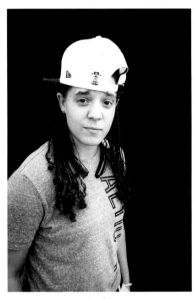

Jai, 25

Dany, 18, HVAC

Trey, 18, student

Robert, 22, student

Phillip, 51, caregiver

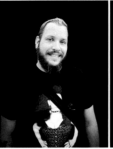

Troy, 38, nanny

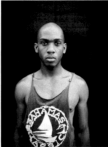

Terrio, 22

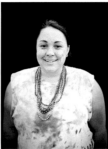

Drea, 19, sales associate

Rhett, 18, food service
specialist

Magen, 18, student

Aubrey, 18, piercer

Allura, 21, piercer

Omri, 23, daycare teacher

Shelby, 22, senior sales
consultant

Jewel, 18, gymnastics coach

Taylor, 20, student

Taylor, 20, customer service

Hailey, 18

Amanda, 18, student

Lakisha, 37, CRS

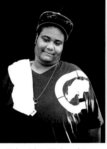

Schenicka, 31, bus driver

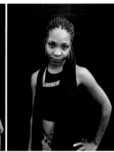

Dominiqiue, 25, customer
service rep

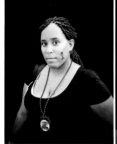

Priscilla, 23, culinary

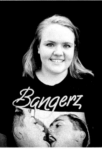

Hannah, 18, student

Carter, 18, student

Jevon, 21, retail

CJ, 38, shift coordinator

Erika, 34, therapist

Craig, 29, clinician

Annie, 24, manager
at GEICO

Kira, 25, group home
manager

Amber, 21, student

Brandy, 33, hairdresser

Robbie, 40, hairstylist

423

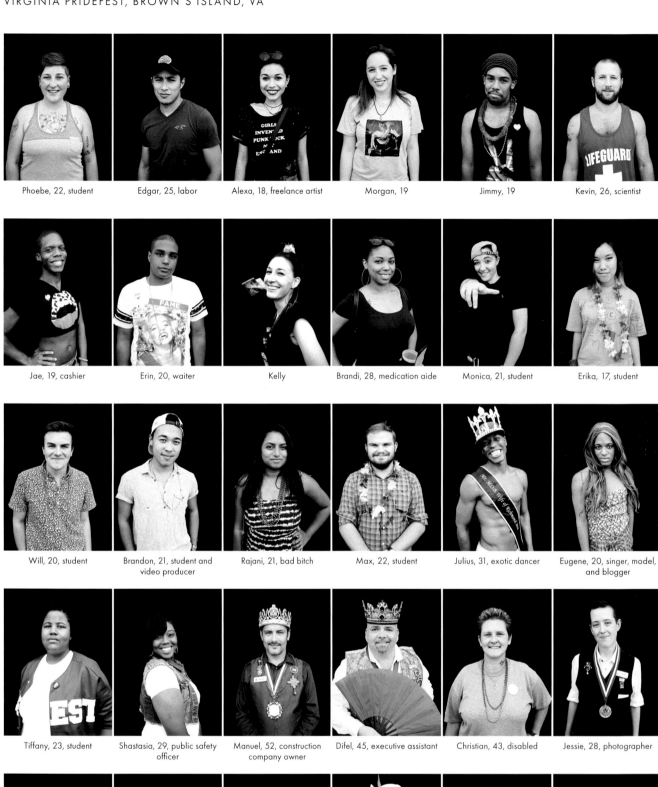

Phoebe, 22, student Edgar, 25, labor Alexa, 18, freelance artist Morgan, 19 Jimmy, 19 Kevin, 26, scientist

Jae, 19, cashier Erin, 20, waiter Kelly Brandi, 28, medication aide Monica, 21, student Erika, 17, student

Will, 20, student Brandon, 21, student and video producer Rajani, 21, bad bitch Max, 22, student Julius, 31, exotic dancer Eugene, 20, singer, model, and blogger

Tiffany, 23, student Shastasia, 29, public safety officer Manuel, 52, construction company owner Difel, 45, executive assistant Christian, 43, disabled Jessie, 28, photographer

Sarah, 33, adjunct professor Jes, 38, professor Salem, 25, community organizer Sirena, 28, artist Shan, 43, drywall mechanic Amber, 36, housewife

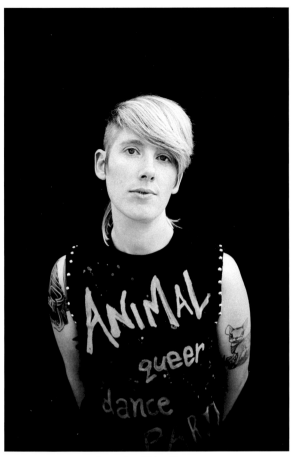

Connie Sue, 35, bookkeeper

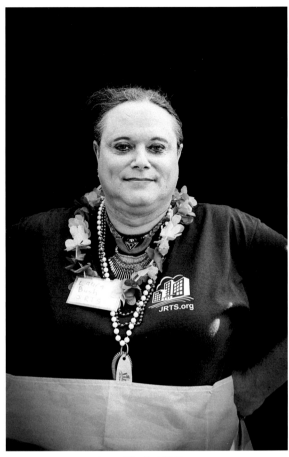

Laura, 49, retired US Navy

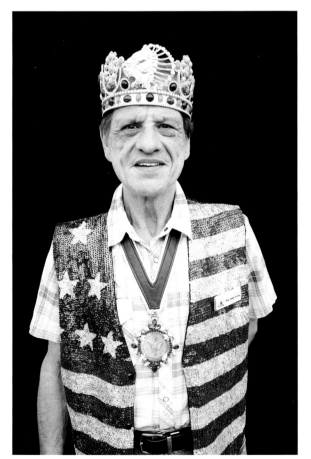

Ken, 62, retired

CJ, 37, police officer

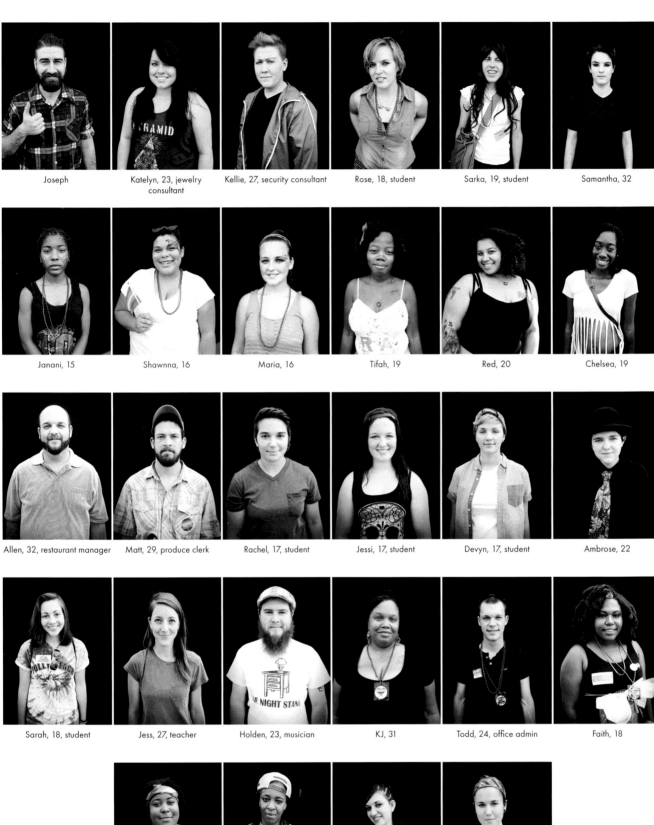

Joseph Katelyn, 23, jewelry consultant Kellie, 27, security consultant Rose, 18, student Sarka, 19, student Samantha, 32

Janani, 15 Shawnna, 16 Maria, 16 Tifah, 19 Red, 20 Chelsea, 19

Allen, 32, restaurant manager Matt, 29, produce clerk Rachel, 17, student Jessi, 17, student Devyn, 17, student Ambrose, 22

Sarah, 18, student Jess, 27, teacher Holden, 23, musician KJ, 31 Todd, 24, office admin Faith, 18

Noelle, 19, student Shanice, 23 Kacey, 22, DMS Brandy, 20, student

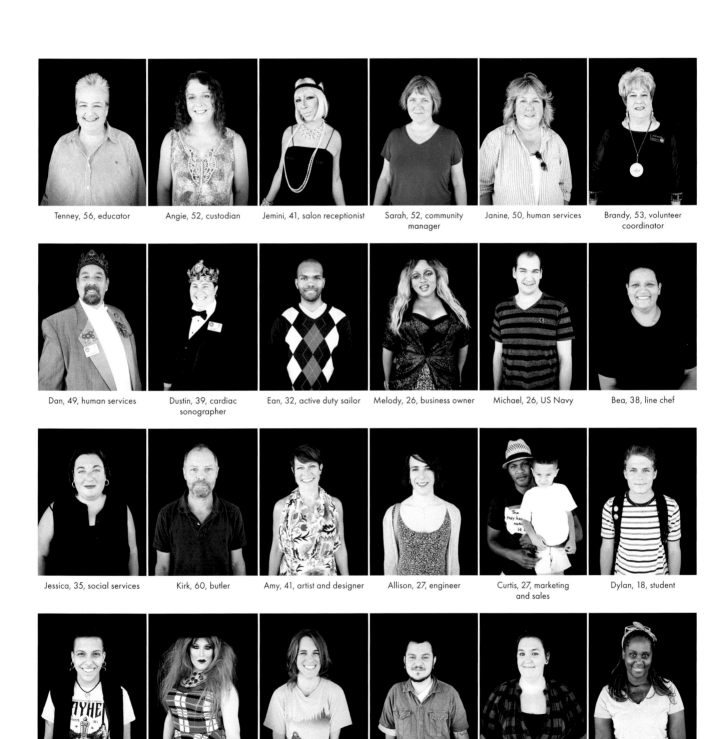

Tenney, 56, educator

Angie, 52, custodian

Jemini, 41, salon receptionist

Sarah, 52, community manager

Janine, 50, human services

Brandy, 53, volunteer coordinator

Dan, 49, human services

Dustin, 39, cardiac sonographer

Ean, 32, active duty sailor

Melody, 26, business owner

Michael, 26, US Navy

Bea, 38, line chef

Jessica, 35, social services

Kirk, 60, butler

Amy, 41, artist and designer

Allison, 27, engineer

Curtis, 27, marketing and sales

Dylan, 18, student

Lilly, 24, mechanic and massage therapy student

Candi, 34, front-end medical practice manager

Kyle, 27, vet tech

Leonard, 26, project administrator

Alia, 23, student

Jess, 22

David, 53, truck driver

Daryl, 37, mayor of New London, CT

Vincent, 27, US Navy

Jamie, 25, packer

Teresa, 21, stay-at-home mom

Kelly, 42, music teacher

Jay, 26, US Navy

The Red Knight, 29, pro wrestler

Justin, 23, US Navy

Kyle, 23, residential life

Vincentina, 69, gadfly

Margaret, 76, artist

Lise, 60, self-employed

Katie, 30, attorney

Joanne, 57, marine designer

Ginny, 68, retired teacher

Judith, 64, psychotherapist

Kasey, 21, US Navy

Anthony, 30, business manager

Brian, 49, event designer

Keith, 54, retired banker

Charlie, 24, medical tubing

Maria, 35, manager

Maria, 42, humorist

Constance, 45, nonprofit management

Brittany, 26, childcare

Kim, 34, builder

Paula, 56, counselor and therapist

Ethan, 34, engineer

Gina, 27, pharmacy tech

Nick, 23, coach

Jasmine, 31, business owner

Aimee, 26, bartender, DJ, and event coordinator

Ray, 18, student

Elise, 20, student

Simone, 18, student

Emma, 18, student

Bryne, 18, student

Linas, 22, student

Jason, 20, student

Shannon, 20, student

Eli, 21, student

Aston, 19, student

Brittany, 21, student

Ivy, 27, screenprinter
and RV park manager

Sarah, 18, student

Tegan, 26, ABA therapist

Oliver, 20, vet tech

Callan, 21, student

Elizabeth, 22, teacher

LJ, 19, student

Emma, 19, student

Adam, 19, student

Alyssa, 18, student

Hannah, 21, student

Danielle, 23

Kayla, 24, student

Wynston, 26, retail manager

Aaron, 19, student and gallery assistant

Dove, 19, student

2015

Holli, 40, hair

Cara, 24, model and actor

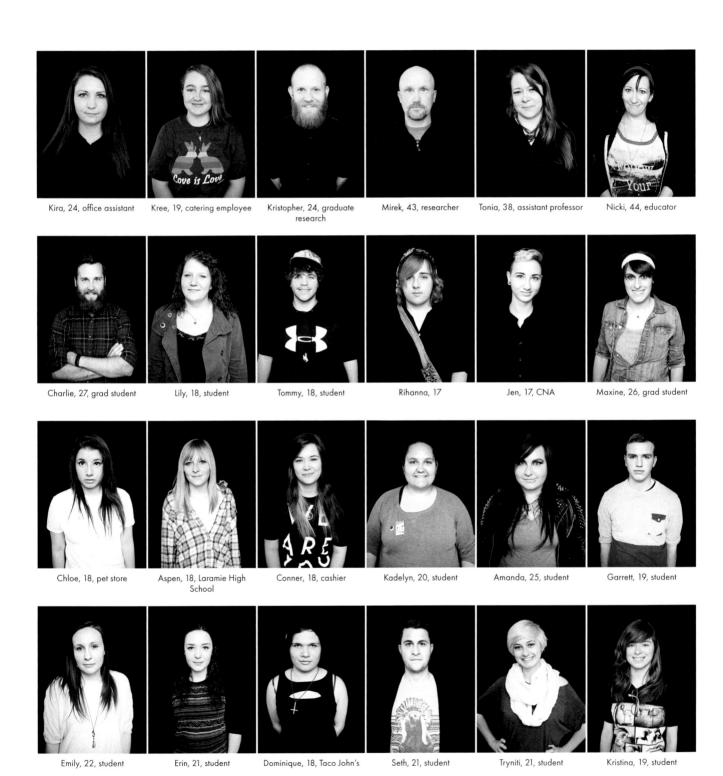

Kira, 24, office assistant

Kree, 19, catering employee

Kristopher, 24, graduate research

Mirek, 43, researcher

Tonia, 38, assistant professor

Nicki, 44, educator

Charlie, 27, grad student

Lily, 18, student

Tommy, 18, student

Rihanna, 17

Jen, 17, CNA

Maxine, 26, grad student

Chloe, 18, pet store

Aspen, 18, Laramie High School

Conner, 18, cashier

Kadelyn, 20, student

Amanda, 25, student

Garrett, 19, student

Emily, 22, student

Erin, 21, student

Dominique, 18, Taco John's

Seth, 21, student

Tryniti, 21, student

Kristina, 19, student

Val, 54, teacher educator

Aaron, 18

Azimath, 51, astrologer

Emily, 22, student
and police dispatcher

Renee, 21, student

Ana, 20, student

Chanel, 19

Nicholas, 21, student

Meglana, 23, student

Evan, 19, student

Bria, 20, student

Clayton, 20, student

Martha, 27, student

Craig, 29, law student

Katie, 16, student

Kylie, 22, student

Julia, 18, student

Anna, 15, student

Anthony, 17, student

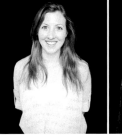

Malachi, 17

Angela, 43, professor

Liza, 57, rancher

Brie, 20, student

Sierra, 23, student

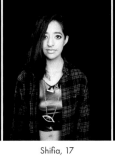

Sharon, 26, student

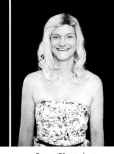

Shifia, 17

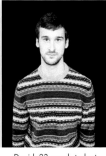

Sean, 31, student

David, 23, grad student

Robert, 54, retired FBI

DJ, 53, banker

Travis, financial advisor

Melvin, 32, counselor

Randall, 25, US Air Force

Ramon, 51, producer,
educator, and artist

David, 55, attorney

Megan, 20, student

Danielle, 53, customer service

Tony, 45, student

Jonas, 41, engineer tech

Kaleo, 38, teacher

Cyrus, 30, medical
receptionist

Anne, 43, family therapist

David, 68, physician

Dan, 43, finance

Chara, 23, nanny
and server

Jacqui, 29, research associate

George, 51, manager

Daniel, 34, customer service

Lakota, 43, retired

Rodney, 33, home manager

Puakea, 61, professor

Susan, 51, audiologist

James, 50, accountant

Jeff, 51, property management

Stacie, 50, electronics tech

Rachel, 31, dance teacher

Jonee, 33, teacher

Tim, 48

Willie, 47, technical director

Mark, 54, bar manager

Lucy, 47, dance therapy intern

Luna, 33, customer experience manager

Jojo, 34, surfing instructor

Maxine, 26, social work

Jack, 68, business

Scott, 45, realtor

Denny, 51, cardiologist

Rena, 35, teacher and barista

Reverend Kyle, 55, clergy

Butch, 46, business owner

Michael, 42, community organizer

Lani, 15, school

Steve, 51, elementary school teacher

Ryan, 35, lawyer

Camaron, 45, LGBT coordinator

Bridget, 31, therapist

Jen, 41, music therapist

Jasmine, 27, builder, farmer, and entrepreneur

Carolina, 66, paralegal and trans activist

Enzi, 31, student

Shane, 28, US Army

Jes, 41, massage therapist

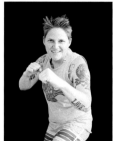

Rachel, 27, USN

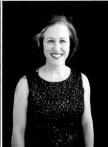

Shelley, 43, social media
strategist

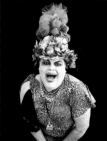

Sister Face, 43, entertainer

Susan, 57, business system
analyst

Ernest, 70, retired actor

Nicole, 35, teacher

Natasha, 36, analyst

Azure, 28, self-employed

Jarred, 33, hospitality

Reverend Pam, 67, clergy

Keiki, 76, retired
Honolulu PD

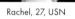

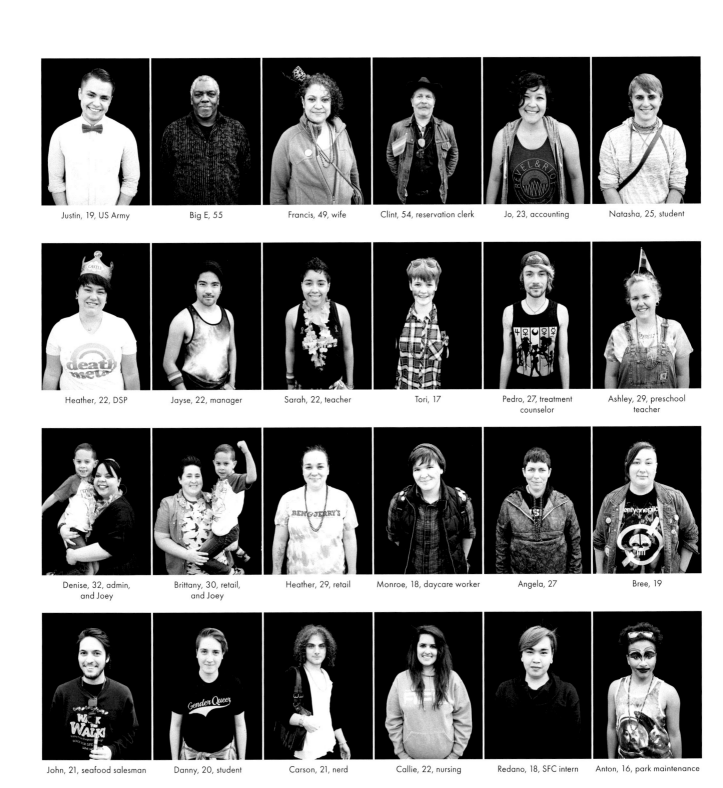

Justin, 19, US Army

Big E, 55

Francis, 49, wife

Clint, 54, reservation clerk

Jo, 23, accounting

Natasha, 25, student

Heather, 22, DSP

Jayse, 22, manager

Sarah, 22, teacher

Tori, 17

Pedro, 27, treatment counselor

Ashley, 29, preschool teacher

Denise, 32, admin, and Joey

Brittany, 30, retail, and Joey

Heather, 29, retail

Monroe, 18, daycare worker

Angela, 27

Bree, 19

John, 21, seafood salesman

Danny, 20, student

Carson, 21, nerd

Callie, 22, nursing

Redano, 18, SFC intern

Anton, 16, park maintenance

Sharlette, 39, file clerk

Danny, 24, dental assistant

Joane, 24, accounting tech

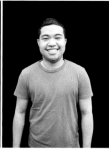
Eric, 22, teller

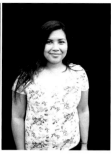
Ashley, 25, data analysis

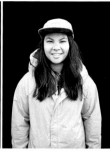
Marianne, 23, CMA

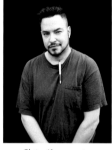
Chris, 41, computer
engineering student

Stephanie, 30, cook

Ali, 38, government

Katrina, 30, student

Amy, 33, manager

Faust, 23

Aaron, 22

Jamie, 24

Kace, 16

Jessica, 18

Liard, 18, dewatering

Calista, 17

Kira, 16, student

Heather, 45, manager

Chris, 26, pharmacist

Eric, 32, physician

Keith, 52, data analyst

Billy, 23, youth
engagement specialist

Daniel, 25, civil engineer

Shelby, 39, account tech

Michael, 18

Ben, 23, caseworker

David, 23

Sam, 16

Franny, 21, preschool teacher

Fred, 59, nurse

Amanda, 35, oil and gas

Katy, 24, cashier and singer

Allison, 43, teacher

Emily, 19

Robert, 58, self-employed

Briody, 53, cook

Losa, 33, quality assistant

Allie, 47, care coordinator

Kay, 28, student

Violet, 28, gas station attendant

Sarabi, 19, admin assistant

Erin, 33, saving the world

Megan, 22, student

Katy, 19, EMT firefighter

Meghan, 25, firefighter

Eric, 32, finance

Billy Dean, 35

Landen, 16, drag queen and artist

Carson, 17

Emma, 16, artist

Miguel, 45, administrator

Parker, 15

C Lee, 38, admin assistant

Priya, 27, business owner and student

Shy, 31, paralegal

Kevin, 44, designer

Khyle, 16

Kaitlyn, 23, Planned Parenthood

Evie, 26, chiropractic office lead

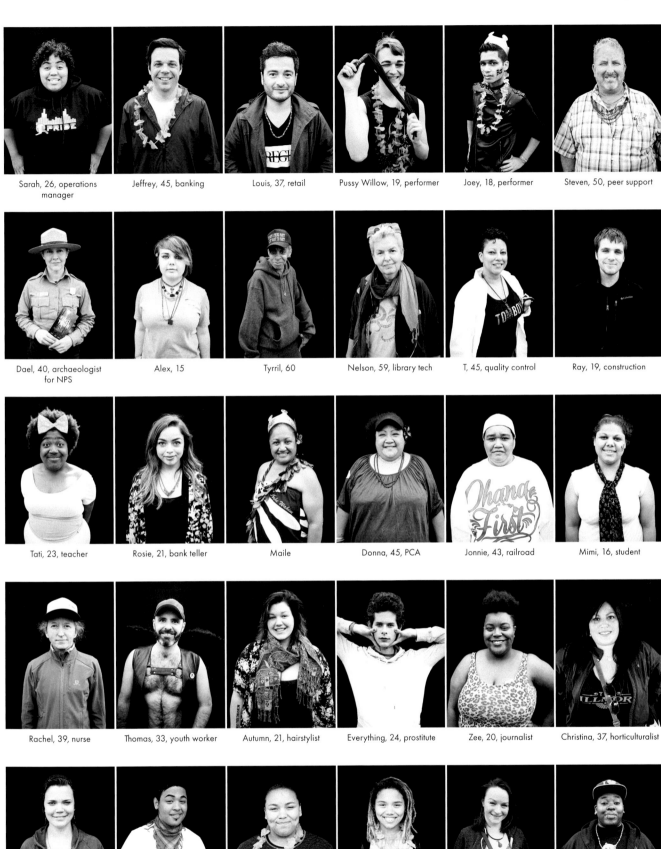

Sarah, 26, operations
manager

Jeffrey, 45, banking

Louis, 37, retail

Pussy Willow, 19, performer

Joey, 18, performer

Steven, 50, peer support

Dael, 40, archaeologist
for NPS

Alex, 15

Tyrril, 60

Nelson, 59, library tech

T, 45, quality control

Ray, 19, construction

Tati, 23, teacher

Rosie, 21, bank teller

Maile

Donna, 45, PCA

Jonnie, 43, railroad

Mimi, 16, student

Rachel, 39, nurse

Thomas, 33, youth worker

Autumn, 21, hairstylist

Everything, 24, prostitute

Zee, 20, journalist

Christina, 37, horticulturalist

Liberty, 22, EMT

Lewis, 19, caregiver

Darlene, 17, cashier

Ebony, 20

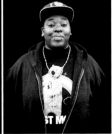

Allana, 29, nurse

Ursula, 29, caretaker

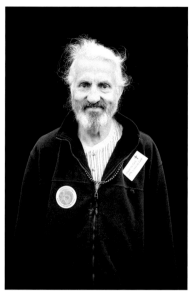

Terry, 60, disability

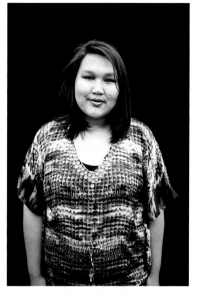

Zacchareus, 18, gardener

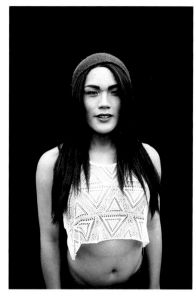

Vesna, 19, retail

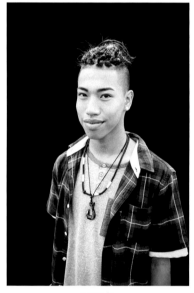

Junior, 16

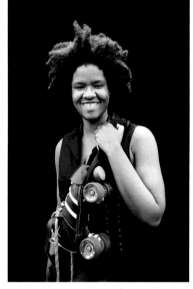

Deenay, 27, student

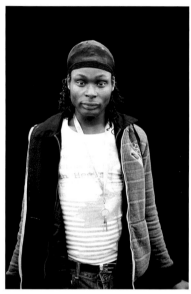

Roy, 24

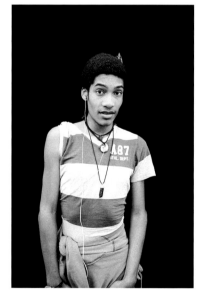

Jordan, 22

Matthew, 16

Cas, 13

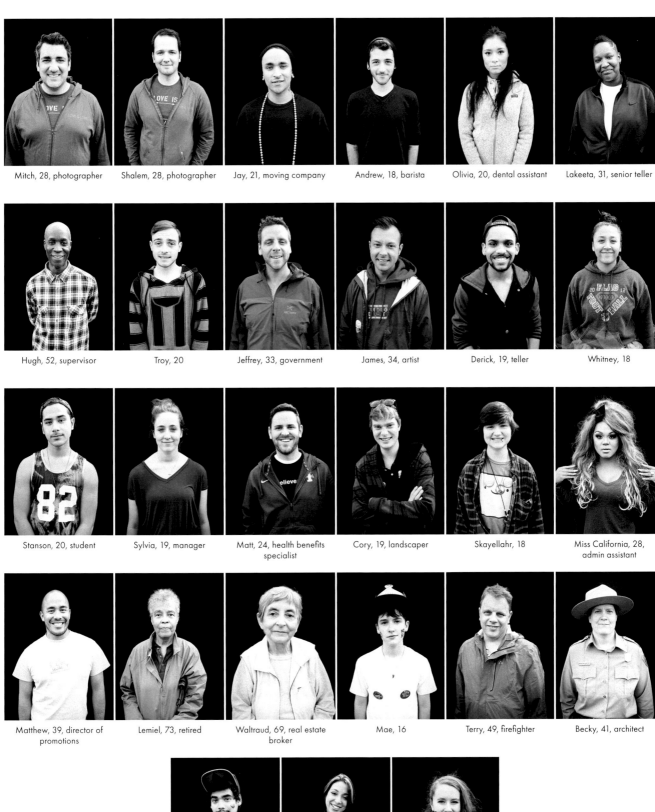

Mitch, 28, photographer

Shalem, 28, photographer

Jay, 21, moving company

Andrew, 18, barista

Olivia, 20, dental assistant

Lakeeta, 31, senior teller

Hugh, 52, supervisor

Troy, 20

Jeffrey, 33, government

James, 34, artist

Derick, 19, teller

Whitney, 18

Stanson, 20, student

Sylvia, 19, manager

Matt, 24, health benefits specialist

Cory, 19, landscaper

Skayellahr, 18

Miss California, 28, admin assistant

Matthew, 39, director of promotions

Lemiel, 73, retired

Waltraud, 69, real estate broker

Mae, 16

Terry, 49, firefighter

Becky, 41, architect

Willy, 22, gaming attendant

Cassandra, 27, consumer loan underwriter

Zoey, 19, student

Ronnie, 57, program
coordinator

Jazzy, 52, HIV-AIDS
specialist

Johnny, 50, case manager

Bella, 25, model and momma

Troy, 21, chef

Emma, 20, intern

Brittany, 28, behavioral
therapist

Jacob, 23, comedian

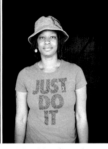

Mia, 39, independent
copyeditor

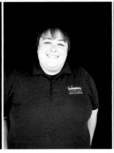

Stephanie, 38, daycare cook

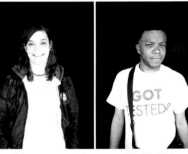

Maria, 24, account specialist BK, 29, CNA

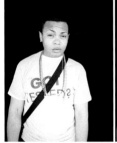

Geoffrey, 26, customer
service rep

Ricardo, 27, HIV-AIDS
specialist

Pamela, 33

Mel, 33, teacher

Anthony, 30, healthy

Kate, 48, artist

Camela, 37, teacher

Michael, 55, art director

Michael, 22, student

Valery, 62, engineer

Jacqueline, 36,
psychotherapist

Joey, 39, security officer

Julie, 30, case manager

Joanna, 32, search engine optimization

Monique, 28, student

Nicole, 30, student

Zion, 26, education

Diamond, 18

Dria, 19, student

Matthew, 27, research assistant

Bruce, 65

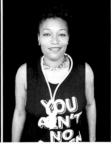

Tameka, 37, medical assistant

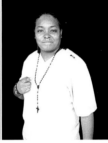

KJ, 31, support service tech

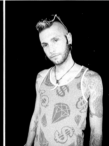

Ryan, 34, bartender

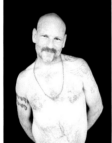

Doug, 44, carpenter

Mike, 38, hairstylist

Don, 62, project management

Teea, 45, PHA

Andrea, 19, Amazon associate

Tameka, 26, retail

Joey, 21, Android developer

Riva, 24, customer service

Gracie, 36, reiki practitioner

Crystal, 30, graphic design student

Sarah, 30, government

Chelsey, 22, student

Adrian, 28, racial justice youth organizer, and Ali

Shawn, 24

Tricia, 37, social work

Jeanine, 38, USPS mail handler

Dee, 44, hairstylist

Dani, 23, youth LGBT promoter

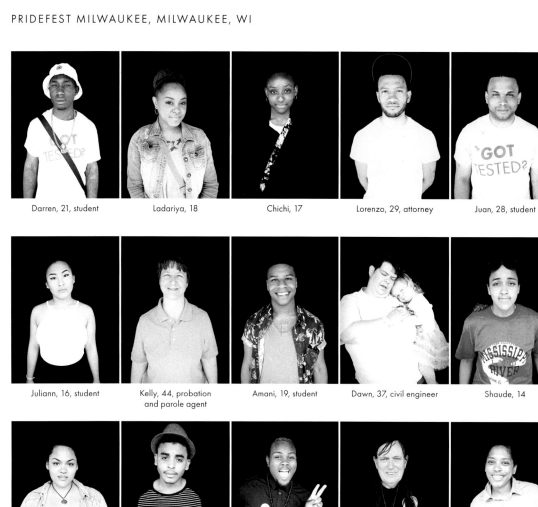

Darren, 21, student

Ladariya, 18

Chichi, 17

Lorenzo, 29, attorney

Juan, 28, student

Edith, 24, coffee educator

Juliann, 16, student

Kelly, 44, probation and parole agent

Amani, 19, student

Dawn, 37, civil engineer

Shaude, 14

Scott, 48, LGBT group

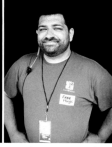
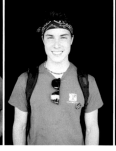
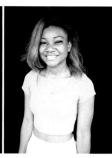

Kalee, 19, student

Javon, 20, host and busser

Donnie, 19, Boston Market

Ellen, 67, retired

Shavonne, 28, management

Danielle, 25, prevention specialist

Maddy, 19, general manufacturer

Elena, 58, engineer

Cori, 39, server

Anthony, 34, nonprofit coordinator

Avi, 19, performer and student

Yiesha, 17, student

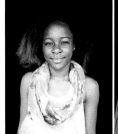

Tya, 17, school

Patrick, 70, retired

Trish, 24

Rosalie, 19, student

Annaleah, 18, ironworking apprentice

Devon, 24, donor testing lab technologist

Franni, 21, warehouse worker

Amitrius, 21, SNA and PCW

Angelina, 29, creative director

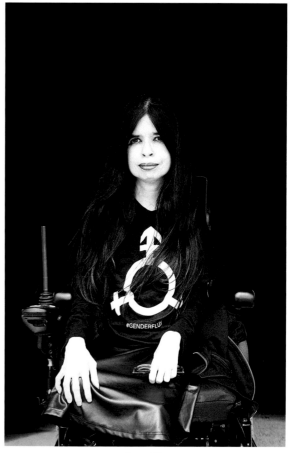

Laura, 49

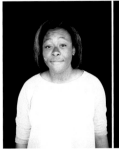

Abby, 16, lifeguard

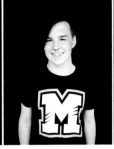

Brenden, 16, student

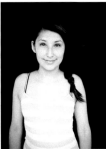

Kels, 17

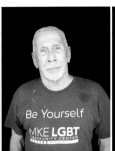

David, 72, early childhood trainer

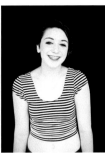

Gabbie, 15

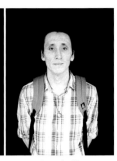

Joseph, 21

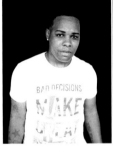

Armani, 33, community service

Kenyon, 36, salesperson

Ben, 15

Abigail, 20, landscaper

Jesse, 54, IT

Chao, 24, student

Xaxona, 19, server

Aletheia, 19, factory worker

Shandi, 19

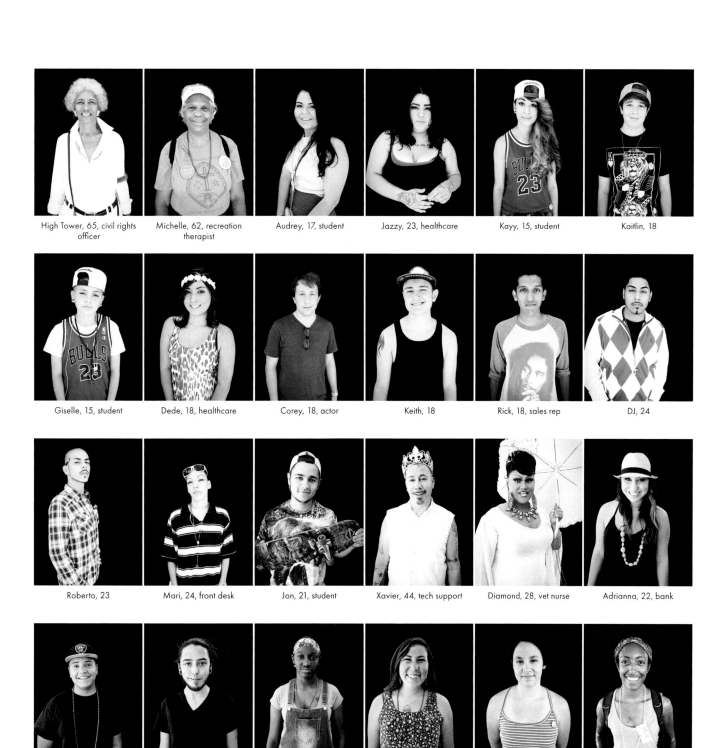

High Tower, 65, civil rights officer

Michelle, 62, recreation therapist

Audrey, 17, student

Jazzy, 23, healthcare

Kayy, 15, student

Kaitlin, 18

Giselle, 15, student

Dede, 18, healthcare

Corey, 18, actor

Keith, 18

Rick, 18, sales rep

DJ, 24

Roberto, 23

Mari, 24, front desk

Jon, 21, student

Xavier, 44, tech support

Diamond, 28, vet nurse

Adrianna, 22, bank

Antonio, 15

Simone, 25, cosmetologist

Whitney, 23, student

Bianca, 23, respite provider

Casper, 29, medical coding

Hanna, 24, social worker

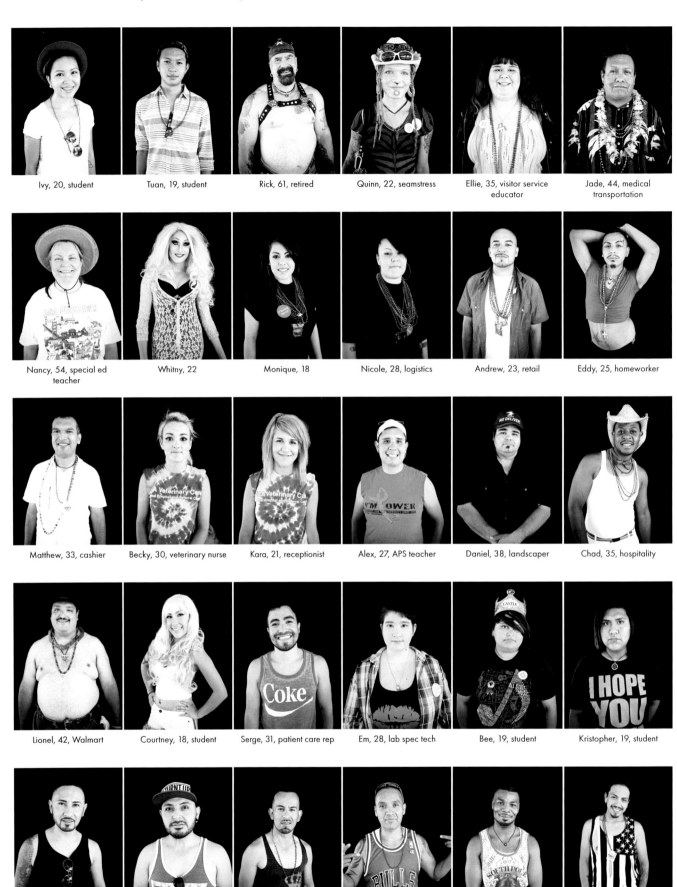

Ivy, 20, student

Tuan, 19, student

Rick, 61, retired

Quinn, 22, seamstress

Ellie, 35, visitor service educator

Jade, 44, medical transportation

Nancy, 54, special ed teacher

Whitny, 22

Monique, 18

Nicole, 28, logistics

Andrew, 23, retail

Eddy, 25, homeworker

Matthew, 33, cashier

Becky, 30, veterinary nurse

Kara, 21, receptionist

Alex, 27, APS teacher

Daniel, 38, landscaper

Chad, 35, hospitality

Lionel, 42, Walmart

Courtney, 18, student

Serge, 31, patient care rep

Em, 28, lab spec tech

Bee, 19, student

Kristopher, 19, student

Eddie, 33, police officer

Rene, 30, barber

JC, 33, driver

Carlos, 35, social worker

B, 38, order filler

Joe, 24, medical assistant

Leo, 42, order filler

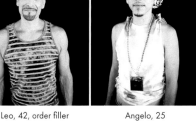

Angelo, 25

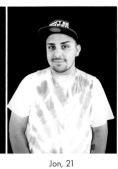

Jon, 21

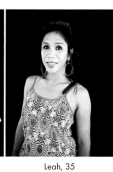

Leah, 35

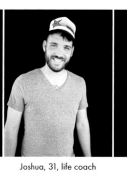

Joshua, 31, life coach

Alex, 21, secretary

Kristoffer, 21, personal
assistant

Amy, 22, CSR

Nikki, 35, insurance agent

Crystal, 36, nurse

Shyanne, 20, cook

Mary-Ashley, 21,
sales associate

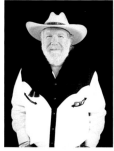

Keith, 66, farm and
ranch hand

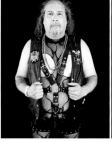

Rob, 51, retired US Army

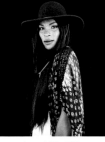

Irmaul, 23, CSR

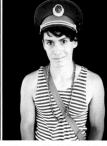
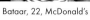

Bataar, 22, McDonald's

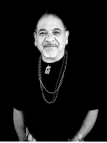

Miguel, 58, college
administrator

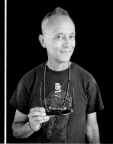

Esteban, 52, caregiver

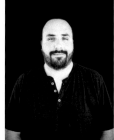
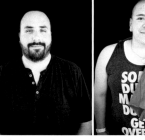
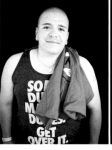

Jacob, 35, social worker

Anthony, 31, security

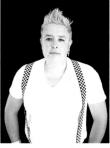

Trey, 36, sales

Maegan, 36, homemaker

Carol, 70, retired

Kimberly, 55, teacher

Kelly, 47, construction,
farm, and ranching

Gabby, 52

William, 48, analyst

Melissa, 33, store manager

Bubbles, 25, cashier

Tasha, 22, sex worker

Mark, 46

Jean Paul, 38, vet tech

Amber, 33, mom and wife

Jess, 38

Stu, 57, retired

Daisuke, 20, interpreter

Kathryn, 66, retired

Tina, 53, system administrator

Kerri, 24, student
and teacher

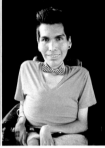

Adrian, 27, student

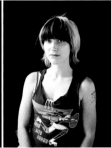

Madgina, 24, comic book
sales

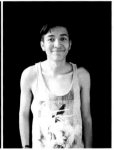

Mario, 21, cinema associate

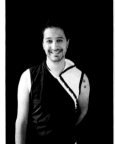

Ivan, 29, T-Mobile

Gina, 18, student

Ptolema, 40, sex-positive
chapter leader

Francesca, 26, supported
living for disabled

NORTH JERSEY PRIDE

MAPLEWOOD, NJ

JUNE 14, 2015

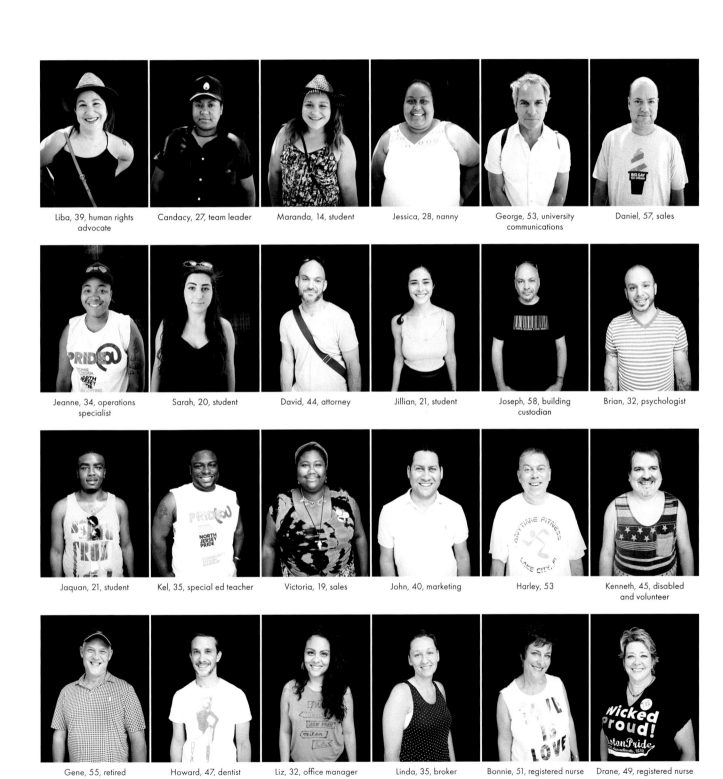

Liba, 39, human rights advocate

Candacy, 27, team leader

Maranda, 14, student

Jessica, 28, nanny

George, 53, university communications

Daniel, 57, sales

Jeanne, 34, operations specialist

Sarah, 20, student

David, 44, attorney

Jillian, 21, student

Joseph, 58, building custodian

Brian, 32, psychologist

Jaquan, 21, student

Kel, 35, special ed teacher

Victoria, 19, sales

John, 40, marketing

Harley, 53

Kenneth, 45, disabled and volunteer

Gene, 55, retired

Howard, 47, dentist

Liz, 32, office manager

Linda, 35, broker

Bonnie, 51, registered nurse

Drane, 49, registered nurse

BatFred, 18, student

Franz, 39, doctor

Stephen, 54, doorman

Anjan, 41

Erica, 35, teacher

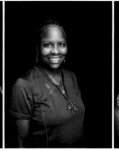
Roslyn, 46, swim coach

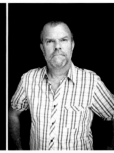
Hal, 51, retired

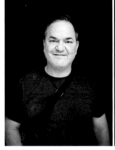
Jim, 52, marketing

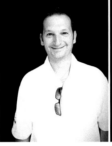
Gary, 44, sales

Carol, 44

Jackie, 56, machine operator

Maria, 43, admin

Jessica, 43, medical secretary

Nathalie, 52, manager

Nat, 31, fashion curator

Lexie, 17, Sunday school teacher

Gina, 18, actress

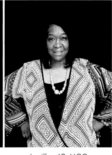
Lucille, 49, UCC

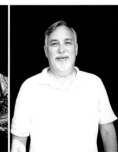
Mickey, 63

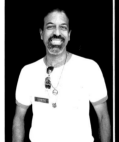
John, 45, cashier

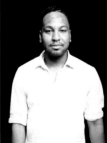
Marcial, 25, visual presentation

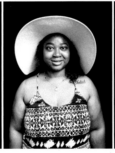
Javon, 25, banker

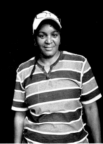
Latusia, 50, UPS

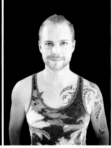
Michael, 29, sales

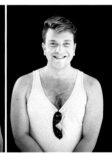
Ryan, 26, PA

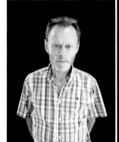
James, 58

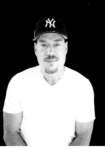
Michael, 56, community advocate

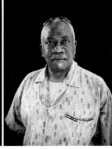
James, 60, volunteer

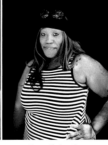
Kitti, 40, banker

Bee, 36, nurse

Ruben, 34, employed

Nikki, 40, student

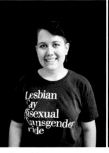

Gina, 23, case manager

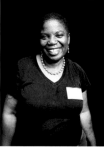

Jennifer, 47, shop owner

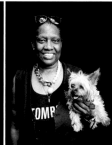

Asabi, 61, retired

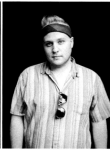

Louis, 24, artist

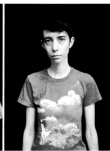

O, 26, Starbucks

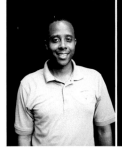

Terron, 33, teacher

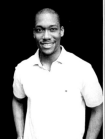

Mayne, 34, teacher

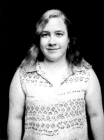

Victoria, 23, jeweler

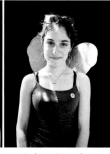

Sydney, 24, student

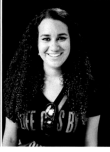

Carmen, 25, dog walker

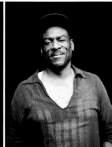

Taurance, 51, hairstylist

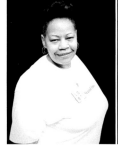

Robin, 53, tech mechanic

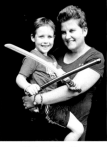

Claire, 46, editor

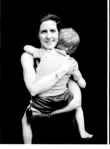

Jill, 39, IT manager

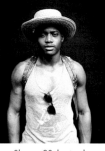

Shawn, 28, bartender
and actor

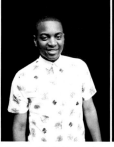

Braxton, 29, flight attendant

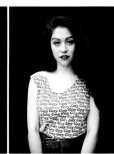

Izzie, 24, actress
and musician

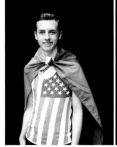

Stephen, 16, student

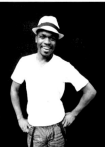

Kharis, 23, choreographer

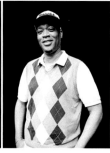

Robert, 49, accounting

Valerie, 58, sales

Yvonne, 53, athletic director

Kellie, 48, paraprofessional

Millie, 26

Andrew, 22, student affairs

Caryn, 23, occupational
therapy student

John-Deric, 37, personal
assistant and dancer

Vivian, 41, consultant

Barbara, 43, financial advisor

Alyssa, 22, student

Emily, 22, teacher

RBK, 46, director and teacher

Princess, 52, teacher

Ashle, 26, blogger

Ashley, RN

Zoe, 32, hairdresser

Queen Bee, 45, admin assistant

Sarah, 45, director

Ryan, 18, student

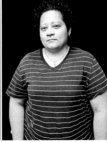

Rosemary, 44, deputy director

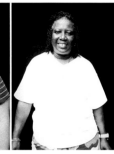

Lynell, 46, corporate consultant

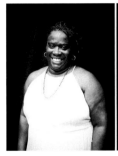

Joy, 47, homemaker

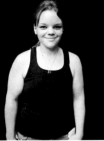

Virginia, 28, custodian

Ana, 19, babysitter

Erin, 26, account manager

Lauren, 20, student

Makai, 12, student

Sofia, 15, student

Karen, 31, vet tech

Gabby, 31, resident manager

Devon, 35, education

Aileen, 30, victim advocate

JD, 22

Angela, 29, salon owner

Meagan, 22

Talia, 22, student

Cris, 18, sales associate

Simon, 18, student

Anna, 18, sales associate

Joy, 21, neuroscience student

Linda, 54

Gina, 42, cook

Julia, 52

Kim, 56, TV stage manager

Sara, 24, grad student

Chanel, 19

Rhiannon, 18

Saydi, 19, student

Perry, 22, student

Kim, 20, student

Kayla, 18, student

Mandy, 34, office service
coordinator

Liz, 50, executive director

Lisa, 43, community director

Alex, 61, retired

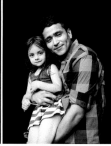

Johnny, 22, waiter

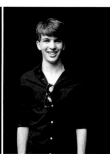

Russell, 18

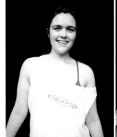

Ino, 15, student

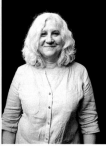

Ingrid, 57, librarian

Timbo, 50, certified life coach

Edwin, 38, analyst

Liam, 44, writer

Storm, 25, medical assistant

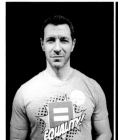

Roger, 42, so many things

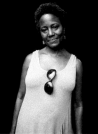

Lisa Marie, 49, educational
administrator

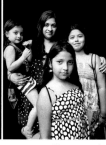

Anny, 27, office rep, and
Kimberly, Ana, and Emma

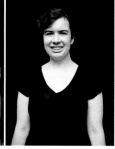

Charlotte, 16, student

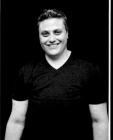

Steph, 34, student affairs

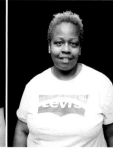

Erica, 40, actor

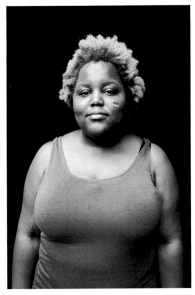

Topaz, 17, student

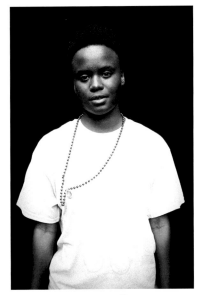

Dominique, 20

Mark, 32

Darian, 23, student

Maiyah, 24, artist

Andy, 29, executive director

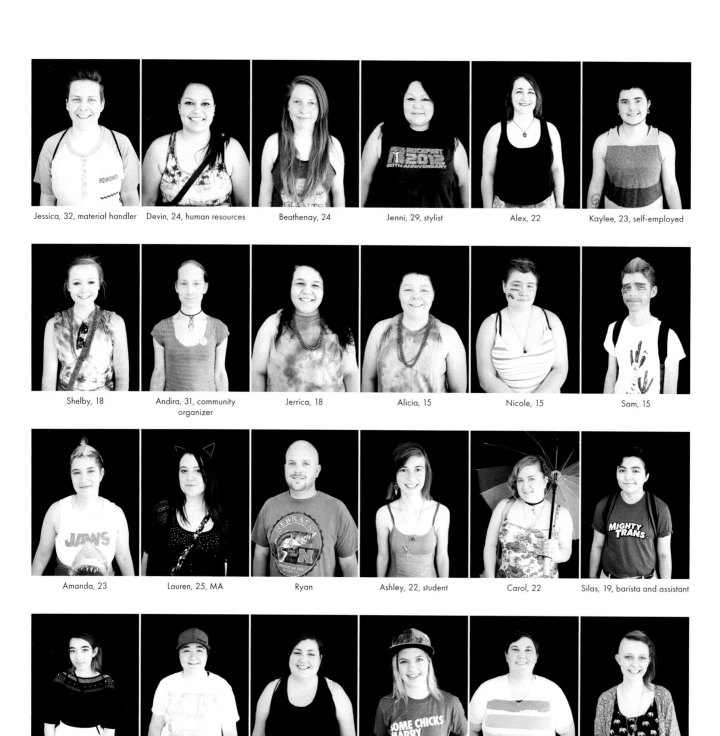

Jessica, 32, material handler | Devin, 24, human resources | Beathenay, 24 | Jenni, 29, stylist | Alex, 22 | Kaylee, 23, self-employed

Shelby, 18 | Andira, 31, community organizer | Jerrica, 18 | Alicia, 15 | Nicole, 15 | Sam, 15

Amanda, 23 | Lauren, 25, MA | Ryan | Ashley, 22, student | Carol, 22 | Silas, 19, barista and assistant

Tatiana, 18, barista and student | Kimi, 19, student | Ashleigh, 28, payroll specialist | Kelsey, 20, childcare | Sara, 26, guest services at zoo | Olivia, 20

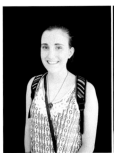

Kendra, 20

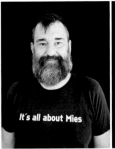

Bill, 54, museum director

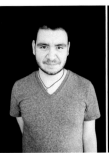

Kris, 23, CNA

Cedric, 38, sales associate

Taylor, 31, self-employed

Trevor, 32, healthcare

Tony, 30

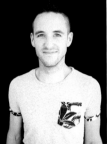

Jon, 26, teacher

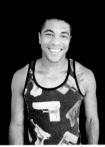

Kyle, 25

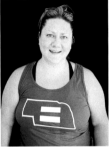

Kephanie, 33, sales manager

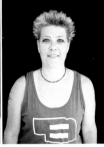

Holly, 42, caterer

Victoria, 33, cashier

Clara, 35, cashier

Talia, 38, medical receptionist

Amber, 38, postal worker

Steven, 54, counselor

George, 60, manager

Tom, 43, real estate

Jason, 19, server

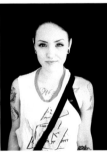

Krissy, 20, delivery driver

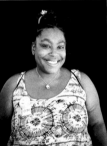

Destiny, 29

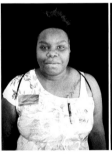

Brandi

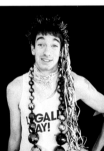

Matt, 20, actor

Janet, 37, customer service

Lisa, 38, government

Harry, 67, retired

Karma, 26, administrative
assistant

Elissa, 36, accounting

Nerissa, 31, scenic painter

Brenda, 48, printer

Michael, 53

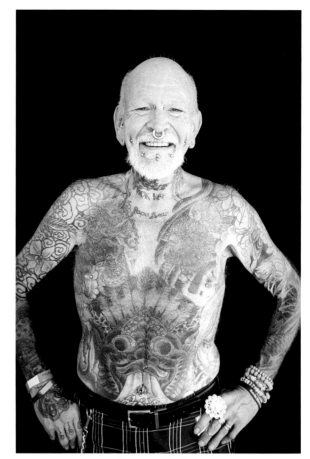

Papa Bear, 53, retired

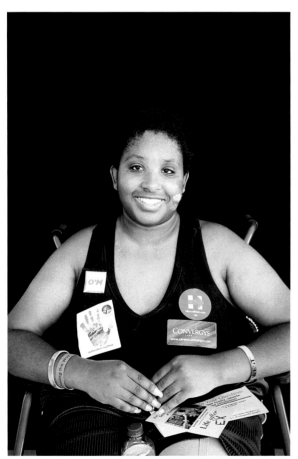

Patricia, 31

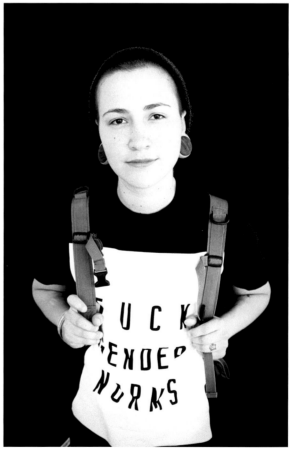

Benji, 21, Starbucks

Mike, 44, driver

Chuck, 41, US military

Jordan, 24, disabled veteran

Joshua, 28, veterans' service rep

Lynn, 52, manager

Stephanie, 20

Paige, 21, student

Chon, 20, student

Demetris, 19

Jose, 26

Juanito, 21

Dandyce, 26, university bookstore

Sarah, 24, donor center tech

Tyler, 25, data entry

Pete, 41, stylist

Terell, 29, reservations

Poli, 30, military

Fantasia, 36, admin assistant

Caryn, 39, mail carrier

Vida, 20, student

Sam, 19

Adrianee, 43, data analyst

Benny, 22, military

Amanda, 21, surveyor

Patrisha, 30, caseworker and disability barber

Siobhan, 35, disabled veteran

Bubba, 19, grower

Ithuriel, 18

Nick, 34, retail manager

Katana, 24

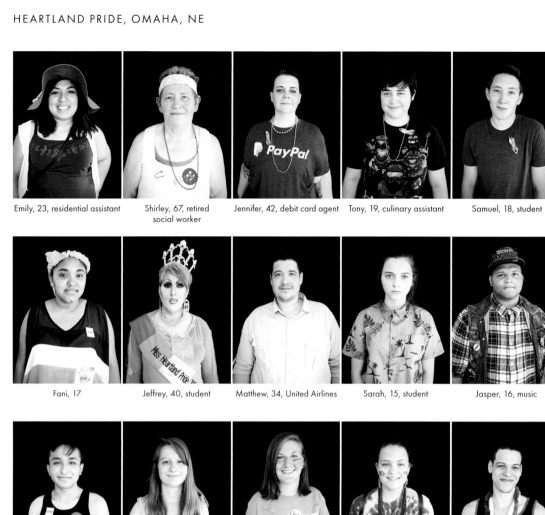

Emily, 23, residential assistant

Shirley, 67, retired social worker

Jennifer, 42, debit card agent

Tony, 19, culinary assistant

Samuel, 18, student

Andy, 20, customer service

Fani, 17

Jeffrey, 40, student

Matthew, 34, United Airlines

Sarah, 15, student

Jasper, 16, music

Zoe, 14

Rafael, 16, host

Megan, 16, host

Annie, 15, student

Riley, 15

Marquise, 22, customer service

Chelle, 21

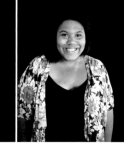
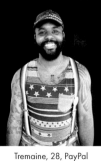
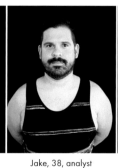
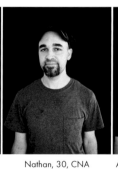

Corean, 22, customer service

Jatie, 27, graphic designer

Travis, 45, admin

Evan, 27, sales

Liz, 30, barista

Redwookie, 27, CSTL

Jen, 21, nanny

Demi, 24, teacher

Tremaine, 28, PayPal

Jake, 38, analyst

Nathan, 30, CNA

Adam, 39, arts management

Bryce, 23, student

Jeff, 46, sales

Ben, 19

Emma, 15, student

Mystic Delite, 36, postal clerk

Sara, 20, plumber

Matthew, 35, civil

Jeff, 51, payroll manager

Perry, 20, service technician

Jessika, 21, server

Cameron, 22, server

Shaunalyn, 39, shipping operator

Samantha, 20, student

Ernest, 38, tech support

Amber, 23, insurance

Becky, 24, insurance

Toria, 19, student

Maddie, 20, student

Rhoda, 37, finance

Abri, 13

Ashley, 20, tech support

Caleb, 18, cashier

Julia, 18, cashier

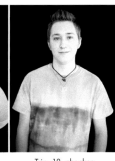
Trip, 18, checker

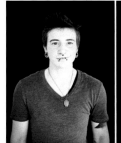
Kypton, 21, medical courier

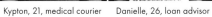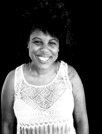
Danielle, 26, loan advisor

Chris, 47, PE IC analyst

Erika, 25, bartender

Sherry, 54, 3M

Alex, 23, assistant store manager

467

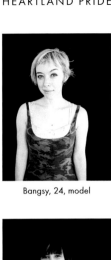
Bangsy, 24, model

Brick, 31, student

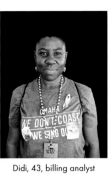
Didi, 43, billing analyst

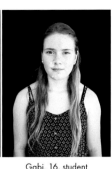
Gabi, 16, student

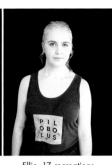
Ellie, 17, recreations supervisor

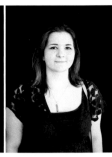
Abi, 19

Ciara, 19, student

Sarah, 19, Kolache manager

Courtney, 19

TyTy, 21

Chelsea, 18, McDonald's

Marilyn, 22, McDonald's

Michaela, 22, student

Kyt, 29, program developer

Dani, 32, owner and field tech

Traneay, 18, cashier

Ellie, 18, cashier

Kristy, 41, project manager

Mira, 15

David, 21, banker

Shay, 23, HSI repair

Rachel, 18

Donnie, 18

Nicole, 22, janitor

Alyssa, 26, culinary

Tena, 36, fitness instructor

Walker, 19, student

Marissa, 19, cashier

Mahlan, 19, cashier

Josie, 13, student

Nannette, 40, marketing

Emily, 44, librarian

John, 49, librarian

Shaun, 29

Reign, 22, teller

Andy, 18

Angel, 24, Kawasaki

Adan, 27

Corey, 23

Marco, 22, reservation agent

Shiloh, 24, firefighter

Ericka, 23, tech

Michaela, 22, student

Chad, 22, preschool teacher

Autumn, 38, self-employed

Telia, 28, caregiver

Adrianna, 38, driver

Meya, 33, fraud analyst

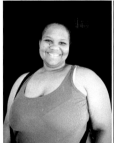

Jennifer, 30, academic advisor

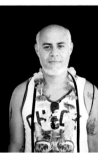

Jay, 27

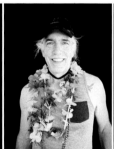

Rick, 50, hospitality

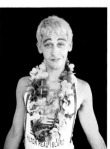

Will, 22, Micky's

JUNE 26, 2015

THE SUPREME COURT RULES THAT
BANS ON SAME-SEX MARRIAGE ARE
UNCONSTITUTIONAL, MAKING MARRIAGE
EQUALITY THE LAW OF THE LAND.

SEATTLE PRIDE

SEATTLE, WA

JUNE 28, 2015

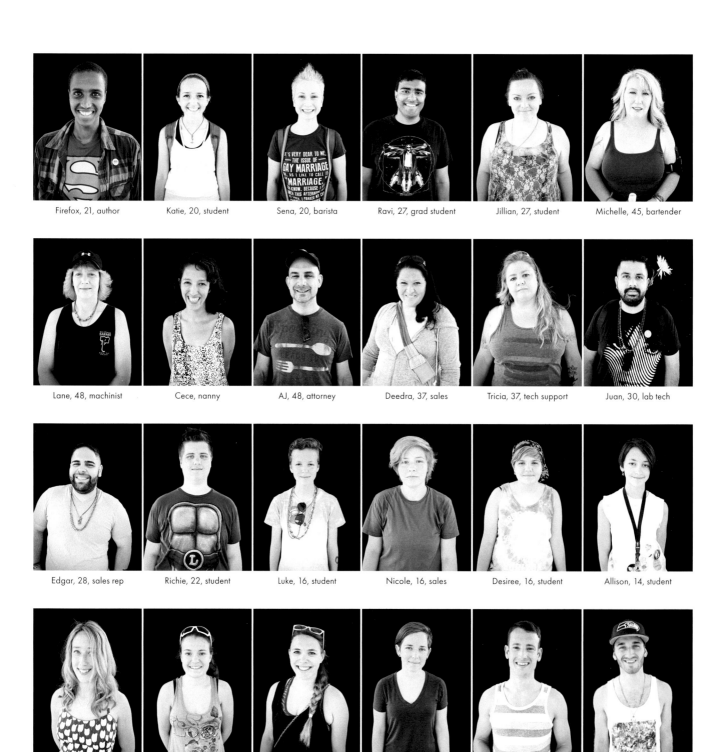

Firefox, 21, author

Katie, 20, student

Sena, 20, barista

Ravi, 27, grad student

Jillian, 27, student

Michelle, 45, bartender

Lane, 48, machinist

Cece, nanny

AJ, 48, attorney

Deedra, 37, sales

Tricia, 37, tech support

Juan, 30, lab tech

Edgar, 28, sales rep

Richie, 22, student

Luke, 16, student

Nicole, 16, sales

Desiree, 16, student

Allison, 14, student

Caitlin, 21, marketing

Tay, 19, retail

Caty, 20, retail

Alex, 31

Danny, 25, engineer

Saturns, 24, graphic designer

Cat, 36. attorney

Traci, 26, truck stop

Justin, 34, train conductor

Elizabeth, 35, costumer

Jen, 38, marketing

Jordan, 32, military

EJ, 19, yacht detailer

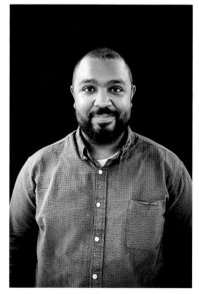

Spencer, 29, city planner

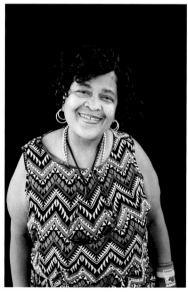

Beth Ann, 49, disabled

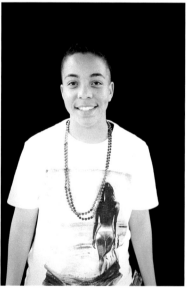

Jasmine, 19, military

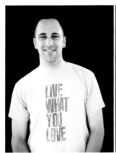

Jay, 28

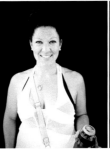

Brittney, 30, NAC

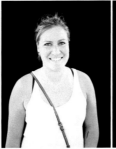

Kate, 28, sales manager

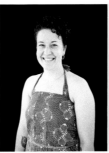

Elizabeth, 28, therapist

Emily, 31, pediatric resident physician

TJ, 22, server

Holly, 52, tutor

Whoretense, 51, engineer

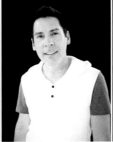

Mark, 48, insurance claims

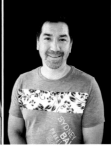

Joseph, 46, flight attendant

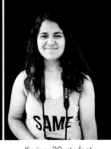

Karina, 20, student

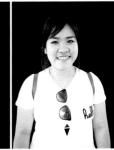

Eva, 23, student

Omar, 31, education

Sean, 29, software developer

Taso, 34, communications

Kevin, 36, GIS specialist

Steve, 26, student

Markus, 25, athletic therapist

Peter, 22, student

Taylor, 25, government

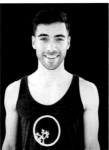

Ryan, 26, software engineer

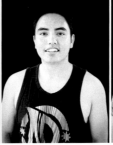

Charles, 22, student

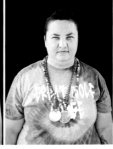

Pay, 36, parent and web developer

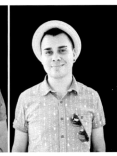

Jay, 23, sneakerologist

Jon, 26, retail

Paul, 31, phsyical therapist

Anne, 30, pharmacy tech

Matthew, 38, registered nurse

Bryn, 29, retail

Tasi, 19, retail

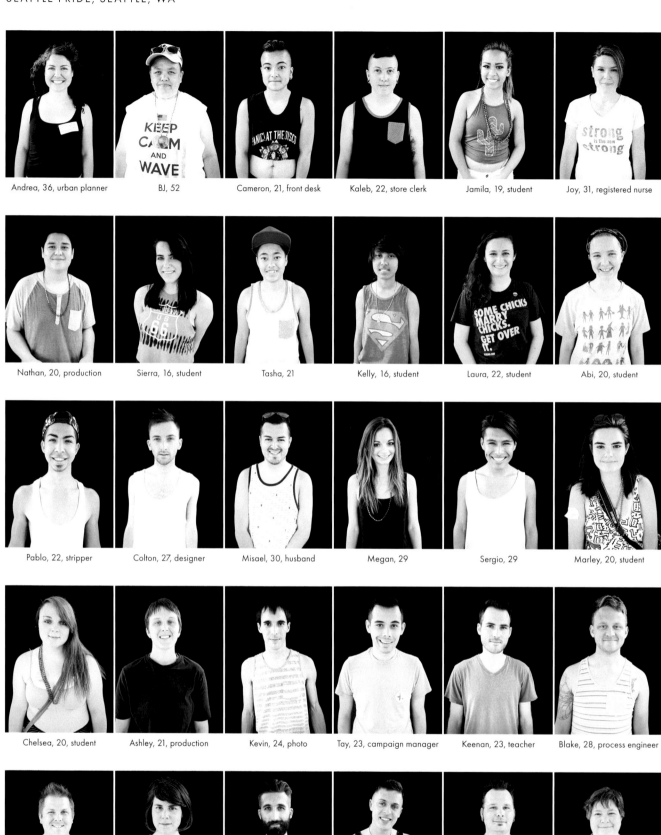

Andrea, 36, urban planner BJ, 52 Cameron, 21, front desk Kaleb, 22, store clerk Jamila, 19, student Joy, 31, registered nurse

Nathan, 20, production Sierra, 16, student Tasha, 21 Kelly, 16, student Laura, 22, student Abi, 20, student

Pablo, 22, stripper Colton, 27, designer Misael, 30, husband Megan, 29 Sergio, 29 Marley, 20, student

Chelsea, 20, student Ashley, 21, production Kevin, 24, photo Tay, 23, campaign manager Keenan, 23, teacher Blake, 28, process engineer

Quaid, 32 Anna, 29, librarian Chris, 29, librarian Brett, 25, gamer Edward, 36 Leri, 37, mother

Emily, 47, vet tech

Hannah, 19, student

Alexis, 19, student

Andrew, 19, student

Jessa, 19, student

Boston, 19

Miranda, 21, barista

Kate, 25, deli cook

Chris, 23, legal assistant

Sara, 54, college faculty

Caroline, 18, student

Michelle, 27, RN

Annie, 31, product manager

Aya, 23, au pair

Caro, 20, nanny

Christopher, 33, marketing director

Ken, 33, IT support tech

Johnny, 25, US Marine

Alex, 26, flight attendant

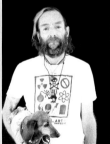

Scott, 60, retired

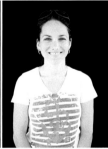

Tamor, 38, doctor

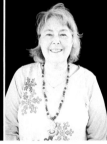

Maxine, 71, retired

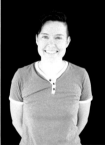

Sarah, 33, software engineer

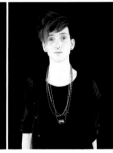

Seth, 23, hairstylist

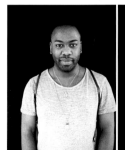

Eleven, 25, hairstylist

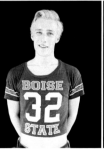

Breckenridge, 22, professional stylist

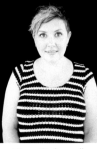

Missy, 35, dog walker

Guy, 44, software engineer

Claire, 24, student

Caitlin, 43, civil rights lawyer

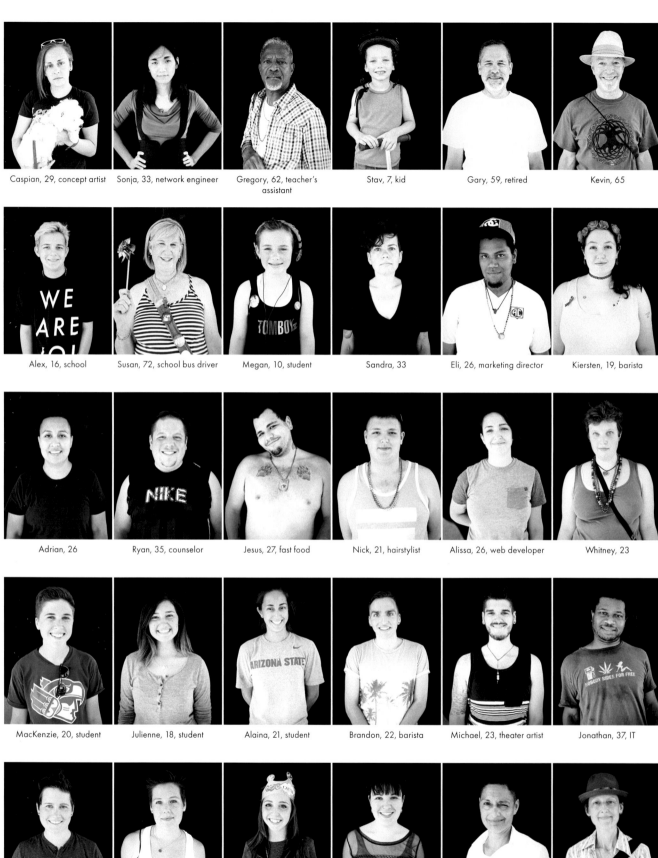

Caspian, 29, concept artist Sonja, 33, network engineer Gregory, 62, teacher's assistant Stav, 7, kid Gary, 59, retired Kevin, 65

Alex, 16, school Susan, 72, school bus driver Megan, 10, student Sandra, 33 Eli, 26, marketing director Kiersten, 19, barista

Adrian, 26 Ryan, 35, counselor Jesus, 27, fast food Nick, 21, hairstylist Alissa, 26, web developer Whitney, 23

MacKenzie, 20, student Julienne, 18, student Alaina, 21, student Brandon, 22, barista Michael, 23, theater artist Jonathan, 37, IT

Hannah, 26, consultant Sarah, 25, legal assistant Adrienne, 14, being awesome Tara, 25, sales Bella, 55, server Jodi, 50

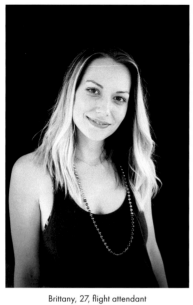

Brittany, 27, flight attendant

Beano, 23, cook

Aaron, 28, social work

Reese, 20, student

Marielle, 24, scientist

Derek, 20, student

Sunny, 49, homemaker

Rikki, 50, student

Damion, 21

SEATTLE PRIDE, SEATTLE, WA

 Brittany, 25, retail sales
 Lindsay, 24, hairstylist
 Kylee, 24, eye bank tech
 Denise, 20, student
 Diana, 25, project manager
 Polly, 24, nonprofit development

 Johnny, 28, fermenter
 Nicole, 31, sales
 Jessica, 28, medical
 Vida, 33, chef
 Kathryn, 29, dancer
 Ike, 25, software engineer

 Natali, 22
 Darcy, 41, surgeon
 Nicole, 39, acupuncturist
 Myell, 22, student
 Sylvie, 23, data control technician
 Morgan, 23

 Sarah, 23, volunteer
 Farah, 23, student
 Scott, 26, therapist
 Tiffany, 24, student
 Meanie, 28, customer service
 Gavin, 29, designer

 Levin, 32, graphic designer
 Amy, 27, designer
 Lucy, 24, admin assistant
 Madelyn, 25, nanny
 Sarah, 24, optometrist
 Marci, 24, social work

480

Simone, 24, therapist

Matt, 50, computer
programmer

Stephen, 60, architect

Scott, 18, sales associate

Harrison, 30, operator

Zak, 21, cook

Pierre-Yves, 37, physical

Casey, 21, manager
at McDonald's

Allen, 57, ultrasound
technician

Derek, 30, computer
technician

Savy, 21, customer service

Cheri, 35, software developer

Renee, 30, software
developer

Chris, 19, student

Pat, 20, intern

Joy, 18, student

Annemarie, 46, research
coordinator

Lara, 29

Barett, 32, IT

Kieran, 27, science editor

Ana, 29, bartender

Julian, 27, chiropractic

Dina, 43, psychotherapist

Sarah, 26, teacher

Meghan, 28, barista

Logan, 24

Amanda, 27, liquor vendor

481

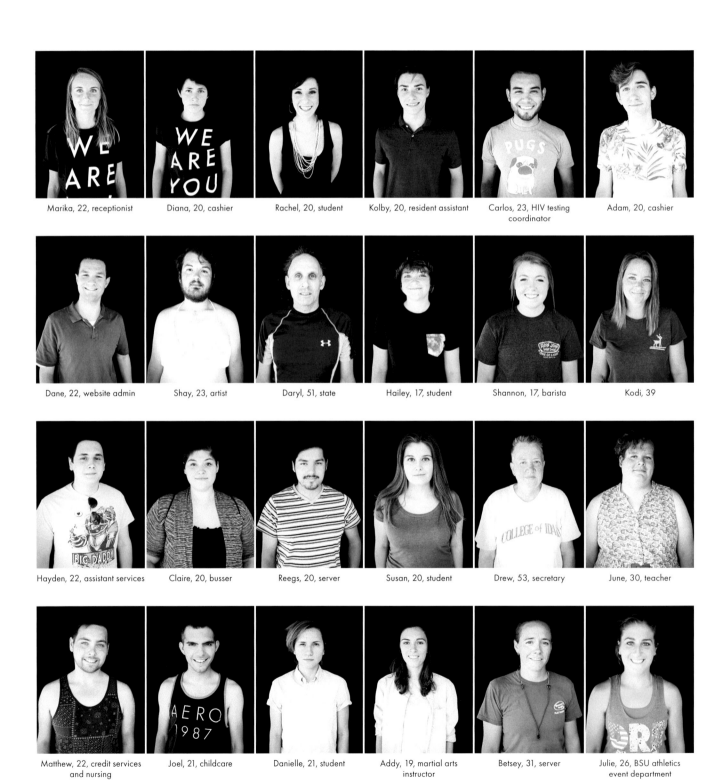

Marika, 22, receptionist

Diana, 20, cashier

Rachel, 20, student

Kolby, 20, resident assistant

Carlos, 23, HIV testing coordinator

Adam, 20, cashier

Dane, 22, website admin

Shay, 23, artist

Daryl, 51, state

Hailey, 17, student

Shannon, 17, barista

Kodi, 39

Hayden, 22, assistant services

Claire, 20, busser

Reegs, 20, server

Susan, 20, student

Drew, 53, secretary

June, 30, teacher

Matthew, 22, credit services and nursing

Joel, 21, childcare

Danielle, 21, student

Addy, 19, martial arts instructor

Betsey, 31, server

Julie, 26, BSU athletics event department

DW Wiona, 13, brand ambassador

Joe, 25, web designer

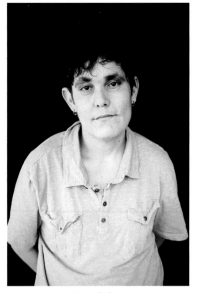

Jai, 35, web designer

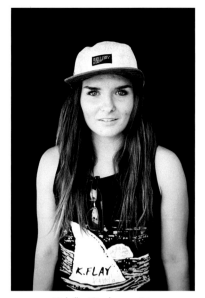

Michelle, 19, sales associate

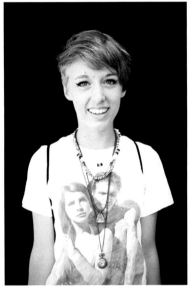

Nelson, 18, student

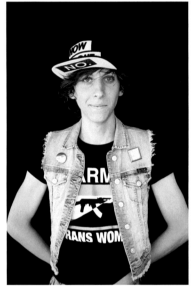

Astrid, 22, bartender

Lauren, 23, AmeriCorps

Callie, 24, prep cook

David, 49, archaeologist

Reverend Deborah, 59, Episcopal priest

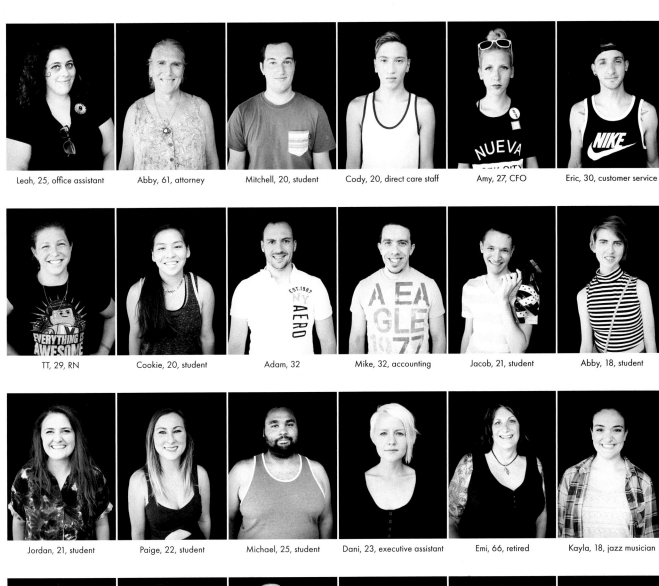

Leah, 25, office assistant Abby, 61, attorney Mitchell, 20, student Cody, 20, direct care staff Amy, 27, CFO Eric, 30, customer service

TT, 29, RN Cookie, 20, student Adam, 32 Mike, 32, accounting Jacob, 21, student Abby, 18, student

Jordan, 21, student Paige, 22, student Michael, 25, student Dani, 23, executive assistant Emi, 66, retired Kayla, 18, jazz musician

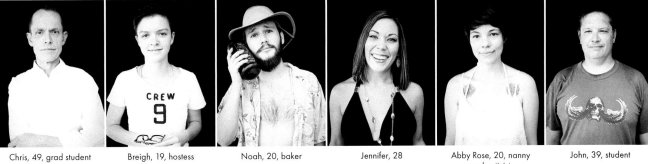

Chris, 49, grad student Breigh, 19, hostess Noah, 20, baker Jennifer, 28 Abby Rose, 20, nanny and activist John, 39, student

JULY 27, 2015

BOY SCOUTS OF AMERICA LIFTS ITS
NATIONAL BAN ON OPENLY GAY LEADERS
AND EMPLOYEES.

LOS ANGELES, CA
NOVEMBER 2015

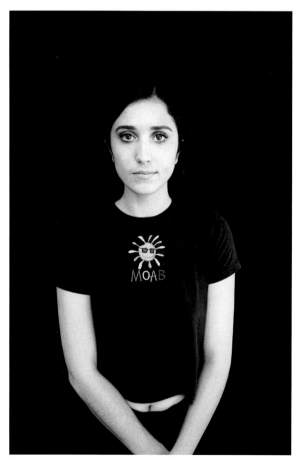

Amelia, 18, student

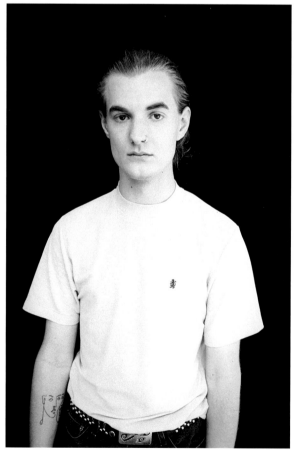

Walker, 20, student and artist

Jill, 49, artist

Adwoa, 23, model, activist, and actor

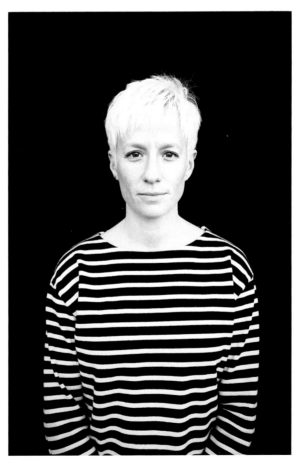

Megan, 30, athlete

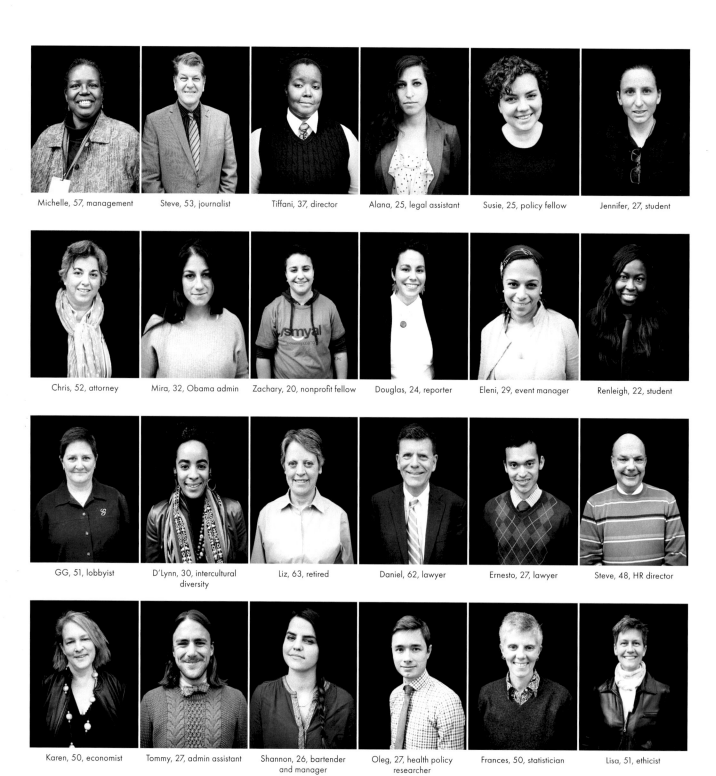

Michelle, 57, management

Steve, 53, journalist

Tiffani, 37, director

Alana, 25, legal assistant

Susie, 25, policy fellow

Jennifer, 27, student

Chris, 52, attorney

Mira, 32, Obama admin

Zachary, 20, nonprofit fellow

Douglas, 24, reporter

Eleni, 29, event manager

Renleigh, 22, student

GG, 51, lobbyist

D'Lynn, 30, intercultural diversity

Liz, 63, retired

Daniel, 62, lawyer

Ernesto, 27, lawyer

Steve, 48, HR director

Karen, 50, economist

Tommy, 27, admin assistant

Shannon, 26, bartender and manager

Oleg, 27, health policy researcher

Frances, 50, statistician

Lisa, 51, ethicist

2016

9,387–9,459 Rainbow Pride of West Virginia
 Charleston, WV

9,460–9,492 Big Sky Pride
 Helena, MT

9,493–9,592 Mississippi Pride
 Jackson, MS

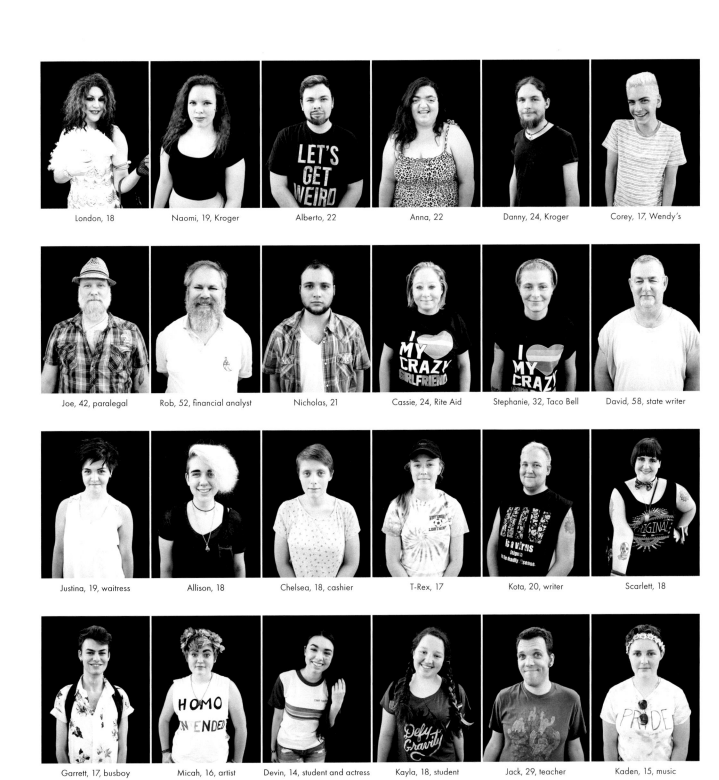

London, 18 Naomi, 19, Kroger Alberto, 22 Anna, 22 Danny, 24, Kroger Corey, 17, Wendy's

Joe, 42, paralegal Rob, 52, financial analyst Nicholas, 21 Cassie, 24, Rite Aid Stephanie, 32, Taco Bell David, 58, state writer

Justina, 19, waitress Allison, 18 Chelsea, 18, cashier T-Rex, 17 Kota, 20, writer Scarlett, 18

Garrett, 17, busboy Micah, 16, artist Devin, 14, student and actress Kayla, 18, student Jack, 29, teacher Kaden, 15, music

Raegan, 19, Journeys key holder

Raigan, 16

Liv, 18, student

Jessica, 18, daycare provider

Brooke, 16

Anthony, 20, cashier

Amanda, 19, assistant general manager

Lucky, 25

Isaiah, 15, dancer

Jeff, 54, registration clerk

Randy, 34, IT

Dawn, 49, paralegal

Jackie, 50, risk manager

Kelli, 41, social worker, and Anevay

Emily, 15

Paul, 27, student

Missy, 29, PR

Allie, 23, nurse

Stacie, 30, CPS

Bob, 57, accountant

Andy, 47, higher education

Eric, 30, clerk

Noel, 20, cashier

Rosa, 13

Brandon, 24, cashier

Robert, 52, writer

Jerry, 50, stylist

Kelly, 48, vet tech

AJ, 28, customer service

Laura, 42, PT

Kaitlyn, 23, server

Alexis, 35

Cody, 22, school board

Angie, 50, librarian

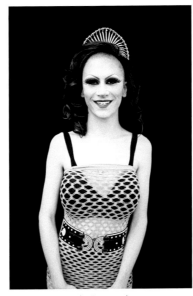

Angel, 18, atmosphere

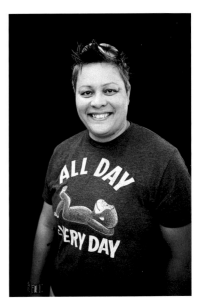

Diane, 39, retired US Marine

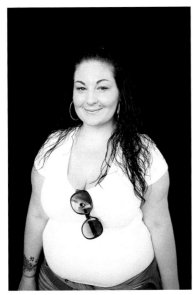

Sweetness, 31, dental assistant

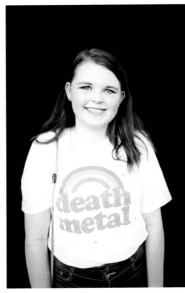

Haylee, 16

Jason, 66, retired

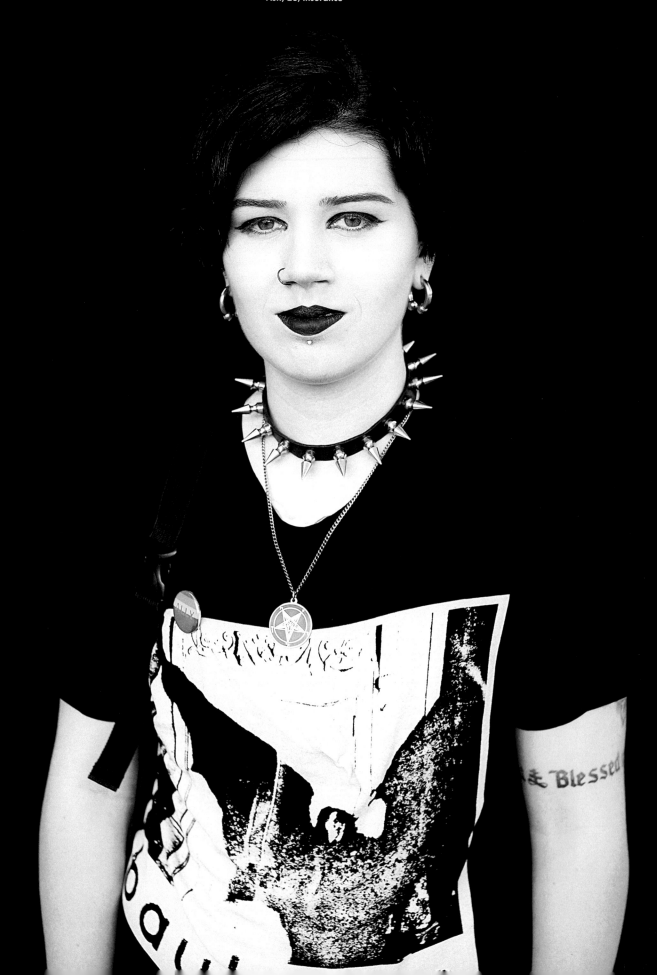

Ash, 23, insurance

Blake, 19

Cristy, 41, social worker

Chad, 24, server

Kayla, 24, AP clerk

Pebbles, 23, mailroom

Amanda, 23, mailroom

Robbie, 22, unemployed

Lauren, 15, student

David, 66, assistant

JUNE 12, 2016

THE PULSE NIGHTCLUB SHOOTING
BECOMES THE DEADLIEST INCIDENT OF
VIOLENCE AGAINST LGBTQ+ PEOPLE IN
UNITED STATES HISTORY.

BIG SKY PRIDE
HELENA, MT
JUNE 21, 2016

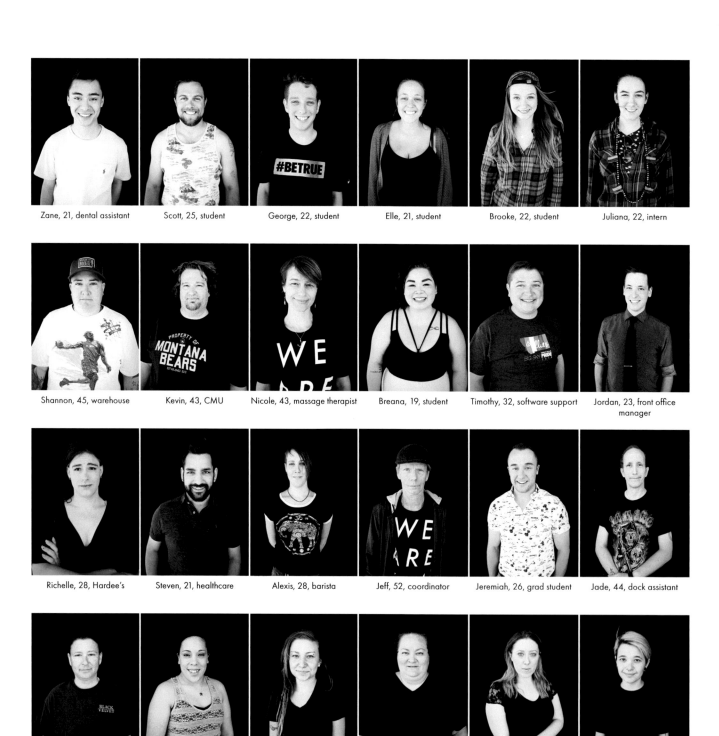

Zane, 21, dental assistant

Scott, 25, student

George, 22, student

Elle, 21, student

Brooke, 22, student

Juliana, 22, intern

Shannon, 45, warehouse

Kevin, 43, CMU

Nicole, 43, massage therapist

Breana, 19, student

Timothy, 32, software support

Jordan, 23, front office manager

Richelle, 28, Hardee's

Steven, 21, healthcare

Alexis, 28, barista

Jeff, 52, coordinator

Jeremiah, 26, grad student

Jade, 44, dock assistant

Julie, 46, laborer

Lexi, 29, general manager

Haley, 22, student

Nina, 37, disabled

Crystal, 19, student

Jasmine, 21, student

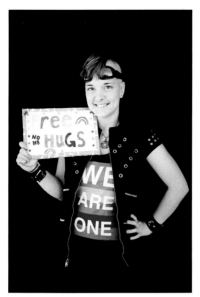

Alex, 21, unemployed

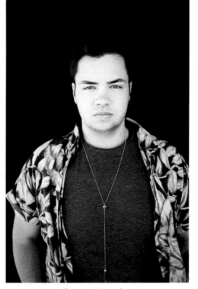

Thomas, 18, student

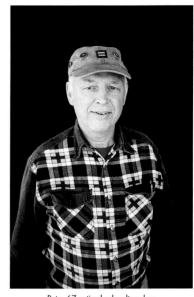

Pete, 67, retired schoolteacher

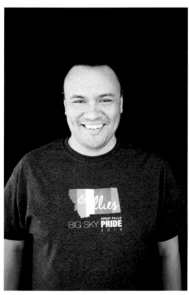

Kimo, 41, software

Joshua, 34, assistant foreman

Tom, 39, engineer

Taylor, 19, stay-at-home mom

Kelly, 37, 911 dispatcher

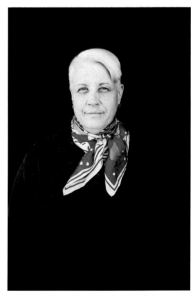

Jennie, 58, healthcare provider

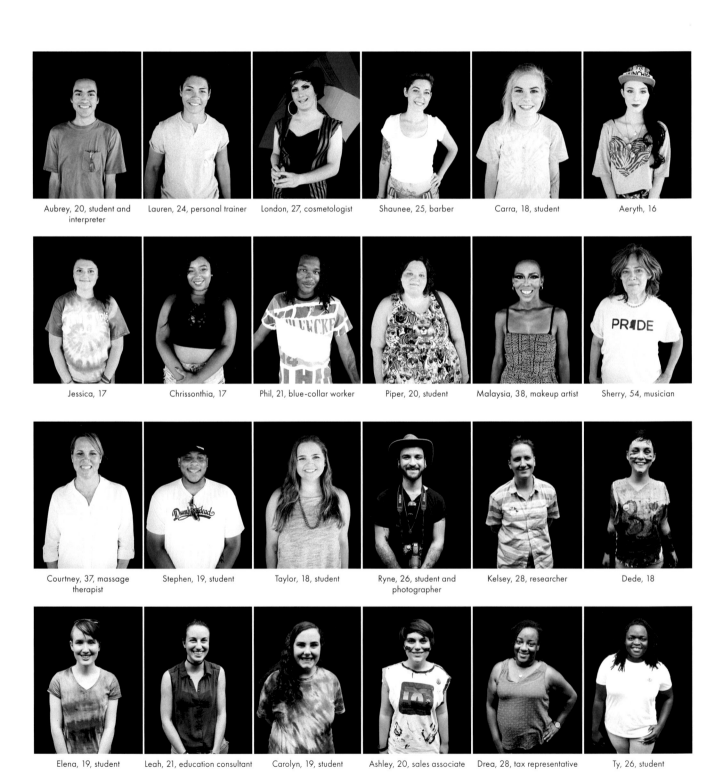

Aubrey, 20, student and interpreter

Lauren, 24, personal trainer

London, 27, cosmetologist

Shaunee, 25, barber

Carra, 18, student

Aeryth, 16

Jessica, 17

Chrissonthia, 17

Phil, 21, blue-collar worker

Piper, 20, student

Malaysia, 38, makeup artist

Sherry, 54, musician

Courtney, 37, massage therapist

Stephen, 19, student

Taylor, 18, student

Ryne, 26, student and photographer

Kelsey, 28, researcher

Dede, 18

Elena, 19, student

Leah, 21, education consultant

Carolyn, 19, student

Ashley, 20, sales associate

Drea, 28, tax representative

Ty, 26, student

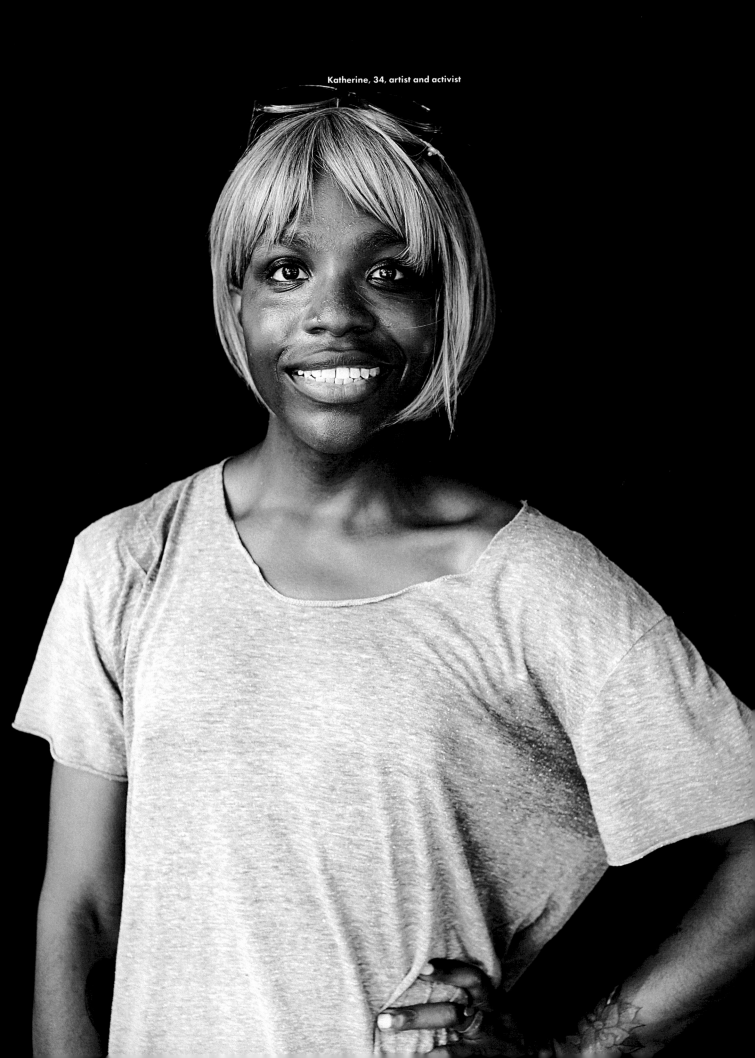

Katherine, 34, artist and activist

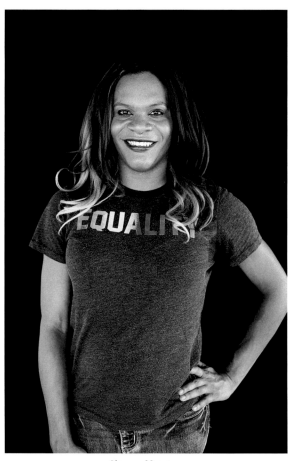

Blossom, 29, actress

Peaches, 18, military

Alexis, 24, customer service

Keasha, 43

David, 49, disabled

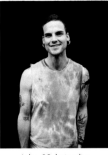

Jake, 29, hairstylist

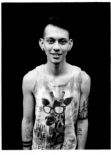

Ed, 23, retail management

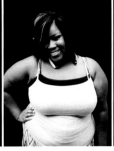

Cent, 24, student

Lynn, 47, executive director

Dan, 26, HRC faith director

Caleb, 22

Chelsea, 19, server

Boy, 33

Carlie Ann, 21, student

Kayley, 21, RN

Taylor, 20, retail management

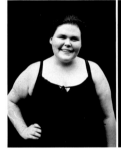

Shay, 21, teacher

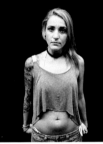

Vanessa, 33, ortho tech

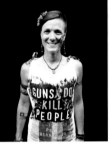

Amelie, 38, activist

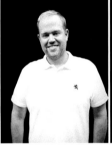

Jack, 37, broadcast media

Mitchell, 25, interior design

Duck, 18, student

Elizabeth, 51, retired welder

Michael, 52, retired

Jim, 57, registered nurse

Hannah, 16, student

Alexa, 23, art teacher

Maria, 20, student

Cari Ann, 30, cardiovascular surgeon

Gregory, 21, artist

AJ, 39, student and mother

Nick, 58, health educator

Joseph, 28, accountant

Aaron, 30, RN

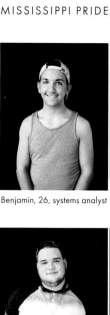

Benjamin, 26, systems analyst

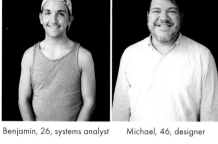

Michael, 46, designer

Bob, 48

Jasmine, 24, customer service

Natasha, 29, customer service

Liz, 26, photographer

Anthony, 23, server

Buffy, 28, crew chief

Morgan, 20, nurse

Maggie, 23, cashier

White Mudd, 22, supervisor

Paige, 21, corrections officer

Rachel, 21, student

Kasey, 22, teacher

Brian, 29, human resources

Kylie, 21, student

Desiree, 22, caregiver

Levi, 20, student

Meryl, 26, market research analyst

Brooke, 33, attorney

Desmond, 28, CNA

Kenonce, 31, customer service

Kit, 30, actor

James, 27, cashier

Nancy, 52, financial advisor

Suzi, 47, photographer

Sean, 48, jeweler

Emily, 25

Alan, 35, public administration

Brian, 43, jeweler

Haley, 17, student Loy, 74, gardener Eion, 37, property manager Rickey, 30 Shawn, 26, teller Victor, 28, cook

Seth, 23, student Eyra, 32 Robin, 59, musician Beverly, 37, customer service Kam, 16, artist

507

2017

9,593–9,598 Los Angeles, CA

Layshia, 25, athlete

Jessica, 30, sports manager

Phoebe, 28, designer

Jesse, 41, actor cop

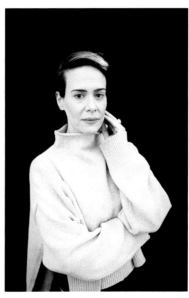

Sarah, 41, actor

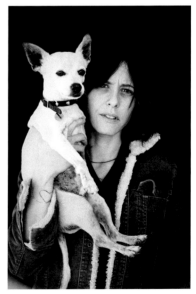

Kate, 39, actor

NOVEMBER 7, 2017

DANICA ROEM BECOMES THE FIRST OPENLY
TRANSGENDER CANDIDATE ELECTED TO A
STATE LEGISLATURE WHEN SHE WINS A SEAT
IN THE VIRGINIA HOUSE OF DELEGATES.

2018

9,599–9,616 New York, NY

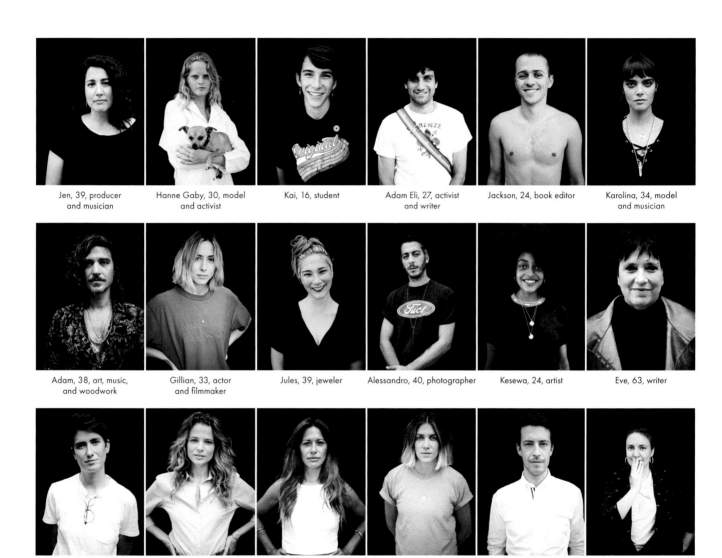

Jen, 39, producer and musician

Hanne Gaby, 30, model and activist

Kai, 16, student

Adam Eli, 27, activist and writer

Jackson, 24, book editor

Karolina, 34, model and musician

Adam, 38, art, music, and woodwork

Gillian, 33, actor and filmmaker

Jules, 39, jeweler

Alessandro, 40, photographer

Kesewa, 24, artist

Eve, 63, writer

Danielle, 32, video editor

Allison, 27, actor

Helena, 40, shopkeeper

Fabiana, 32, shopkeeper

Nick, 35, editor

Lena, 32, writer

MARCH 23, 2018

PRESIDENT DONALD TRUMP'S
ADMINISTRATION ANNOUNCES A POLICY
BANNING MOST TRANSGENDER PEOPLE
FROM SERVING IN THE MILITARY.
IN JANUARY 2019, AFTER SEVERAL
HEARINGS, THE SUPREME COURT ALLOWS
THE BAN TO GO INTO EFFECT.

2019

9,617–9,644	Levi's Los Angeles, CA
9,645–9,662	Levi's New York, NY
9,663–9,772	New York, NY
9,773–9,787	New York, NY
9,788–9,852	Los Angeles, CA
9,853–9,874	Los Angeles, CA
9,875–10,000	New York, NY

LEVI'S
LOS ANGELES, CA
SEPTEMBER 5, 2019

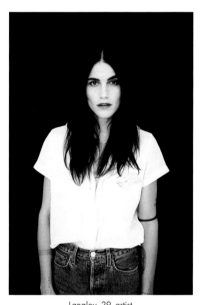

Langley, 29, artist

Rocco, 39, artist and organizer

Janicza, 38, director

Vickie, 26, artist

Sarah, 30, talent manager

Zackary, 36, artist and producer

Corey, 26, model

Jacob, 28, writer

Nomi, artist

Future, 31, director

Patrisse, 36, community organizer

Elise, 30, artist

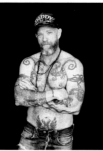

Buck, 57, activist

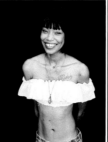

Lulu, 29, carpenter

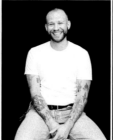

Eli, 40, barber

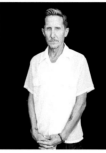

GG, 55, design

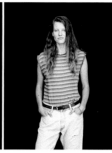

Dace, 30, designer

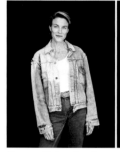

Maggie, 33, brand marketing

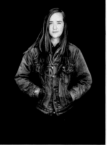

Cortney, 33, producer
and director

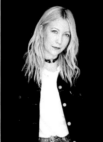

Sera, 39, hairdresser

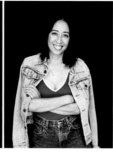

Jenn, 34, interior designer

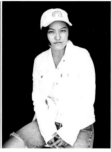

Paco, 34, small business
owner

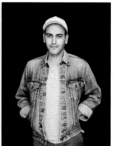

Sina, 33, writer
and cartoonist

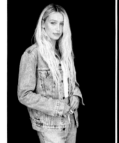

Cailin, 25, entertainer

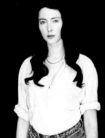

Hayden, 31, artist

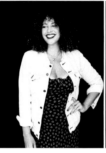

Matisse, 31, model
and makeup artist

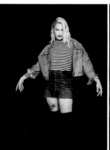

Pearl, 28, drag queen

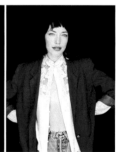

Nicole, 32, actress

LEVI'S
NEW YORK, NY
SEPTEMBER 7, 2019

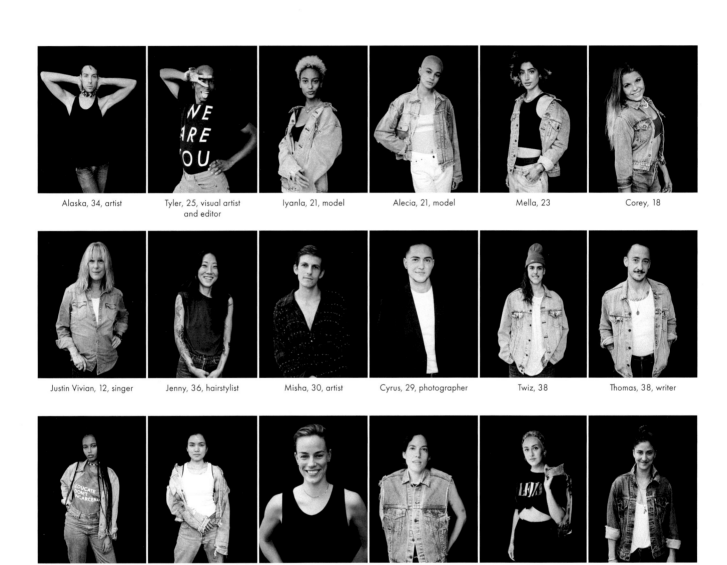

Alaska, 34, artist

Tyler, 25, visual artist
and editor

Iyanla, 21, model

Alecia, 21, model

Mella, 23

Corey, 18

Justin Vivian, 12, singer

Jenny, 36, hairstylist

Misha, 30, artist

Cyrus, 29, photographer

Twiz, 38

Thomas, 38, writer

Saada, 32, co-founder
of Everyday People

Christelle, 35, director
and photographer

Elliott, 37, model
and advocate

Sarah, 33, cinematographer

Amanda, 25, artist

Olimpia, 33, artist

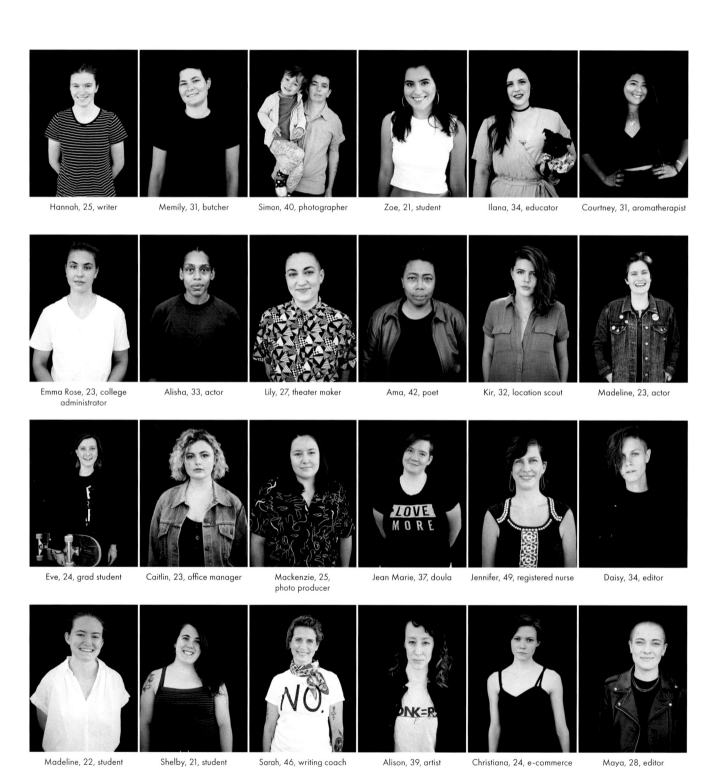

Hannah, 25, writer

Memily, 31, butcher

Simon, 40, photographer

Zoe, 21, student

Ilana, 34, educator

Courtney, 31, aromatherapist

Emma Rose, 23, college
administrator

Alisha, 33, actor

Lily, 27, theater maker

Ama, 42, poet

Kir, 32, location scout

Madeline, 23, actor

Eve, 24, grad student

Caitlin, 23, office manager

Mackenzie, 25,
photo producer

Jean Marie, 37, doula

Jennifer, 49, registered nurse

Daisy, 34, editor

Madeline, 22, student

Shelby, 21, student

Sarah, 46, writing coach
and poet

Alison, 39, artist
and parent

Christiana, 24, e-commerce
production

Maya, 28, editor
and grad student

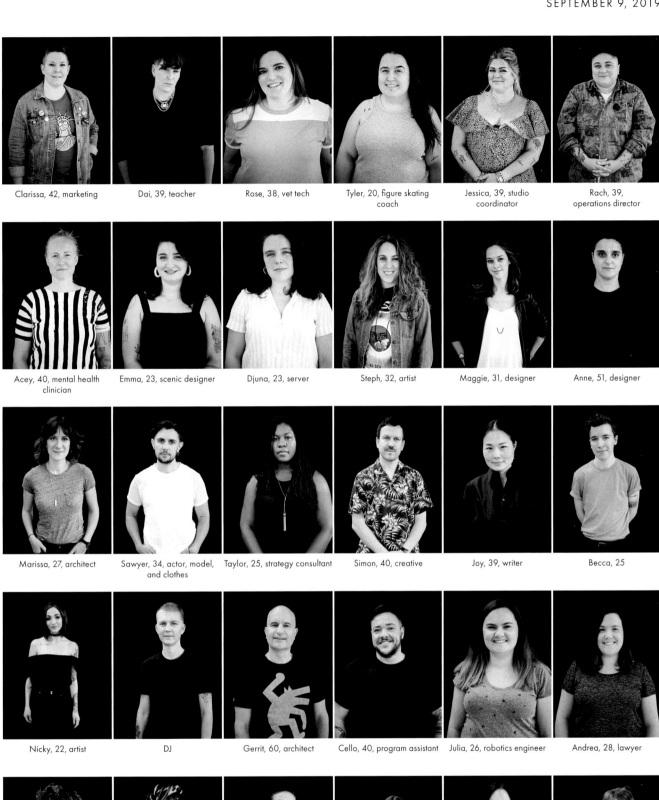

Clarissa, 42, marketing

Dai, 39, teacher

Rose, 38, vet tech

Tyler, 20, figure skating coach

Jessica, 39, studio coordinator

Rach, 39, operations director

Acey, 40, mental health clinician

Emma, 23, scenic designer

Djuna, 23, server

Steph, 32, artist

Maggie, 31, designer

Anne, 51, designer

Marissa, 27, architect

Sawyer, 34, actor, model, and clothes

Taylor, 25, strategy consultant

Simon, 40, creative

Joy, 39, writer

Becca, 25

Nicky, 22, artist

DJ

Gerrit, 60, architect

Cello, 40, program assistant

Julia, 26, robotics engineer

Andrea, 28, lawyer

Alex, 25, photographer

PJ, 60, professor

Nikki, 23, performer

Sarose, 26, event producer

Micaela, 23, artivist

Nikki, 38, designer

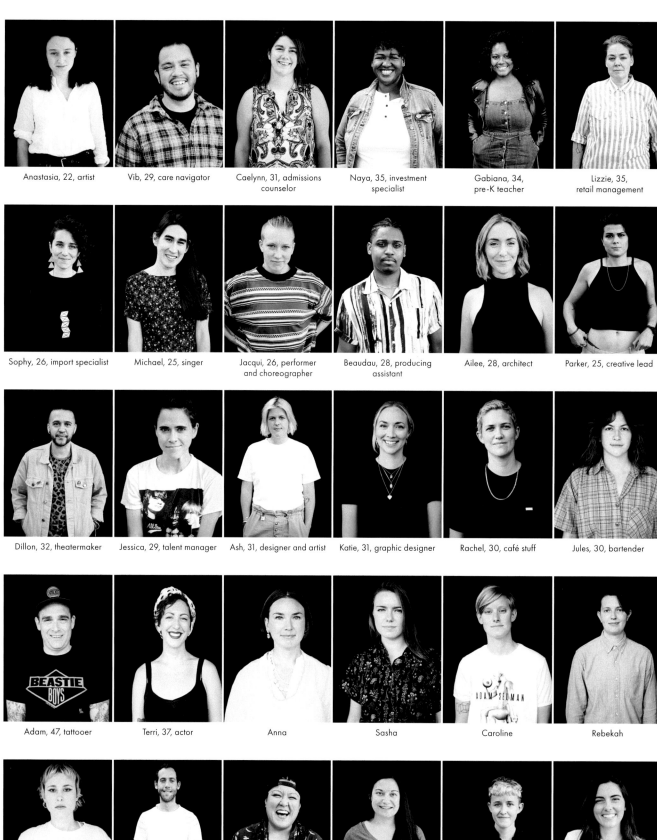

Anastasia, 22, artist

Vib, 29, care navigator

Caelynn, 31, admissions counselor

Naya, 35, investment specialist

Gabiana, 34, pre-K teacher

Lizzie, 35, retail management

Sophy, 26, import specialist

Michael, 25, singer

Jacqui, 26, performer and choreographer

Beaudau, 28, producing assistant

Ailee, 28, architect

Parker, 25, creative lead

Dillon, 32, theatermaker

Jessica, 29, talent manager

Ash, 31, designer and artist

Katie, 31, graphic designer

Rachel, 30, café stuff

Jules, 30, bartender

Adam, 47, tattooer

Terri, 37, actor

Anna

Sasha

Caroline

Rebekah

Nati, 29, hairstylist

Omer, 26, artist

Ednita, 35, barber and bartender

Alissa, 27, environmental specialist

Jess, 26, frame shop manager

Sophia, 27, manager

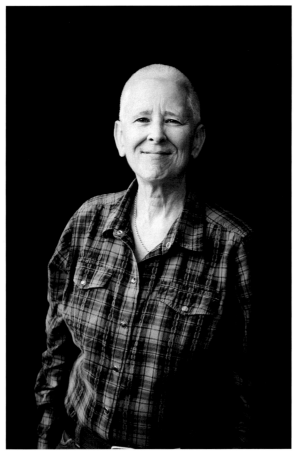

Michelle, 62, custodian

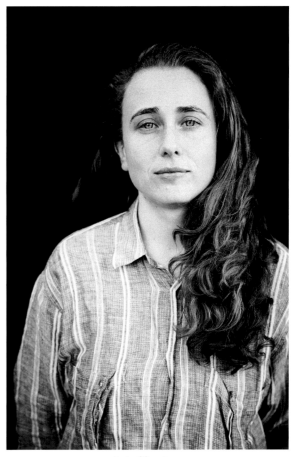

Annie, 25, waitress

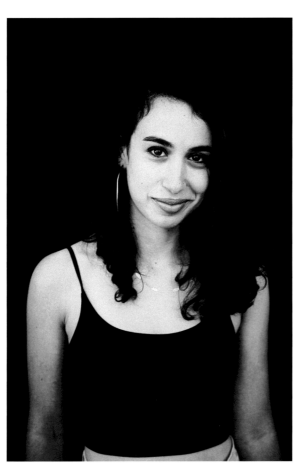

Michela, 24, nonprofit

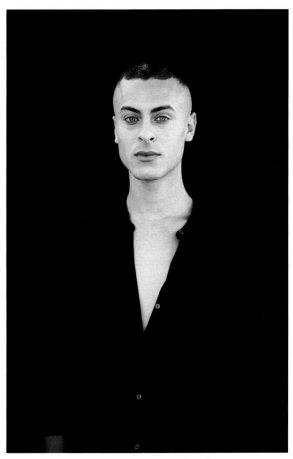

Cory, 28, model, musician, and speaker

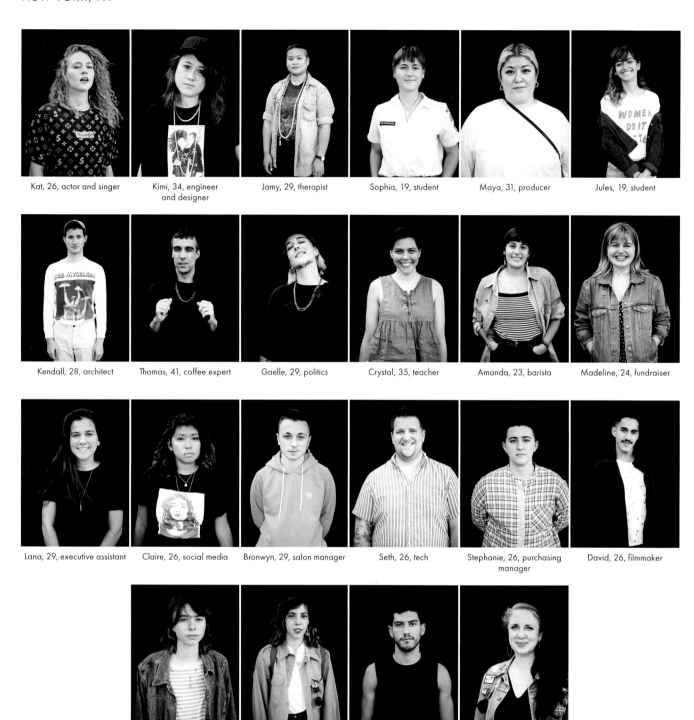

Kat, 26, actor and singer

Kimi, 34, engineer and designer

Jamy, 29, therapist

Sophia, 19, student

Maya, 31, producer

Jules, 19, student

Kendall, 28, architect

Thomas, 41, coffee expert

Gaelle, 29, politics

Crystal, 35, teacher

Amanda, 23, barista

Madeline, 24, fundraiser

Lana, 29, executive assistant

Claire, 26, social media

Bronwyn, 29, salon manager

Seth, 26, tech

Stephanie, 26, purchasing manager

David, 26, filmmaker

Avishag, 24, musician

Mika, 28, writer

Frank, 28, writer and performer

Erin, 39, museum membership

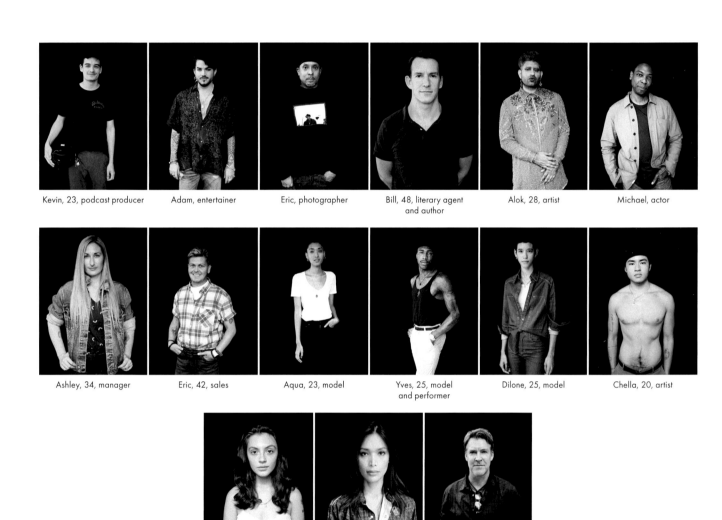

Kevin, 23, podcast producer Adam, entertainer Eric, photographer Bill, 48, literary agent and author Alok, 28, artist Michael, actor

Ashley, 34, manager Eric, 42, sales Aqua, 23, model Yves, 25, model and performer Dilone, 25, model Chella, 20, artist

MaryV, 21, photographer Geena, 35, producer Brian, 48, actor

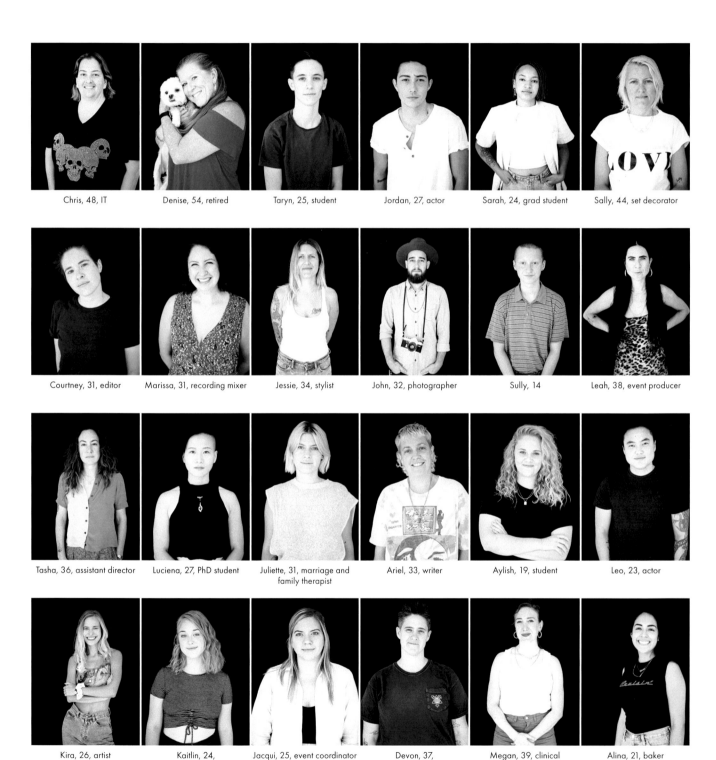

Chris, 48, IT

Denise, 54, retired

Taryn, 25, student

Jordan, 27, actor

Sarah, 24, grad student

Sally, 44, set decorator

Courtney, 31, editor

Marissa, 31, recording mixer

Jessie, 34, stylist

John, 32, photographer

Sully, 14

Leah, 38, event producer

Tasha, 36, assistant director

Luciena, 27, PhD student

Juliette, 31, marriage and family therapist

Ariel, 33, writer

Aylish, 19, student

Leo, 23, actor

Kira, 26, artist

Kaitlin, 24, behavior therapist

Jacqui, 25, event coordinator and graphic designer

Devon, 37, writer and director

Megan, 39, clinical psychologist

Alina, 21, baker

Lee, 27, learning and development specialist

Elliot, 23, actor

David, 27, software engineer

Griffin, 37, actor and writer

Oya, 24, singer

Alexys, 42, production design

Bridgid, 35, writer

B, 22, filmmaker

Jill, 30, advertising

Selina, 29, VFX

Luke, 26, PR and marketing

Aria, 32

Mindy, 35, designer

Rook, 42, professor

Genna, 26, retail and artist

Marina, 50, photographer

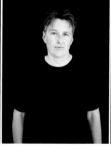

Bobby, 28, musician and artist

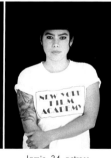

Cole, 27, photographer

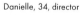

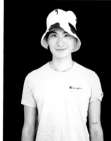

Danielle, 34, director

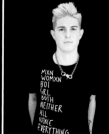

Kris, 27, model

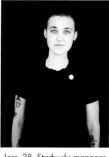

Nina, 26, cannabis

Conner, 17, high school

Andrea, 46, professor

Jamie, 34, actress, producer, and realtor

Dicko, 27, artist

Kai, 27, actor

Jess, 28, Starbucks manager

Lauren, 27, architect

Tori, 28, architect

Matt, 27, writer

Cat, 33, creative director Tat, 34, DJ Alexis, 32, comedian Em, 24, graphic artist Evey, 24, theatrical educator Ashley, 30, kitchen server

Travis, 35, manager Joshua, 38, writer Kaitlin, 31, marketing manager Derrick, 37, office worker Regan, 23, rowing coach

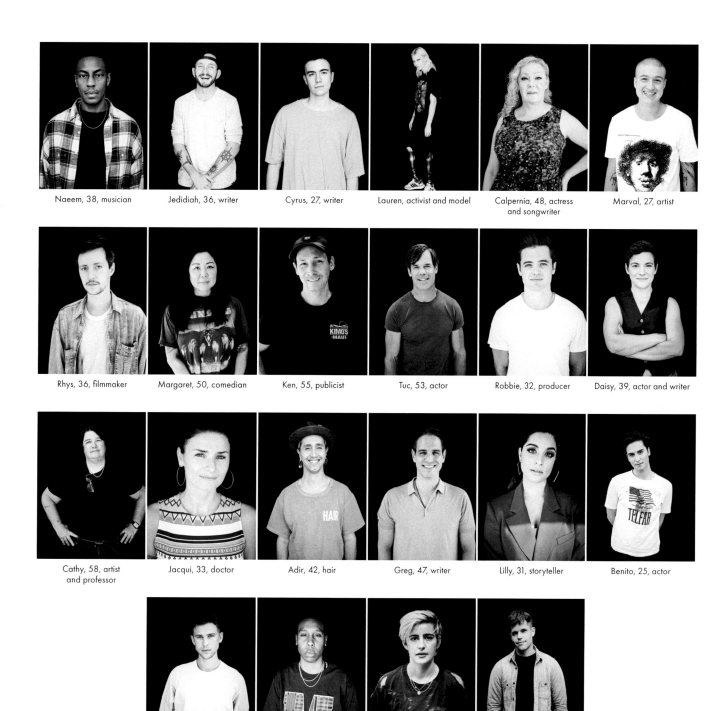

Naeem, 38, musician

Jedidiah, 36, writer

Cyrus, 27, writer

Lauren, activist and model

Calpernia, 48, actress and songwriter

Marval, 27, artist

Rhys, 36, filmmaker

Margaret, 50, comedian

Ken, 55, publicist

Tuc, 53, actor

Robbie, 32, producer

Daisy, 39, actor and writer

Cathy, 58, artist and professor

Jacqui, 33, doctor

Adir, 42, hair

Greg, 47, writer

Lilly, 31, storyteller

Benito, 25, actor

Tommy, 27, actor and writer

Lena, 35, writer, producer, and actor

Jacqueline, 27, actor

Charlie, 31, actor

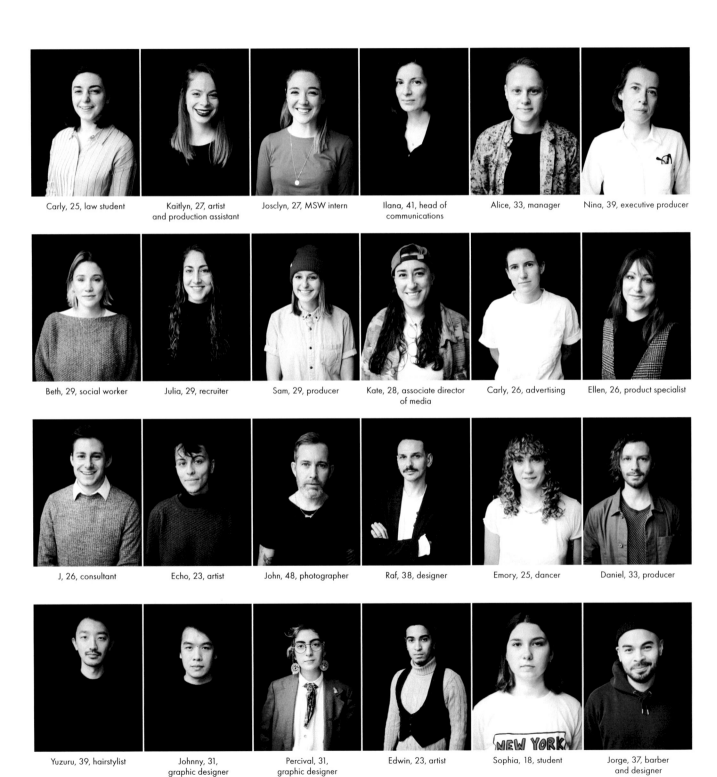

Carly, 25, law student

Kaitlyn, 27, artist
and production assistant

Josclyn, 27, MSW intern

Ilana, 41, head of
communications

Alice, 33, manager

Nina, 39, executive producer

Beth, 29, social worker

Julia, 29, recruiter

Sam, 29, producer

Kate, 28, associate director
of media

Carly, 26, advertising

Ellen, 26, product specialist

J, 26, consultant

Echo, 23, artist

John, 48, photographer

Raf, 38, designer

Emory, 25, dancer

Daniel, 33, producer

Yuzuru, 39, hairstylist

Johnny, 31,
graphic designer

Percival, 31,
graphic designer

Edwin, 23, artist

Sophia, 18, student

Jorge, 37, barber
and designer

Brian, 30, freelance design

Katie, 35, CEO of Higher Dose

Nela, 34, photographer

Sophia, 24, artist

Casey, 25, brewer

Yael, 29, hairdresser

Josh, 27, artist

Rhiana, 41, attorney

Lia, 28

Faith, 21, server

Andrew, 31, higher ed admin

Laura, 34, academic and artist

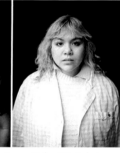

Caroline, 36, art teacher

Kit, 26, stripper

Denise, 35, unemployed

Jaime, 45, marketing

Santo, 20, illustration student

Katlyn, 20, student

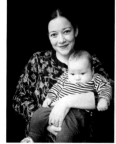

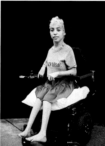

Lisa, 37, community marketing

Jillian, 32, model

Ashima, 42, creative director

Allison, 44, photographer

Steph, 29, interior design

Tara, 27, copywriter

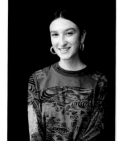
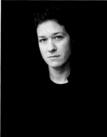
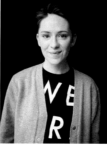
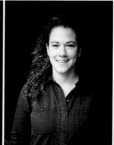

Hailey, 25, public media and vintage clothing hawker

Achs, 40, creative director

Q, 23, editorial assistant

Rachel, 30, communications

Fredrick, 41, marketing

Jules, 29, architectural designer

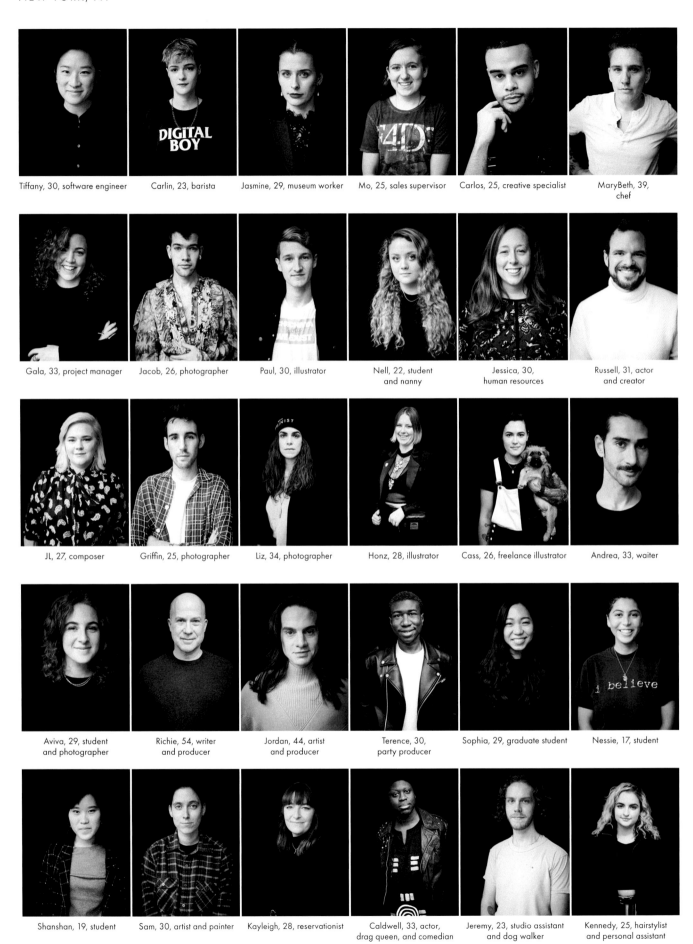

Tiffany, 30, software engineer

Carlin, 23, barista

Jasmine, 29, museum worker

Mo, 25, sales supervisor

Carlos, 25, creative specialist

MaryBeth, 39,
chef

Gala, 33, project manager

Jacob, 26, photographer

Paul, 30, illustrator

Nell, 22, student
and nanny

Jessica, 30,
human resources

Russell, 31, actor
and creator

JL, 27, composer

Griffin, 25, photographer

Liz, 34, photographer

Honz, 28, illustrator

Cass, 26, freelance illustrator

Andrea, 33, waiter

Aviva, 29, student
and photographer

Richie, 54, writer
and producer

Jordan, 44, artist
and producer

Terence, 30,
party producer

Sophia, 29, graduate student

Nessie, 17, student

Shanshan, 19, student

Sam, 30, artist and painter

Kayleigh, 28, reservationist

Caldwell, 33, actor,
drag queen, and comedian

Jeremy, 23, studio assistant
and dog walker

Kennedy, 25, hairstylist
and personal assistant

Mikaela, 20, musician

Kiersey, 26, actor

Ebony, 27, stunt performer

Quinn, 26, director

Christine, 30, artist and writer

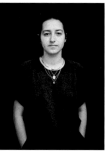

Nicolette, 26, real estate agent

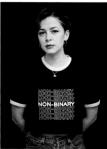

Jacqueline, 24

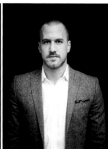

Jesse, 30, real estate sales

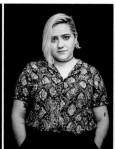

Allison, 24

Jaymes, 24, writer and producer

Gaby, 36, program manager

Michael, 36, accounting manager

Marissa, 37, agent

Hannah, 23, agent's assistant

Cole, 17, student

Marine, 24, executive assistant

Lauren, 28, social worker

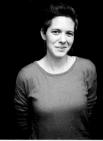

Melissa, 41, store manager

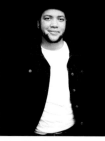

Yaz, 30, software engineer

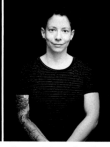

Kristina, 34, social worker

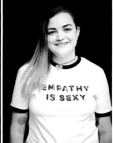

Fara, 25, architect

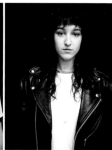

Natalie, 21, student

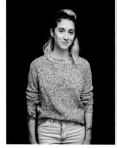

Rachel, 32, dancer and yoga instructor

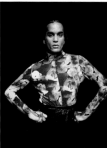

Richie, 27, photographer

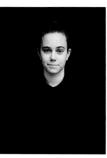

Sarah, 27, social worker

Tess, 26, health policy and advocacy

Maddy, 23, mental health worker

Nix, 22, actor and writer

Oscar, 51, producer and husband

Carter, 21, oral historian and photographer

Axelle, 24, photo assistant

Will, 40, photographer

Liliet, 28, photographer and videographer

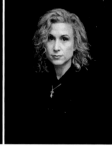

Jamie, 39, creative direction and photography

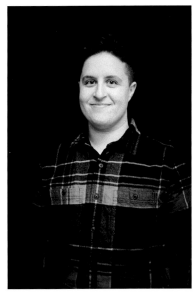

Trace, 28, teacher

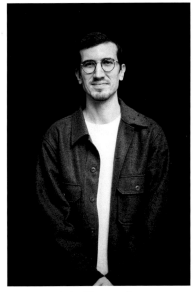

Ruda, 30, prop maker

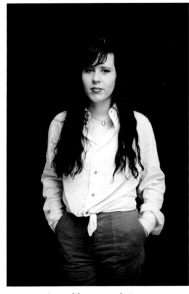

Lowri, 30, costume designer

Blaise, 39, marketing

Luca, 27, HR business partner

Julio, 32, comedian

Rachel, 41, manifester

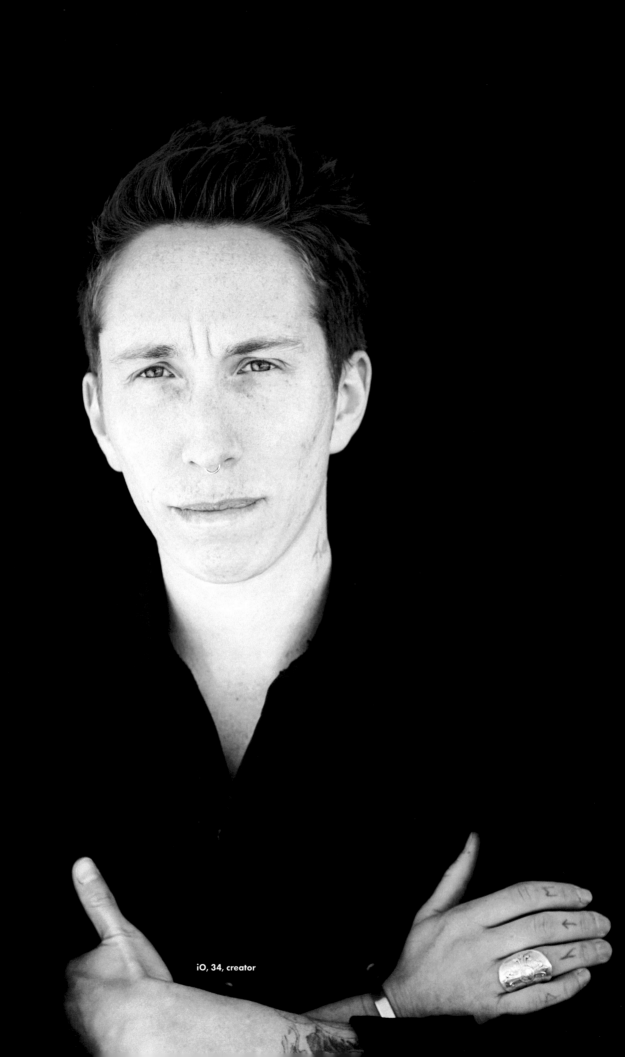

iO, 34, creator

WE
ARE
YOU

iO Tillett Wright is the founder and photographer behind the Self Evident Truths project. A polymath native New Yorker, he now calls Southern California home. He is the author of *Darling Days: A Memoir* (2016) and host and producer of the podcast *The Ballad of Billy Balls*. He has co-hosted MTV's *Catfish: The TV Show* and was the creator in 2012 of the hit TED Talk "50 Shades of Gay."

iO's life purpose is encouraging people to be real about who they are and to get psyched about it.

ACKNOWLEDGMENTS

Thank you to every person in this book for being vulnerable and honest and showing yourself.

I want to thank all the parents who showed up with their children, sometimes having come from across town, sometimes having driven many hours. Each of you keeps every one of us alive.

Thank you to everyone who has purchased a We Are You shirt to keep the lights on.

Yosi Sergant for the invitation that led to this idea.

Seth Tillett for telling me the idea wasn't strong, so I could defy you.

Cassidy Karakorn for being the first to spot the project's potential and support it; RIP, friend.

Kashi Somers for signing on to be my co-pilot and riding with me for so many years.

Eve Ensler for believing in the project and launching it into the stratosphere.

James Lecesne for being my fairy godfather and believing in this vision.

Tyler Renner for following me into the sunset and sleeping on countless couches.

L.A. Hall for tireless devotion and a beautiful eye.

Liz Gipson, Jenny Seo, Sam Alavi, Luke Kawasaki, Bronte Price, Maggie Davis, Allyce Engelson, and Camille Breslin for being the crew that kept it forward-moving along the way.

Jess Oldham for keeping the lights on for real!

Chad Hinson, for unequivocally believing in me and this project, and shepherding it to its final resting place. You are a king.

My number one, Rachel Lee Wright.

Sarah Weichel, for patience and guidance.

Thank you to Raimy Rosenduft, Dan Monick, Bianca Butti, Amelia Tovey, and Tegan Quinn.

Nathan Drillot, Jeff Petry, Vanessa Smith, Amara Untermeyer, Daniel Ramirez, Mira Chang, Lydia Tenaglia, Sandy Zweig and others for trying to document this spinning wheel over the years.

Alessandro Zuek Simonetti for encouraging me to keep shooting pictures.

Finally, Bill Clegg, Rebecca Wright, Anthony Bourdain, Olivia Thirlby, Amber Heard, Ali Gitlow, Fraser Muggeridge, Aimee Selby, Caroline Noseworthy, and my godchildren, Lucia, Aiya, Nina, Mishi, and Aidan.

© Prestel Verlag, Munich · London · New York, 2020
A member of Verlagsgruppe Random House GmbH
Neumarkter Strasse 28 · 81673 Munich

Prestel Publishing Ltd.
16–18 Berners Street
London W1T 3LN

Prestel Publishing
900 Broadway, Suite 603
New York, NY 10003

Library of Congress Control Number: 2020930977

A CIP catalogue record for this book is available from the
British Library.

Editorial direction: Ali Gitlow
Copyediting: Aimee Selby
Design and layout: L.A. Hall and Fraser Muggeridge studio
Production management: Friederike Schirge
Separations: Reproline Mediateam, Munich
Printing and binding: C&C Printing

FSC
www.fsc.org
MIX
Paper from
responsible sources
FSC® C008047

Verlagsgruppe Random House FSC® N001967
Printed in China
ISBN 978-3-7913-8691-1
www.prestel.com